SURREALISM

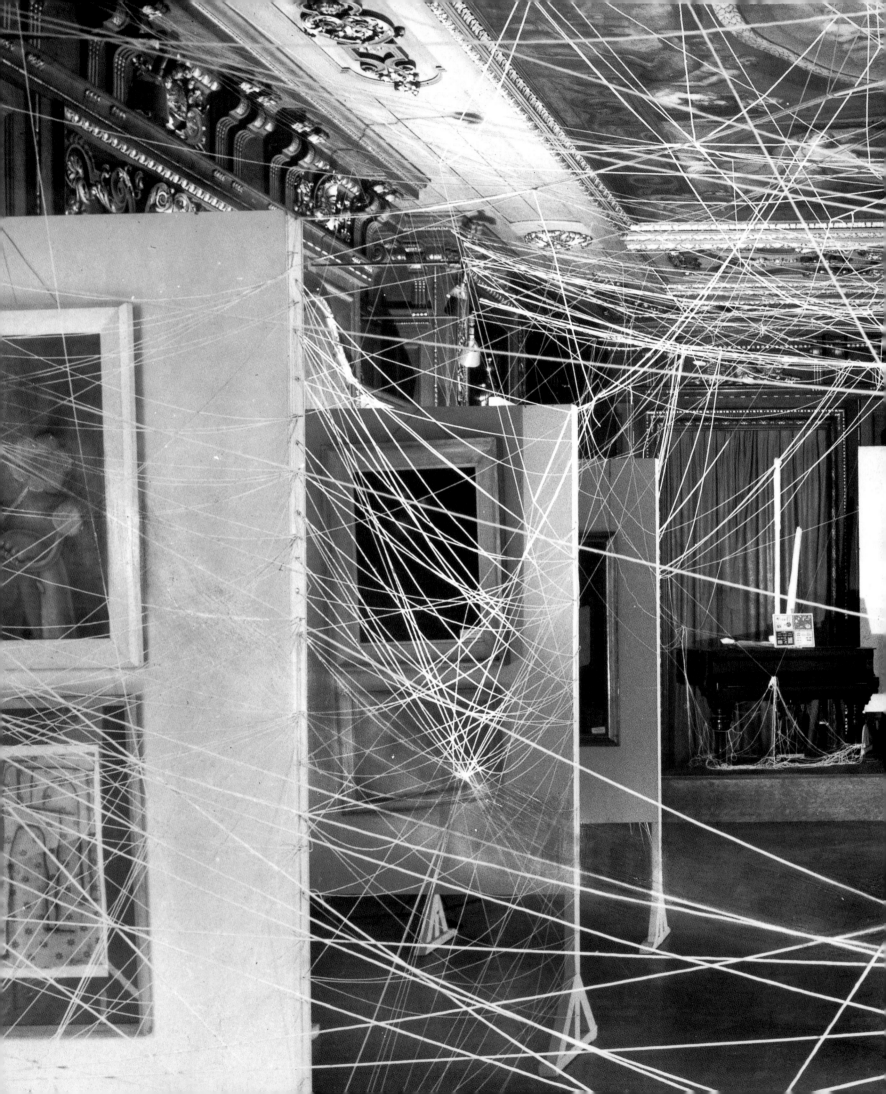

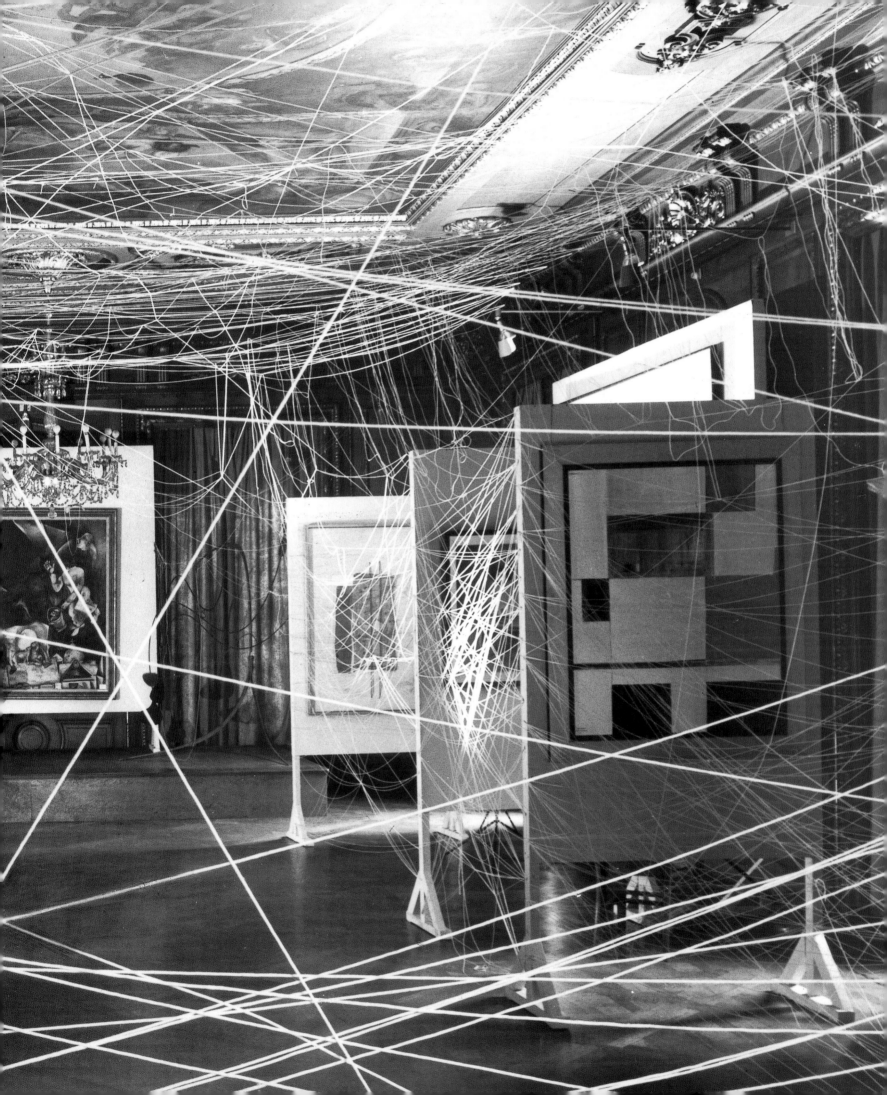

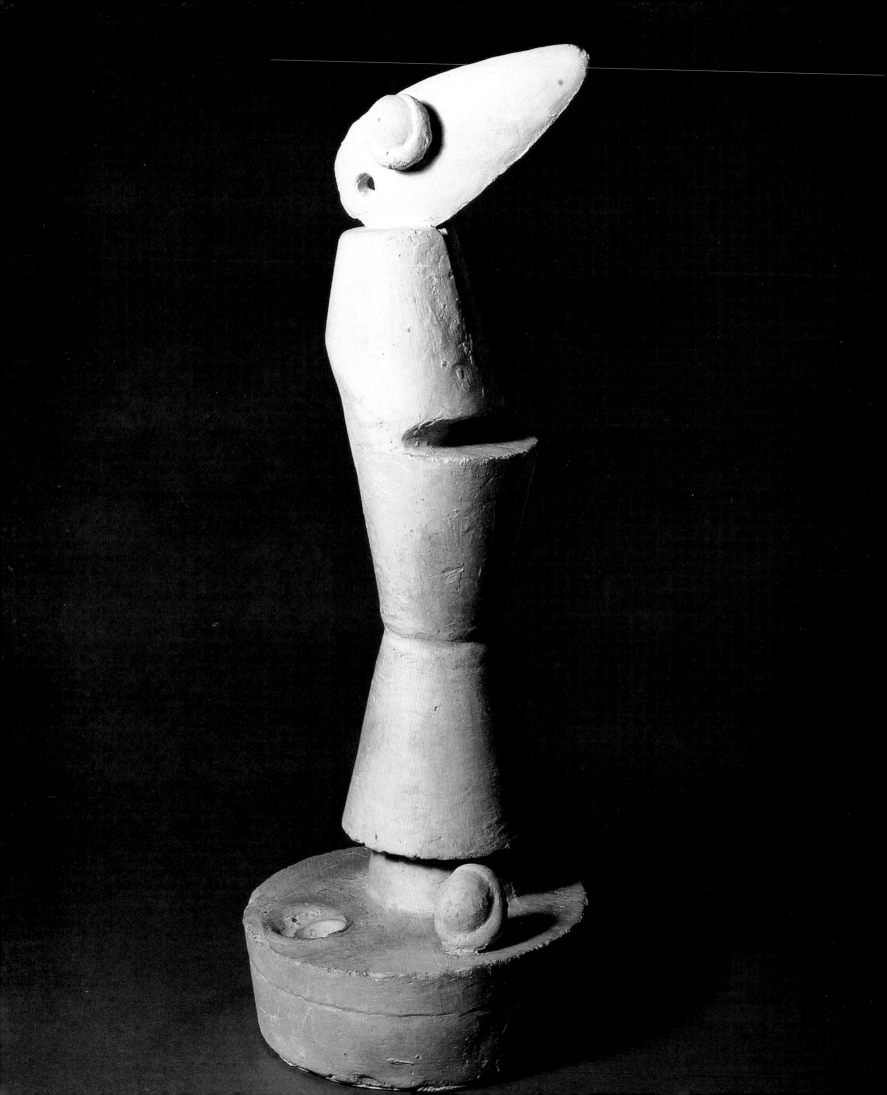

SURREALISM

EDITED BY MARY ANN CAWS

WORKS page 48

DESIRE page 118

DELIRIUM page 144

INFINITE TERRAINS page 166

PRE-FACE

BY MARY ANN CAWS

The selection and arrangement of material for a survey on such a major subject as Surrealism, while difficult and exacting, would have been well-nigh impossible were it not for the impressive and ongoing intellectual labour of a great assembly of critics, art historians, curators, editors, translators, writers, collectors and scholars of many disciplines. Apart from the individual acknowledgements to be found elsewhere in this book, I want to make that general statement before anything else, and mean it to be taken as a serious thanksgiving.

As for the conception and layout of this volume, the separate sections – constellations of images and writings coresponding to prevailing themes at different stages – are ultimately intended less as divisions than as holders of infinitely mobile elements, often exchangeable with one another. Like the surrealist notion of communicating vessels, these containers participate in the notion of passage: the edges are open, so that one idea or image or thought or term can pass into another. This in turn resembles the surrealist game of 'one in the other' (*L'un dans l'autre*), in which something leads to something else that the rational mind might not have thought of, the dreamer might not have dreamed of. The point of any surrealist gathering, whether of persons or texts or interpretations, is to stress our willing openness to the unexpected, holding our material and ourselves, in so far as possible, in a surrealist state of readiness.

SUR-
BY MARY ANN CAWS
VEY

Our thought is an eye.

Xavier FORNERET (1809-1884)

'Poetic Surrealism … has focused its efforts up to this point on re-establishing dialogue in its absolute truth, by freeing both inter-locutors from any obligation of politeness … The words, the images are only so many springboards for the mind of the listener.' – André Breton, *Manifesto of Surrealism*, 1924.[1]

To open any survey of an art movement, in particular such a self-willed, revolutionary one, with a return to its so obvious leader is a choice made on instinctive and personal grounds. Of all the Surrealists it is surely André Breton – the instigator and chief interpreter of the movement for over four decades – whose words have been the most lasting over the years. The theoretical and experimental writings of Louis Aragon,

René Crevel and Robert Desnos are often vivid, even brilliant, to say nothing of those of Antonin Artaud or Salvador Dalí; the lyrical texts of Paul Éluard are celebrated, just as those of Benjamin Péret should be; and so on. But Breton's voice will start off here, as it did in the beginning, partly because it prepares us for the inclusion of the other voices necessary for us to hear. Inclusions, exclusions, invitations and banishments: all of these are part of the well known history of surrealist party politics, as it changes. Our concern here is what we listen to initially, and what endures.

If Breton considers the surreal as a *dialogue* with the other (with what is encountered by way of dreams, coincidences, correspondences, the marvellous, the uncanny; a reciprocal exchange, connecting conscious and unconscious thought) then so shall we.[2] As readers and viewers we are empowered to remain in discourse with both his and Surrealism's many other voices and ways of being, as they continue to engage our own. As in the epigraph, the ultimate truth resides in the interchange itself, as well as in its very possibility. When we ascribe Breton's adjective 'poetic' – in its full meaning, far beyond that of any genre – to the noun 'surrealism', the choice already informs our gaze. The poetic is the opposite of the expected; it is spontaneous – a crucial criterion for the

surrealist notion of the marvellous, that which unexpectedly arouses wonder when we chance upon it, or when it chances upon us. Never predetermined, it is created on the spot, in the terrain – like a 'conducting wire' fusing the external with the internal world – often through a quest we didn't know we had, or were up to. Our new perception is made possible by our openness to whatever might happen: this is the *comportement lyrique*, the 'lyric behaviour' that surrealist living, seeing and creating requires.

The Surrealists championed this spontaneity – with its jagged edges manifest in their writings and artworks – as a deliberate defying of the linear, rational discourses they held responsible for the catastrophes of war in their time. Often feeling so present in relation to our own unruly discourses, Surrealism's language, images and ideas hold our attention still, strangely. What remains at stake in these intense encounters between the everyday and the imaginary can be indicated through the ideas of the erstwhile postman[3] turned Sorbonne professor and philosopher of science, Gaston Bachelard – described

by some of Breton's circle as the philosopher of Surrealism.[4] In Bachelard's first book, begun as a series of empirical studies of natural phenomena, an intuitive sense of poetry drew him towards the seductiveness of flames (*The Psychoanalysis of Fire*; *La Psychanalyse du feu*, 1938),[5] even as the scientist in him wanted to resist, to preserve strict objectivity.[6] In the books that followed, such as *Water and Dreams* (*L'Eau et les rêves*, 1942),[7] he continued, now affirmatively, to explore each element in relation to the life of the mind. His intertwining of the imaginative and poetic with the analytical and scientific suggested the possibility of reaching beyond such commonplace dualities as inside and outside, day and night, awake and dreaming, experienced no longer as oppositions but as complementary and coexistent states. These investigations of what Bachelard came to call *surrationalisme* parallel Breton's evolving exploration of those states of mind and being which in the early 1920s he had chosen to name by the recently coined word *surréalisme*.[8]

For Breton, the possibility of arrival at a point of convergence (in both the perceived object and the receptive mind) of the daily and specific on the one hand and the marvellous and universal on the other, has the ability to modify, often profoundly, our perception and experience of the world. For us, such an encounter has the potential to alter the way we read. Crucially, this entails never placing a prior grid of theory over the text or the work of art. Whatever interpretation is relevant comes into being through our confrontation with the other in the work itself. Here it is important to hear in its full intent

Karl BLOSSFELDT Campanula, from *Art Forms in Nature* [*Urformen der Kunst*], published 1928; reproduced alongside Georges Bataille's '*Le Langage des fleurs*', *Documents*, 3, 1929
Kay SAGE Small Portrait, 1950

that memorable poem by Breton which starts 'Always for the first time'.[9] The enterprise is to be one of inclusion rather than reduction. As the Surrealists often asserted, the only bounds to our world are those which are self-imposed by the limitations of our own imagination and its verbal and visual expression. This too accords with Bachelard's thought, delivered as both philosopher and messenger – the postman of possibility.

Surrealism aimed above all to preserve a sense of the extraordinary, the unexplained and inexplicable. René Char, the Provençal poet who was briefly allied with the Surrealists (1929–33), warned readers and writers alike of the perils of too much clarity: 'do not strip the heart of the rose' ('*ne pas effeuiller le coeur de la rose*').[10] The dissident Georges Bataille's microscopic examination of a flower produced only further shocks, nothing perfumed and reassuring ('*Le Langage des fleurs*', *Documents*, 3, 1929). In Claude Cahun's paradoxical text '*Les Paris sont ouverts*' ('All Bets Are Open',

 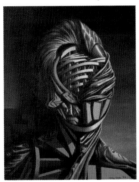

1934), she finds poetry keeping its own secret even as, and precisely when, it is revealed.

Breton's words, whether written or spoken, conveyed an intricate, complex prose lyricism, on the formal side, and on the visual side, an intense, mystical communion with paintings. Surrealism was to remain at once a public statement and a privileged domain. This cherished, contradictory stance is conveyed by the oft-quoted expression: 'Do not distribute the *pain maudit* to the birds.' The 'cursed bread', of course, is more hallowed than cursed by its secrecy. Much of the value of Surrealism depends on the creation of this margin of mystery. It is an art based on desire, and desire requires a necessary otherness, or it withers into boredom. Too radical an unveiling falls into platitude, satiety.

Thus, despite the intensive collectivity of its games and experiments, the surrealist universe is one in which a sense of solitude often prevails. The architecture of individual dream, so often invoked, calls upon the inner view. Surrealist art, like surrealist literature, often seems to arouse in the viewer a corresponding feeling of isolation. The intense

loneliness sensed in such poems of Robert Desnos as '*Jamais d'autre que toi*' ('Never Anyone But You', 1930) where the word 'alone' repeats and echoes – '*Et moi seul seul seul …*'[11] – also penetrates the visual realm, in the still and solitary images that come to haunt painters such as René Magritte, Kay Sage and Dorothea Tanning.

To detect such introversion is in no way to allege that Surrealism was quiet and hushed as a way of being, however. Just as before them the Futurists, Vorticists and Dadaists had loudly proclaimed their ideas and presence, so the Surrealists converged noisily in the aftermath of the First World War with their tracts and manifestos, but with a significantly different energy and purpose. Their concerns were serious, and their commitment to a dialogue with the other entailed actual political engagements, such as their attacks on French colonialism and nationalism, their serious thinking about the reconciliation of orthodox Marxism with avant-garde experimentation, their anti-fascist campaigns and their later anti-Stalinist efforts. These are all examples of their commitment to involvement in the world beyond their individual and collective dreams, images and imaginations.

Dialogue with Dada

In the midst of war in 1916 Dada had been launched in Zurich by the poet Tristan Tzara – small in stature but large in genius and charisma – along with fellow poets Hugo Ball and Richard Huelsenbeck and the artists Hans (Jean) Arp, Marcel Janco and Hans Richter. Totally rejecting the society and values it held responsible for such devastating conflict, Dada was a negative, contradictory and at the same time strident and exuberant movement, which quickly spread at the end of the war to New York, Barcelona, Berlin, Hanover, Cologne and finally Paris. It set itself up against reason and rationalism, against bourgeois society and culture, and should be considered, first and foremost, as a method of action and manifestation. As Tzara noted in his 1922 'Lecture on Dada': 'We have had enough of the intelligent movements that have stretched beyond measure our credulity in the benefits of science. What we want now is spontaneity. Not because it is better or more beautiful than anything else. But because everything that issues freely from ourselves, without the intervention of speculative ideas, represents us.'[12]

Tzara first came into contact with the Parisian scene through his correspondence with figures such as the artist

Francis Picabia and the poet Guillaume Apollinaire, and from around 1919 through the review *Littérature*, which Breton and the writers Philippe Soupault and Louis Aragon had founded in March of that year. *Littérature* encouraged and supported other young French writers such as Paul Éluard, Benjamin Péret and Jacques Vaché (1895–1919). The latter's embrace of the random, futile and absurd, and tragically young, possibly suicidal, death left a profound mark on the group.[13] It also began to exchange contributions to periodicals with the Dadaists outside of France, of whom the editors were aware through Tzara's Parisian connections. In January 1920 Tzara arrived in Paris in person to a grand welcome, and Dada became and remained for some time the movement to be dialogued with – at times Surrealism's mother and father, at others its brother and sister and, even, its self. Whereas Dada often better qualified itself as a performance than as a movement *per se*, Surrealism can also be seen as an action, a manifestation, but based on a desire for knowing and

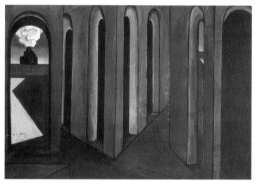

perceiving. That the object of knowledge and perception is desire itself in no way lessens that desire. Surrealism, like Dada, was always a shared endeavour – an experiment in how to extend the possible forms of writing, experiencing, deciphering, depicting and above all, thinking, as a collective experience.

Littérature also harboured the seeds of irony.[14] This was not the classic version of 'literature' but rather the semi-mocking *Lis tes ratures* ('read your leavings') or *Lits et ratures* ('beds and scrapings'). It was to be the cradle of Surrealism, and was open to new discovery and influence. *Littérature* continued until 1924, when the surrealist movement began in full force. In October of that year Breton published his *Manifeste du surréalisme*, which was followed, two months later, by the first issue of the newly organized group's review *La Révolution surréaliste*. He also brought out his first collection of critical and polemical essays, written between 1917 and 1923, which look back over the Parisian avant-garde scene and Dada and

towards Surrealism. They were titled *Les Pas perdus* (*The Lost Steps*), evoking the pacing up and down in waiting rooms of railway stations until the final moment of departure or arrival. The train is an icon of surrealist imagination, exemplified by that classic but anonymous photograph printed in the journal *Minotaure* in 1937, full of eroticism and longing, nostalgia and impossibility, where an abandoned train can be imagined rushing full speed ahead just as it was halted in its tracks by the virgin forest and its encroaching vines.[15] Giorgio de Chirico – whose 'metaphysical' scenes, rearranging the objects of sight to correspond to another, poetically ordered world, so influenced early Surrealism – continually returns to the image of a distant train which could equally be arriving or leaving, in the background of enigmatic paintings such as *The Anxious Journey* (1913) or another of 1914 evoking the Paris railway station *Gare Montparnasse*, subtitled *The Melancholy of Departure*.

Breton's '*Lâchez tout!*' ('Leave Everything!'), in *Les Pas perdus* shows his original espousal of the deliberately and, for some, delightfully negative outlook of Dada:

'Leave everything. Leave Dada. Leave your wife. Leave your mistress. Leave your hopes and fears. Leave your children in the woods. Leave the substance for the shadow. Leave your easy life, leave what you are given for the future. Set off on the roads.'[16]

Those seeking a kind of cult pilgrimage to nowhere but the opposite of where one is would have found the 'leave everything!' model alluring, even before – perhaps especially before – what one was leaving everything for had been clearly defined. Even Dada was supposed to be left, and so it was in its broad outlines. But some of its creators, such as Picabia and above all Marcel Duchamp were particularly esteemed by Breton and his group for their explorations of psychic and erotic themes via the phenomena of the machine age, as well as for their resolute independence. Later, Breton would find where he was going, evolving into a state of serious determination to found a new collective group whose revolution against the current state of affairs would be taken seriously. An openness to whatever might come would continue to be at the centre of Surrealism's self-definition. It remained a movement of high energy, diverging in various

Giorgio de CHIRICO The Anxious Journey, 1913

Anonymous photograph illustrating Benjamin Péret, '*La Nature dévore le progrès et le dépasse*', *Minotaure*, 10, Winter 1937

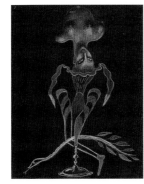

directions as the years went by – excited at first, looking for its way, then gradually cohering into something more formal: meetings every day at six o'clock in the same café, lasting for exactly one and a half hours. For a time in the early 1930s everyone would even consume the same beverage – in summer, Pernod, in winter, mandarin Curaçao. However, despite Breton's stress on such outward unanimity and discipline, what characterized Surrealism most, in his own thinking as much as in that of dissenters, was its insistence on constantly questioning and reinventing itself.

La Révolution surréaliste demonstrated the Surrealists' early exaltation and desire to show the public its findings. In December 1924, the first issue published the dream experiments initiated by the Bureau of Surrealist Research, established that October and whose stated intent was to 'gather all the information possible related to forms that might express the unconscious activity of the mind'.[17] In contrast to the avant-garde typography of dadaist tracts this new journal deliberately set itself up to resemble scientific periodicals of the time such as *La Nature*. Reports on dreams by Breton, de Chirico and Renée Gauthier were followed by examples of automatic writing, including contributions by Aragon, Jacques-André Boiffard, Robert Desnos, Éluard and Georges Malkine, and 'chronicles' by Aragon, Soupault, Max Morise and others, which began to explore the realms of imaginative encounter with significant objects and desires that would preoccupy the Surrealists for years to come.

One of the activities that emerged from this collective impulse during the following year was the '*cadavre exquis*' ('exquisite corpse'), a game based on folded papers. The first player puts down a noun, the second an adjective, the third a verb, and so on, in the order dictated by the French language, until the paper is unfolded and the sentence is read. The original one went: *le cadavre exquis boira le vin nouveau* (the exquisite corpse will drink the new wine). The same game was played with drawings: a head, a neck, a torso, the legs, the feet

... and what is unwrapped is generally a rather unusual body.[18]

The role of games in Surrealism is crucial to every moment of its development. In no sense were they considered trivial or frivolous diversions – they are always played seriously, as open-ended investigations of possibility. Of the *jeux de mots* (puns, or literally, games of words) Breton had remarked in 1922: 'Let it be quite understood that when we say "word games", it is our surest reasons for living that are being put into play. Words, furthermore, have finished playing games. Words are making love.'[19] Especially in the game of chess, referred to and played by so many of the Surrealists and which eventually becomes Duchamp's principal activity, the ongoing reason for play emerges: it is the play of the mind itself, lit up at its grandest moments. As William Rubin noted in his *Dada and Surrealist Art* (1968): 'Chess seemed to make possible a constant renewal of the formative process ... involving as it does a combination of mathematics and space, logic and imagination, in which the result is zero in the sense that the board is swept clean.' It carried forward into the domain of Surrealism the Dada conviction 'that the value of creative activity lies in the doing, in the act of making, rather than in the aesthetic significance of the thing made'.[20]

Against all that had hitherto been deemed aesthetic, as well as the two enemies of rationalism and nationalism, the budding surrealist revolution of thought took its stance. When Breton and Soupault collaborated to write the first 'automatic' text, *Les Champs magnétiques* (*The Magnetic Fields*) as an experiment in 1919, several years before the idea of Surrealism was coherently defined, they were espousing a sense of openness to what might appear, be heard, transpire.[21] It is worth noting that the speed at which they took dictation from the unconscious is marked down in the entries here: it is not just what comes into the mind that matters, but the rate at which it can be transcribed. In the first manifesto Breton describes how they set out to record 'a monologue spoken as rapidly as possible without any intervention on the part of the critical faculties, a monologue consequently unencumbered by the slightest inhibition and which was, as closely as possible, akin to spoken thought.'[22]

From the beginning this use of spontaneous expression was part of the surrealist agenda. To overcome the hesitations of the rational and conscious mind the resort to automatic

writing was widespread. The unleashing of the full potential of the unconscious was the point of these experiments, which evolved into sleep séances to induce automatic speech while in a trance. The poet Desnos was the hero of these sessions. He was particularly noted for his ability to fall asleep at almost any time and in any place and to continue speaking, writing, acting and responding while in this trance-like condition – even picking up a brush and painting for the first time, to everyone's astonishment. Aragon describes these sessions in *Une Vague de rêves* (*A Wave of Dreams*, 1924):

'In a café, amid the sound of voices, the bright light, the jostlings, Robert Desnos need only close his eyes, and he talks, and among the steins, the saucers, the whole ocean collapses with its prophetic racket and its vapours decorated with long oriflammes. However little those who interrogate this amazing sleeper incite him, prophecy, the tone of magic, of revelation, of revolution, the tone of the fanatic and the apostle, immediately appear. Under other conditions,

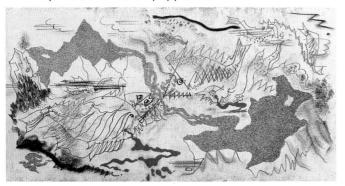

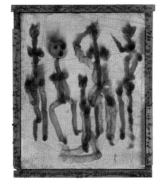

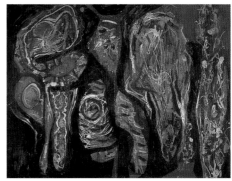

Desnos, were he to cling to this delirium, would become the leader of a religion, the founder of a city, the tribune of a people in revolt.'[23]

Was it genuine, and does that matter? As Aragon goes on to say: 'Is simulating a thing any different from thinking it? And what one thinks exists. You will not alter my conviction on this.'[24] Moreover, Desnos advocated for drawing and painting the unpremeditated procedure of scribbling on the surface, and subsequently starting from those lines to construct the final work. Such techniques for liberating the rational self into free expression, informally termed 'doodling', were exemplified by the early automatic drawings and paintings of André Masson and Yves Tanguy in particular. Automatism continued along its path through Surrealism and beyond, long after it ceased to be the centre of interest for Breton and other original members of the group. It is the impetus which underlies the working methods initiated by artists such as Óscar Domínguez, born in the Canary Islands, who joined the

Paris group in 1934, a year later rediscovering the technique of *decalcomania*, a kind of transfer in which paint is spread onto smooth coated paper and another sheet is pressed, usually several times, onto it, for inkblot images to emerge – a method used for inspiration by several European writers of the Romantic era and adapted as an analytical tool by the psychologist Rorschach in the 1920s but which, crucially, in Surrealism was performed without any preconceived objective. Other innovators included the Austrian painter and writer Wolfgang Paalen, a Surrealist by 1936, who introduced his technique of *fumage*, where the deposit of smoke from a candle or oil lamp forms the image; and the Chilean artist Roberto Matta, who began participating in surrealist exhibitions in 1938 and developed out of automatic techniques and forms his complex spatial depictions of inner landscapes of the mind, which he termed 'psychological morphologies'. Such ideas were transmitted, through Matta, the expatriot British artist Gordon Onslow Ford and the New

York painter Robert Motherwell, to the generation associated with Abstract Expressionism, including William Baziotes, Gerome Kamrowski, Jackson Pollock and the Armenian born Arshile Gorky, who in the early 1940s were described by some commentators as Abstract Surrealists.[25] Motherwell never lost his enthusiasm for what he had experienced as 'plastic automatism', applying the automatic techniques of writing to painting.[26]

As Masson explained it, doodling was primarily about making a mental void within yourself: 'the automatic drawing, having its source in the unconscious, must appear like an unpredictable birth. The first graphic apparitions on the paper are pure gesture, rhythm, incantation, and as a result: pure doodles.'[27] In the second stage, he said, the image would reappear and reclaim its own rights.[28] Just as many of his works register combat and conflict – such as the *Battle of Fish* (*Bataille de poissons*, 1926) which emerges from layers of glue and sand and lightning strokes of pen and brush – they also

André MASSON Battle of Fish [*Bataille de poissons*], 1926
Wolfgang PAALEN Untitled [*fumage*], 1937
William BAZIOTES, Gerome KAMROWSKI, Jackson POLLOCK Collaborative Painting, 1940-41

illustrate the energy that arises from this discord, which both vivifies and balances the calmer background.[29] In their anxious lines and consciousness of extraneous matter this painting and its sequels, such as *Fish Drawn in the Sand* (*Poissons dessinés sur le sable*, 1927), combine a notion of elemental nature – in the atomized state of sand as it mixes with the glue and paint – with animal energy – the fish – and a sense of violence conveyed through its quickfire gestures.[30]

Chasing Down the Unconscious

The point of these experiments in expression was summarized in the well-known definitions of the first manifesto:

'SURREALISM, *n*. Psychic automatism in its pure state, by which one proposes to express – verbally, by means of the written word, or in any other manner – the actual functioning of thought. Dictated by thought, in the absence of any control exercised by reason, exempt from any aesthetic or moral concern.

'ENCYCLOPAEDIA. *Philosophy*. Surrealism is based on the belief in the superior reality of certain forms of previously neglected associations, in the omnipotence of dream, in the disinterested play of thought.'[31]

To shake off the fetters of the rational in the thinking individual – permitting the imagination to take its free course – was to undercut the terms of the conventional, to find what lay beneath the veneer of an over-sophisticated society. As the writer of Surrealism's first major history, Maurice Nadeau, described it, the aim of Surrealism was 'to rediscover life under the thick carapace of centuries of culture – life pure, naked, raw, lacerated'.[32] This enthusiasm for the unveiling of the unconscious was seen as closely allied with the findings of psychiatry. In 1916 Breton, then a young medical student, began his work in psychology under former students of Jean-Martin Charcot, the influential neuropsychiatrist who had analysed and photographed female subjects in the 1870s, displaying symptoms of the conditions then described as hysteria. In 1917 Breton and Aragon first met while serving as medical auxiliaries in the psychiatric ward of a military hospital, working with soldiers traumatized by the war. It was through the soldiers' accounts of their delirious and compulsively repeated morbid visions that Breton first intuited the ideas which would form a psychic basis for Surrealism. Simultaneously but probably unknown to Breton

at that time Sigmund Freud was developing his notion of compulsive repetition from which would emerge his theories of the uncanny and the death drive, not published in France until some time later, his paper on '*Das Unheimlich*' ('The Uncanny', 1917–19) not appearing in translation until 1933.[33]

Although Breton was initially unable to study Freud's works at first hand, relying on digests until the translations began to be available from 1922 onwards, he was predictably eager to meet the Viennese doctor, convinced that the Surrealists' experiments with dreams, trance-like states, and their interpretation would fascinate him. After all, one of Freud's most important works was *The Interpretation of Dreams* (1900), so how could the surrealist efforts in psychic automatism possibly leave him cold? Alas, when they finally met in Vienna in 1921 Freud was profoundly unmoved and Breton was gravely disappointed by his general lack of interest in the French movement. All the same, the surrealist passion for the discoveries of the unconscious remained unabated. Breton's *Les Vases communicants* (*Communicating Vessels*), published in 1932, is composed of dream interpretation, its title drawn from a phrase he used to compare the relationship of dreams to reality with the gases that are circulated in scientific experiments from one glass jar to another, charged with all the energy of exchange.

Dream is, of course, commonly considered as the peak of the unconscious mind's experience, and a resource for the conscious analysis of that experience. The opening up of the field of possibilities was never more exciting to the group than in dream phenomena, whether interpreted collectively or singly. Far beyond the dull colours of the real, as the young Surrealists perceived them, stretched this glorious uncontrollable openness, as far as the mind could reach. 'To sleep, perchance to dream … Ay, there's the rub'; from a surrealist perspective, Hamlet's precarious state of anxious vision was to be embraced. The 'rub' (quite literally in the case of Max Ernst's *frottage* technique of arriving at images by rubbing over various objects) was a visionary one, stirring up unforeseen occurrences and creating otherwise unthought of relationships. As Aragon writes in *Une Vague de rêves*: 'there are other relationships besides the real that the mind can grasp and which are just as primary, such as chance, illusion, the fantastic, the dream. These diverse species are united and reconciled in a genre which is Surrealism.'[34]

Freud's theories of the dream work underlie much of

Breton's major writing on and experimentation in this mode, epitomized in *Les Vases communicants*, in which various of his dreams are interpreted in the light of surrealist thought.[35] Yet Breton's reservations about Freud are visible, especially on two points: 'Freud, for whom the whole substance of the dream is nevertheless taken from real life, cannot resist the temptation of declaring that "the intimate nature of the unconscious [the essential psychic reality] is as unknown to us as the reality of the exterior world", giving thereby some support to those whom his method had almost routed.'[36] And more depressing still for Breton is Freud's declaration, 'ambiguous to say the very least, that "psychic reality" is just a form of particular existence that must not be confused with "material reality". Was it really worth it to have attacked, as he did previously, the "mediocre confidence of psychiatrists in the solidity of the causal link between the body and the mind"?'[37] For the Surrealists, the acknowledgement of that link is crucial, just as is the convergence of the exterior world

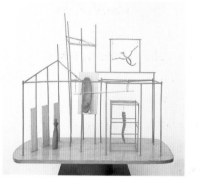 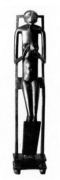 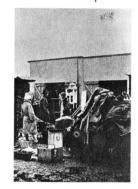

and the interior, of reality or the conscious daytime element and the world of night and the unconscious.

Encounters and Objects

The sculptures and drawings that Alberto Giacometti made during his affiliation with the Surrealists in the early 1930s often evoke the uncontrolled events of chance and the suggestion of reawakened memories, dreams and nightmares. In one of his manifestly open sculptures, *The Palace at 4 a.m.* (*Le Palais à quatre heures du matin*, 1932–33), simple pillars indicate the walls, and the entire structure is exposed to the universe, suggesting ultimate possibility. In *Minotaure*, 3–4 (December 1933) writing of this and other works of the period he described how 'once the object is constructed, I tend to find in it, transformed and displaced, images, impressions and facts that have moved me profoundly (often unknown to me), and forms that I feel to be very close to me, although I am often incapable of identifying them,

which makes them all the more disturbing to me.'[38] The last of his surrealist works, *The Invisible Object* (*L'Objet invisible*, 1934–35) shows an elongated female figure, reminiscent of carvings from the Pacific islands, with an angular face – derived, according to Breton's account in his experimental narrative *L'Amour fou* (1937), from an enigmatic metal mask which he and Giacometti had discovered together in one of their trips to the *Marché aux puces*, the Paris flea market at Saint-Ouen.[39] The figure's hands are raised – significantly in front of her breasts – and are just wide enough apart to hold something, a gesture which for Breton evoked the 'desire to love and to be loved' through 'the invisible but present object'.[40] He hoped that nothing would ever come to rest there, for fear that the hands might alter their position[41] and indeed they would remain forever unchanged, lending the void between them the feeling of being a space where the viewer can place whatever sentiment is evoked at any particular moment.[42]

The all-important notion of the found object – the *trouvaille* or *objet trouvé* – hinges on that which one comes across by chance. You find something in the outer world, says Breton, which responds to a question in the inner world that you had not consciously asked.[43] You happen upon it and – if you are someone inclined to the lyric behaviour of the Surrealists – you are naturally impelled to consider it significant. For the art historian Hal Foster, both the notion of chance, with its dependency on the act of encounter, and the *trouvaille* partake at once of the *imprévu* – that which could not have been expected – and the *déjà vu* – that which has already been seen.[44] Being a Surrealist means being in a constant state of receptivity and attentiveness to those chance occurrences in which objects, scenes and mental associations communicate themselves with more intensity than at ordinary moments.

The role of the surrealist object as such is first discussed by Breton in his *Introduction au discours sur le peu de réalité* (*Introduction to a Discourse on the Paucity of Reality*) written in 1924 and published in 1927:

'Recently I suggested that as far as is feasible one should manufacture some of the articles one meets only in dreams, articles which are as hard to justify on the ground of utility as on that of pleasure. Thus the other night during sleep, I found myself at an open-air market in the neighbourhood of Saint-

Malo and came upon a rather unusual book. Its back consisted of a wooden gnome whose white Assyrian beard reached to his feet. Although the statuette was of a normal thickness, there was no difficulty in turning the book's pages of thick black wool. I hastened to buy it, and when I woke up I was sorry not to find it beside me. It would be comparatively easy to manufacture it. I want to have a few of the same kind made, as their effect would be distinctly puzzling and disturbing.'[45]

In such thoughts lay the impetus behind the finding, creation or assemblage of the many forms of surrealist object which became prevalent in the early 1930s, brought together in their first large group exhibition at the Galerie Charles Ratton in Paris in 1936. The Surrealists artfully devised a series of categories, such as found objects, discovered in the flea markets; natural objects such as stones, to search for which Breton sometimes organized walks along the river Seine; 'interpreted' found or natural objects, which were

subtly altered by the artist in some way to reveal a new aspect; certain works dating from the Dada period, such as the readymade objects of Duchamp and 'assisted' readymades, which include Man Ray's alarming domestic iron, bristling with its sharp row of nails (*Gift*, 1921); 'perturbed' objects – natural or manufactured articles which have undergone some kind of deformation; assemblages; incorporated objects; phantom objects; dreamt objects; optical machines; poem-objects; mobile and mute objects; symbolically functioning objects; 'mathematical' objects, and so on.[46]

The most sustained engagement with the object would emerge in the work of the American artist Joseph Cornell – a fellow traveller alongside the movement – in the decades that followed his first box constructions of the 1930s, although Cornell insisted on his objects and views belonging to 'white magic' rather than the 'black magic' he associated with Surrealism. Here he describes one of his typical sightings while out walking:

'Bank window 59th Street. Exhibition of miscellaneous objects found in trunks of sailors (Seaman's home?) – shells, toy snake, whales' teeth, beads (exotic), a butterfly, box primitively constructed passe partout with wallpaper, glass, broken paper cover. (1 April 1943)'[47]

Cornell was a true master framer, bringing back to life in his mysterious shadow boxes all the haunting quality of nineteenth-century Romanticism – its singers, dancers and spirit. Like miniature stages, metonyms of the whole theatre of art, they invite the imaginative participation of the viewer, who is not so much an onlooker as an inlooker. With these emblems of a bygone era, which mark the haunting, ephemeral quality of what we have most cherished, Romanticism is reworked and relived ('we are', said André Breton, 'the tail of Romanticism, but how prehensile!').[48] Hotels in which there is no dwelling over any sustained period; perches from which the birds have disappeared; games forgotten, abandoned and unplayed: Cornell evokes the strongest presence exactly when he has marked an absence. Like Eugène Atget's hauntingly still photographs of empty Paris streets and shop window displays which so captivated the Surrealists, Cornell's memories become our own, his transfixed desires entering our own time and space. Of all the windows verbally displayed before us, and most closely corresponding to Cornell's shadow magic, Aragon's prose work *Le Paysan de Paris* (*Paris Peasant*, 1926) is the most lastingly hypnotic; in particular, as we read it now, a passage about a hairdressing salon, its Marcel wave[49] reminding us of Marcel Duchamp and, thus recalled, his haunting alter ego, Rrose Sélavy:

'I have seen the heads of hair uncoiling in their grottoes. Serpents, serpents, you never cease to fascinate me. So one day, in the Passage de l'Opéra, I found myself contemplating the pure, lazy coils of a python of blondness ... I have known hair that was pure resin, topaz hair, hair pulsing with hysteria. Blond as hysteria, blond as the sky, blond as tiredness, blond as a kiss. My palette of blondnesses would include the elegance of motorcars, the odour of sainfoin, the silence of mornings, the perplexities of waiting, the ravages of glancing touches. How blond is the sound of the rain, how blond the

song of mirrors! From the perfume of gloves to the cry of the owl, from the beating of the murderer's heart ... blondness of roofs, blondness of winds, blondness of tables or palm trees, there are whole days of blondness ... Blond everywhere: I surrender myself to this pitch pine of the senses, to this concept of a blondness which is not so much a colour as a sort of spirit of colour blended with the accents of love ... The dead hair suddenly took on a port-wine glint: the hairdresser was beginning the Marcel waving.'[50]

As if signalling across time to Rrose Sélavy, Cornell collages into one of his later works a photographic portrait by Man Ray of the young Breton, overpainting it to accentuate the curly locks, and calls it *Laundry Boy's Change*.

Word and Image

Surrealism is above all about discovering the terrains of the extraordinary in the midst of the ordinary, quotidian world. This is true both in the sphere of writing and that of the visual image, since in Surrealism they are so interdependent. As the movement had its initial impetus in the field of writing, it is natural that verbal pyrotechnics should have played a predominant role thereafter, both in the creation of the artworks and their reception. This may also account for some of the literalism that attaches to the images of painters such as Magritte. Along with the visual surprise, the observer may be tempted – inveigled, you might put it – into a literal-minded missing of the joke: a huge boulder doesn't belong in a domestic room; a train shouldn't emerge from a fireplace, and so on.[51]

More importantly, the written works, in their frequent brilliance of effect, are significant for the visual art both in terms of its theoretical shaping and its actual accomplishment. Thus the emphasis, in the chronological overview offered later in this essay, on the literary productions. The dates of many of the major pieces of surrealist writing are given here, since they are invaluable elements in the reception of the visual side of Surrealism. Furthermore, the impact of, say, Breton's narrative *Nadja* (1928) depends in part on the pictures – black and white reproductions of surrealist drawings, paintings, objects and personages, and Boiffard's photographs of seemingly mundane yet significant corners of Paris – which punctuate the text, disrupting readers'

habitual expectations. Similarly, the graphic quality of Robert Desnos' erotic text *La Liberté ou l'amour!* (*Liberty or Love!*, 1927) is accentuated by the full page facsimile of a calendar page for Monday 12 January 1870, opposite the line: 'Corsair Sanglot knew well the date when the calendar had stopped.'[52] A year earlier in *Le Paysan de Paris*, Aragon had similarly interspersed his writing with fastidiously recreated typographic signs, adverts and notices. In their journals and editions, the Surrealists frequently juxtaposed writings and poems with drawings, engravings, photographs and collages.

Much of the literature is, in fact, graphic in its detail and its overall effect. If one takes the idea of the convulsive, as in Breton's celebrated maxim from the end of *Nadja*, about the doomed, disturbed woman whom he briefly loved: '*la beauté sera convulsive ou ne sera pas*' ('beauty will be convulsive or will not be'), one instantly feels a visual charge. Images from Charcot's photographs of female hysterics convulsed in their seizures rush into the mind.[53] Later, in his essay '*La Beauté sera convulsive*' (*Minotaure*, 5, May 1934) Breton presents the image of a dancer caught up in her whirling skirts – illustrated with a photograph by Man Ray; convulsion attaches, mentally, to this idea of the *explosante-fixe*, at once impossible and totally convincing. The *explosante-fixe*, an object which is both stabilized and exploding in energy; the *érotique-voilée*, the clue to perception both heavily eroticized and somehow veiled over, and the *magique circonstancielle*, the happenstance that in the essential attentiveness or state of expectation turns out to be magically significant – these three tenets are in evidence everywhere and are at the heart of the surrealist notion of lyric behaviour. There is indeed something convulsive in many of the leading literary images; and in the visual art a sort of electrifying charge is set up, along the conducting wire that Breton claims leads from the eye of the beholder to the object seen.[54] It works in both directions.

Foster, in his study of Surrealism, *Compulsive Beauty* (1993), makes a convincing connection between the convulsive and the compulsive, and shows that the latter element resides in some of the principal components of surrealist theory, like the belief in automatic writing and speaking: 'If automatism points to an unconscious less liberatory than compulsive, this is all the more true of the marvellous, the concept that superseded automatism as the basic principle of Bretonian Surrealism.'[55] This idea is encapsulated in Breton's statement that the marvellous is

what tends to become the real.[56] One of the most interesting documents on this topic is Pierre Mabille's *Le Miroir du merveilleux* (*The Mirror of the Marvellous*, 1940), in which he attempts to revise and extend Breton's formulations:

'For me, as for the realists of the Middle Ages, there is no fundamental distinction between the elements of thought and the phenomena of the world, between the visible and the understandable, between what is perceived and what is imagined.

'And for that reason, the marvellous is everywhere. Understood in things, it appears as soon as we manage to penetrate any object at all. The humblest thing … is the result of the transformations that have taken place since the origin of the world, containing in germ the innumerable possibilities that the future will manage to bring about …

'Then consciousness will no longer enclose living impulses in an iron corset; it will be at the service of desire; reason, going past the sordid layout of common sense and logic

 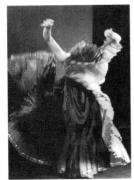

where it is dragging about today, will rejoin, now transcendent, the great possibilities of imagination and Dream.'[57]

Foster considers these surrealist categories of the marvellous – convulsive beauty and objective chance – in terms of the uncanny: 'as anxious crossings of contrary states, as hysterical confusings of different identities'. In his reading, *Nadja* and *L'Amour fou* show evidence 'that the two primary forms of objective chance, the unique encounter and the found object, are not objective, unique, or found in any simple sense. Rather, they are uncanny, and this to the degree that they invoke past and/or fantasmatic traumas.'[58]

In *L'Amour fou: Photography and Surrealism*, a major reassessment of photography's previously neglected role, researched and compiled with Jane Livingston as a book and touring exhibition (1985–86), the critic Rosalind Krauss examined the three categories of experience which Breton described in his *L'Amour fou* of 1937 and demonstrated how they enter the field of photographic work:

'In cutting into the body of the world, stopping it, framing

it, spacing it, photography reveals that world as written. Surrealist vision and photographic vision cohere around these principles. For in the *explosante-fixe* we discover the stop-motion of the still photograph; in the *érotique-voilée* we see its framing; and in the *magique circonstancielle* we find the message of its spacing.'[59]

Foster also emphasizes this connection, elaborating on the joining of elements in surrealist imagery. For example, recalling the anonymous photograph of the abandoned train described earlier, he analyses how through the sentence 'Train engine lies engulfed in a bed of vines … Nature devours the progress of the train that it once emblematized', the reader perceives the 'immanence of death in sexuality'. He continues: 'This violent arrest of the vital, this sudden suspension of the animate, speaks not only of the sado-masochistic basis of sexuality posed by the death drive theory, but also of the photographic principle that informs so much surrealist practice.' The photographic shock to the observer derives from the way in which this is a 'reality convulsed into a writing' – a combination of the 'veiled-erotic: nature configured as a sign' and the fixed-explosive: nature arrested in motion.[60]

One of the more riveting notions in Surrealism is the realization of an essential connection between the making of one of its creations, visual, verbal or critical,[61] and the entire surrealist project, whether one is on the receiving or creating end. Precisely in this lies a primary distinction between Surrealism and other movements. By way of illustration, if we take some examples of surrealist imagery which demonstrate typical ways of revising habitual thinking and seeing, it is possible to draw up some characteristics, this time in the work of some of its painters. Surrealist paintings often exhibit many of the same traits: a deeply mysterious atmosphere, with unexplained elements that seem to refer to something else seen, read or imagined beyond the canvas:

In a dusky urban setting with no human presence, where the scale and perspective of buildings, vistas and objects follows an unearthly logic, a single red glove is pinned to a wall, signalling something yet seeming as void as the gaze of a statue's head that floats beside it. (Giorgio de Chirico, *The Song of Love*, 1914.) A couple are suspended, copulating, in the night sky, their legs intertwined in a crescent with the moon. The erotic charge seems connected to the alchemical symbols depicted beneath, and the scene, full of an

Jacques-André BOIFFARD photograph reproduced in André Breton's *Nadja*, 1928: 'The Luminous Mazda poster on the Grands Boulevards'
MAN RAY *Explosante-fixe*, c. 1933–34

interiorized theatricality, works itself out both in the heavens and below. (Max Ernst, *Men Shall Know Nothing of This*, 1923.) Hieroglyphic signs – a black triangle and a white circle on the left, echoed by a red circular shape on the right, trailing a thin yellow thread like a kite – and all variety of shadows and shapes and tracks and traces, are inscribed against a greyish canvas, like a field of possibilities. (Joan Miró, *The Birth of the World*, 1925.) In a vaguely Mexican Mayan setting a red stream snakes down a series of steps and snags the yellow-ochre stream that winds alongside it, while another stream, this time white, converges with one that is blue. These issue forth from a strangely angled church with a singularly chilly architecture, under a blue-white sky which is as inexplicably ominous as the liquid streams. (Ithell Colquhoun, *Tepid Waters*, 1939.) Sails made out of bedsheets rise up from a slanted surface, enclosed in a rope, or path, with sharp spikes pointing up from it, as it passes smaller forms, no less angular. Beyond, on a dull brown surface, the sail shapes are

linked in an utter lack of freedom. For the surrealist-inspired Mexican painter Frida Kahlo, the very act of repetition – seen, for example, in her disturbing double self-portrait *The Two Fridas* (1939) – seems fraught with danger; violence lurks everywhere.

All these indications of the mysterious and the marvellous, of the sometimes diametrically and sometimes more subtly opposed elements in surrealist art, have parallels in surrealist writing. Traces, tracks and signals point outward and inward. A great drama seems to be enacted before our eyes, or has just taken place, leaving its setting behind. Relationships between objects and persons are sketched, suggested, yet rarely spelled out. Cruelty seems common, and chilling. And yet a certain dignity, an impassivity before a terrible fate, makes itself felt. The objects in the world are no longer benevolent, and each seems to carry within it a charge of something unspoken, often threatening.

Giorgio de CHIRICO The Song of Love [Le Chant d'amour], 1914
Max ERNST Men Shall Know Nothing of This [Les Hommes n'en sauront rien], 1923
Joan MIRÓ The Birth of the World [La Naissance du monde], 1925
Ithell COLQUHOUN Tepid Waters, 1939

repeated flatly to the horizon, between the dull brown and the grey sky. No colour relieves the dullness, no soft form compensates for the spikes. (Kay Sage, *In the Third Sleep*, 1944.) In dark sombre gloom, in the midst of a section of brown-black rocks and the ochre forms of collapsed buildings, rises the white tower of a church with a handless clock. (Toyen, *Tremor in the Crystal*, 1946.) In a great reversal, an interchange has taken place between sky and land, with tree and roots upside down, branches plunging deep into the earth. (Meret Oppenheim, *Paradise is in the Earth*, 1946.) In the images of Magritte, objects – an apple, a glass, a bowler hat, a cloud, a sphere – will not stay in place, but wander, as it were, over to another picture, another naming, another definition.[62] Relationships can be evoked, but the ephemeral nature of association is more in evidence. Often his human figures, particularly women, do not stay single and separate, but merge, either violently, with their parts mingling and cut off, or simply stand, sit or lie there, as doubles of each other,

Violent World, Violent Work

A number of commentators have linked the violence and anguish that is present or implied in much surrealist art to the trauma of the First World War. In the book that accompanied her exhibition *Anxious Visions: Surrealist Art* (1990) the curator and scholar Sidra Stich traces its influence in images of 'conflict, disorder, irrationality'.[63] Describing Masson's painting *Man* (*L'Homme*, 1924–25; reproduced on page 52), Stich sees the figure taking shape as 'a transparent, ethereal body and as a contorted mass, wrapping around itself and pulsating outward. Unformed and formless, the figure attains the semblance of a head and genitalia, albeit of a non-human planetary and aviary order. "Man" is presented as a receptive, metamorphic being, riddled with discordance and full of divergent, convulsive energies.'[64]

The fluid techniques of painters such as Masson can be in part attributed to the impact of such violence: his line wanders in a kind of uncertainty in such a world in its terrible change, in its loss of any belief in one certain truth, in any hope of progress, in any trace of what had been conceived of (with far too great an optimism) as an overruling order. Catastrophe has changed everything.

Surrealism turned, with a kind of desperate hope, towards non-western cultures, towards the non-linear, the cross-cutting of images and thoughts it found and greatly admired in Eastern ways of perceiving. Look at the way in which, in the third issue of *La Révolution surréaliste* in April 1925, one of Antonin Artaud's open letters addresses Tibet's spiritual leader, the Dalai Lama:

'Send us your illumination, in a language which our contaminated European minds can understand … No one source or system reigns supreme, for all interpenetrate in a dynamic but disjunctive world where identity is obscured and laid bare in the face of perpetual change, where form is discontinuous and uncertain, and where meaning is repeatedly violated and obstructed. In this world evolution proceeds by explosive, unexpected cross-connections and not by linear progression.'[65]

Explosion without, explosion within. Shocked into another consciousness, the surrealist artists and writers made

free expression every gesture inexplicable except through such obsessions. Traces of shell-shock, amnesia and war imagery underlie the 'combat and discord' which are constants in Masson's work.

Trauma and the horror of its traces characterize much of the art of this period, in its deformations and displacements, in its deprivations: the figures seem unsexed, lifeless, undefined. Krauss and others insist on Bataille's term, *informe* ('unformed', in a literal rendering, although the term goes further into a kind of formlessness that, precisely, informs much of the best surrealist criticism). In *The Haunted Self: Surrealism, Psychoanalysis, Subjectivity* (2001), David Lomas discusses in detail the parallels between Bataille's notions of the *informe* and the soft forms developed by Dalí in his paintings of the 1930s, and their fascination with terror and disgust. He links this orientation with the psychoanalyst and literary theorist Julia Kristeva's study *Powers of Horror: Essays on Abjection* (1980) in which she interprets the uncanny

Kay SAGE In the Third Sleep, 1944
TOYEN Tremor in the Crystal, 1946
Meret OPPENHEIM Paradise Is in the Earth, 1946

another turning, from outward appearance towards a definite fascination with the deeply visceral, the reality inside. The body's internal organs, made so explicit in some of Masson's paintings, are explored in such texts of the time as '*L'Homme et son intérieur*' ('Man and His Interior') by the writer and ethnologist Michel Leiris, introduced to Surrealism by Masson, and becoming one of its first defectors, along with Bataille, in whose short-lived journal *Documents* (1929–30) it was originally published.[66] As Denis Hollier, Rosalind Krauss and David Lomas have each written in different contexts, Bataille's thinking underlies, even as it challenges, much surrealist work.[67] Obsessive reiteration (present in such images as Ernst's engraving-collages for Éluard's 1922 collection of poems, *Répétitions*, with its horrific rows of disembodied eyes or hands) and repeated images of dismemberment and mutilation, have been deliberately overlooked in much of the positive discourse about surrealist creation, in favour of the need to enlist on the side of spontaneous and

as a 'destructuration' of the self.[68] And he allies Dalí's 'phenomenology of repugnance'[69] with Bataille's focus on putrefaction and the excremental, in opposition to the lyric sensibility of Breton.

While Bataille stresses disunion, Breton stresses – after the aesthetic position of the poet Pierre Reverdy – a convergence of contraries. The styles are completely different: although Breton was, like Bataille, haunted by ideas and images of protean forms, of metamorphosis, he abhorred Bataille's preoccupation with the pornographic and what we now call the polymorphous perverse. In the winter of 1935–36 they did briefly come together, with around forty other artists and intellectuals, to form the underground anti-fascist organization *Contre-attaque*, but the diametrical opposition of personality and approach between the two made any long-term arrangement impossible. Breton's fear of defections from Surrealism to the Bataille group was most strongly articulated in the *Second Manifeste du surréalisme* in 1929,

where he contrasted the mental discipline (derived from Hegel) which he advocated for Surrealism with what he characterized as Bataille's 'offensive return to the old non-dialectical materialism'.

In 1929 a split occurred between Dalí and Bataille (although by no means as violent as those that occurred between both of them and Breton) when Dalí, having just decided to align himself with Breton's group, refused to let Bataille illustrate his essay entitled '*Le Jeu lugubre*' ('The Lugubrious Game'), with his painting of the same name. The text was therefore published in the seventh issue of *Documents* alongside a schematic drawing substituting for the withdrawn photograph of the painting. In the same month Breton's attack on Bataille was published in the second manifesto. Such divisions of personality and principle are widely documented in the material devoted to Surrealism. It was by no means always a movement of like-minded individuals. The history of exclusions and introductions,

although centred on intense and important political debates, often also has some-thing of the arbitrary about it and, more than often, some personal enmity behind it. So many different reasons provoke, incite and encourage wrath: taking the wrong side in issues political and personal, turning against group thought, taking some surrealist hero's name in vain, working for a living. Desnos, for example, expelled in 1930 for both the latter reasons, had named a bar after Maldoror, the anti-hero of the Comte de Lautréamont (author and poet Isidore Ducasse, 1846–70) and was working in publicity for the radio.[70]

Lautréamont's *Les Chants de Maldoror* (1869) was one of the group's most venerated texts – by turns macabre, cynical, grotesque, lyrical and exalted. Its anti-hero (whose name puns on *mal d'aurore*, 'dawn sickness') epitomized their virulent assault on the norms of bourgeois society. The book served Dalí – who discovered it independently before coming to Paris – as ample fodder for his delight in both the excremental and the intensely cruel. It is worth noting, as Lomas does, that the famous phrase so often quoted by the

Surrealists: 'as beautiful as the chance encounter of a sewing machine and an umbrella on a dissection table', was originally spoken by Maldoror in praise of a young man: 'He is as beautiful as ... ' The excision of the first part of the sentence reflects Breton's aversion to suggestions of the homoerotic or whatever he decided to deem 'perverse', the signs of which in Dalí's work provoked him in ways to which Dalí deliberately played up.[71]

Any reaction to the words and images of Surrealism is dependent on the mind and imagination of the reader or viewer. Even less than in other artistic and literary movements will one reading suffice. In this, as in other ways, Surrealism remains intensely poetic. Many surrealist works have been interpreted as positive instances of the marvellous. These include de Chirico's painting *The Child's Brain* (*Le Cerveau de l'enfant*, 1914) – which famously provoked Breton, around 1916, to leap from a bus to inspect it when he glimpsed it in the window of the Galerie Paul Guillaume in Paris, and the yet-to-be surrealist painter Yves Tanguy to do exactly the same around six or seven years later when, having been purchased by Breton in 1919, it was loaned for another exhibition there.[72] Celebrated as a serenely composed figure whose closed eyes signify an inner world of connection with childlike wonder, the image can equally be read as harbouring signs of repressed sexuality and Oedipal conflict. Conversely, the surrealist work most directly connected with this image, Ernst's *Pietà, or Revolution by Night* (1923) invites detailed psychoanalytical readings alluding to Ernst's relationship to his father – also a painter, who had once depicted his son as the Christ-child – while it is equally important not to lose sight of the way Ernst's image works through de Chirico's legacy in terms of painterly representation, attempting to indicate emerging surrealist notions of 'sightless' vision.[73]

David Lomas sees another kind of subversive dialogue with patriarchal authority in the image of the unruly female 'hysteric' – such as the photographs of women in '*attitudes passionnelles*' from Charcot's clinic at Salpêtrière which illustrated Aragon and Breton's article commemorating 'Fifty Years of Hysteria' (*La Révolution surréaliste*, March 1928). This includes an invocation of 'the uncanny as a conceptual parallel for the state of estrangement the Surrealists sought to induce in the beholder, whereby the family, and also the self (oneself included) is suddenly rendered strange or alien.'[74] Everywhere, a pathogenic permutation of roles, of fantasies

Giorgio de CHIRICO The Child's Brain [*Le Cerveau d'enfant*], 1914
Max ERNST *Pietà, or Revolution by Night* [*Pietà, ou la révolution de la nuit*], 1923

of unconscious desire, is allied with the surrealist narrative.[75] The writings on psychic drives and identity formation of the French psychoanalyst Jacques Lacan, who was admired by both Breton's group and Bataille in the early 1930s, are paralleled in Dalí's concurrent fascination with the problem of aggressiveness as intrinsic to human psychology. Central to Dalí's investigation was an exploration of the dialectics of paranoia, in his 'paranoid-critical' writings and in images where, for example, the suggestion of a face emerges from a configuration of objects or figures.[76]

Associated with these plausible if partial explanations of the surrealist fascination with disgust and deformation, stemming from the wartime experience, and abetted by the strong allure of Bataille's theories on myth and the unconscious, is the equal fascination, even obsession, with the violent and the criminal. When Breton claimed in the Second Manifesto that an appropriate surrealist act was to descend into the street and fire a revolver into the crowd,

 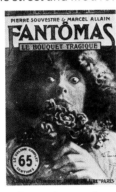

it was not just bravado – echoing the real actions of turn-of-the-century anarchists whom he had earlier admired – but, couched in his penchant for the accidental and arbitrary, is also reminiscent of folk tales where the first person to pass by is the chosen victim. Beyond the evocation of random chance and fate in such images, the Surrealists venerated both fictional and real criminal figures as icons of social transgression and subversion. On a page of *La Révolution surréaliste*, 1 (December 1924) photographs of Surrealists and several associates or mentors, such as Picasso and Freud, encircled a police photograph of the anarchist Germaine Berton, who in January 1923 had shot Marius Plateau, a leading member of the right-wing royalist group *L'Action française*. In November 1924, a year after being acquitted of murder on grounds of insanity, she had committed suicide. The image was accompanied by a quotation from Baudelaire: 'Woman is the being who projects the greatest shadow or the greatest light upon our dreams.' At the time Berton was

acquitted, Aragon, Morise and Breton's first wife Simone had sent her a basket of red roses and carnations.

The shadowy influence of Fantômas, the fictional anti-hero of Pierre Souvestre and Marcel Allain's pre-First World War crime thrillers (adapted for the eponymous film by Louis Feuillade in 1913), was also pervasive. At the Surrealist Research Bureau, a volume of *Fantômas* had been fixed to the wall with table-forks, and the character inspired artworks such as Tanguy's early painting *Fantômas* (1925), Magritte's *L'Assassin menacé* (*The Threatened Murderer*, 1926) and a differently gendered manifestation, *La Voleuse* (*The Female Thief*, 1927), Brauner's *Fantômas* (1932), the Prague Surrealist Jindrich Styrsky's 1929 series of cover designs for actual volumes of the thrillers, and writings such as '*La Complainte de Fantômas*' ('The Lament of Fantômas', 1933) by Desnos. This became a musical stage production, directed by Artaud with music by Kurt Weil and a cast of over a hundred, touring France and Belgium in the year in which it was written.

A master of disguises, Fantômas infiltrates and commits appalling crimes against the Parisian bourgeois high society in which he moves with such ease and assurance. He poisons a victim with a deadly bouquet, he causes trains to collide and crash, he even sinks an ocean liner, yet always triumphantly escapes justice.

This celebration of transgression becomes more complex and politicized in the cases of Violette Nozières and the Papin sisters. Nozières had murdered her father but gave as her reason that he had committed incest, thus breaking the strict taboo of the time against revealing incestuous relations. The Surrealists saluted her as the courageous victim and defier of a hypocritical social order, and while she was awaiting trial published a collective tribute, *Violette Nozières*, in December 1933, with a cover by Man Ray, poems by Breton, Char, Éluard, Péret and others, and illustrations by Dalí, Tanguy, Ernst, Brauner, Magritte, Marcel Jean, Arp and Giacometti. Earlier in the same year, the May issue of *Le Surréalisme au service de la révolution* had discussed and reproduced photographs of the notorious sisters Léa and Christine Papin, 'before', when they were model servants in a bourgeois home, and 'after' their arrest for the apparently unpremeditated, brutal murder and dismemberment of their employers. In their reactions to this event the Surrealists' communist-leaning sympathy with the oppressed servant was combined with new psychoanalytical perspectives (that

year Lacan published a paper in the third issue of *Minotaure* on the Papins' 'paranoiac crime') and analogies with the spontaneous and violent actions of Lautréamont's Maldoror.

In Parts

The dislocated and separated body parts that appear frequently in surrealist imagery can thus be interpreted negatively as a trace of trauma and psychological disturbance, as discussed by Stich and Lomas, but they can also be a positive manifestation of desire. In the credo of Breton's *L'Amour fou* the separating out or distortion of parts of the female body can be read as a continuation of the Renaissance blazon or celebration of the individual glories of one's lover, and thus of the individual delights of beauty.[77]

But then again, this is not always a positive glorification. The equally admired and loathed German artist Hans Bellmer, with his dread-inspiring and brilliant manipulation of body parts in the *Poupée* works begun in 1933 – dolls, indeed,

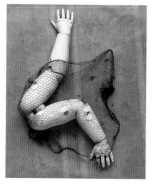

but not only that – clearly cherishes the separate parts as he recombines them: here a hip, there a vagina, there a thigh, everything in a ghastly roundness. Not much less shocking is the assemblage of the Danish artist Wilhelm Freddie, who paints a penis plastered around a mannequin-woman's cheek, poised above a wine glass perched on her breast (*Paralyzasexappeal*, 1936).

The impositions of the American Man Ray, in his photographs and films of the 1920s, are more elegant, even eloquent. The patterns cast by various surrounding objects, such as the shadows of a Venetian blind or the mesh of a curtain, or as a result of processes such as solarization, enhance the beauty of the woman standing there – his first lover Kiki de Montparnasse or his collaborator and model the photographer Lee Miller – evoking an idea of the female itself. The face or torso is beautiful; the grains and patterns of light and shadow are no less so.

Just as the Renaissance poets sang of them, so Breton enumerates, one after the other, the beauty of each element of his lover's body, in his 'L'Union libre' (1931). The union is

free, the poem is free, and the parts are free mutually to celebrate each other and reassemble, recreating the woman so loved. The same is true of some of Magritte's images, and those of the other surrealist painters: it is an honoured tradition. Breton's poem begins and continues with an individual praising of the beloved's self, external and internal, tinged not only with love but danger, that essential part of desire:

My love whose hair is woodfire
Her thoughts heat lightning
Her waist an hourglass
My love an otter in the tiger's jaws [...]
My love her eyes full of tears
Of violet panoply and magnetic needle
My love of savannah eyes
My love her eyes of water to drink in prison
My love her eyes of wood always to be chopped
Eyes of water level earth and air and fire[78]

Desire and violence are the two poles that support much of surrealist theory and practice, both verbal and visual, conferring an atmosphere of risk and danger upon much of its imagery. It is this junction of the two terms that encourages desire to remain desire, unabated, unabashedly enduring. *Le Dur Désir de durer* (the difficult desire to endure) as Éluard, by then a resistance hero, titled his collected poems of 1946.

Even the dolorous delights of love, as Desnos describes them, are made up of details – body parts and their ornaments:

Oh pangs of love! [...]
My laugh and my joy crystallize about you. Your make-up, your powder, your rouge, your snakeskin bag, your silk stockings ... and also that little fold between the ear and the nape of your neck, near its base, your silk stockings and your delicate blouse and your fur coat, your round belly is my laughter and your feet my joys [...][79]

En Voyage

The Surrealists' desire for immersion in all that was initially viewed as 'other' also led over time to an informed involvement with art and ideas from non-western cultures.

Hans BELLMER Ball-Joint [*Jointure à boule*], 1934–36
Wilhelm FREDDIE Paralyzasexappeal, 1936

Differentiating themselves from the exoticizing tendencies in the vogue for 'primitivism', they helped give voice to dissent from Europe's continuing colonialism. Leiris, with his dual roles as an ethnologist as well as a poet, drew on a detailed knowledge of diverse cultures in his writings and articles for *Documents*, and from as early as 1924, when he had introduced Bataille to Breton and the other Surrealists, the work of anthropologists, such as Lucien Lévy-Bruhl, Marcel Mauss and later Claude Lévi-Strauss, influenced the thinking of a number of members of the group. Tzara, in Dada times and later, imported into his *poèmes nègres* a genuine African vocabulary – word for word, eschewing the frequent aesthetic version, the smoothing over of the literal. In 1931, at the time of the Colonial Exhibition in Paris, the group took a publicly anti-colonial stance, putting out a protest pamphlet, '*Ne visitez pas l'exposition coloniale*', and staging a fringe exhibition on the 'truth about the colonies'. This accorded with the more general goal of disrupting the western world's self-assurance,

Cover of *Minotaure*, vol. 1, no. 2, by Gaston-Louis Roux, 1933

its belief in its superiority over what it conceived as 'the primitive', its confidence in rational and logical constructions.[80] In 1933 the second issue of *Minotaure* was devoted to a 'Dakar–Djibouti ethnographic and linguistic expedition' with articles on culture and rituals based on field research among the people of the Sudan, Cameroun and Abyssinia (Ethiopia). The Surrealists admired and associated with poets such as Léopold Sédar Senghor from Senegal, who would later become the first president of his country on independence. Surrealism also found followers among the Caribbean intellectuals in Paris and the French-speaking world, such as Léon-Gontran Damas from French Guyana and Aimé Césaire of Martinique, both of whom would combine Surrealism in their poetry with the emancipatory political and cultural creed of *négritude*, championed by Senghor.[81] In 1932 a group of Caribbean students in Paris founded the anti-colonialist journal *Légitime Défense*, named after Breton's 1926 essay on Surrealism and revolution, in which he had criticized the narrow cultural vision of the French communist party and its uncritical acceptance of prevailing 'Graeco-Roman' values, which implicitly and often explicitly conveyed prejudice against African and 'oriental' cultures.

Breton, Éluard, Bataille and others had from early on studied and collected statues and artefacts from Africa, Oceania and the Americas. From the 1930s onwards some of the Surrealists attempted to learn from such cultures at first hand. Artaud wrote impassioned memoirs of his visits in 1936 to the Tarahumaras, people of the Chihuahua region of Mexico, extolling their vision-inducing drugs such as peyote and their rituals.[82] From 1938 when Breton visited Diego Rivera, Frida Kahlo and Trotsky in Mexico, and during his wartime exile, he visited various indigenous groups and observed their cultures, travelling in New Mexico and Arizona and in 1944 spending time among the islands outlying the rugged Gaspé peninsula in Canada and the coastlines of the Northwest Pacific. In *How Natives Think* (1910) Lévy-Bruhl had written of the 'law of participation': 'objects, beings and phenomena can be, in a way that is incomprehensible to us, at once themselves and something other than themselves.'[83] To be in two subject positions at the same time, to hold simultaneously two points of view: this is an idea that would occupy Breton in Surrealism's post-war years, in his notion of *l'un dans l'autre* (*one in the other*).[84]

Surrealism had thus entered into a dialogue with non-western cultures which had some reciprocity. As for its reception where it spread, it was often not so much brought to other countries from Paris as taken up and used by others to evolve their own vision, such as the Cuban-born painter and sculptor Wifredo Lam, of African, Chinese and Spanish descent. Lam briefly entered the Paris scene before the war, becoming closely associated with and admired by Picasso and the surrealist circle; he then shared refuge with the Surrealists in Marseille during the Vichy regime in 1940 before returning across the Atlantic to explore his highly individual imagery, drawn from local spiritual traditions.

Nevertheless, in the crucial years of Surrealism's birth and development, Paris was and remained at the centre. Not that Ernst's Cologne or Tzara's Zurich, the site of Dada's Cabaret Voltaire, do not count, but during those inter-war years Paris and its cafés were Surrealism's true home. From Aragon's *Le Paysan de Paris*, with its celebration of the Passage de l'Opéra and the Parc des Buttes-Chaumont, to Breton's evocation in *Nadja* of the Hôtel des Grands Hommes on the Place du Panthéon, where Péret also lived, the great and enduring surrealist adventure moved through the city of Paris.[85] In 1928 it was home to the real woman known as

Nadja, who had inspired Breton's homage; and in 1937 he met Jacqueline Lamba in a café there, giving rise to their *amour fou*, or mad love. The Tour Saint-Jacques rises up as a reminder of the haunts of the fourteenth-century Parisian Nicolas Flamel, one of the alchemists whose experimental quests are linked by Breton in the *Second Manifesto* and elsewhere with those of Surrealism. In the communal atmosphere of 54 rue du Château, near the Gare de Montparnasse, a house owned by the poet Jacques Prévert's friend Marcel Duhamel, the surrealist group sometimes met, and some of its members – Péret, Desnos, Aragon, Tanguy, Prévert, Georges Sadoul – stayed there. Near the Place Blanche, in the ninth arrondissement, Breton's apartment at 42 rue Fontaine, and cafés like the Cyrano and the Batifol, served as meeting places. Paris is always evoked in surrealist works as feminine, with all her guiles. In *L'Amour fou* the Hôtel de Ville becomes the cradle of this maternal city which has, as *Nadja* tells us, that 'profoundly secluded place' the Place Dauphine as its sex.[86]

Stich has commented on the impact of the Second World War on the movement, as it was forced to bid farewell to this intrinsic relationship between itself and Paris (to the endurance of which many of the movement's historians and adherents have continued to subscribe): 'If the First World War created the delicate balance that made Paris the centre of some of the most exciting intellectual and social developments of the day, the Second World War irrevocably destroyed that balance. The Surrealism of inter-war Paris had been firmly rooted in this world, and once it ceased to exist the movement was no longer the same. Surrealism survived and continued after the war, but the special unity between Surrealism and Paris disappeared with the 1930s.'[87]

In fact, Surrealism had spread rapidly from the beginning. Soon after the Paris excitement other groups formed in Yugoslavia (1924), Belgium (1926), Romania (1928), Czechoslovakia and Denmark (1929); then in the early 1930s the influence of Surrealism spread outside Europe to the Canary Islands (1932), Egypt (1934) and elsewhere.[88] Some of the most gripping surrealist images come from such widely scattered groups, whose emergence is sketched out below.

Surrealism's Evolving Story

In Nadeau's classically conceived *History of Surrealism*, written while Europe was still at war,[89] the movement's development is divided into three stages: a heroic period, 1923–25; an analytical period, 1925–30; and a period of autonomy, 1930–39. Then follows an epilogue that includes the wartime era of exile in the United States. There are, of course, later perspectives in which the heroic period is viewed as having extended throughout the 1920s. For yet others, the movement continues through Pollock's drip paintings, beyond Breton's return to France in 1946 and the second surrealist wave there, past his death twenty years later in 1966, to Jean Schuster's declaration of Surrealism's demise in 1968, and even up until the present and on into the future.[90] Why not indeed? Surrealism was always multiple; Surrealisms deserve to flourish and, in our minds, may well still live.

What follows here is a simplified outline of Surrealism's long and complex chronology.[91] One of the threads running through this particular selection of dates and events is the interrelationship described above between the verbal and the visual which characterizes Surrealism throughout its changing manifestations.

In 1918 Breton begins corresponding with de Chirico, who had lived in Paris from 1911 to 1915, mixing with Apollinaire and other writers and artists. His poetically conceived and titled paintings also influence Ernst in Cologne (whose first Paris exhibition will be in 1920) and later Magritte in Brussels when, already familiar with some of Ernst's published collages, in 1922 he will come across a magazine reproduction of de Chirico's painting *The Song of Love*.[92]

In March 1919 the first issue of *Littérature* appears, edited by Aragon, Breton and Soupault. In the April and May issues it publishes works by Lautréamont, which Breton had copied out by hand from the sole copy of the *Poésies* in the Bibliothèque nationale, after Aragon discovered the poet's work by chance in 1917.

The October issue publishes texts from Breton and Soupault's *Les Champs magnétiques*, later described by Breton as the first work that incontestably broke away from Dada towards Surrealism, since it was the result of a 'systematic application of automatic writing'. By the start of its second series in March 1922 *Littérature*, now edited solely by Breton, has an incipient surrealist tone. Also during this year Masson arrives in Paris and establishes a friendship with the poet

Passage de l'Opéra, Paris, early twentieth century

Leiris and with Miró.[93] Tanguy's encounter with de Chirico's work sets him on the path of becoming a painter.[94] Éluard and Ernst collaborate on the book *Répétitions*, described earlier, and Man Ray publishes *Les Champs délicieux*, an album prefaced by Tzara, showing twelve 'Rayographs', a personal variant of the photogram in which mysterious images are produced directly from everyday objects placed on light-sensitive paper, in what appear to be random, chance configurations.

During 1923 Breton's group dispute the meaning and use of the term 'surrealism' with the literary and theatrical figures Ivan Goll and Paul Dermée, who refer to Apollinaire's original coining of the term '*sur-réalisme*' in 1917 to describe a form of expression which exceeded realistic effects, often through unexpected juxtapositions – a manifestation of what he called 'the new spirit'. (He saw these qualities in Erik Satie's ballet *Parade*, a collaboration with Jean Cocteau and Picasso, and his own play *Les Mamelles de Tirésias*. In autumn 1917 he gave

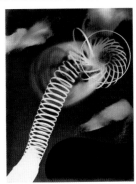

a lecture at the Théâtre du Vieux Colombier on 'The new spirit and the poets', where he referred to poets 'who will lead you, alive and awake, into the nocturnal, closed world of the dream'.) Goll and Dermée enlist important writers such as Pierre Albert-Birot to support their notion of 'surrealism', described in a single issue journal of that name. In its notions of the poetic image and interest in cinema it is not that far removed from the ideas of Breton's group; where it differs most strongly is in completely dismissing the roles of psychology and experimentation. By the close of 1924, the rival group concedes the ground, after the more sophisticated and extended theoretical description has been set out in Breton's manifesto, enabling the movement to break free from narrow literary and artistic definitions.[95]

By 1924 Breton's group have begun meeting regularly, at his apartment in rue Fontaine or the nearby Café Cyrano, along from the Moulin Rouge, and have made contact with the other group congregated around Masson, Miró, Leiris,

Artaud and others at rue Blomet. Aragon's *Une Vague de rêves* describes the trance experiments begun two years earlier, and Desnos publishes a collection of the strange and often macabre statements and stories which had emerged from his 'sleeping fits', titled *Deuil pour deuil* (*Mourning for Mourning*). Breton bids farewell to Dada in *Les Pas perdus*. In October he publishes the *Manifeste du surréalisme* and in December the first issue of *La Révolution surréaliste* publicizes the activities of the Bureau of Surrealist Research, which begins to invite members of the public to visit and join in or try out the experiments at home. Small printed cards of the kind known as '*papillons*' ('butterflies') are scattered or pinned up in public places. One from 1925 reads: 'Parents! Recount your dreams to your children.' *La Révolution surréaliste* invites responses to the question 'Is suicide a solution?' and these responses are published in the second issue in January 1925. The third issue in April contains Artaud's tirades against the tyranny of institutions, in the form of open letters to the Pope, the leaders of universities and directors of psychiatric institutions, as well as welcoming messages to the Dalai Lama and the Buddhist schools. In the same issue the editor Pierre Naville asserts the view that there can be 'no such thing as surrealist painting', and Michel Leiris publishes '*Glossaire: J'y serre mes gloses*' (loosely translated, 'in the glossary I store my glosses'), in which the standard definitions of words – the most conventional and unpoetic genre of writing – are replaced by poetic word games.

During 1925 the first collective 'exquisite corpse' texts and drawings are made at the communal house owned by Marcel Duhamel in the rue du Château where, among others, Tanguy and Prévert become part of the scene. Arp and Ernst now have studios in Paris near to Miró's. In August Ernst develops the technique of *frottage*, experimented with very briefly several years earlier, but now used to generate entire images in which strange terrains and creatures emerge from rubbings on paper over various surfaces and objects – later adapted to works in paint on canvas with the scraping technique he names *grattage*.[96] In July Breton publishes his first text on 'Surrealism and Painting', a considered response to Naville, in the fourth issue of *La Révolution surréaliste*, and takes over

as editor. In November the first group show, titled 'La Peinture surréaliste', is held in Paris at Galerie Pierre. It includes Arp, de Chirico, Ernst, Paul Klee (his only inclusion in the movement's exhibitions, showing the Surrealists' interest in his closeness to automatism and the spontaneous art of children and 'outsiders'), Masson, Miró, Picasso (closely affiliated but never officially enlisting as a Surrealist, despite the group's invitations) Man Ray, and the painter Pierre Roy, whose realistic style often combines de Chirico's influence with an atmosphere of solitary childhood games. This first exhibition does not yet include any of the women artists who will join later to emerge as significant presences, at least within the movement if not in most histories or museum exhibitions until the 1970s, such as Claude Cahun, Léonor Fini, Frida Kahlo, Jacqueline Lamba, Dora Maar, Meret Oppenheim, Mimi Parent, Judit Riegl, Dorothea Tanning, Toyen and Remedios Varo.[97] Artaud's extraordinary and anguished texts in poetry and in prose, published under

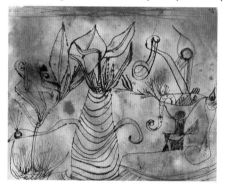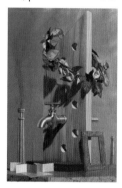

the title L'Ombilic des limbes (Umbilical Limbo), explore the depths of consciousness and creativity. Similarly Crevel's first autobiographical novel Mon corps et moi (My Body and Me) articulates a deeply experienced split between the material and the mental, a psychology inherited from the romantics, like much else in Surrealism. The brilliance of his later Êtes-vous fous? (Are You Mad?) and his suicide have made him one of the surrealist heroes of the unconventional. Éluard and Péret's 152 proverbes mis au goût du jour, bring proverbs – the traditional form of received knowledge – 'up to date' through insights received directly from the unconscious: 'cherries fall where texts fail'; 'a crab, by any other name, would not forget the sea' ...

In March 1926 the new Galerie Surréaliste in rue Jacques-Callot opens with an exhibition of work by Man Ray set alongside artefacts from the Pacific islands, collected by Aragon, Breton, Éluard and others. Miró and Ernst are temporarily excommunicated by the group because they

design costumes and scenery for the Diaghilev ballet in May, Roméo et Juliette – looked upon as a concession to bourgeois culture which compromises Surrealism's revolutionary ideals. In November Artaud and Soupault are expelled for the similar reason that they engage in 'purely literary activity'. Also in 1926 Éluard publishes what is often considered his most important collection of poems, Capitale de la douleur (Capital of Pain). In its abandonment of reason and its anguished exploration of desire, revolt, vertigo and madness, it seems to exemplify Surrealism's creative intentions. Aragon publishes his lyrical celebration of wandering and dreaming in the city, Le Paysan de Paris. In October he arranges an official contact between the Paris Surrealists and the Brussels group founded in 1926 by Magritte and E.L.T. Mesens, which also includes the theoretician and photographer Paul Nougé, the writer Louis Scutenaire and the experimental composer André Souris. In 1928 they will start publishing their own surrealist-slanted review on modern culture, Variétés.

In response to Naville's pamphlet La Révolution et les intellectuels, exhorting the Surrealists to embrace the materialist communist ideals of the time, Breton counters in September 1926 with his missive Légitime défense, in which he sets out his concerns, shared by most French intellectuals at that moment, about the restrictiveness of prevailing communist goals in relation to cultural ideals of free expression and action. Despite these reservations, the subject of complex debates and about turns throughout this period, Aragon, Breton, Éluard, Péret and the writer and journalist Pierre Unik join the French Communist Party in January 1927 and Breton quietly withdraws Légitime défense from circulation. However, Breton is repeatedly criticized by the party for the apparent incomprehensibility of Surrealism, and by May the group publish a dossier of five letters, Au grand jour (In Broad Daylight), the first affirming a solidarity between Surrealism and communism but the fifth, addressed to 'the communists', expressing grave disappointment that there should have been so much mutual misunderstanding. For the next few years Breton's group continue to hope that the communist party's hostility to their ideas can be overcome.[98]

In May 1927 Tanguy's paintings are shown for the first time at the Galerie Surréaliste, alongside South American objects from Aragon, Breton and Éluard's ethnographic collections. Masson exhibits some of his sand paintings begun the previous year. In August Magritte joins the Paris group and

Paul KLEE Still Life with Serpent, 1924

Pierre ROY Honour to Unlucky Courage [Honneur au courage malheureux], n.d.

settles in nearby Perreux-sur-Marne, where he stays until 1930, and in Madrid Dalí becomes interested in Surrealism, largely through its publications and coverage in Spanish reviews such as *L'Amic de les Arts*. Artaud writes the scenario for Germaine Dulac's film *La Coquille et le clergyman* (*The Shell and the Clergyman*)[99] and Breton publishes his first text on 'surrealist objects', written in 1924: *Introduction au discours sur le peu de la réalité*. The manifesto 'Hands off Love' is published in English translation in Eugène Jolas' journal *transition* and reprinted in French in the October issue of *La Révolution surréaliste* (where 'exquisite corpse' drawings are also published for the first time). Signed by thirty-two male members of the group it protests against the show-trial like prosecution of politically left-wing actor Charlie Chaplin by his wife for alleged sexual indecency towards her. Not free of mysogyny, this text is nevertheless an important assertion of sexual freedom as an intrinsic aspect of personal and political liberty. In the same year Desnos publishes his major novel *La Liberté ou l'amour!* (*Liberty or Love!*).

Dalí enters the Paris scene in 1928, making several trips from Madrid to meet Miró, Picasso and the surrealist group. He and Luis Buñuel make the film *Un chien andalou* (*An Andalusian Dog*), at first screened at an art cinema, the Studio des Ursulines, to an invited audience which includes Picasso, Jean Cocteau and Le Corbusier. Its first public showing is at the Studio 28 cinema in October the following year and then, backed by a commercial promoter, it runs for eight months. Desnos and Man Ray collaborate on the film *L'Étoile de mer* (*Sea Star*). Aragon's *Traité du style* (*Treatise on Style*) and Breton's collected essays on artists, *Le Surréalisme et la peinture* (*Surrealism and Painting*) attempt to delineate the boundaries of surrealist writing and painting respectively, while Breton's 'anti-novel' *Nadja*, a paean to the love he encounters with the disturbed Nadja, intertwines biography, invention and a record of his concurrent intellectual concerns. Giacometti begins sculpting from memory.

In April 1929 Bataille founds *Documents* in collaboration with Leiris, Desnos and Prévert. It juxtaposes current art with work from other cultures and epochs, and ethnographic and sociological texts. In the same year the New York photographer Lee Miller begins working with Man Ray in Paris. Around this period Giacometti, Dalí, Buñuel and Char join the group while Miró and Masson begin to distance themselves from it. In Prague a surrealist group begins to form around

Jindrich Styrsky, Toyen (Maria Cerminova) and Vitezslav Nezval. Ernst completes his first collage 'novel', *La Femme 100 têtes*, which, with its deliberate pun on *cent* and *sans* (without) may be translated, albeit with loss of its original startling ambiguity, as *The Hundred-Headless Woman*. In December the first page of *La Révolution surréaliste* announces that this is the last issue. The explanation will be found below, under the red lipstick-like imprint of seven women's kisses. Here Breton's *Second Manifeste du surréalisme* begins. Concerned that Surrealism's increasing diversity might lead to dissipation, he attempts to revise and hone down its principles. In a statement almost as influential as the definitions of the first manifesto he asserts: 'Everything leads one to believe that there exists a certain place in the mind where life and death, reality and imagination, past and future, the communicable and the incommunicable, high and low, will cease to be perceived in opposition.'[100] Aware of the difficulty, perhaps even futility, of the quest for this mental state, which he later compares with the researches of alchemists, he repositions surrealist activity as 'a dogma of absolute rebellion, total insubordination and outright sabotage'. 'Everything remains to be done, and all means are valid, to demolish the ideas of family, homeland, religion.' With the exception of Lautréamont, other literary precursors mentioned in the first manifesto, such as Baudelaire, Rimbaud, Poe and Sade, are dismissed, as are those in the group who are perceived to have lost their way, among them Artaud, Masson, Soupault and the playwright Roger Vitrac, who with Artaud had co-founded the Théâtre Alfred Jarry in 1927 – the bourgeois and commercial affiliations of theatre itself being enough to exclude even this radical project from Surrealism's aims. Drawing on his reading of Hegel and prevailing communist ideas of 'self-criticism' Breton castigates yet others for lack of social engagement or mental discipline in addressing 'the problems of love, dreams, madness, art and religion'. It is here that he first describes Surrealism as the 'prehensile tail-end' of Romanticism.

Desnos and Bataille – both strongly criticized by Breton – organize a collective reply published in January 1930: *Un cadavre* (*A Corpse*). Accused of converting Surrealism into a 'religion' of which he is the self-styled 'Pope', Breton – just turned thirty-three, by tradition the age of Jesus at the crucifixion – is depicted in Boiffard's photomontage with closed eyes like a laid out corpse, crowned with a wreath

of thorns. Breton's insults to the memory of the eulogized patriotic novelist Anatole France in the original collective text *Un cadavre* of 1924 are turned against him, followed with further insults by the signatories (who are not all those whom Breton had named; Artaud, Masson, Naville and Soupault refuse to join in). In July Breton launches the new journal *Le Surréalisme au service de la révolution*. Echoing the movement's committed but uneasy relationship with communism, each issue will carefully balance its visual and poetic contributions with texts that address social and ideological concerns. Buñuel and Dalí's film *L'Âge d'or* (*The Golden Age*) is screened at Studio 28 in November, its scandalous anti-establishment imagery provoking riots by right-wing extremists who also smash paintings by Dalí, Ernst, Miró and Tanguy exhibited in the entrance. The film is banned by the police. During this year Breton and Éluard publish *L'Immaculée conception* (*Immaculate Conception*) a text that explicitly links the intensity of the imaginative

to inspire awe and allegiance to colonialism at a time when the first mass uprisings against enforced labour and other abuses are taking place in Africa and Indo-China. In September a counter-exhibition is set up: '*La Vérité sur les colonies*' (The truth about the colonies). As well as presenting documentary information it contains a section designed by Tanguy where artefacts from Africa, Oceania and the Americas are juxtaposed with various items of folk art labelled 'European fetishes', ranging from religious statuettes to effigies of 'negroes'. In November A. Everett ('Chick') Austin, director of the Wadsworth Atheneum, Hartford, Connecticut, presents the first major surrealist show in the United States, 'Newer Super-Realism'. In December *Le Surréalisme au service de la révolution* publishes Dalí's essay on 'objects with a symbolic function' and an example of the 'paranoid-critical' method he has been developing – a painting of a 'paranoiac face' based on the outlines of a large face discerned in a postcard of a group of people sitting around a hut. In the

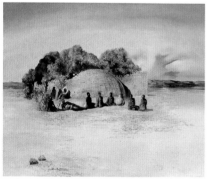 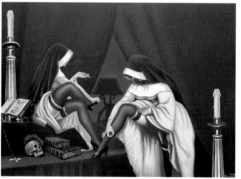

poetic impulse with obsession and psychological disturbance, written as if it emanated from these states of mind. Ernst introduces a new kind of figure into his repertoire of images: Loplop, a bird, distantly echoes his perturbed conflation, as an infant, of the death of his beloved pet bird with the birth of his baby sister. Yet unlike most of Ernst's earlier bird personages, Loplop constantly shifts shape, identity and mood – a bird yet at the same time something else entirely, such as a snake, an anthropomorphic being, or a form of walking easel on whom pictures are presented. These are often Ernst's own works or details from them, as pictures, or traces of them, within the picture. Thus Loplop becomes an intermediary, flitting between the artist's persona, his imagery and its re-presentation.[101]

In May 1931 the pamphlet '*Ne visitez pas l'exposition coloniale*' is circulated and handed out to factory workers in response to the large official event being held intentionally in the working-class, communist dominated area of Vincennes

same issue Giacometti publishes the drawings and texts that describe his sculptural objects based on memories and dreams, and a new discovery, Clovis Trouille, is introduced with one of his scandalously anticlerical pictures (an attitude which goes back at least as far as Duhamel's photograph of Péret insulting a priest, published in *La Révolution surréaliste*, 8, December 1926).

In January 1932 the Wadsworth Atheneum exhibition comes to Julien Levy's gallery in New York, retitled 'Surrealist Group Show'. Between then and 1936 Levy and Pierre Matisse introduce Dalí, Miró, Masson and others to the American public through solo shows and publications.[102] Aragon's 1930 poem '*Front rouge*' ('Red Front') is circulated. Invoking the wrath and bombs of the communist proletariat on the rich upper classes, it leads to his imprisonment for incitement to violence. In 'Misère de la poesie' Breton attempts to defend freedom of expression, opposing the idea of the poem as a literal statement, but Aragon disagrees: either surrealist

Salvador DALÍ Paranoiac Face [*Visage paranoïaque*], 1935
European Fetishes [*Fétiches Européens*], published in *Le Surréalisme au service de la révolution*, 3/4, December 1931
Marcel DUHAMEL photograph of Benjamin Péret insulting a priest, published in *La Révolution surréaliste*, 8, December 1926
Clovis TROUILLE Convent Dialogue [*Le Dialogue au Carmel*], 1944

poetry means what it says or it does not. He abandons Surrealism for communism. Also in 1932 Breton publishes his recounting of dreams and their interpretation, *Les Vases communicants* (*Communicating Vessels*), in which he attempts to reconcile Freudian and Marxist thought. Giacometti has his first solo exhibition in Paris at the Galerie Pierre Colle. He and Arp introduce the Swiss artist Meret Oppenheim to the group. In Belgrade Marko Ristic, the Serbian poet and instigator of Surrealism in Yugoslavia since the mid 1920s, launches the review *Nadrealizam danas i ovde* (*Surrealism Here and Today*). During this year in Germany the National Socialists make large gains in local elections and in January 1933 Adolf Hitler becomes chancellor.

The last issue of *Le Surréalisme au service de la révolution* comes out in May 1933. Already a new review of modern art and culture, *Minotaure*, has been launched by the Swiss publisher Albert Skira in partnership with the editor Tériade (Efstratios Elefteriades). In its first issue it published a text

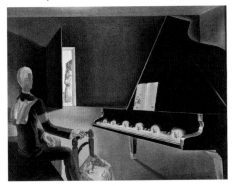

by the psychoanalyst Jacques Lacan, on 'The problem of style and the psychiatric conception of paranoid forms of experience'. Although not envisioned as a surrealist review, by issue 3–4 in December its chief contributors are Breton, Dalí, Éluard, Maurice Heine, Mabille and Péret. During the year the Romanian artist Brauner is introduced to the group by Tanguy. Two major group shows are held, at Galerie Pierre Colle and the Salon des Surindépendents. In December the group publish their tribute to the parricide Violette Nozières.

In January 1934 Dalí is held to account by the group for what they consider to be his irresponsible use of references to Lenin and Hitler in his paintings, but he will continue to be included in exhibitions.[103] In May Breton publishes his text '*La Beauté sera convulsive*' ('Beauty will be Convulsive') in the fifth issue of *Minotaure*, illustrated with photographs by Brassaï and Man Ray. During this year the French-speaking Egyptian writer and later Trotskyist activist Georges Hénein returns from his stay in Paris to Cairo and founds the surrealist inspired Art and Freedom group; Domínguez officially joins the Surrealists and Brauner has his first exhibition. Claude Cahun publishes her political defence of poetry, *Les Paris sont*

ouverts (*All Bets Are Open*). In Brussels Breton publishes the anthology *Qu'est-ce que le surréalisme?* illustrated by Magritte. Georges Hugnet writes a critical introduction to surrealist poetry for the *Petite anthologie poétique du surréalisme*. At his own expense Bellmer has a small book printed in Karlsruhe: *Die Puppe* (*The Doll*), which presents his staged photographs of a disturbingly fragmented, automaton-like female doll that he began making the year before. With his encouragement, his cousin Ursula, one of the catalysts of his obsession, brings eighteen slides of the doll to Paris where she is studying, and delivers them to Breton. They are published across a double page in the sixth issue of *Minotaure* in December.

In 1935, the first international exhibitions of Surrealism are organized in Tenerife, Copenhagen and Brussels. Breton and Éluard visit the Czech Surrealists in Prague. Breton is refused permission to address the First International Congress of Writers for the Defence of Culture, and the major consequence is the break of the Surrealists with the communists. Crevel, devastated by this and also stricken with advanced tuberculosis, takes his own life. Breton and Bataille are briefly reconciled when they launch the underground anti-fascist movement *Contre-attaque*. The British poet David Gascoyne publishes *A Short History of Surrealism*. Mussolini invades Abyssinia. Germany withdraws from the League of Nations.

In May 1936 Charles Ratton, a Parisian dealer in non-western art, presents the '*Exposition Surréaliste d'Objets*'. The International Surrealist Exhibition is held at the New Burlington Galleries in London, and *Surrealism*, edited and introduced by the English art critic, Herbert Read, is published, with contributions by Breton, Éluard and Hugnet. In New York, The Museum of Modern Art presents 'Fantastic Art, Dada, Surrealism', curated by Alfred H. Barr, Jr., with a comprehensive catalogue. The first attempt to appraise the movement art historically, it juxtaposes Surrealism with fantastical art of previous eras, from Bosch and Arcimboldo to Piranesi and William Blake. Shortly before the show, Julien Levy's gallery screens Cornell's *Rose Hobart*, a film comprised almost wholly of images from *East of Borneo*, a 1931 movie starring the actress Rose Hobart. Cornell condenses the feature-length film into seventeen minutes, preserving only the fragments of scenes where Hobart appears and non-narrative details which take on a surrealistic quality; in some screenings, its magic is heightened by Cornell's use of a blue

projection filter. In Brussels, the painter Paul Delvaux allies himself with the Belgian Surrealist group. Artaud begins his Tarahumara cycle of writings described earlier. Breton and Éluard publish their 'Notes sur la poésie' and Péret publishes his 'Je sublime' ('Sublime Self', or 'I Make Sublime'), counterpart to Breton's mention, in a letter to his infant daughter Aube, of the 'point sublime', the miraculous convergence of contraries – negation and affirmation; being awake and being asleep – which he designates but, as he says, could not inhabit. In Spain, anti-republican general Franco becomes head of state.

In 1937 Breton publishes *L'Amour fou*, and opens the new gallery Gradiva, whose glass door is designed by Duchamp, cut out in the shape of a man and woman standing side by side. In his 1907 article 'Delusion and Dream in Wilhelm Jensen's *Gradiva*', Freud explored this fictional figure's symbolism of the hinterland between waking reality and unconscious desires. In the novel (1903), an archaeologist

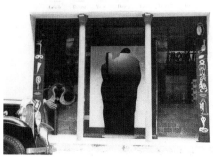
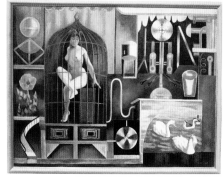
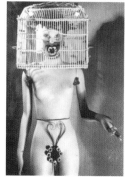

falls in love with the image of a young woman on a Roman sculptural relief. He gives her the Latin name *Gradiva* ('she steps forth') and dreams that he sees her walking in Pompeii on the day Mount Vesuvius erupted, but when he rushes towards her finds that she is just a stone figure, partially buried under the ashes. In Japan in June and July – just as the conflict with China erupts into war – the poet and theoretician Shuzo Takiguchi, who has followed Surrealism and been instrumental in translating Aragon, Breton and Éluard's writings since 1926, asserts both an artistic and political solidarity with the movement at this time of crisis, mounting exhibitions of surrealist works in Tokyo, Kyoto and Osaka, organized in collaboration with his colleague on the journal *Mizue*, Nobuo Yamanaka, and with help from Éluard, Hugnet and the English artist Roland Penrose. A special issue of *Mizue* titled *Album surréaliste*, with text in French and Japanese, surveys Surrealism and reproduces 136 works. Barcelona-based artists Esteban Francés and Remedios Varo

establish links with the Paris group. The Collège de Sociologie (1937–39) is founded by Bataille, Leiris and Roger Caillois. Éluard publishes his *Avenir de la poésie* (*The Future of Poetry*). Picasso exhibits *Guernica* – each evolving stage of which has been photographed by his lover, the artist Dora Maar – at the Spanish Pavilion of the World's Fair. Matta takes part in the production of the pavilion and meets the painter Gordon Onslow Ford, who introduces him to Dalí.

1938 opens with the 'Exposition Internationale du Surréalisme' at the Galerie Beaux-Arts in January. Its elaborate installation, shrouded in darkness, aims to create an atmosphere of erotic and disorienting encounter; it includes in its central area Duchamp's 1,200 stuffed coal sacks overhead with a hot brazier beneath; beyond, a pool; the aroma of coffee; a recording of the hysterical laughter of psychiatric patients; Dalí's delirious 'rainy taxi' occupied by mannequins, crawling live snails and running water; and a further series of mannequins, transformed by Ernst, Marcel Jean, Masson, Dalí, Matta and others. In February the chilling Nazi exhibition which presents what it describes as '*Entartete Kunst*', 'degenerate art', opens in Munich. It includes works by Ernst. Breton departs on a lecture tour to Mexico and meets Trotsky while staying with Diego Rivera and Frida Kahlo. Together they write the manifesto *Pour un art révolutionnaire indépendant* (*For an Independent Revolutionary Art*), signed by Rivera, as it is too dangerous for Trotsky to do so. Dalí, Éluard, Ernst and Hugnet leave the group and Onslow Ford joins. Bellmer and Lam arrive in Paris. Masson's work takes on a harsh form and lurid colours, as anxiety mounts regarding the world situation. The pamphlet '*Ni de votre guerre, ni de votre paix*' ('Neither Your War Nor Your Peace') accuses democracies of having allowed Italy to annihilate Abyssinia. Matta, influenced by Einstein's theories of relativity and Ouspensky's visionary writings, and convinced that visual art can depict time, change, growth and simultaneity, explains his new concept, 'psychological morphology'. It is manifested in painting and drawing as 'the graphic trace of transformations which result from the emission of energies and their absorption in the

object, from its first appearance to its final form, in a geodesic, psychological environment. The object ... intercepts these pulsations, which suggest transformations in an infinite number of directions.'[104] Artaud, in the same year as his most influential book *Le Théâtre et son double* (*The Theatre and its Double*) is published, is diagnosed with 'paranoid delirium', institutionalized and repeatedly subjected to electro-convulsive therapy.

In 1939 Dalí goes to New York and continues the showman-ship begun with his 'rainy taxi', recreating this at the Bergdorf Goodman department store in Fifth Avenue, and proposing a *Dream of Venus* panorama (eventually rejected) for the World's Fair in June. Breton, Éluard and Péret are mobilized, as war is declared. Ernst, still a German citizen, is arrested as an enemy alien. The last issue of *Minotaure* is published. Tanguy and Matta leave for the United States. In Martinique Césaire completes his important epic poem *Cahier d'un retour au pays natal* (*Return to My Native Land*). Surrealism briefly

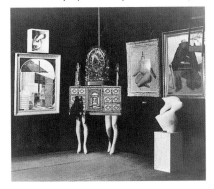

George **PLATT LYNES**, photograph of preparations for Dream of Venus: *background*, Salvador Dalí, *unidentified model*, Gala Dalí; *foreground*, Edward James, Julien Levy, 1939

Detail of an installation at Exposition Internationale du Surréalisme, Paris, 1938, with object-chest by André Breton at centre

starts up in Chile, with the publication *La Mandrágora* (*The Mandrake*), and in Peru, with the review *El uso de la palabra* (*The Use of Speech*) produced by the poet and artist César Moro and fellow poet Emilio Westphalen.

In January 1940 Moro collaborates with Breton and the painter Paalen, who had taken refuge in Mexico the year before, on the 'Exposición Internacional del Surrealismo' at the Galería de Arte Mexicano in Mexico City. Breton's *Anthologie de l'humour noir* (*Anthology of Black Humour*) appears briefly before being suppressed, not to be available again until 1945 in a much revised edition. Mabille publishes *Le Miroir du merveilleux* (*Mirror of the Marvellous*). After France is occupied and Pétain's Vichy government established in July, Varian Fry of the American Committtee of Aid to Intellectuals provides a refuge for Breton and many of the group at the large, secluded Villa Air Bel in Marseille. Miró finds a haven in Palma, Mallorca; Brauner flees to the southern Alpine region; Arp and Sophie Taeuber Arp also go

to the south, eventually to take refuge in Switzerland. In August Man Ray returns to New York; Tanguy and Sage marry and will settle in Connecticut.

In 1941 Breton, Lam, Masson and the anthropologist Lévi-Strauss sail to Martinique, where Césaire and the Caribbean philosopher René Ménil have recently launched the review *Tropiques* to which Surrealists will contribute. Lam goes to Santo Domingo in the Dominican Republic and the others continue to New York, where Ernst also makes his way via Lisbon. Breton breaks relations with Dalí, mocking him with the anagram 'Avida Dollars'. Motherwell begins to mix with the exiled Surrealists, particularly Matta and Seligmann. The New York journal *View* devotes two special issues (December 1940–January 1941, and October–November 1941) to Surrealism. Péret and Remedios Varo join Paalen in Mexico. Still in Paris but to be banned from exhibiting until the liberation, Picasso has written the underground surrealist play *Le Désir attrapé par la queue* (*Desire Caught by the Tail*, to be published in 1944). Among those still in the surrealist group who stay and are active in the resistance movement are Cahun, Desnos and Raoul Ubac. Several younger followers of the Surrealists including the writer Noël Arnaud and the painter Jacques Hérold found the underground Éditions de la Main à plume (from Rimbaud's '*La main à plume vaut la main à charrue*' – the hand that writes is equal to the hand that ploughs), producing clandestine reviews such as *La Main à plume*; *Géographie Nocturne, Tranfusion du verbe* (both 1941); *La Conquête du monde par l'image* (1942); and *Le Surréalisme encore et toujours* (1943). The English surrealist group hold meetings in Soho bars in London throughout the war. These are attended by painters such as John Banting, Emmy Bridgewater and Edith Rimmington; the writer and translator Simon Watson Taylor, the French exiled poet and filmmaker Jacques B. Brunius and the Belgian poet E.L.T. Mesens, who organizes the London shows 'Surrealism Today' (1940) and 'Surrealist Diversity' (1945).

By 1942 Surrealism's strongest presence is in New York. In March the Pierre Matisse Gallery shows fourteen 'Artists in Exile'. In April and May *View* devotes special issues to Ernst and Tanguy. In June appears the first issue of the new surrealist-oriented periodical *VVV*, edited by the sculptor David Hare, with Breton and Ernst as advisors. Motherwell introduces the idea of automatic writing and drawing to

Baziotes and Pollock. In October Breton and Duchamp organize the exhibition 'First Papers of Surrealism' (as in immigration papers) at 451 Madison Avenue, with Duchamp's famous web, or maze, of string simultaneously disrupting and bringing together the exhibition and the contrasting neo-baroque space of the room it is placed in, and above all disorienting viewers as they navigate their passage. Peggy Guggenheim opens Art of This Century, which is both a small museum of her largely surrealist collection and a gallery for new work. The organically shaped forms of its innovative interior, designed by the emigré architect Frederick Kiesler, echo the biomorphic shapes of Arp, Miró and Tanguy. In December Breton gives a lecture, 'Situation du surréalisme entre les deux guerres' at Yale University. In Mexico Paalen founds a new periodical exploring connections between the arts and sciences, Dyn ('the possible' in Greek). Contributors will include Breton and the Mexican poet Octavio Paz, the photographers Manuel Alvarez Bravo and Eva Sulzer, the

ascendency over the destructiveness and bankruptcy of the masculinist world order. The last issue of VVV appears. Dalí publishes his surrealist novel Hidden Faces. In Paris on the eve of liberation Leiris, Maar, Queneau, Jean-Paul Sartre and Simone de Beauvoir are among a small group who read Picasso's Desire Caught by the Tail in a private performance directed by Albert Camus. In the summer of 1945 Breton journeys through the American West, visiting indigenous people of the Hopi and Zuni territories in New Mexico and Arizona. In December he arrives for a lecture tour in Haïti, where with Mabille, now the French cultural attaché, he engages with the local culture and witnesses voodoo ceremonies. In January of the next year he will open an exhibition of Lam's paintings in Port-au-Prince, and his first lecture – perhaps because Surrealism is so surprisingly free of the expected paternalism and misunderstandings of colonialists and liberals alike – inspires an enthusiastic response, to which Breton anecdotally attributes the ensuing

general strike, four days of riots, and flight of the dictator-president, Lescot, although this insurgence has been planned for some time. Back in the United States, Dalí designs a surrealistic dream sequence

ethnologists Alfonso Caso and Miguel Covarrubias, and artists such as Picasso, Henry Moore, Alexander Calder, Motherwell and Pollock. Despite its surrealist links, from the first issue onwards Dyn proclaims its independence from the surrealist project. In Paris Desnos publishes a collection of writings, Fortunes. Germany invades the Free French zone. By 1944, denounced for his subversive underground writings, Desnos will be deported and interred in a series of concentration camps, eventually to die at Theresienstadt (Terezin, Czechoslovakia).

During 1943 Leiris publishes his poetic collection, Haut mal, literally, High Malady: 'it's from his own insides that the poet gathers his matter' – like a bullfight with himself, we might think, reading his later works – and Bataille publishes L'Expérience intérieure (Interior Experience), its title reminiscent of Henri Michaux's Espace du dedans (Space Inside). In 1944 Breton publishes Arcane 17 – a vision of a non-repressive society where desire has free rein and feminine values have

for Alfred Hitchcock's film Spellbound. Brauner and Masson return to Paris. Artaud publishes his Tarahumaras memoirs. The periodical Les Temps modernes (Modern Times) is founded by Sartre, the philosopher Maurice Merleau-Ponty and the sociologist Raymond Aron. In these pages Sartre begins a new debate on the necessity of politically committed literature, as against what he sees as the obscurity of surrealist writing, based in his view on private, self-referential worlds of inner mental associations. In Mexico, Péret publishes his Le Déshonneur des poètes (The Dishonour of Poets) as a counter to a collection of clandestinely published poems by Aragon, Éluard and others from Paris, titled L'Honneur des poètes. Péret reaffirms his conviction that poetry and politics are separate domains.

Breton finally returns to Paris in 1946. Artaud is released from the psychiatric hospital at Rodez and publishes his Lettres de Rodez. The Surrealists exhibit again in Paris, at the Galerie Adrien Maeght, but the artists in New York, such as

Cover of View, vol. 1, no. 3, April 1943, by Kurt Seligmann
Back cover of VVV, 2–3, March 1943, by Frederick Kiesler and Marcel Duchamp
Interior of VVV, 2–3, March 1943, with die-cut optical viewing "instrument", and installation view of Art of This Century, designed by Frederick Kiesler

Baziotes, Adolph Gottlieb, Gerome Kamrowski and Motherwell are now perceived as working in what Harold Rosenberg has called the 'international idiom of twentieth century painting ... a transcendental world style'. The surrealist influence has done its work in America, and has been absorbed into a wider orbit. In Paris a widening, often hostile gulf emerges between the emigré Surrealists and those who endured the occupation. When Tzara, Motherwell and others ask Duchamp why he prefers his quiet, relatively isolated existence in New York to the Paris café society he must surely miss, he describes the Paris scene as a 'basket of crabs'.[105] Ernst, Tanning, Tanguy, Sage, Onslow Ford and others, dispersed across the United States, also stay, responding to its diverse cultures and landscapes.

Just as 1938 marked the end of Surrealism's avant-garde phase, 1947 is held by many to mark the beginning of its demise, at least as a coherent, pre-eminent movement. At Adrien Maeght's gallery, Breton's second international exhibition of Surrealism, elaborately designed by Duchamp and Kiesler, closes on 5 October. It has brought together, among others, Hare, Sage, Man Ray, Gorky, Enrico Donati, Isamo Noguchi, Dorothea Tanning and the Canadian painter Jean-Paul Riopelle. The question in many minds is what kind of shock can Surrealism possibly administer after the terrors of the war? Hare makes the point that surrealist scandal has become accepted as part of a defunct history. As he puts it, there are no longer any genuine battles to be found within the movement, just 'a small group of people amusing themselves with ideas they invented in 1929'.[106] But the seeds of a continuing surrealist movement are being planted: the young and enthusiastic Jean Schuster is invited by Breton to meet him at 5.45 p.m., exactly fifteen minutes before the Surrealists' regular meeting, now ressurrected in Paris. Subsequently, he is invited to attend twice a week, and in the long run becomes a fully fledged member of the group.

In New York by 1947, Art of This Century has closed its doors and Peggy Guggenheim has returned to Europe. Now other galleries take on Motherwell, Baziotes, Gottlieb and Hans Hofmann. Motherwell and Rosenberg, with the architect Pierre Chareau, start a journal called *possibilities*; as with Eugène Jolas' earlier journal, *transition*, the use of lower-case and the title itself indicate some continuing impulse towards open-endedness. Paalen's *Dyn* and the arts journal associated with the Abstract Expressionists, *Tiger's Eye*,

absorb and transform the original ideas of automatism. In Paris, Breton attends a conference at the Sorbonne, in which he has refused to be a respondent to Tzara, whom he calls a Stalinist, and prefers to heckle from the audience. Tzara accuses him and Surrealism of having exiled themselves at a moment of urgency. Surrealism, he says, is 'absent from our hearts, and from our actions'. Surrealist meetings continue to be held with a new group of participants, but the spirit has changed. A dissident group, *Surréalisme Révolutionnaire*, is founded in Belgium, led by the poet and artist Christian Dotremont. An antecedent of Lettrism and the Situationist International, it attacks Breton's increasing preoccupation with the esoteric and occult.

Through 1948 decisions continue to be made about who is in and who is out. Matta is excluded on intellectual grounds, Brauner for his break with surrealist discipline, and so on. In the United States, after a period of chronic depression due to tragic events both in his life and those of his people, the massacred Armenians, Gorky hangs himself. After Vaché and Crevel, yet another surrealist suicide, to be followed a decade later by Domínguez, Sage and Seligmann. So ends the surrealist group adventure – in tragedy and diminished energy; that is, in the eyes of some. The official surrealist movement in fact continues during the 1950s and early 1960s, with Breton and Schuster at the helm. Schuster initiates a new periodical, *Médium*, in 1951; another, edited by Breton, *Le Surréalisme, même*, runs from 1956–59. When, in 1966, a ten-day meeting on the subject of Surrealism is held at the International Centre at Cerisy-la-Salle Schuster is the person who – along with José Pierre, the art historian – telephones Breton, too unwell to attend, every evening to tell him how the day's proceedings have gone. Later that year Breton's life ends. Schuster, behind his perennial green glasses, perseveres in maintaining the international surrealist movement until, in 1968, it is disbanded and separate groups begin to go their own way.

But the art and the visions endure, as do their legacy – whether consciously evoked or otherwise – in such recent creations as those of the Brazilian-born Vik Muniz (to select just one artist among many others since the 1960s), with his gingerbread façade (*CandyBAM*, 2002), made from blown-up photographs of an actual gingerbread cake, which enveloped Brooklyn Academy of Music during its restoration over 2002–3, creating a sense of heightened anticipation and

childlike wonder while preserving and transforming the memory of the real building underneath, and appealing to the possibility of Breton's claim for Surrealism, that what we imagine tends to become the real. In such works there is also an echo of the Surrealists' fascination with fantastical buildings – for Dalí, the art nouveau architecture of Antoni Gaudí in Barcelona and Hector Guimard in Paris; for Breton, Picasso and others, the celebrated *Palais idéal* (1879–1913), a concrete realization of his visions patiently built by the postman Ferdinand Cheval in his back garden, stone by stone, with rocks he collected from the wayside.

Or Muniz again – with his earlier photographic series *Pictures of Dust* (2000) shown at the Whitney Museum of American Art, New York, in 2001, this time recalling the quite different legacies of Man Ray's photograph of accumulated dust on the surface of Duchamp's 'Large Glass' (*Élevages de poussière*, or *Dust Breeding*, 1920); Bataille and his fascination with the formless and unformed, reflected in such

texts as the 1929 entry on 'Dust' in his 'Critical Dictionary' published in *Documents*; and Raoul Ubac's 'fossil' photographs of the late 1930s. In *Pictures of Dust* – following a lineage of works that artists have made since the mid 1960s, exploring the significance of the index or trace[107] – Muniz gathered dust from the museum's offices, used it to make drawings based on photographs of minimalist and post-minimalist sculptures from the permanent collection and then photographed the dust drawings, evoking a parallel world conveyed through representations of representations ...

Representing Surrealism

'Surrealism not dead, except at Beaubourg', read the headline in *Le Monde* on Friday 28 June 2002. It was referring to '*La Révolution surréaliste*' at the Centre Georges Pompidou in Paris, conceived by the distinguished curator and scholar of Surrealism, Werner Spies, which ran from March to June that year. The whole point of the movement, claimed the

author of the article, Michaël Lowy, was its well-known double motto which combined Karl Marx's statement, 'to transform the world', with Arthur Rimbaud's, 'to change life'. It was certainly not, he continued, the anodyne reduction printed in the exhibition guide: 'to participate in the organization of society'. Here he did have a point, since this sounds more like a call for participation in the church bazaar, signalled in a local newspaper, than the universe- and mind-transforming venture called for by the grand term of revolution.[108]

Of course, any attempt by curators to represent such a would-be subversive and challenging group action within a museum-like enclosure is asking for trouble. At William Rubin's equally major survey of Dada and Surrealism held at the Museum of Modern Art, New York, in 1968, there had been no less protest. In the streets, young and less young manifesting Surrealists and would-be Surrealists held up banners reading: 'MUSEUM MAUSOLEUM!' During the conference held to accompany the show, Duchamp, when asked if he would like to make a statement, put his position in a nutshell with the single word: 'No.'

The legacies of the surrealist movement are largely demonstrated by its exhibitions, in which very often a present form of Surrealism is added to the inheritance.

Perhaps it is time now, after thirty years, for curators to consider recreating a show like those the group themselves devised, such as the first exhibition of surrealist painting (Paris, 1925); the first and second international exhibitions (Paris, 1938; 1947); 'EROS' ('*Exposition inteRnatiOnale du Surréalisme*', Paris, 1959) or '*L'Écart absolu*' (Paris, 1965), whose title, conveying endless divisibility and diversity, symbolized the complete refusal to fit into any established way of thinking, doing, showing or being. Reviewing '*La Révolution surréaliste*', one critic noted how the 'sense of estrangement' had been 'central to the Surrealists' own radical installations'. The 1925 exhibition had 'opened at midnight ... an hour chosen to underscore the movement's affinity with the unconscious worlds of dreams. At the 1938 international surrealist exhibition, visitors were given flashlights to illuminate art displayed in the darkness.'[109]

Between Rubin's 1968 exhibition and the early twenty-first century a number of surveys provided major additions to our

Vik MUNIZ CandyBAM, Brooklyn Academy of Music, New York, 2002
Ferdinand CHEVAL *Palais Idéal*, Hauterives, France, 1879–1913 [detail]
Vik MUNIZ After Barry le Va, from Pictures of Dust, 2000

knowledge of Surrealism, including '*I surrealisti*' (Palazzo Reale, Milan, 1989); '*Die surrealisten*' (Schirn Kunsthalle, Frankfurt am Main, 1989–90); and shows that opened up new critical perspectives, such as 'Dada and Surrealism Reviewed' (Hayward Gallery, London, 1978 – a reappraisal centred on a detailed examination of the numerous reviews and periodicals); the touring show '*L'Amour fou*: Photography and Surrealism', initiated at the Corcoran Gallery of Art, Washington, 1985–86; '*Regards sur Minotaure: La Revue à tête de bête*' (Musée d'art et d'histoire, Geneva, 1987); and 'Anxious Visions: Surrealist Art' (University Art Museum, Berkeley, California, 1990).

In particular, the installation of 'Surrealism: Desire Unbound', curated by Jennifer Mundy at Tate Modern, London, in 2001 (very different from its subsequent redesign at the Metropolitan Museum of Art, New York) demonstrated how contemporary presentations do not need to be antiseptic.[110] One of the first artworks one encountered, suspended in

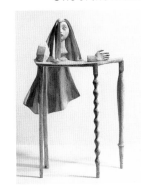
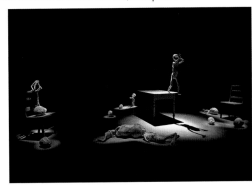

Alberto GIACOMETTI Table, 1933
Catherine HEARD Sleep [installation view], 2000

a dark void, was Ernst's large and explicit painting, briefly described earlier, of a kind of celestial intercourse: *Men Shall Know Nothing of This* (1923). Emanating, as it were, from the painting and its surrounding darkness was the recording of a heartbeat sound.[111] Echoing several of the Surrealists' own uses of sound in their exhibition installations, this kept alive the original pulse of Surrealism's aims, implying both its intensity and the Freudian relationship between the struggle for life and the erotic impulse. At the Centre Pompidou Ernst was undoubtedly more present but perhaps less alive. In any case '*La Révolution surréaliste*' included some major works, many of which, as at the Tate show, had not been shown in public before. These included the transposition of the lifetime's collection of artworks, objects and artefacts from the wall behind Breton's desk in his Paris studio, and the equally important contribution of a range of surrealist books and documents, including Nadja's sketches and drafts of letters to Breton.[112] Giacometti's *Table* (1933) was set up

brilliantly so that just the hand was visible from the next room through a small square opening, like a window into another space. But the heartbeat was fainter.

To mention only a few of the exhibitions held during the last decades of the twentieth century which aroused a new interest in hitherto underexposed aspects of the movement, 'Surrealism: Revolution by Night' at the National Gallery of Australia, Canberra, in 1993 demonstrated the impact of European Surrealism in Australia in the 1930s and 1940s; the major contribution of Surrealism in Eastern Europe was explored in a number of retrospectives such as 'Styrsky, Toyen, Heisler', at the Centre Pompidou, Paris, in 1982; the significant extent of British Surrealism was rediscovered in exhibitions such as '*Peinture surréaliste en Angleterre*' at Galerie 1900–2000, Paris, in 1982; and Scandinavian work was revisited in shows such as '*Surrealismi*' at Rettretti Art Centre, Savonlinna, Finland, in 1987. In Canada Surrealism's legacies have re-entered public consciousness through the work of artists such as Diana Thorneycroft, whose photographs explore extreme and heightened forms of experience through stagings of the artist's body, and Catherine Heard, whose installations combine bodily imagery with references to pre-Columbian myths. Their work refers both to the legacy of figures such as Bataille and Bellmer and to the self-performance of contemporaries such as Cindy Sherman. The extraordinary legacy of Surrealism is evident in these extensions of the movement's ideas and vision into contemporary life, in the work of diverse artists across many continents – Caribbean and Japanese Surrealism being other examples of important historical bodies of work that are gradually being uncovered.[113] In the work of the present which draws on this legacy, we can still encounter an atmosphere of excitement, paradox, genuine trouble and partial resolution, and above all, openness to chance. What emerges from such contemporary convergences of the uncanny, the unexpected and the impassioned just might be – depending on how we witness it, remaining in a state of readiness – that transformed state of consciousness in which Surrealism continues to exist.

1 André Breton, *Manifeste du surréalisme*, Paris, 1924; trans. Richard Seaver and Helen Lane, in André Breton, *Manifestos of Surrealism*, University of Michigan Press, Ann Arbor, 1969.

2 What the surrealist notion of otherness might entail is here introduced in basic terms. In Breton's thinking, as it develops, the simple opposition of one and its other gives way to a notion of simultaneous experience of 'one in the other' (*L'un dans l'autre*), described further in note 84 below. For a number of Surrealists, this can extend to experiences or visions *through* an other, or multiple others.

3 Born in 1884 in Bar-sur-Aube, Gaston Bachelard began his career as an employee of the postal service, first in Remiremont, then in Paris (1907–13). Coincidentally the dream-inspired *Palais idéal* (1879–1913) constructed by Ferdinand Cheval, also a postman and known as 'le Facteur Cheval', was to be an important inspiration for Breton, Picasso and others. See photographs on pages 16 and 42.

4 See Mary Ann Caws, *Surrealism and the Literary Imagination: A Study of Breton and Bachelard*, Mouton & Co., The Hague and Paris, 1966, 12, note 3: G.C. Christofides refers to Bachelard as 'le philosophe du surréalisme' in 'Bachelard's Aesthetics', *Journal of Aesthetics and Art Criticism*, XX (1962) 263.

5 Gaston Bachelard, *La Psychanalyse du feu*, Éditions Gallimard, Paris, 1938; trans. Alan C.M. Ross, *The Psychoanalysis of Fire*, Orion Press, New York, 1964.

6 Bachelard begins by regarding the seductiveness of fire as ' ... the most dangerous obstacle to scientific discipline, since it lures us into subjective dreaming. At the opposite pole from the surrealistic delight in the marvellous stands his diatribe against the hypnotic state into which we sink when "we marvel before an elusive object ..." ... But it is essential to note that already in *Le Nouvel Esprit scientifique*, written in 1934, Bachelard was developing his revolutionary concept of *surrationalisme*. Bearing the same relationship to ordinary or "closed" rationalism as Surrealism does to Realism, surrationalism is an open rationalism in which the mind never rests but always questions what it has just discovered. To supplant the older metaphysics of the contradictory dialectic, Bachelard calls for an ontology of the complementary ... where the opposites coexist, intuitive images and their scientific denial. *The Psychoanalysis of Fire* itself ends with an unexpected invocation of the "alert dialectic" stimulated in the contemplator of fire. Poetry is not to be denied, nor does it come second to science ... the two must remain in perfect balance.' Mary Ann Caws, *Surrealism and the Literary Imagination*; *op. cit.*, 15–16.

7 Gaston Bachelard, *L'Eau et les rêves*, Librairie José Corti, Paris, 1942; trans. Edith R. Farrell, *Water and Dreams: An Essay on the Imagination of Matter*, Pegasus, Dallas, Texas, 1983.

8 The word is recorded as first being used by the poet Guillaume Apollinaire, around 1917, as described later in this essay on page 33.

9 André Breton, 'Always for the first time', in *Poems of André Breton*, trans. Mary Ann Caws and Jean-Pierre Cauvin, University of Texas Press, 1982.

10 René Char, 1954; quoted in Mary Ann Caws, 'Rhythm: Char and His Others', *The Surrealist Look, op. cit.*, 42.

11 Robert Desnos, '*Jamais d'autre que toi*', 1930; reprinted in Robert Desnos, *Oeuvres*, Éditions Gallimard, Paris, 1999, 563–4.

12 Tristan Tzara, 'Lecture on Dada', 1922; trans. Robert Motherwell, in his *The Dada Painters and Poets*, George Wittenborn, New York, 1951.

13 Vaché was a traumatized ex-soldier in Breton's medical care, who introduced him to a random, spontaneous attitude to life. Malcolm Haslam records the group's comparison of Vaché with Lafcadio, the detached and disinterested fictional hero of André Gide's novel *Les Caves du Vatican*, published in 1914. (*The Real World of the Surrealists*, Galley Press, New York, 1978, 19–25.)

14 Aside from the puns, the title itself, *Littérature*, suggested by the poet Paul Valéry, was an ironic allusion to Verlaine's *Art poétique*, which concludes: 'And all the rest is literature'.

15 This image was first described by André Breton in *L'Amour fou*, as 'a photograph of a speeding locomotive abandoned for years to the delirium of a virgin forest'. *L'Amour fou*, Éditions Gallimard, Paris, 1937; trans. Mary Ann Caws, *Mad Love*, University of Nebraska Press, Lincoln, 1987, 10. However the photograph itself was not reproduced in the text but appeared in *Minotaure*, 10 (Winter 1937) where it illustrated Benjamin Péret's text '*La Nature dévore le progrès et le dépasse*' in which he portrays the forest and the locomotive as at first adversaries, then lovers. See Hal Foster, *Compulsive Beauty*, MIT Press, Cambridge, Massachusetts, 25–8, note 16.

16 André Breton, '*Lâchez tout!*', *Les Pas perdus*, Éditions de la *Nouvelle revue française*, Paris, 1924; trans. Mark Polizzotti, *The Lost Steps*, University of Nebraska Press, 1993.

17 See Gérard Durozoi, *Histoire du mouvement surréaliste*, Éditions Hazan, Paris, 1997; trans. Alison Anderson, *History of the Surrealist Movement*, University of Chicago Press, 2002, 63.

18 The first reproductions of these were published, without identification of their creators, in *La Révolution surréaliste*, 9–10 (October 1927).

19 André Breton, '*Les Mots sans rides*' ('Words without Wrinkles'), *Littérature*, 2nd series, 7, Paris, December 1922.

20 William S. Rubin, *Dada and Surrealist Art*, Harry N. Abrams, Inc., New York, 1968, 43.

21 'Magnetism' was a term used by J.-M. Charcot and other nineteenth-century psychiatrists as an analogy for the way hypnosis would draw out an ailment from a patient through speech and actions while in a trance. In particular Théodore Flournoy carried out experiments between 1894–99 with the medium Catherine Müller, known by the pseudonym Hélène Smith. He discovered that her creativity was greatly expanded during hypnosis, and in 1900 he published an account of her otherworldly visions, *From India to the Planet Mars*. In 1908 her paintings were shown in Geneva and Paris.

22 André Breton, *Manifeste du surréalisme*; *op. cit.*

23 Louis Aragon, 'Une Vague de rêves', *Commerce*, 2, Paris, Autumn 1924; extracts here quoted from Maurice Nadeau, *Histoire du surréalisme* (first volume published in Paris, 1945); definitive version, Éditions du Seuil, Paris, 1965; trans. Richard Howard, *The History of Surrealism*, Macmillan, New York/ Jonathan Cape, London, 1965; reprinted by Belknap Press, Harvard University, Cambridge, Massachusetts, 83–4.

24 *Ibid*. A newly translated extract from *Une Vague de rêves* is included in the Documents, page 198.

25 See Dickran Tashjian, *A Boatload of Madmen: Surrealism and the American Avant-Garde, 1920–1950*, Thames and Hudson, London and New York, 1995, 232. See also Martica Sawin, *Surrealism in Exile and the Beginning of the New York School*, MIT Press, Cambridge, Massachusetts, 1995.

26 See the interviews between Robert Motherwell and the author published in her book, *Robert Motherwell: What Art Holds (Interpretation in Art)*, Columbia University Press, New York, 1996. Max Ernst's technique of dripping paint from a tin can, as in *Young Man Intrigued by the Flight of a Non-Euclidian Fly* (1942–47) was also influential. Jackson Pollock first saw this work in progress in Ernst's studio in 1942.

27 André Masson, *Le Rebelle du surréalisme: Écrits*, ed. Françoise Will-Levaillant, Hermann, Paris, 1976, 37.

28 Ibid.

29 See also Miró's doodles in many of his compositions, his reworkings, and his 'successive deconstructions' of the self, discussed by David Lomas in *The Haunted Self: Surrealism, Psychoanalysis, Subjectivity*, Yale University Press, 2001, New Haven, Connecticut, 209.

30 As the art historian and curator Jean Clay points out, the analysis of the painting by its maker now picks up on all the techniques of '*tressage, débordements, chevauchements*' ('inter-braiding, excesses and spillings, leapings over') so that painting 'goes beyond the problematics of the surface to reach ... the category of the layered, the thickness ... braiding, pleating, interstice ... the flutter of space.'. (Jean Clay, *De l'Impressionnisme à l'art moderne*, Hachette, Paris, 1975) This specificity of matter in painting, such as the sand in Masson's works, became a subject of fascination. The particular matter to be worked on, and the way in which *la pâte* (paste/impasto) defines the hand of the artist is also discussed by the art historian Daniel Arasse: in the traces and trails of the brushstroke, 'as it is isolated from the painting and its representative logic, the pictorial detail shows imagining matter in its gestation, not yet metamorphosed to become transparent to what it reproduces ... the virtual potential embryo of the image'. Daniel Arasse, *Le Détail: Une histoire rapprochée de la peinture*, Flammarion, Paris, 1992, 275.

31 André Breton, *Manifeste du surréalisme*; *op. cit.*,

32 Maurice Nadeau, *The History of Surrealism*; *op. cit.*

33 See Hal Foster, *Compulsive Beauty*; *op. cit.*, 1–2; other important studies of the impact of wartime trauma, psychology and theories of the unconscious on the development of Surrealism include Sidra Stich, *Anxious Visions: Surrealist Art*, University Art Museum, Berkeley, California and Abbeville Press, New York, 1990; and David Lomas, *The Haunted Self: Surrealism, Psychoanalysis, Subjectivity*; *op. cit.* The dates and details of French translations of Freud's principal works are listed in Jennifer Mundy, *et al.*, *Surrealism: Desire Unbound*, op. cit., 58.

34 Louis Aragon, 'Une Vague de rêves'; *op. cit.*

35 See the exchange of letters between Freud and Breton included in Mary Ann Caws and Geoffrey T. Harris' translation of Breton's *Les Vases communicants: Communicating Vessels*, University of Nebraska Press, 1990.

36 André Breton, *Communicating Vessels*; *op. cit.*, 11.

37 *Ibid.*, 13.

38 Alberto Giacometti, *Minotaure*, 3–4, December 1933.

39 Breton's account was disputed by the Giacometti scholar Reinhold Hohl (author of *Alberto Giacometti*, Gerd Hatje verlag, Stuttgart, 1971) who suggested that the face is derived from a Solomon Islands seated statue of a deceased woman which the artist would have seen at the Ethnological Museum in Basel. Rosalind Krauss notes that the mask found in the flea market was a prototype for an iron protection mask designed by the French Medical Corps in the First World War (Rosalind E. Krauss, 'No More Play', *The Originality of the Avant-Garde and Other Modernist Myths*, MIT Press, Cambridge, Massachusetts, 1985). See also Sidra Stich's discussion of this work in *Anxious Visions: Surrealist Art*; *op. cit.*

40 André Breton, *L'Amour fou*; *op. cit.*, 26.

41 See Hal Foster, *Compulsive Beauty*; *op. cit.*, 37: 'In a moment of "feminine intervention" Giacometti had lowered the hands to reveal the breasts – a disastrous move, according to Breton, in which the invisible object was lost (with the return of the breasts, we might say, the lost object was lost again).'

42 See also Yves Bonnefoy, *Giacometti*, Flammarion, Paris, 1991; trans. *Giacometti: A Biography of His Work*, Flammarion, 2001.

43 Breton, *L'Amour fou*; *op. cit.*, 15–16.

44 Hal Foster, *Compulsive Beauty*; *op. cit.*, 29.

45 André Breton, *Introduction au discours sur le peu de réalité*, Éditions Gallimard, Paris, 1927; reprinted in *Point du jour*, Éditions Gallimard, Paris, 1933; trans. Mark Polizzotti and Mary Ann Caws, *Break of Day*, University of Nebraska Press, Lincoln, 1999.

46 For concise descriptions of the various types of surrealist object see Sarane Alexandrian, *Surrealist Art*, Thames and Hudson, 1970, 140–50.

47 *Joseph Cornell's Theater of the Mind: Selected Diaries, Letters and Files*, ed. Mary Ann Caws, MIT Press, Cambridge, Massachusetts, 2000, 85.

48 André Breton, *Second Manifeste du surréalisme*, in *Manifestos of Surrealism*; *op. cit.*

49 The first 'natural-looking' wave effect, created with curling irons by the Parisian hairdresser, Marcel Grateau in 1872, and still popular in the 1920s.

50 Louis Aragon, *Le Paysan de Paris*, Éditions Gallimard, Paris, 1926; trans. Simon Watson Taylor, *Paris Peasant*, Pan/Picador, London, 1971; reprinted by Exact Change, Boston, 1994, 53–4.

51 As James Harkness notes in the introduction to his translation of Michel Foucault's essay on Magritte, *This Is Not a Pipe*, Magritte remained faithful to the 'ascendency of poetry over painting' which he realized when he first encountered de Chirico's work in 1922. He read widely in philosophy and poetry and 'disliked being called an artist, preferring to be considered a thinker who communicated by means of paint'. Michel Foucault, *Ceci n'est pas une pipe*, Fata Morgana, Montpellier, 1973; trans. James Harkness, *This Is Not a Pipe*, University of California Press, Berkeley and Los Angeles, 1983, translator's introduction, 2.

52 Robert Desnos, *Oeuvres*; *op. cit.*, 330–1.

53 For an extended analysis of this subject see Georges Didi-Huberman, *Invention de l'hystérie; Charcot et l'iconographie photographique de la Salpêtrière*, Macula, Paris, 1982; trans. *Invention of Hysteria: Charcot and the Photographic Iconography of the Salpêtrière*, MIT Press, 2003.

54 André Breton, 'Fil conducteur' (1945) in *Essais*, Folio, 259; also see his essay 'Arshile Gorky', in *Le Surréalisme et la peinture*, Éditions Gallimard, Paris,

revised edition, 1965.

55 Hal Foster, *Compulsive Beauty*; *op. cit.*, 19.

56 See, for example, Breton's emphatically reiterated statement derived from the first manifesto, in the pamphlet *What Is Surrealism* (Brussels, 1934): 'I am resolved to deal severely with that hatred of the marvellous which is so rampant among certain people, that ridicule to which they are so eager to expose it. Let us speak plainly: The marvellous is always beautiful, anything marvellous is beautiful; indeed, nothing but the marvellous is beautiful. What is admirable about the fantastic is that there is no longer a fantastic; there is only the real.'

57 Pierre Mabille, *Le Miroir du merveilleux*, Éditions du Sagittaire, Paris, 1940; reprinted by Éditions de Minuit, Paris, 1977. Translation of this extract by Mary Ann Caws, 2002.

58 Hal Foster, preface, *Compulsive Beauty*; *op. cit.*, xix; see the chapter titled 'Compulsive Beauty', 19–54.

59 Rosalind Krauss, 'Photography in the Service of Surrealism', *L'Amour fou: Photography and Surrealism*, ed. Rosalind Krauss, Jane Livingston, Abbeville Press, New York, 1985, 40.

60 Hal Foster, *Compulsive Beauty*; *op. cit.*, 27.

61 For there is, of course, a way of performing criticism as a Surrealist, for example, in the contemporary work of Annie Le Brun (see note 108 below, and bibliography).

62 The spatial complexity and interpenetration of surrealist spaces can be related to characteristics found in Baroque art and poetry. See, for example, Jean Rousset's description of the baroque: 'To the

intuition of an unstable and moving world, of a multiple and inconstant life, hesitating between being and seeming, fond of disguise and of theatrical representation, there correspond, on the expressive and structural level a rhetoric of metaphor and *trompe l'oeil*, a poetics of surprise and variousness, and a style of metamorphosis, of dynamic spread and dispersion in unity. In order to produce the desired effect of motion and expansion, of an action constantly beginning over and never completed, of perpetual transmutation central to the work, the baroque creator will have recourse to several stylistic means: open and complex forms, the elimination of articulations, a construction on several levels at once, an unstable equilibrium due to the multiplicity of perspectives, of organizing centres, and of mental and imaginative registers.' Jean Rousset, introduction to his edited *Anthologie de la poésie baroque française*, Armand Colin, Paris, 1961; reprinted by José Corti, Paris, 1988; quoted in Mary Ann Caws, *The Surrealist Look*, op. cit., 6.

63 Sidra Stich, *Anxious Visions: Surrealist Art*; *op. cit.*, 11.

64 *Ibid.*, 12.

65 Antonin Artaud, '*Addresse au Dalai-Lama*', *La Révolution surréaliste*, 3 (April 1925); quoted in Sidra Stich, *Anxious Visions: Surrealist Art*; *op. cit.*, 12.

66 Michel Leiris, '*L'Homme et son intérieur*', *Documents*, 5 (1930).

67 See Denis Hollier, *La Prise de la concorde*, Paris, 1974; trans. Betsy Wing, *Against Architecture*, MIT Press, Cambridge, Massachusetts, 1989; Rosalind Krauss's

writings on Surrealism in general, and in particular, *The Optical Unconscious*, MIT Press, Cambridge, Massachusetts, 1993 and, with Yve-Alain Bois, *Formless: A User's Guide*, Zone Books/MIT Press, Cambridge, Massachusetts, 2000; and David Lomas, *The Haunted Self: Surrealism, Psychoanalysis, Subjectivity*; *op. cit.*

68 David Lomas, *The Haunted Self: Surrealism, Psychoanalysis, Subjectivity*; *op. cit.*, 162–63; Julia Kristeva, *Pouvoirs de l'horreur. Essai sur l'abjection*, Éditions de Seuil, Paris, 1980; trans. Léon Roudiez, *Powers of Horror: An Essay on Abjection*, Columbia University Press, New York, 1982.

69 David Lomas, *The Haunted Self: Surrealism, Psychoanalysis, Subjectivity*; *op. cit.*, 170.

70 See Katharine Conley, *Robert Desnos, Surrealism and the Marvellous in Everyday Life*, University of Nebraska Press, 2003.

71 See David Lomas, *The Haunted Self: Surrealism, Psychoanalysis, Subjectivity*; *op. cit.*, 168.

72 These dates vary in anecdotal recollections. Karin von Maur dates Tanguy's encounter as 1922, while previously it was often recorded as 1923 or 1924; *Yves Tanguy and Surrealism*, Staatsgalerie, Stuttgart/Hatje Cantz, 2000/Menil Collection, Houston, Texas, 2001.

73 See Uwe M. Schneede, 'Sightless Vision: Notes on the Iconography of Surrealism', in Werner Spies, ed., *Max Ernst: A Retrospective*, Tate Gallery, London/Prestel verlag, Munich, 1991, 351–6.

74 David Lomas, *The Haunted Self: Surrealism,*

Psychoanalysis, Subjectivity; *op. cit.*, 7.

75 *Ibid.*, 55.

76 *Ibid.*, 244. Dalí's paranoid-critical method is discussed by Lomas in relation to the lectures of Alexandre Kojève, which were attended by Lacan as well as the writer Raymond Queneau, a major figure in the Collège de Pataphysique, site of the organization OULIPO (Ouvroir de Littérature Potentielle – Workshop of Potential Literature), which aimed to liberate the poetic potential in language by transforming it in experimental forms of writing. In Kojève's words: 'The I of Desire is an emptiness, which receives a real, positive content only by negating the action that satisfies Desire, in destroying, transforming and "assimilating" the desired non-I.' See Alexandre Kojève, *Introduction to the Reading of Hegel*, trans. James H. Nichols Jr., Cornell University Press, Ithaca, New York, 1980, 158. Lacan attended Kojève's lectures on Hegel's Phenomenology of the Mind, delivered at the École des Hautes Études in Paris from 1933 to 1939.

77 For an extended discussion of these ideas see Mary Ann Caws, 'Decor: Desnos in Mourning', *The Surrealist Look*, MIT Press, Cambridge, Massachusetts, 1997, 151–67.

78 André Breton, '*L'Union libre*' (1931), in *Le Revolver à cheveux blancs*, Éditions Gallimard, Paris, 1948; trans. Mary Ann Caws and Patricia Terry, in *Surrealist Love Poems*, ed. Mary Ann Caws, Tate Publishing, London/University of Chicago Press, 2002, 24–6.

79 Robert Desnos, from '*À la mystérieuse*' (1926), in *Corps*

et biens, Éditions Gallimard, Paris, 1930; trans. Mary Ann Caws, in *Surrealist Love Poems*; *op. cit.*, 58.

80 For recent treatments of this subject see Jack Flam and Miriam Deutsch (eds), *Primitivism and Twentieth-Century Art: A Documentary History*, University of California Press, Berkeley and Los Angeles, 2003; and Susan Hiller (ed.), *The Myth of Primitivism: Perspectives on Art*, Routledge, London and New York, 1992.

81 See, for example, Aimé Césaire, *Cahier d'un retour au pays natal*, Présence Africaine, 1956; trans. John Berger and Anna Bostock, *Return to My Native Land*, Penguin Books, 1969; and Léopold Sédar Senghor (ed.), *Anthologie de la nouvelle poésie nègre et malgache de la langue française*, prefaced by Jean-Paul Sartre's '*Orphée noir*', Presses universitaires de France, Paris, 1948; reprinted 1977.

82 See vol 6. of Antonin Artaud, *Oeuvres complètes*, Éditions Gallimard, Paris, 1956 (6 vols.); trans. Victor Corti, *Collected Works*, John Calder, London, 1999 (vols. 1–4 published; 5–6 in preparation).

83 Sidra Stich, *Anxious Visions: Surrealist Art*; *op. cit.*, 16.

84 Also translated as 'One into Another', this was a game devised by Breton and Péret. Breton described the rules as follows: 'One of us went out of the room, and had to decide on a particular object (for example, a staircase), with which he would identify himself. While he was out the rest of us had to agree on another object which he would have to represent (for example a bottle of champagne). So he had to describe himself in terms of a bottle of champagne, but

with such peculiarities that gradually the image of the bottle would be eclipsed and finally replaced by the image of the staircase.' Cited in Sarane Alexandrian, *Surrealist Art*, Thames and Hudson, London, 1970, 218–19.

85 See also Louis Aragon's earlier text set in Paris, *Anicet ou le panorama*, Éditions de la *Nouvelle revue française*, Paris, 1921.

86 André Breton, *Nadja*, Éditions de la *Nouvelle revue française*, Paris, 1928; trans. Richard Howard, Grove Press, New York, 1960; reprinted by Penguin Books, 1999, 80.

87 Sidra Stich, *Anxious Visions: Surrealist Art*; *op. cit.*, 218.

88 See Michel Remy, *Surrealism in Britain*, Lund Humphries, London, 2001, 16.

89 Maurice Nadeau, *The History of Surrealism*; *op. cit.* Written in 1944, the first volume was published in 1945.

90 For a recent reflection on the continuing relevance of Surrealism see Norman Bryson, 'The Unfinished Project of Surrealism', in Bice Curiger (ed.), *Hypermental: Rampant Reality 1950–2000. From Salvador Dalí to Jeff Koons*, Kunsthaus Zurich, 2000, and Curiger's introductory text in the same publication. This was the catalogue for a group show examining the legacy of surrealist ideas in the work of a diverse range of post-war and contemporary artists.

91 For the most detailed historical account see Gérard Durozoi's *History of the Surrealist Movement*; *op. cit.*

92 For a discussion of de Chirico's influence on Magritte see Suzi Gablik, *Magritte*, Thames and Hudson, London and New

York, 1970, 23–40.

93 See also Robert Desnos' essay on Miró's work in the collection *Écrits sur les peintres*, ed. Marie-Claire Dumas, Flammarion, Paris, 1983.

94 For a comprehensive survey of Tanguy's work see Karin von Maur, *Yves Tanguy and Surrealism*; *op. cit.*

95 See Gérard Durozoi, *History of the Surrealist Movement*; *op. cit.*, 65–6.

96 A new translation of Ernst's account of his discovery is printed here in the Documents section, 215.

97 From the 1980s onwards the independent contribution of women artists within the surrealist movement has been recuperated into its historical accounts and its critical theory. This was initiated by Whitney Chadwick's *Women Artists and the Surrealist Movement* (Little, Brown & Co., Boston, 1985). In her introduction she describes how, based on her conversations with living artists, they felt positively supported, if occasionally misunderstood, by their male counterparts; much of the exclusion that arose came from the bias of certain critics, historians, curators and institutions. For a critical analysis of the situation of women as makers of art, from the surrealist period onward, which also advances a critique of certain feminist positions, see Rosalind Krauss, *Bachelors*, MIT Press, Cambridge, Massachusetts, 1999. See also Mary Ann Caws, Rudolf E. Kuenzli and Gwen Raaberg (eds.), *Surrealism and Women*, MIT Press, Cambridge, Massachusetts, 1991; and Whitney Chadwick (ed.) *Mirror Images: Women, Surrealism and Self-*

Representation, MIT Press, Cambridge, Massachusetts, 1998. Also indispensible is the impressively researched *Surrealist Women: An International Anthology*, ed. Penelope Rosemont, University of Texas/Athlone Press, London, 1998.

98 For a detailed account of the Surrealists' political debates and affiliations see Gérard Durozoi, *History of the Surrealist Movement*; *op. cit.*, 126–47.

99 Included in Mary Ann Caws (ed.) *Surrealist Painters and Poets: An Anthology*, MIT Press, Cambridge, Massachusetts, 2001.

100 This mental state is described later by Breton as the '*point sublime*', in his letter to his infant daughter Aube, published in *L'Amour fou* (1937).

101 See Werner Spies, *Loplop the Artist*, Thames and Hudson, London and New York, 1983. Loplop's first emergence was in 1929 as a figure in the collages of *La Femme 100 têtes*.

102 See Ingrid Schaffner and Lisa Jacobs (eds), *Julien Levy: Portrait of an Art Gallery*, MIT Press, Cambridge, Massachusetts, 1998.

103 For a critical account of this episode see Dawn Adès, *Dalí and Surrealism*, Thames & Hudson, London, 1982, 106–8.

104 Quoted in David Lomas, *The Haunted Self*; *op. cit.*, 219.

105 Marcel Duchamp, letter to Tristan Tzara, 1946, cited in Martica Sawin, *Surrealism in Exile*, *op. cit.*, 385.

106 Quoted in *Ibid.*, 398.

107 See Rosalind Krauss, 'Notes on the Index: Seventies Art in America', *October*, 3 (Winter 1976–1977), 2–15; reprinted in *The Originality of the Avant Garde and Other Modernist Myths*, MIT Press,

Cambridge, Massachusetts, 1985. Here Krauss explicitly linked a number of early 1970s artworks with precedents in the work of Duchamp and in Man Ray's photograph, *Dust Breeding*.

108 At around this time Surrealism's legacy began to be viewed in a peculiar fashion from some quarters. As the Centre Pompidou's exhibition was being prepared, critic and curator Jean Clair published an article on Surrealism in *Le Monde* on 22 November 2001. Quoting the Surrealists' anti-western and anti-capitalist views, he referred to the sketched-out *Surrealist Map of the World* (1929) in which the scale of countries was changed to match their relative cultural or political interest to the group. Thus the communist former Soviet Union and countries such as Afghanistan, for example, appear huge, while North America is represented by the sites of native American culture in Labrador, Alaska and Mexico, with the United States disappearing altogether. From this there seemed to be an inference that the World Trade Center catastrophe in New York on 11 September that year had some connection with Surrealism's political legacy. Among others, Annie Le Brun, a member of the post-war Parisian surrealist group and a highly articulate defender of Surrealism's values past and present, responded in a *Le Monde* article of 8 December entitled 'Clarity of Breton, Darkness of Clair'. Later, in her column for *La Quinzaine littéraire*, she described how she had been asked to write for *Beaux-arts* magazine about the Paris exhibition, before seeing it. That she

accepted the commission only demonstrates that past and present-day Surrealists are never limited by the visual senses alone. She questioned the entire concept of the exhibition, terming it 'a Surrealism without a blade to which the handle is lacking' (playing on Georg Lichtenberg's famous definition of a knife). All of this demonstrates the continuing interest in and debate around the topic. Surrealism has not died when one of its exhibitions can be termed – as it was on the cover of *Beaux-arts* – 'The Revolution Usurped'.

109 Leslie Camhi, 'Extended Boundaries', *Art in America*, February, 1992.

110 When the exhibition was redesigned at the Metropolitan Museum it became too didactic, losing the eroticism and sensitivity of the Tate's installation.

111 This recalls Marcel Duchamp's use of a throbbing and palpitating ceiling in the Fetishist Room, organized by Mimi Parent at the 1959 'EROS' exhibition. A soundtrack also played back erotic female sighs and moans recorded by the poet Radovan Ivsic. This was used in another section of 'Surrealism: Desire Unbound' at Tate Modern; Ivsic's description of his original commission and the public's reactions is included in *Surrealism: Desire Unbound*, op. cit., 287.

112 Breton's atelier in rue Fontaine, Paris, was preserved since his death by members of his family, but they were unable to continue this without financial assistance, which, despite their long-term efforts and international appeals, was not secured.

The entire collection was sold by auction in 2003. A small core collection of some of the most significant works was acquired for the Centre Georges Pompidou. The collection of African and Oceanic art at the Louvre also includes examples from the collections of Breton and the anthropologist Claude Lévi-Strauss.

113 See, for example, Vera Linhartova, 'La Peinture surréaliste au Japon (1925–1945)', *Cahiers du Musée national d'art moderne*, 11, Paris, 1983, and *Dada et surréalisme au Japon*, Publications Orientales de France, 1987; and Michael Richardson and Krzysztof Fijalkowski, *Refusal of the Shadow: Surrealism and the Caribbean*, Verso, London and New York, 1996. Academic research is furthered by organizations such as the AHRB Research Centre for Studies of Surrealism and its Legacies, a three-way partnership between art historians and literary specialists at the Universities of Essex and Manchester, England, and the curators and conservators of the Tate's surrealist collections. Of the contemporary artists working with ideas which engaged the Surrealists, Susan Hiller has extensively researched and explored areas such as dream and automatism. Her useful bibliography on dream, compiled with David Coxhead, was published in Coxhead and Hiller, eds, *Dreams: Visions of the Night*, Thames & Hudson, 1989 and can also be found at http://www.diacenter.org/hiller/dreamresource.html

WORK-S

EILEEN AGAR

JEAN ARP

ANTONIN ARTAUD

HANS BELLMER

JACQUES–ANDRÉ
BOIFFARD

BRASSAÏ

VICTOR BRAUNER

ANDRÉ BRETON

JACQUES BRUNIUS

LUIS BUÑUEL

CLAUDE CAHUN

LEONORA CARRINGTON

GIORGIO DE CHIRICO

JOSEPH CORNELL

SALVADOR DALÍ

PAUL DELVAUX

OSCAR DOMÍNGUEZ

MARCEL DUCHAMP

NUSCH ÉLUARD

MAX ERNST

LÉONOR FINI

ESTEBAN FRANCÉS

WILHELM FREDDIE

ALBERTO GIACOMETTI

ARSHILE GORKY

JINDRICH HEISLER

GEORGES HUGNET

VALENTINE HUGO

MARCEL JEAN

FRIDA KAHLO

ANDRÉ KERTÉSZ

FREDERICK KIESLER

GRETA KNUTSON-TZARA

WIFREDO LAM

JACQUELINE LAMBA

LEN LYE

DORA MAAR

F.E. MCWILLIAM

RENÉ MAGRITTE

MAN RAY

ANDRÉ MASSON

ROBERTO MATTA

HENRI MICHAUX

LEE MILLER

JOAN MIRÓ

PIERRE MOLINIER

HENRY MOORE

MAX MORISE

PAUL NOUGÉ

GORDON ONSLOW FORD

MERET OPPENHEIM

WOLFGANG PAALEN

ROGER PARRY

ROLAND PENROSE

PABLO PICASSO

KAY SAGE

KURT SELIGMANN

JINDRICH STYRSKY

MAURICE TABARD

YVES TANGUY

DOROTHEA TANNING

TOYEN

TRISTAN TZARA

RAOUL UBAC

REMEDIOS VARO

WOLS

CHANCE AND FREEDOM

For years, anyone involved in Surrealism placed, or rather, had to manifest, an almost unlimited faith in automatic processes of many kinds. To turn the alert, thinking being over to the illogicalities of chance would, it was hoped, free the self from its logical restrictions, into a new world. Various conceptual, visual and verbal bridges between the sleeping and waking worlds, the here and now and the distant and unimaginable, were each put in play in their turn. Whatever might emerge was welcomed as a signal of the revolution against what André Breton called the 'unacceptable human condition' of rationalist, materialist living. Everything encountered for the first time was, in principle, to be tried out, lived freshly through 'lyric behaviour' (*comportement lyrique*); this was itself defined by its openness to chance. The surprise generated by any spontaneous action, free from subjective determination, was celebrated as the very essence of Surrealism.

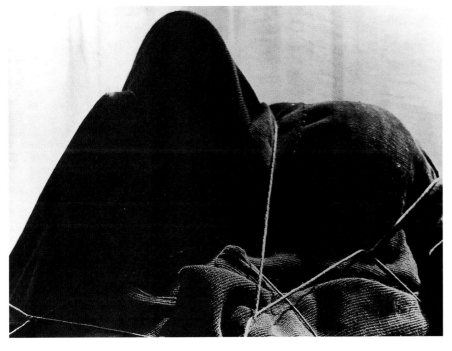

MAN RAY

The Enigma of Isidore Ducasse

L'Énigme d'Isidore Ducasse

1920

Gelatin silver print

Published in *La Révolution surréaliste*, 1, December, 1924

Man Ray assembled this unidentifiable object, wrapped it in a horse-blanket, secured it with rope, and photographed it. The resulting image appeared in the introduction to the first issue of the review *La Révolution surréaliste* in December 1924, which publicly announced Surrealism as a revolutionary movement. The assemblage itself was lost, although in 1971 Man Ray made several reconstructions. The title alludes to the Symbolist poet Isidore Ducasse ('Le Comte de Lautréamont', 1846–70), author of *Les Chants de Maldoror* (*The Songs of Maldoror*), and in particular to what soon became the Surrealists' most quoted phrase: 'the chance encounter of a sewing-machine and an umbrella on a dissecting-table', one of a litany of uncanny images compared by Ducasse to a youth's beauty. A complication arises, however, in translating the poet's startling similes into the sphere of vision. It cannot be known from the photograph what the concealed, enigmatic form actually is. In a contortion of its evidential function, the documentary image preserves the object, or perhaps group of objects, as an encounter for the eye which is fixedly unfathomable and disorienting.

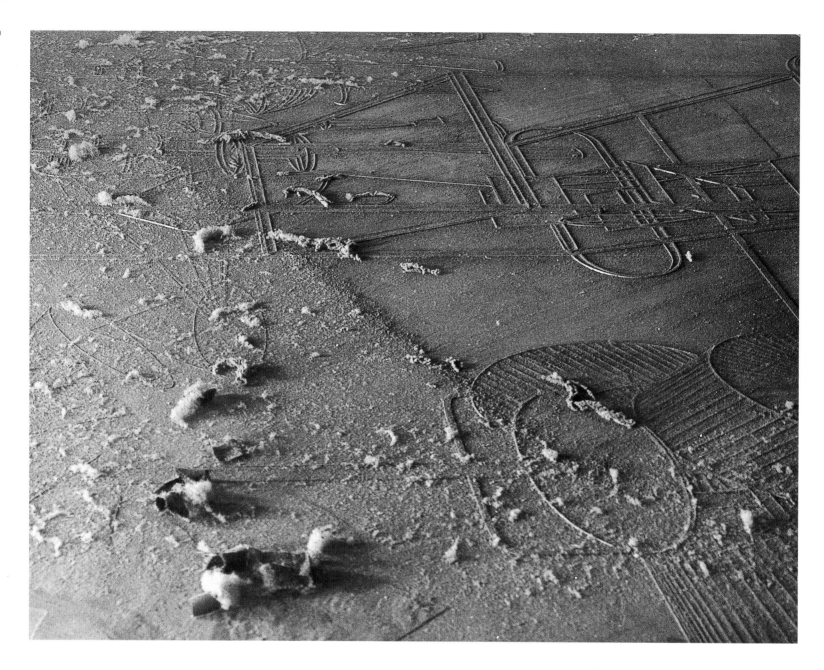

MAN RAY and Marcel DUCHAMP
Dust Breeding
Élevages de poussière
1920
Gelatin silver print

This is one of several long-exposure photographs Man Ray took with a wide view camera, in the dim light of Duchamp's studio in New York. The subject was the lower panel of Duchamp's 'Large Glass', *The Bride Stripped Bare by Her Bachelors, Even* (1915–23), which had been lying flat on sawhorses collecting dust and lint. The images were originally untitled. Another view from a different angle, in which a blank area, like a 'sky', appears above the glass, accompanied an article on Duchamp published in *Littérature*, 5 (October 1922). It was titled *Voici le domaine de Rrose Sélavy. Vue prise en aéroplane 1921. Comme il est aride. Comme il est fertile. Comme il est joyeux. Comme il est triste!* (*Here is Rrose Sélavy's domain. Seen from an aeroplane 1921. How dry it is. How fertile it is. How joyous it is. How sad it is!*) As David Bate notes, this was the first photograph to be published in its own right in a periodical of the emerging surrealist group (*Surrealism and Photography*, 2004). With its title it suggests a vaguely familiar yet strange terrain of uncertain scale, signalled as belonging to desire (*Rrose*: eros), described as hovering between contradictory states: the inert and the inspired, the marvellous and the melancholic.

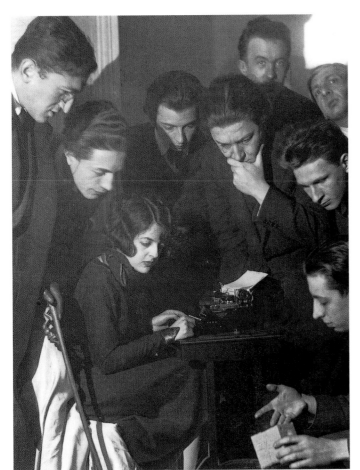

Waking Dream Séance [detail]
1924
Gelatin silver print
Reproduced as vignette on cover of *La Révolution surréaliste*, 1, 1924
top, left to right, Max Morise, Roger Vitrac, Jacques-André Boiffard,
André Breton, Paul Eluard, Pierre Naville, Giorgio de Chirico; *lower
right*, Robert Desnos; at the typewriter, Simone Kahn/Breton

This photograph stages for public view a session such as those held alternately
at Breton's and Picabia's studios in the winter of 1922–23. In the foreground the poet
Robert Desnos communicates a message in a trance-like state, while Simone Kahn,
then married to Breton, transcribes his speech on a typewriter. Breton, at centre, and
the others loom over them with intense concentration. On 11 October 1924, the Bureau
des recherches surréalistes opened at 15, rue de Grenelle, on the left bank of Paris.
Details were sent to the press, and reports such as this one in *Les Nouvelles
Littéraires* portrayed the project as a collective, experimental and open-ended field
of enquiry: ' … Surrealism proposes a gathering of the greatest possible number of
experimental elements, for a purpose that cannot yet be perceived. All those who have
the means to contribute, in any fashion, to the creation of genuine surrealist archives,
are urgently requested to come forward: let them shed light on the genesis of an
invention, or propose a new system of psychic investigation, or make us the judges
of striking coincidences … or freely criticize morality, or even simply entrust us with
their most curious dreams and with what their dreams suggest to them.'

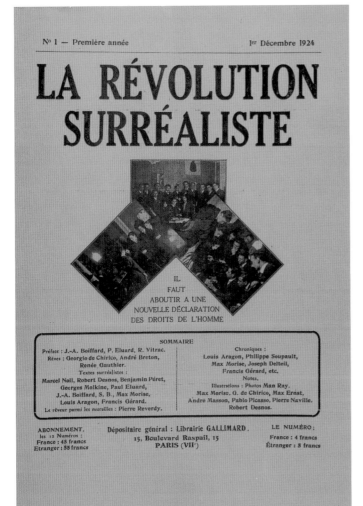

Cover, *La Révolution surréaliste*, 1
1 December 1924

Two of the most uncompromising members of the newly formed group, Pierre Naville
and Benjamin Péret, edited the first issue of *La Révolution surréaliste*. Naville insisted
on the dry, formal layout which resembled *La Nature*, a journal of 'science and its
application to art and industry' founded in the previous century (also a source for
several of Max Ernst's collages and paintings in the preceding few years). This
distinguished it from the experimental typographic design of other avant-garde
reviews, and made its contents more startling, as they were presented in the guise
of documentary evidence. The issue opens with a preface by Jacques-André Boiffard,
Paul Éluard and Roger Vitrac exalting absolute imaginative and political freedom:
The issue's contents included photographs by Man Ray; drawings by Ernst, Masson,
de Chirico, Naville, Desnos, Morise; a cubist work (guitar) by Picasso; and a Buster
Keaton film still. These images were accompanied by automatic writings; accounts
of dreams; 'chronicles' experimentally investigating language, everyday actions and
material found in newspapers, adverts and films; and a questionnaire on attitudes
to suicide, for which responses were to be sent to the Bureau des recherches
surréalistes and published in the next issue. The periodical would continue until
December 1929, edited by Breton from the fourth issue in July 1925 onwards.

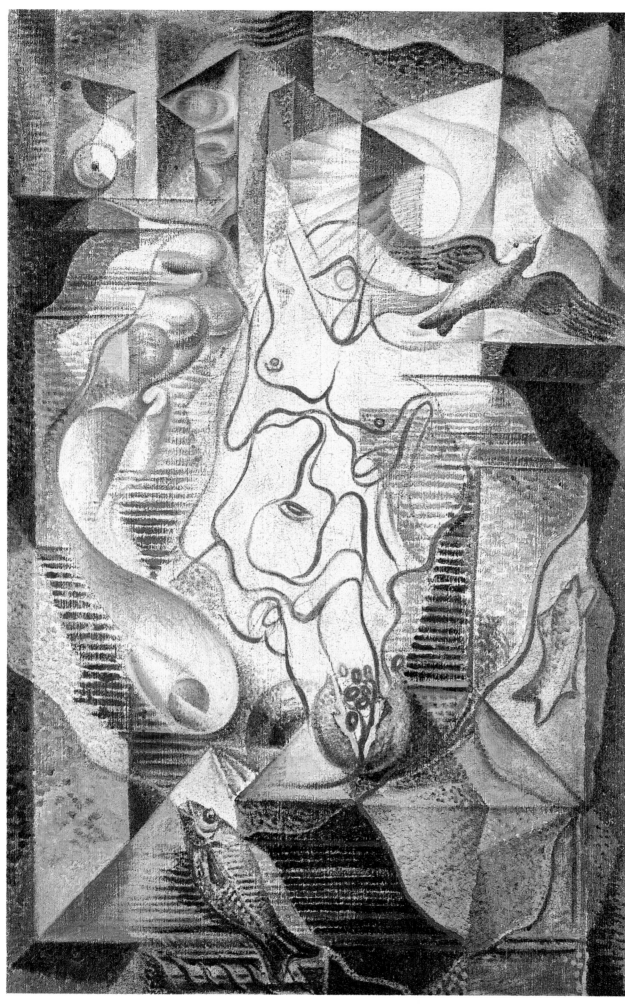

André <u>MASSON</u>
Man
L'Homme
1924–25
Oil on canvas
100 × 65 cm [39.5 × 25.5 in]
Private collection

Man was exhibited in the Surrealists'
first group show, 'La Peinture
surréaliste', at Galerie Pierre, Paris,
in November 1925. It was purchased
by Antonin Artaud, who responded to its
cubist-derived, dislocated figuration and
its dissolving of boundaries between
human and natural realms, explored
in a number of related paintings in this
period. During the First World War
Masson had seen the head of a soldier
split open like a 'ripe pomegranate'.
In Artaud's text below the pomegranate-
like form in the painting also becomes
a grenade.

'… The painting is well enclosed
in the limits of its canvas. Like a closed
circle, a sort of whirling chasm, dividing
down the middle. Like a mind which
sees and searches through itself,
kneaded and endlessly worked over by
the mind's clenched hands. Yet the mind
sows its phosphorous.

The mind is sure. It really has one
foot in this world. The grenade, the belly,
the breast are like proofs testifying to
reality. There really is a dead bird, and
leafy columns. The air is full of pencil
strokes, like knife slashes, like scratches
from magic finger nails. The air has been
stirred up enough.

And now it sets itself out in cells
where the seeds of unreality grow …'
– Antonin Artaud, *Ombilic des limbes*
(*Umbilical Limbo*), 1925, trans.
Victor Corti

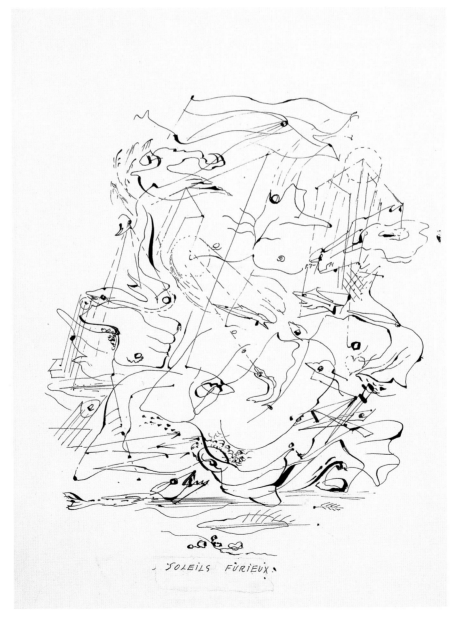

André <u>MASSON</u>

Furious Suns

Soleils furieux

1925

India ink on paper

42 × 32 cm [16.5 × 12.5 in]

Collection, The Museum of Modern

Art, New York

Masson's automatic drawings were begun in late 1924 although conceived of as a possibility some time before meeting the Surrealists. They are the most widely represented artworks in the early issues of *La Révolution surréaliste*. At the time, they seemed the closest visual counterpart to automatic writing, exemplifying 'the succession of images, the flight of ideas' which Max Morise, in the first issue, suggested would be central to surrealist art. Masson viewed these drawings as having an erotic basis, albeit extended from a human to a cosmic scale and charged with disturbing undertones. A delirious intermingling of human, animal and vegetal forms is often accompanied by evocations of splitting, bursting, fragmentation or compulsive repetition. Forms resembling fragments of hands, breasts, or knives recur, while in other images, sun or starlike shapes proliferate. *Soleils furieux* was reproduced in *La Révolution surréaliste*, 5, October 1925. Its central male torso and other elements echo and transform those in the painting opposite.

Joan <u>MIRÓ</u>

Catalan Landscape [The Hunter]

Paisage catala [El Cacador]

1923-24

Oil on canvas

65 × 100 cm [26 × 40 in]

Collection, The Museum of Modern Art, New York

In the winter of 1923–24, the beginnings of Miró's association with the Surrealists led him gradually to depart from most of his earlier fauvist and cubist-derived principles. This is first visible in *Tilled Field*, begun in July 1923, which retained some rationality of pictorial structure, but introduced biomorphic forms and irrational features such as an ear sprouting from a tree, all marked by a childlike sense of play. This was followed by *Catalan Landscape*, in which the vestiges of recognizable forms, perspective and three-dimensionality have all but disappeared. Floating on a unified, indeterminate background, partly inspired by Romanesque frescoes and folk art of Catalonia, the iconographic forms, such as the pipe-smoking hunter on the left, are more than just abstractions and have become closer to symbols.

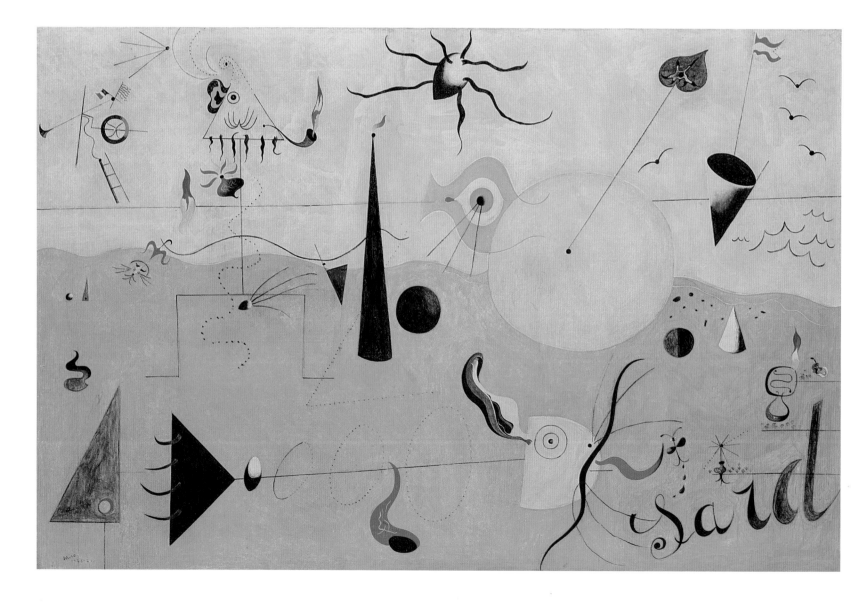

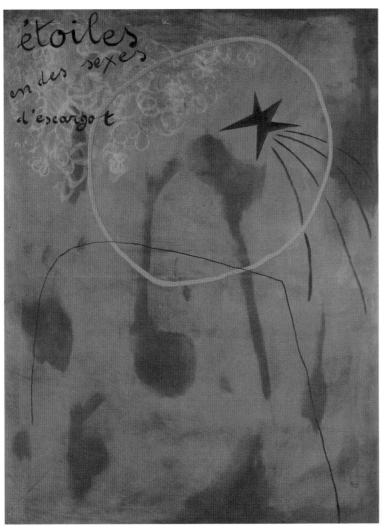

Joan <u>MIRÓ</u>
Étoiles en des sexes d'escargot
Stars in the Sexes of a Snail
1925
Oil on canvas
129.5 × 97 cm [51 × 38 in]
Collection, Kunstsammlung Nordrhein-Westfalen, Düsseldorf

After joining the Paris Surrealists, Miró began to explore the workings of chance in his compositions of 1925–27. He would begin painting without a consciously conceived idea, and allow forms to assert themselves as a random outcome of the process. However, once the suggestion of a symbolic form had emerged, it would be precisely developed as an element in the final composition, thus departing from the 'purer' automatism of Masson's drawings. In a number of these works Miró, who considered himself a painter-poet, incorporated words or phrases, most of them painted in a free calligraphic style which draws together the text and the other visual signs on the canvas. Word and image are further unified by the message or impulse conveyed by both – poetic and often, as here, erotic.

Joan <u>MIRÓ</u>
Painting [Blue]
1927
Oil on canvas
116 × 90 cm [46 × 36 in]
Private collection

References to the colour blue are pervasive in the automatic writings and accounts of dreams by a number of Surrealists in this period, when Miró made a number of vivid blue paintings. One example from 1925 is composed entirely of a field of blue; another, with a cloud-like daub of blue floating on plain canvas, is inscribed *Photo. ceci est la couleur de mes rêves* (Photo. This is the Colour of My Dreams, 1925). Paintings such as this one, with its predominantly geometric, angular shapes and relationships of pure, glowing colours, may seem highly formalistic, yet Duchamp later described such works as 'canvases in which form, submitted to strong colouring, expressed a new two-dimensional cosmogony without the least tie to abstraction' (1946, quoted in *Miró. Ceci est la couleur de mes rêves: Entretiens avec Georges Raillard*, 1977). When the Abstraction-Création group invited him to join them in the 1930s, Miró vehemently declined. The balance between freedom and formality of the blue canvases has been interpreted in terms of his 'will to retain the imagistic force of traditional painting. The word "abstraction" then seemed to stand for a practice based on a formal and ideological dogmatism, bent on banishing all but the most elliptical references to life as lived in the body.' (Carolyn Lanchner, *Joan Miró*, New York, 1993.) For Miró this would have conflicted with his consistent focus on the relationships of bodies and forms to the spaces they inhabit.

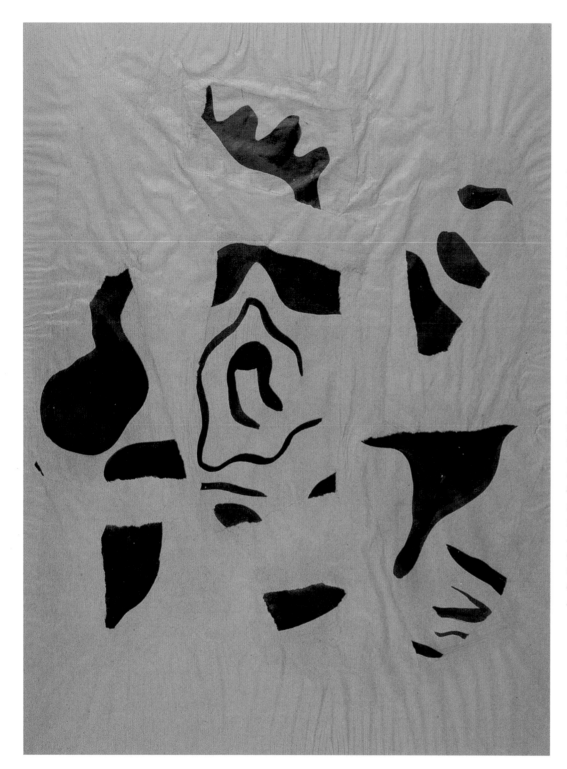

Jean ARP
Torn drawing
1930
Torn ink drawing, collage on
wrapping paper
64.5 × 49.5 cm [25.5 × 19.5 in]
Collection, Arp Estate,
Switzerland

In 1916–17 Arp had made collages of square and rectangular shaped pieces of torn paper which he later titled as collages 'arranged according to the laws of chance'. Anecdotally it was recorded that he made them by dropping the pieces randomly onto a surface but their composition appears meticulously ordered. The notion of chance he was then portraying differed from the torn paper works he began to make in 1930, after Galerie Goemans in Paris invited him to exhibit some of the early collages. Taking them down from his attic, he was struck by their deteriorated state, blemished with spots, mould, cracks and blisters. Now informed by surrealist automatism he saw the potential in this to escape the handmade precision of his earlier work. He began to tear up earlier drawings, pasting them roughly together. 'If the ink dissolved and ran I was delighted … and if cracks developed so much the better.' (Jean Arp, 'Looking', *Arp*, 1958.) Although in this example the composition still seems carefully devised, its material and technique convey both a new freedom and energy and a sense of decomposition and decay.

Jean ARP
Lèvres/bouche
Lips/Mouth
1926
Painted wood relief
31 × 22.5 cm [12 × 9 in]
Collection, Arp Museum, Rolandseck, Germany

Arp made his first wood reliefs in Zurich in 1914 and began to paint them in 1916. Made of cut-out shapes mounted on supports, they were assembled like collages. After his return to Paris in 1920, the abstract, organic forms of the earlier works were supplanted by figurative elements – shapes that resemble, for example, parts of the body or articles of clothing. They are configured in unexpected and ambiguous arrangements so that, depending on how they are viewed, they may suggest various different things – a navel, an egg, a leaf, a comma, a moustache, a bow-tie … Often, as here, there is a playful undercurrent of social observation.

L'AIR EST UNE RACINE

L'Air est une racine
The Air is a Root
1933
Text and ink drawings published
in *Le Surréalisme au service de
la révolution*, 6, 1933

Arp's page of poem-drawings, 'L'Air
est une racine' (The Air is a Root) was
published in the final issue of *Le
Surréalisme au service de la révolution*
(15 May 1933), which also included
collective responses to a questionnaire
on topics such as 'irrational knowledge
of the object', and Yves Tanguy's text
and drawing on the 'life of an object'.
Arp explores this fascination with fluid
connections between the living and the
inert in his ambiguous, amoeba-like
drawings and the word-play beneath
them: 'stones are full of entrails. bravo.
bravo. stones are full of air. stones are
branches of water', and so on. As Briony
Fer observes, in the original French
these statements, such as 'stones
[*pierres*] are tormented like flesh [*chair*]'
suggest that any visual resemblance
between stones and flesh 'is mediated
by language: for it is in the rhyme
(*pierre* and *chair*) that they intersect …
The rhyme is also visual, with stones
as "tormented" as flesh because they
take on the turning, circular movements
associated with bodily forms.'
('The Laws of Chance', *On Abstract Art*,
1997.)

les pierres sont remplies d'entrailles. bravo.
bravo. les pierres sont remplies d'air.
les pierres sont des branches d'eaux.

sur la pierre qui prend la place de la bouche
pousse une feuille-arête. bravo.
une voix de pierre est tête à tête et pied à pied
avec un regard de pierre.

quand les pierres se grattent des ongles pous-
sent aux racines. bravo. bravo.
les pierres ont des oreilles pour manger l'heure
exacte.

ARP.

E

les pierres sont tourmentées comme la chair.
les pierres sont des nuages car leur deuxième
nature leur danse sur leur troisième nez.
bravo. bravo.

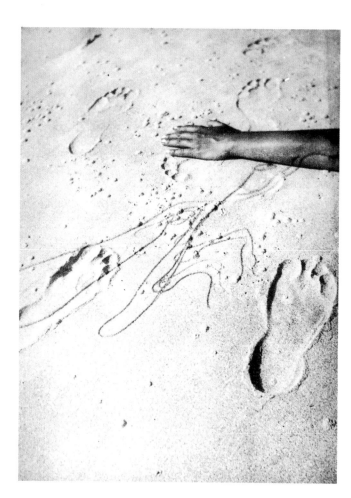

Claude <u>CAHUN</u>
The Arena
L'Arène
1926
Gelatin silver print
10 × 7.5 cm [4 × 3 in]
Private collection

At the time this image was made, much of Cahun's photographic work was unseen and unpublished, and she did not have any close involvement with Breton's surrealist circle until 1932. Born Lucy Schwob, she adopted her androgynous pseudonym in 1917. Although she was aware of the group's activities from the beginning and later considered most of her work as surrealist, during the 1920s Cahun worked independently, publishing writings, photographs and photomontages in established journals such as *Mercure de France*. Nevertheless, from the outset her work engages closely with the preoccupations of the group. Here, one might speculate on the similarity between the ambiguous thread-like lines in the sand and the automatically drawn lines in André Masson's sand paintings of the same period, also noting what would become the recurring surrealist motif of a disembodied hand, which, for example, had appeared in paintings by Robert Desnos made during his sleep trances in 1922–23. Unusually for the time, Cahun places such elements in a photographic *mise-en-scène* which suggests a frozen moment from a film. The title, 'The Arena', suggests struggle, conflict and spectacle, leaving as traces the disembodied parts: the very present outstretched arm; the unpaired footprints leading out of the frame.

André <u>MASSON</u>
Fish Drawn in the Sand
Poissons dessinés sur le sable
1927
Sand, oil and India ink on canvas
100 × 73 cm [39.5 × 29 in]
Collection, Kunstmuseum, Bern

In the winter of 1926–27, noting the 'myriad nuances' in drifts of sand on a beach in southern France, Masson was struck by a way he could bring together the compositional working out of ideas characteristic of his oil paintings with the instant technique of his automatic ink drawings. He started to develop a new process: sand painting. 'I began by placing flat on the ground a piece of canvas. Onto it I threw puddles of glue, which I manipulated, and they took on the aspect of Leonardo da Vinci's wall. Then I spread sand, I shook the canvas again so that there were explosions, puddles, sometimes I raked it with a knife. I obtained something that had no meaning but could provoke it … All with the speed of lightning. I took sand of different sizes, I put on more glue, in successive layers, which ended up as a kind of wall, a very uneven wall, and then these layers at a given moment suggested forms, although usually irrational ones. With a little oil paint I added some lines, but as quickly as possible, and then, already a little calmer, some touches of colour.'
– André Masson, statement cited in *André Masson: 200 Dessins*, Paris, 1976

Masson refers to Leonardo and Botticelli's discussion of the images that freely arise in our imagination when we gaze at a stain on a wall. However, the spontaneity of the sand paintings is tempered by the artist's conscious exploration of themes of battle, wounding and death, played out in an imaginary realm where human characteristics often merge with those of animals.

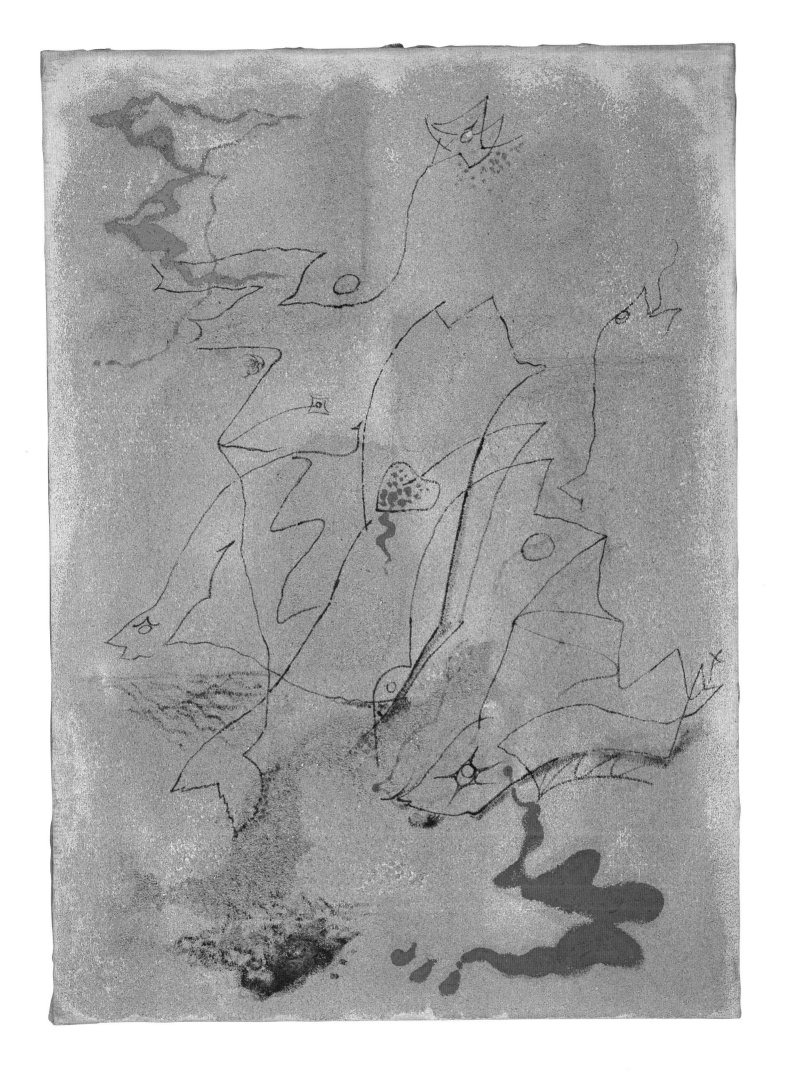

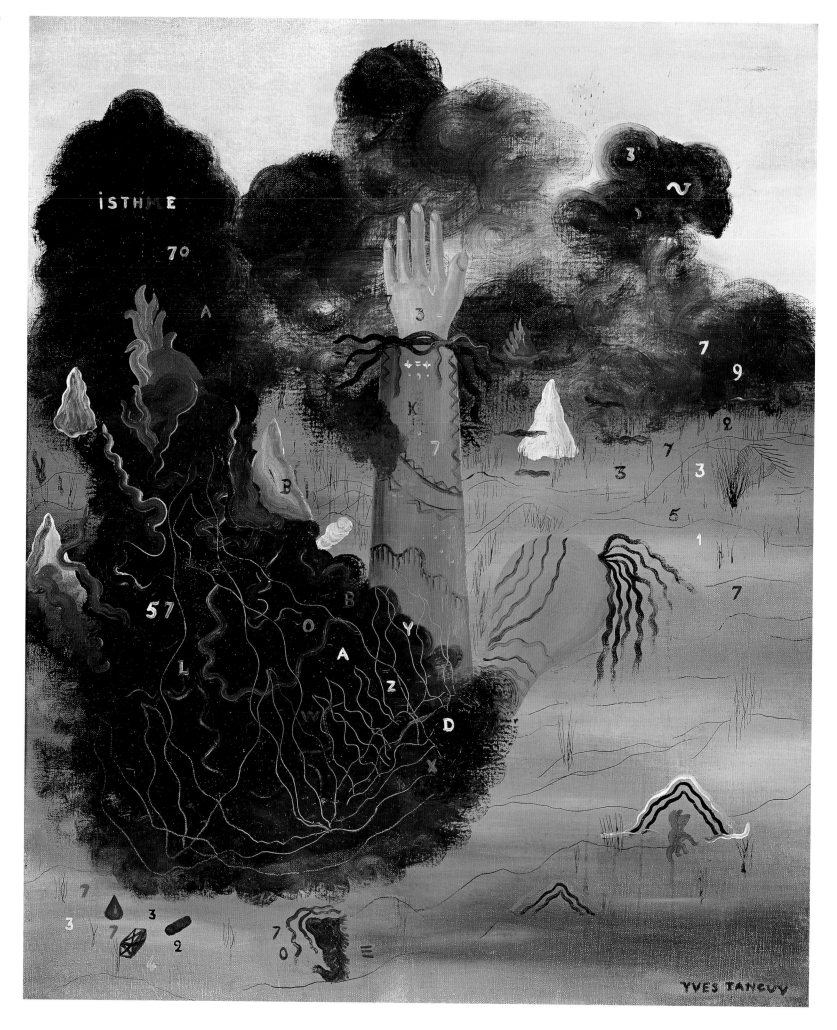

Yves <u>TANGUY</u>

The Hand in the Clouds

La Main dans les nuages

1927

Oil on canvas

65 × 54 cm [25.5 × 21.5 in]

Collection, Staatsgalerie,

Stuttgart

At the Galerie Surréaliste in the summer of 1927 Tanguy's paintings were shown alongside objects from Peru, Mexico, Colombia, New Mexico and British Columbia, lent mainly from Aragon, Breton and Éluard's ethnographic collections. This suggests a context of spiritual or visionary indications, in preference to viewing the paintings as primarily aesthetic objects. Like this image, a number of Tanguy's paintings of this period include words, single letters and numbers dispersed among the iconographic elements in a way that could be read as random or as meticulously following some arcane system. Karin von Maur (*Yves Tanguy and Surrealism*, 2000) has suggested an affinity with Paul Klee's pictorial poems, begun in 1916 and probably seen by Tanguy at Klee's Paris exhibition in 1925. If the painted numbers have a systematic meaning, it can only be guessed, and this would be characteristic of Tanguy's own approach to what appeared on his canvas, but it is likely that they derive from his acquaintance with the Celtic mystical traditions of his native Brittany, through his father's archaeological research. The arm and hand may refer to Druidic hand signal alphabets, but could also be derived from Catholic reliquaries or from the dismembered hands that appeared on several cover illustrations for the Surrealists' favourite thriller series *Fantômas*. The scene also recalls the ceremonial burning of effigies. However it is read, the picture has an intensely fateful atmosphere.

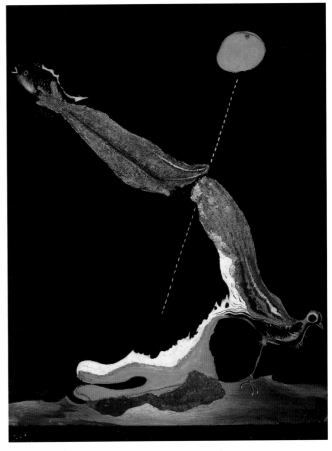

Salvador <u>DALÍ</u>

Bird … Fish

Ocell … Peix

1927–28

Oil and sand on panel

61 × 49.5 cm [24 × 19.5 in]

Collection, The Salvador Dalí Museum, St Petersburg, Florida

During a short period around 1927, while Dalí was familiarizing himself with the work of the Paris Surrealists, he made several paintings which incorporated sand and grit, indirectly influenced by Masson's recent sand paintings and his preoccupation with mutation and metamorphosis. Other elements are possibly related to a working through of ideas from Miró, such as the dotted line device here, and the 'exquisite corpse' game, where the unfolding of a collective drawing often revealed transformations from one kind of creature to another. What is most particular to Dalí's own vision is the reference to putrefaction: the excremental-looking and formless shapes from which the bird and fish seem to be emerging and/or into which they also seem to be dissolving. Around 1925 Dalí had independently discovered Lautréamont's *Les Chants de Maldoror*. It was not only the text's imagery of metamorphosis from man to animal, animate to inanimate, that fascinated him, but its scatological obsession with abjection, rottenness and decay.

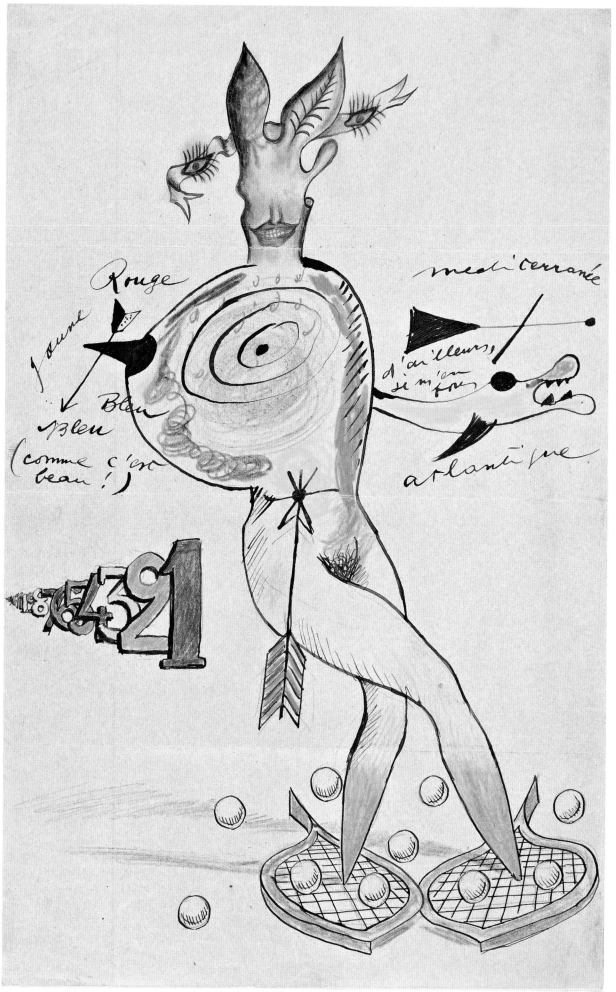

left
Yves TANGUY, Joan MIRÓ, Max
MORISE, MAN RAY
Exquisite Corpse
Cadavre exquis
1927
India ink, pencil and coloured
crayons on paper
22 × 16.5 cm [9 × 6.5 in]
Collection, The Museum of Modern
Art, New York
opposite, clockwise from top left
André BRETON, Nusch ÉLUARD,
Valentine HUGO
Cadavre exquis
1930
Greta KNUTSON-TZARA, Tristan
TZARA, Valentine HUGO
Cadavre exquis
1929
Valentine HUGO, André BRETON,
Nusch ÉLUARD
Cadavre exquis
1931
Nusch ÉLUARD, Greta KNUTSON-
TZARA, Valentine HUGO, André
BRETON
Cadavre exquis
1930
Coloured crayon on black paper
Various dimensions, approx.
33 × 25 cm [13 × 10 in] each
Collection, Musée national d'art
moderne, Centre Georges Pompidou,
Paris

The 'exquisite corpse' was a collective
game devised in 1925, which could be
played with words or images. To make
an exquisite corpse image the first
player draws a 'head' and folds over the
paper so it cannot be seen by the second,
and so on. At the end, a strange,
composite person or creature emerges.
Created by participants unaware of what
the other contributions look like, the
exquisite corpse deliberately invokes
chance in producing a hybrid 'body'.
The same principle is applied to
sentences. The first phrase composed
this way gave the game its name:
'the exquisite corpse will drink the
new wine'. A selection of the drawings
and sentences was first published,
anonymously, in *La Révolution
surréaliste*, 9–10, October 1927.
A number of writers and guests of the
group who were not its central artists
were able to participate in this game.
It continued to be a significant activity
during the 1930s, when it began to take
on more sophisticated forms, as in the
examples opposite.

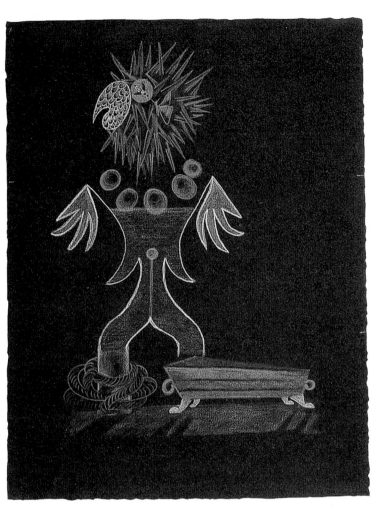

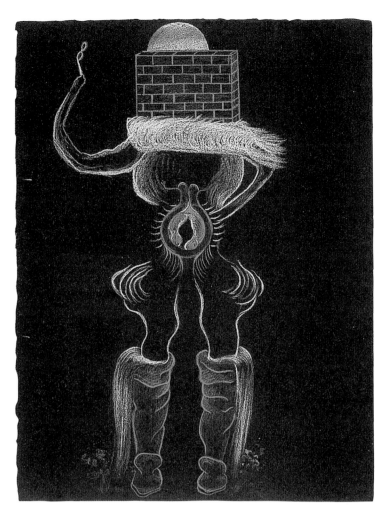

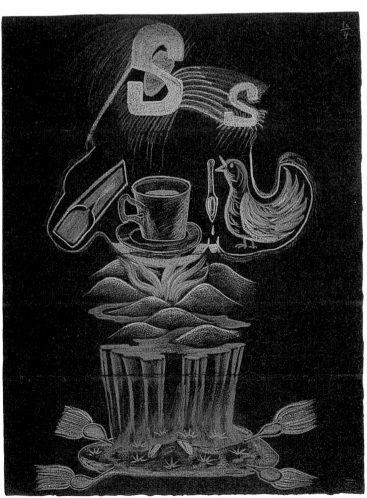

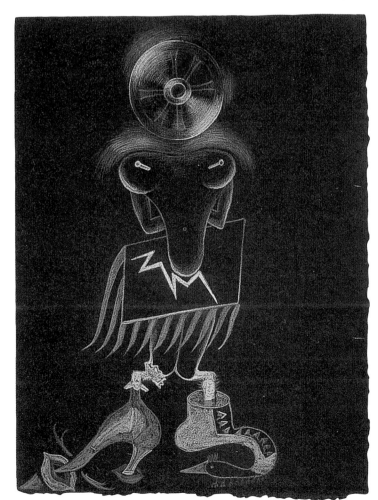

Max ERNST
The Wheel of Light
La Roue de la lumière
1925
Frottage, pencil on paper
25 × 42 cm [10 × 16.5 in]
Private collection
Histoire naturelle, sheet 29

This *frottage* drawing was included in a sequence of related images depicting flora-like, fauna-like and hybrid forms, collectively titled *Histoire naturelle*, which was exhibited and published, with a preface by Jean Arp, in 1926. In his text 'Comment on force l'inspiration', ('How one can force inspiration', *Le Surréalisme au service de la révolution*, 6, 1933) Ernst described the *frottage* technique as a mechanism to intensify the 'mind's powers of irritability'. Involving the rubbing of pencil or chalk on paper over various textured surfaces such as floorboards and leaves, Ernst used this mechanical process in a few of his works made in Cologne, around 1920–21, but then abandoned it. He later rediscovered *frottage* in 1925 as a systematic method by which he could arrive at unpremeditated images in a way that had affinities with automatic drawing. In the 1924 Manifesto Breton had suggested that surrealist drawing should be a process 'simply of tracing', which the *frottages* initially were, but the secondary activity of overdrawing in pencil to arrive at clearly composed forms ran counter to automatism. Ernst then went further by arranging the drawings into groups, which can be classified into subjects such as plant-related, animal-related, myth-related, and so on. In relation to actual 'natural history' illustrations, however, the drawings seem to parody Enlightenment notions of immediate representation. They signal an imaginative liberation from the imitation of nature which is close in spirit to the complete spontaneity sought in Surrealism's first years.

Max ERNST

The Forest

La Forêt

1927–28

Grattage, oil on canvas

96.5 × 129.5 cm [38 × 51 in]

The Solomon R. Guggenheim Foundation, Peggy Guggenheim Collection, Venice

In the winter of 1926–27 Ernst adapted the *frottage* technique to oil painting, using a scraping method he termed *grattage*. A canvas prepared with several layers of oil paint was laid over one or several textured surfaces, such as wood grain, wire mesh, or string, and scraped to allow patterns to emerge. In his writings Ernst emphasized how this technique minimized the roles of authorship and talent; however the next stage was the interpretation and working up of the patterns into an image, in which composition and themes emerge. In the late 1920s and early 1930s this often took the form of a dense wall of tree-like forms rising before a large sun or moon-like disc, sometimes, as here, with outlines of birds or other creatures emerging in the darkness. In a text published in *Minotaure* with photographs by Tracol of tree trunks and branches, Ernst described an interlacing of terror and enchantment evoked by the emblem of the forest: 'savage and impenetrable, black and russet, extravagant, secular, swarming, diametrical, negligent, ferocious, fervent, and likeable, without yesterday or tomorrow …'
– Max Ernst, '*Les Mystères de la Forêt*', *Minotaure*, 5, 1934, trans. Elizabeth C. Childs

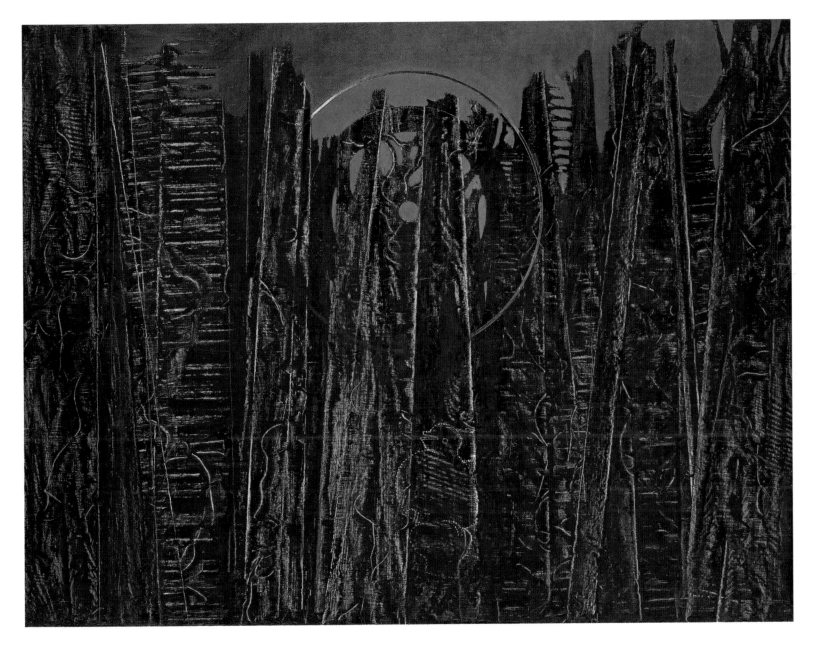

Óscar DOMÍNGUEZ
Decalcomania
1936
Gouache decalcomania on paper
31 × 18.5 cm [12.5 × 7.5 in]
Private collection

The word decalcomania derives from the French *décalquer*, to transfer. Gouache, India ink or diluted oil paint is spread onto a non-absorbent surface such as coated paper; a sheet of paper is pressed against it and peeled away, to reveal blot-like forms which often suggest imaginary landscapes or underwater coral reefs. In the nineteenth century the technique was used for inspiration by a number of Romantic and Symbolist poets and artists, and also by mediums to divine the images of ghostly faces coming through from the spirit world. In 1921 a similar process was adopted by the German psychiatrist Hermann Rorschach to devise his well-known diagnostic 'inkblot' tests. The Spanish artist Óscar Domínguez rediscovered decalcomania in 1936, bringing it into the field of Surrealism by calling his images decalcomanias 'of desire', or 'without preconceived object'. Decalcomanias by Domínguez, André Breton, Jacqueline Lamba, Yves Tanguy, Marcel Jean and Georges Hugnet were first reproduced in *Minotaure*, 8 , 1936, alongside written interpretations by Breton. Domínguez also made decalcomania pictures which resemble identifiable subjects such as animals. Examples such as this one reflect the more open spirit of enquiry the technique initiated. The possibility of visualizing simultaneously rocks or coral, a landscape or an undersea cave, particularly inspired Yves Tanguy, whose decalcomanias were for a short time a parallel practice to his better known paintings and drawings.

Len <u>LYE</u>
Snowbirds Making Snow
1936
Oil on hardboard
94.5 × 145 cm [37 × 57 in]
Collection, Len Lye Foundation, New Plymouth, New Zealand

Lye travelled from Australia to Britain in 1926 and joined the English surrealist group in the 1930s. Influenced by techniques of automatic drawing and painting, he synthesized ideas from diverse sources, from biology to jazz, with imagery derived from artists such as Miró, Aboriginal Australians and Pacific Islanders. In 1935 he made *Colour Box*, a cameraless film which emulated the spontaneity of creole jazz and tribal dance music, with fluid coloured lines and shapes painted directly onto the celluloid. As Michel Remy has noted, the title of this 1936 painting plays, in the causal, chicken-and-egg sense, on the name of the birds, *Junco hiemalis*, which are said to appear when the snow comes. Extending automatic drawing into an area that would be explored by others such as André Masson or Christian Dotrement in the 1950s, 'the calligraphic, almost ideogrammatic, quality of the lines opens a new territory: hieroglyphs.' (Michel Remy, *Surrealism in Britain*, 1999)

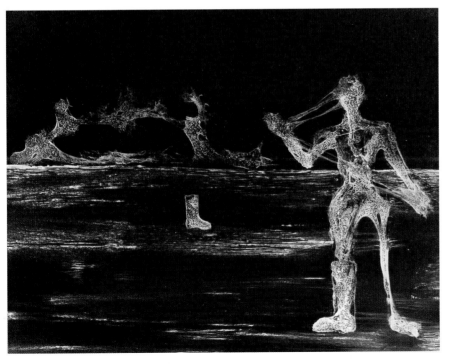

Jindrich <u>HEISLER</u>
Untitled, from the series *De la même farine*
Of the same ilk
1944
Photo-graphique
23 × 30 cm [9 × 12 in]
Private collection

Primarily known as a poet, Heisler made the series *De la même farine* (literally translated: 'from the same flour') while in hiding with his partner, the artist Toyen, during the Nazi occupation of Czechoslovakia. Following the photographic innovations of Man Ray and Raoul Ubac, Heisler developed his own technique of automatism in the darkroom. His *photo-graphiques* – drawings made with light – are visual tracings of dream-like forms, described by Vera Linhartova as 'visual poetry': 'By means of a photochemical process not unlike transfer techniques, he draws within a darkroom spectral scenes similar to pictures by mediums' (*Styrsky, Toyen, Heisler*, 1982). Heisler obtained the effects by replacing the negative with objects, such as twigs, leaves, soap suds and glue. For Vincent Gille, his images are 'of a world entirely dreamed ... entirely formed of darkness, of the germination of the night, mixed with beauty and desolation' (*Trajectoires du rêve: du romantisme au surréalisme*, 2003).

BRASSAÏ
Graffiti
1933-56
Gelatin silver prints
Various dimensions
Collection, Musée national d'art moderne, Centre Georges Pompidou,
Paris
clockwise, from top left; From Series VII, 'Death'; From Series VIII,
'Magic'; From Series VIII, 'Magic'; From Series IV, 'Masks and Faces';
From Series VIII, 'Magic'; From Series VIII, 'Magic'

With the collaboration of his wife, Gilberte, Brassaï sought out graffiti and photographed them in many countries over more than twenty years. Some of the first photographs, taken in Paris in 1933, were published in *Minotaure*, 3–4, in December that year, alongside his article '*Du mur des cavernes au mur d'usine*' ('From Cave Wall to Factory Wall'). For Brassaï, 'the bastard art of the streets of ill repute' is 'not about playing, it is about mastering the frenzy of the unconscious. These abbreviated signs are none other than the origins of writing – these animals, monsters, demons, heroes, phallic deities, are the elements of mythology …' During this period the writer Georges Bataille and his group discussed graffiti in their debates on received ideas of the 'primitive'. This major body of work by Brassaï, finally published as a book in 1960, can be considered in relation to ethnographic fieldwork. He regularly returned to the same walls of graffiti, carefully sketching and noting, as well as photographing, the changes and developments that had occurred there.

Collective Drawing, Marseille
Dessin collectif, Marseille
1940
Pencil, coloured ink, coloured crayons
23 × 30 cm [9 × 12 in]
Wifredo Lam, third drawing at top; André Breton, first drawing below;
Jacqueline Lamba, second drawing below
Collection, Musée national d'art moderne, Centre Georges Pompidou,
Paris

After the Nazi occupation of large areas of France, Breton and other Surrealists made their way to Marseille in the free zone in order to escape persecution as political dissidents. In October 1940 Varian Fry of the American Committee for Aid to Intellectuals moved them into the secluded Villa Air-Bel while they waited for visas. Many people gathered there and collective pursuits soon became their main activity. As well as a set of Tarot cards, replacing the traditional emblems with surrealist ones, they produced sheets of collective drawings. These combined mixed media, techniques and styles of drawing and a number of them also incorporated collage and photomontage. Rather than depending on the elements of concealment and surprise that characterized the 'exquisite corpse' series, these drawings explore an ideal of spontaneity and imaginative freedom in a more consciously disciplined way: the composite faces and emblems, drawn carefully by different hands, are juxtaposed democratically within a grid format.

POETICS OF VISION

One of the most haunting images in surrealist painting is René Magritte's *The False Mirror* (*Le Faux Miroir*, 1928). Here the clouds that enter the observing eye form a perfect visual incarnation of André Breton's notion of a conducting wire (*le fil conducteur*) leading from the person seeing to the object seen. Everything here concerns reflection and exchange: the subject's universe is invaded by the outside, and vice versa. As in emblematic pictures of the Renaissance period where a bodily pose or gesture is imbued with significance, so here a part of the body stands for the whole. This singular eye symbolizes vision itself. The paths of surrealist painting and image making, as they gradually emerged as alternatives to automatic processes, were informed by the need to invent new, disorienting and often paradoxical types of image. These would engage the complexities of the mind's perception amidst the uncertainties of the modern world.

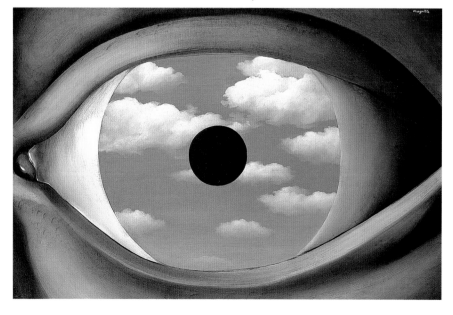

René MAGRITTE
The False Mirror
Le Faux Miroir
1928
Oil on canvas
53.5 × 81.5 cm [21 × 32 in]
Collection, The Museum of Modern Art, New York

Influenced by the work of de Chirico and the Symbolist painters of his native Belgium, Magritte was among the first to introduce illusionistic painting into surrealist art on his arrival in Paris in 1928. This was acceptable to the group because his illusionism was paradoxical, questioning the basis of representational conventions. In this image several associations and interpretations from both the conscious perception of the world and the unconscious imagery of dreams seem to be floating simultaneously: one might be looking at a clouded sky reflected on the eye's surface or a mirror reflection of eye and sky, or perhaps a firmament which exists behind the eye, as if it were a window onto the idea of what appears there.

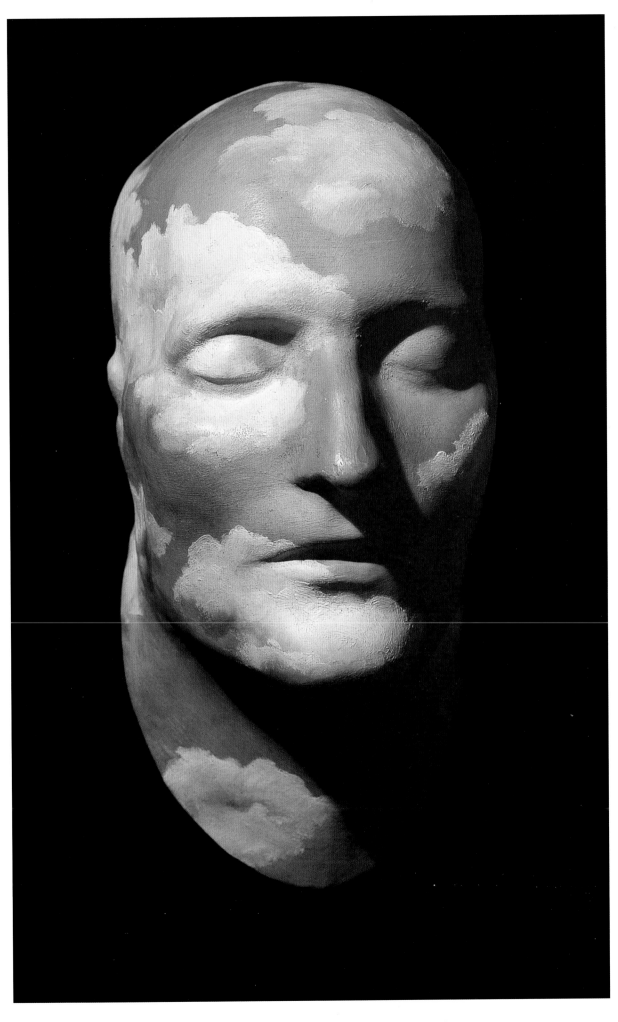

The Future of Statues
L'Avenir des statues
1932
Oil on plaster
h. 32 cm [12.5 in]
Collection, Wilhelm Lehmbruck
Museum, Duisburg

This is one of several versions Magritte made of this work in which a light blue sky with cumulus clouds is painted over a plaster reproduction of the Emperor Napoleon's death mask. While it shares affinities with *The False Mirror* opposite, the reflections it provokes on ideas of inside and outside, the body and space, are achieved by different means. The sky in the former appears only in the white of the eye, framed by the realistically painted part of the face that surrounds it, so that the effect could be described as the unexpected juxtaposition of two elements. Here, however, there is an all-over, camouflage-like appearance: rather than being simply juxtaposed, mask and sky are seen, as it were, one through the other. This is one of the devices by which Magritte, in his second phase of surrealist works in the 1930s, introduces a 'crisis of the object' as a means to continue finding in everyday subject matter an impulse to explore the paradoxes and enigmas opened up by modern philosophy and science. As Jean-Pascal Vermersch suggests, the image also evokes perceptions such as those of the nineteenth-century, anti-bourgeois ironist Villiers de l'Isle-Adam, who wrote of businessmen and bureau-crats: 'their gazes are without thought, their faces the colour of weather'. (*Les Maudits Sujets de réflexion*, 2002.)

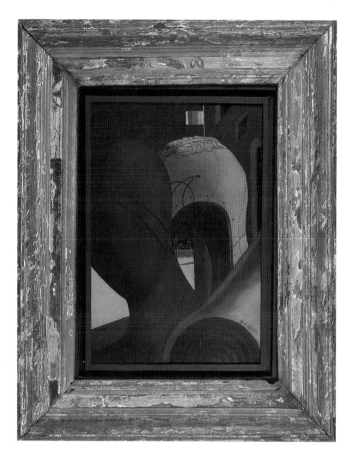

Giorgio de CHIRICO

The Fatal Light

La Lumière fatale

1915

Oil on canvas

54 × 47 cm [21.5 × 18.5 in]

Private Collection

Breton, Éluard, Ernst, Magritte and Tanguy each separately discovered the work of the Italian painter de Chirico in the years leading up to the founding of the surrealist movement. His canvases of 1912 to 1922 seemed to offer the possibility of what surrealist painting could be, before it was conceived of. Reading Schopenhauer and Nietzsche, de Chirico found in the latter's philosophy 'a strange dark poetry, infinitely mysterious and lonely, based … on the atmosphere of an afternoon in autumn when the weather is clear and the shadows are longer than they have been all summer …' This melancholic ambience, recalled in much of Robert Desnos' writings and in de Chirico's own novel *Hebdomeros* (1929), permeates the artist's typical settings of simplified architectural forms, statues, distant trains, seen in uncertain, inconsistent perspectives. In a series of paintings and drawings made in Paris between Autumn 1914 and May 1915, mannequin figures take a central role. Citing this painting and several similar works, the scholar Paolo Baldacci describes how in these scenes 'the heads of the mannequins are opened so that we can see right through them, like the windows of Metaphysical buildings, catching glimpses of ghostly trains … From the well-combed wigs, which make them seem almost human, emerge brightly coloured little flags.' (*De Chirico: The Metaphysical Period, 1888–1919*, 1997.) The half-human, half-mechanical, and spectral aspects of these figures relate them to the exploration of these qualities in the work of Duchamp, Ernst, Man Ray and Picabia in the early 1920s.

Max ERNST

The Pleiades

Les Pléiades

1921

Collage, fragments of retouched photographs, gouache and oil on paper, mounted on cardboard

24.5 × 16.5 cm [9.5 × 6.5 in]

Private collection

When Breton heard of Ernst's 'collages', begun in 1919, he requested 56 of them to be sent to Paris for exhibition at the Au Sans Pareil bookshop in May 1921. Most were not simply collages but what Ernst called 'overpaintings'. Printed material was selected from diverse sources – scientific journals, commercial catalogues, popular illustrations, adverts – referred to by Breton as 'readymade images'. Then ink and gouache was added, blocking out parts of the image to generate a new one. For Breton the moment when he, Aragon, Soupault and Tzara unpacked them at Picabia's house was a revelation. They suggested how objects could be freed from their normal environment and recombined in new relationships. This image was dedicated to Gala, then married to Paul Éluard. Using a turn-of-the century erotic photograph of a woman reclining on a couch, Ernst overpainted the couch as well as her head. He then rotated her body by 90 degrees, disorienting the viewer with this unfamiliar vertical orientation. While retaining the appearance of the real, such images seemed to embody an escape from its rational principles. Sometimes known as 'La Puberté proche', the collage is accompanied by an inscription: 'The onset of puberty has still not taken away the slender grace of our Pleiades / The gaze of our eyes full of shade is drawn towards the pavement, about to fall / The gravitation of undulations does not yet exist.'

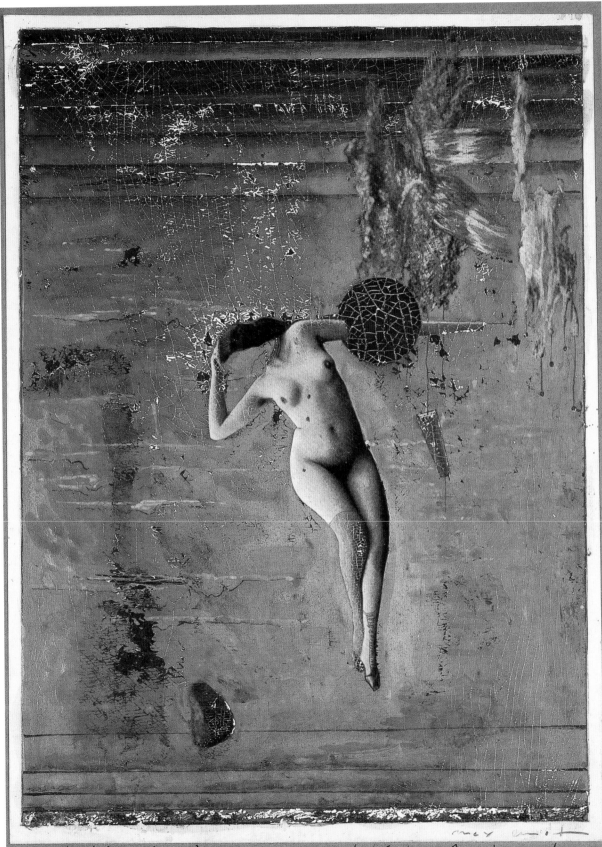

La puberté proche n'a pas encore enlevé la grâce tenue de nos pléiades / Le regard de nos yeux pleins d'ombre est dirigé vers le pavé qui va tomber / La gravitation des ondulations n'existe pas encore

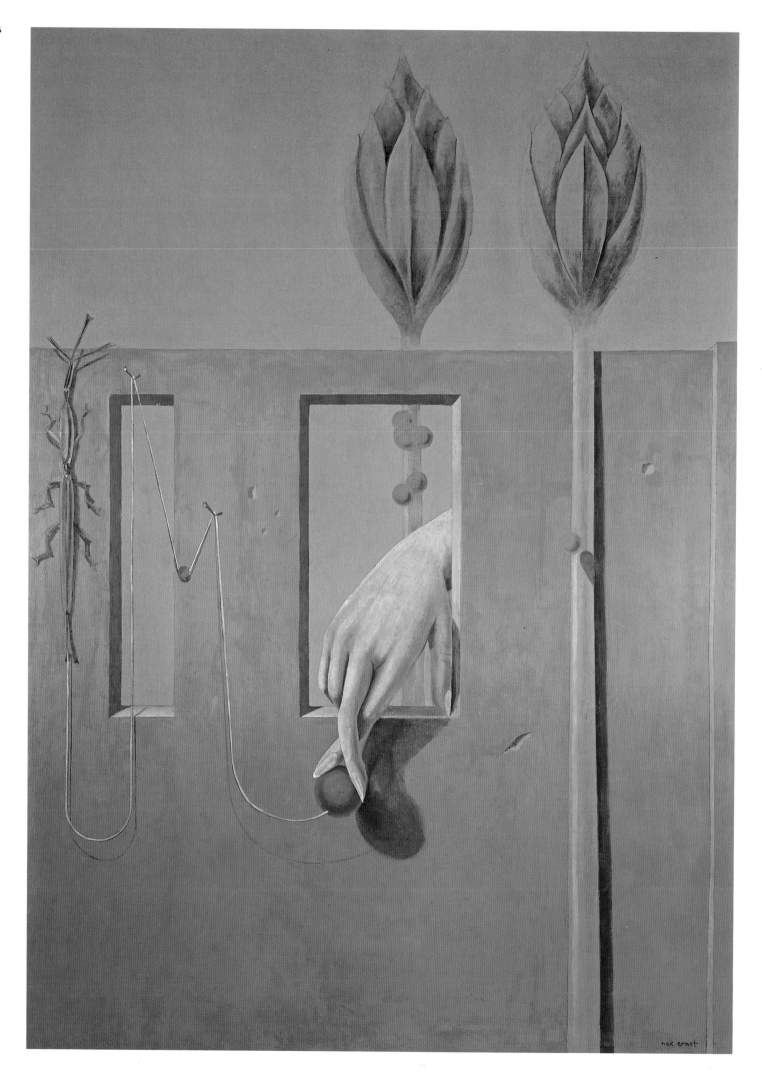

opposite

Max <u>ERNST</u>

At the First Clear Word

Au premier mot limpide

1923

Oil on plaster mural at the house of Paul Éluard at Eaubonne, later

transfered onto canvas

236.5 × 168 cm [93 × 66 in]

Collection, Kunstsammlung Nordrhein-Westfalen, Dusseldorf

During 1923–24 Ernst shared a house at Eaubonne with Paul and Gala Éluard and their daughter Cécile. He decorated the entire house with a cycle of paintings, covering the walls and the doors with fantastic figures, plants and animals. Partly obliterated by subsequent owners, what remained was uncovered under Cécile Éluard's supervision in 1967. A number of sections from the murals, such as this one, were removed and transferred onto canvas. They are reminiscent of ancient Pompeiian wall paintings and this association may have prompted Ernst to evoke here the figure of Gradiva from Wilhelm Jensen's 1903 story, interpreted in relation to a case history by Freud in his *Delusions and Dreams in Jensen's Gradiva* (1907). A young archaeologist, obsessed with the figure of a girl on a Roman relief, dreams of her walking towards him, then suddenly being buried alive by the volcano Vesuvius as it destroys Pompeii. He later recognizes her walk in a real woman to whom he becomes attached. The transformation in Ernst's image is from a hand to the suggestion of a woman's lower torso and legs, the hand based, as Rosalind Krauss has noted, on an illustration for an essay on sensory illusions published in the scientific journal *La Nature*. Krauss suggests a phallic reading of the figure's verticality and the fingers' caress of the little ball; a conflation of meanings which would be explored in much of Surrealism's later imagery. (*The Optical Unconscious*, 1993.)

Max <u>ERNST</u>

Celebes

1921

Oil on canvas

126 × 108 cm [49.5 × 42.5 in]

Collection, Tate Gallery, London

Sometimes known as 'The Elephant Celebes', this was Ernst's first large scale picture, painted in Cologne in 1921. Here the juxtapositions and transformations of his collages and 'overpaintings' combine with elements drawn from his study of de Chirico's compositions and figures. The strange creature which is the central subject hovers disconcertingly, like some of de Chirico's mannequins, between the effect of an inanimate structure resembling a living being, and vice-versa. In the foreground, a headless and hollow female figure seems to be beckoning the creature towards it. As the painting's former owner, Roland Penrose, learned from Ernst, the source for this extraordinary being was a photograph in an ethnographic journal of a huge clay communal corn bin typical of an area in southern Sudan. The name Celebes derived from a scatalogical nonsense verse about elephants favoured by German schoolboys. (Roland Penrose, Charlton lecture, 1975.) Both comical and menacing in its potential Freudian associations, the scene is dreamlike in its irrationality, heightened by the appearance of fish in the sky.

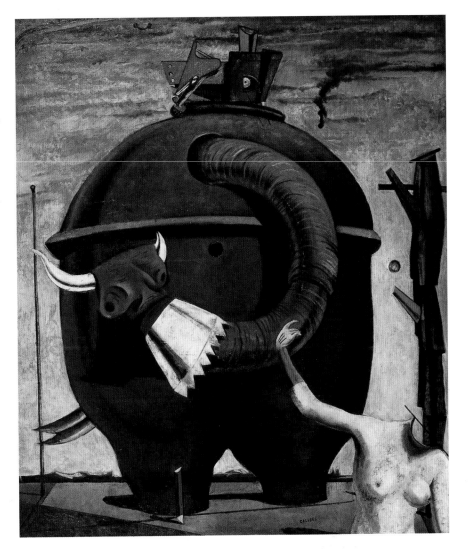

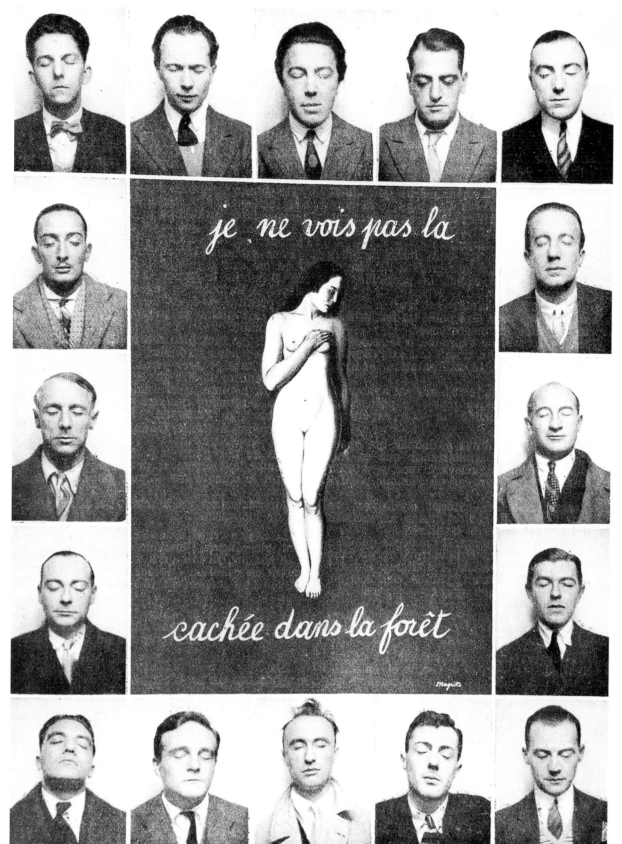

René **MAGRITTE**

*Je ne vois pas la … cachée dans la
forêt*
I do not see the … hidden in the
forest
1929
Photomontage with portraits of
sixteen Surrealists around
Magritte's painting
Clockwise, from top, centre,
André Breton, Luis Buñuel,
Caupenne, Paul Éluard, Marcel
Fourrier, René Magritte, Albert
Valentin, André Thirion, Yves
Tanguy, Georges Sadoul, Paul
Nougé, Camille Goemans, Max
Ernst, Salvador Dalí, Maxime
Alexandre, Louis Aragon

Around a photograph of his own painting
Magritte collaged automated photo-
booth portraits of the Surrealists. The
image was published in *La Révolution
surréaliste*, 12, 1929. With her hand over
her heart, the woman's pose resembles
Renaissance depictions of the goddess
of love, such as Sandro Botticelli's *Birth
of Venus* (c. 1485). A modern woman of
the 1920s, her upright posture suggests
agency rather than passivity. Clearly not
hidden, brightly lit against a darkness
without any trace of trees, and occupying
the place of an unnamed word, she
seems to stand as an icon in the midst
of what Breton, quoting Baudelaire,
called the 'forest of signs', visual and
linguistic, conscious and unconscious,
through which Surrealism navigated.
As many have noted, this enigmatic
image, with its all-surrounding frieze
of male sightless viewers, so unusually
incorporated into the frame of the
habitual object of their gaze, echoes the
1924 photomontage with the anarchist
Germaine Berton at its centre (see page
29). In *Surrealism and Photography*
(2004) David Bate records the usually
overlooked fact of her suicide, and that
in the paradox of that picture, she is still
'alive', looking to camera like the group
around her. The photomontage had
accompanied the Surrealists' 'Enquiry
on Suicide'; this one accompanied their
'Enquiry on Love'.

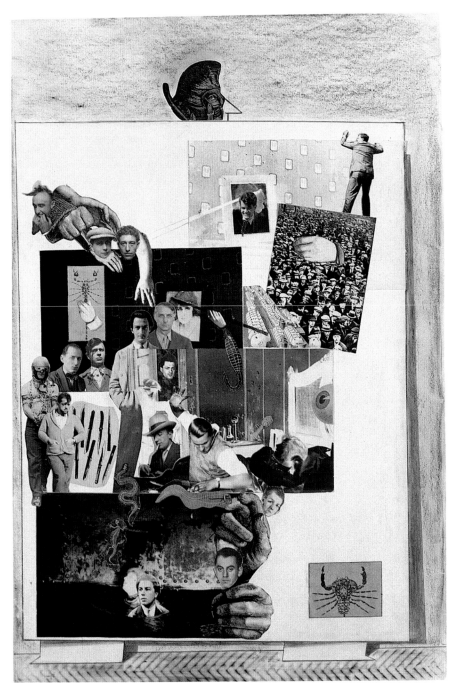

Max ERNST
Loplop Introduces Members of the Surrealist Group
Loplop introduit des membres du groupe surréaliste
1931
Collage of photographs, pencil and frottage
50 × 33.5 cm [20 × 13 in]
Collection, The Museum of Modern Art, New York
from upper left, Yves Tanguy, Louis Aragon, Alberto Giacometti, René
Crevel, Georges Sadoul (from behind with raised arms); *from centre
left*, Luis Buñuel (before helmeted figure), Benjamin Péret, Tristan
Tzara, Salvador Dalí, Max Ernst, Gala Éluard, André Thirion (below
Ernst), Paul Éluard, René Char (arm raised), Maxine Alexandre; *below*,
André Breton, Man Ray

Also sometimes known as the 'bird superior', Loplop first appears in several of
Ernst's collages for *La Femme 100 têtes* (1929). In the early 1930s this spectral figure –
a bird, but never only that – is featured in a series of diverse paintings and collages.
While Loplop's birdlike head might peer, as here, over the top of an image, it is
frequently combined, in Ernst's anthropomorphic fashion, with something else,
animal, vegetable or mineral, such as the two 'feet' here which are like easel-stands
propping up the collage. Described by Ernst as a 'private phantom' who visited him
almost every day, Loplop is often seen as here in the act of 'presenting' or 'introducing'
a series of pictures within a picture, all of them generally being Ernst's own creations.
As an intermediary between artist and viewer this device creates a kind of third space
of detachment between the creator and receiver of the image and its meaning.
This example differs from others in presenting members of the surrealist group
themselves, in an iconographic way which dramatizes the cohesion of what was in
fact a divided group, and the revolutionary and disruptive energy it wished to convey.
The anti-rational method of dada collage is combined with echoes of the purposeful,
revolutionary styles of futurist and constructivist graphics, creating a kind of visual
manifesto where Surrealists are brought into the same space as their imagery.

Max <u>ERNST</u>

La Femme 100 têtes
The Hundred-Headless Woman
1929-30
Collage novel, Éditions du Carrefour, Paris, 1930
Quarto, unpaginated
upper left, 'The might-have-been Immaculate Conception'
lower left, 'Truth will remain simple, and gigantic wheels will ride
the bitter waves'
below, '… and the third time missed'

This was Ernst's first collage novel, comprising 147 collages presented as black
and white printed images with their individual titles. Excerpts appeared at the end
of 1929 in the final issue of *La Révolution surréaliste* and it was published as a book
with a preface by Breton in 1930. Ernst collected a vast range of old and forgotten
illustrations from diverse sources including scientific and geographical periodicals,
illustrated novels, magazines, medical textbooks and zoological guides. These
were usually wood engravings, which by the late nineteenth century had become
increasingly stereotyped in an attempt to compete with photomechanical reproduction
and photogravure. The graphically intense texture of the engravings enabled elements
to blend together seamlessly when Ernst's collages were reproduced on the printed
page. To make these, he pasted onto often recognizable scenes such as Paris streets,
figures and objects from completely other contexts, creating mysterious new
configurations. The series has an astonishing diversity of surprising images and
is free from any unifying structure, yet certain elements recur, such as wheels, cogs
and other disconnected mechanical parts (*lower left*); disembodied parts of a woman
and strange scientific experiments (*below*); and dramatic scenes such as the one
titled, with a typically ironic biblical reference, 'The might-have-been Immaculate
Conception' (*upper left*). This uses an engraving of a medical photographer taking
a picture of a woman having a hysterical attack, from J-M. Charcot's series of clinical
images (reproduced in Georges Didi-Huberman, *Invention de l'hysterie*, 1982).
In Ernst's reworking, a giant bottle looms on the table; a large eye- or breast-like form
emanates from a flash of radiance surmounting the tripod; a rabbit has inexplicably
appeared; and the figure of the child, perhaps turning away in distress, or equally
perhaps just awakening, is positioned as if offering a key to the enigmatic scene.

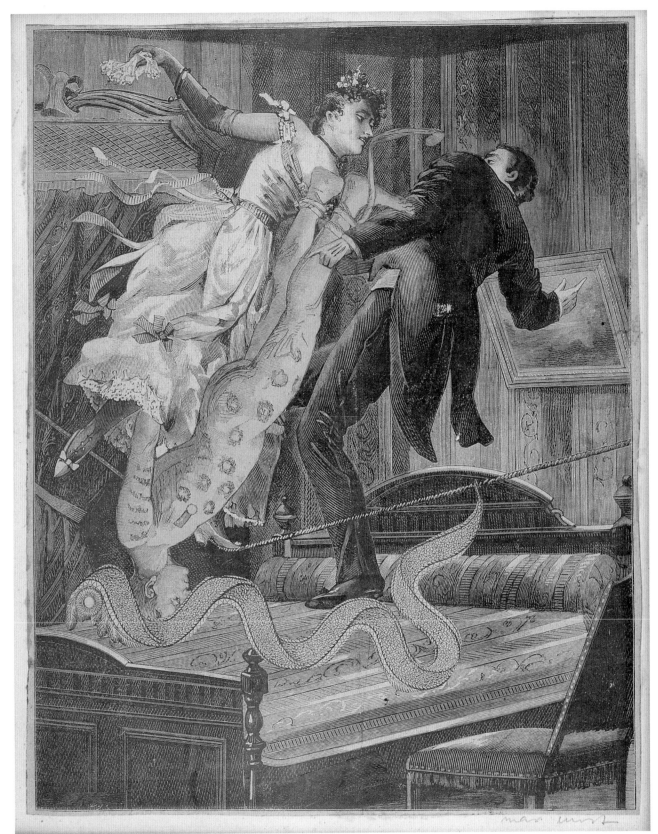

Max ERNST

Let's Go! Let's Dance the
Tenebreuse …

Allons! Dansons la Ténébreuse
1929-30
Collage on paper
24 × 19 cm [6.5 × 6 in]
Original artwork for illustration
in *Rêve d'une petite fille qui
voulut entrer au Carmel*
Private collection

For his second and third collage novels,
*Rêve d'une petite fille qui voulut entrer
au Carmel* (*Dream of a Little Girl Who
Wanted to Enter a Convent*, 1929–30)
and *Une Semaine de Bonté* (*A Week
of Kindness*, 1934) Ernst reduced the
diversity of his sources, focusing on
the already melodramatic style of
illustrations for romantic novels and
thrillers. These were combined with
other material in scenes which,
compared with *La Femme 100 têtes*,
are more consciously contrived, even
virtuoso exercises, but no less
surprising. While in *Une Semaine de
Bonté* nineteenth-century bourgeois
figures are transformed with
mammalian, reptile or bird heads,
claws or wings and nightmarish sights
frequently arrest both the onlooker and
viewers within the picture, in *Rêve d'une
petite fille* the effects are more subtle
and erotic. In this collage, shown here
in its original rather than printed form
to reveal its skilful construction, the eye
is led gradually from taking in the first
impression of rhapsodic whirlwind
dancing by the couple to the fact that they
are apparently on a tightrope suspended
above a bed; that between them is an
upside-down, naked and non-western
man, while beneath them a serpentine
fabric object writhes and swirls.

Roger PARRY
Untitled
1930
Vintage gelatin silver print
29 × 16 cm [11.5 × 6.5 in]
Private collection

Interested in such types of image as Boiffard's photographs of banal Paris scenes which punctuate André Breton's narrative *Nadja* (1928), Parry produced a series of photographs for an illustrated edition of Léon-Paul Fargue's 1922 text *Banalité*. The mundaneness of the scene in Parry's image echoes the book's title. The photograph appears to depict telegraph poles and electricity points, or possibly railway signal posts, seen from the foot of an embankment. Using darkroom techniques he created a double image, superimposing this scene over what seems to be a page from an old children's picture book, so that it is haunted by the ghostly procession of nineteenth-century figures in the background. The sepia apparitions disturb the space of the photograph through their disproportionate size and the angle at which they are situated. In addition, the surface of the photograph is made ambiguous through the simultaneous effect of the recession into and emergence out of the central image.

Jindrich STYRSKY
Little Alabaster Hand
Alabastrová rucicka
1940
Pencil frottage and collage on paper
22 × 30 cm [9 × 12 in]
Private collection

While most of Styrsky's collages are composed of coloured or black and white graphic and photographic images, this work mixes collage elements with the pencil and *frottage* depiction of what seems to be a lace table cloth, combining a surrealist technique with an effect used in cubist collage. Butterflies recur in surrealist imagery, for example in the mysterious collage 'And the butterflies begin to sing', in Ernst's *La Femme 100 têtes* (1929). Similarly, the strangely animated yet disembodied hand recalls other images such as the woman's hand in Buñuel and Dalí's film *L'Age d'Or* (1930) in which it first appears as part of an advertisement but becomes suggestively animated through the erotic delirium of the male protagonist. This collage embodies the poetic roots of Czech Surrealism, where poetry acts in defiance of reality, effecting 'the negation and transformation of unacceptable reality into the reality of desire' (Karel Teige, quoted in Karel Srp, *Karel Teige*, 2001).

Jacques BRUNIUS
Untitled
1936
Collage
11 × 25 cm [4.5 × 10 in]
Private collection

This collage illustrates what Dawn Adès has referred to as Brunius' 'dreamlike intelligence' (*Dada and Surrealism Reviewed*, 1978), combining elements of decorative patterns with human and organic imagery to create a composite image of marvellous metamorphosis. Brunius was an actor, poet, collagist and filmmaker. A pioneering figure in the introduction of 'naïve' artists to the surrealist movement, he wrote articles on the fantastic *Palais idéal* of the postman Ferdinand Cheval for the Belgian review *Variétiés* in 1929, and for the issue of *Cahiers d'Art* devoted to the surrealist object in 1936. Although his visual works have rarely been reproduced, he is a significant figure in the development of the surrealist image.

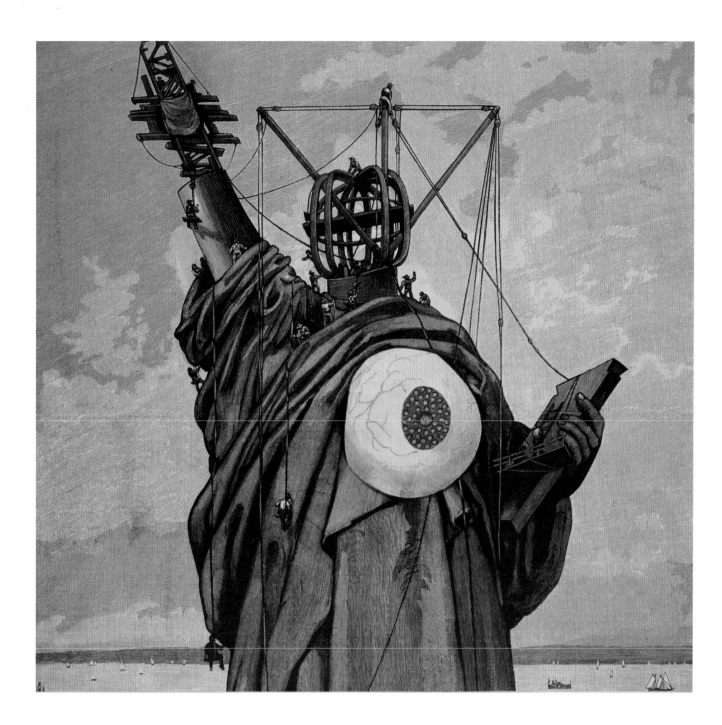

Jindrich <u>STYRSKY</u>
The Statue of Liberty, from *Vanity Case*
Stehovaci Kabinet
1934
Collage on paper
23.5 × 25 cm [9.5 × 10 in]
Private collection

This is one of 65 collages which Styrsky made for the *Vanity Case* series (1934).
An engraving of the American Statue of Liberty's construction is transformed into
a disturbing being, through Styrsky's typically ironic humour. The framework
structure of the head is slightly reminiscent of the mannequins in de Chirico's 1915
paintings. The statue's solid stone form is interrupted by what seems to be either
a gigantic eyeball or, in Elza Adamowicz's reading, a breast which transforms the
figure 'into a grotesque goddess of fecundity' (*Surrealist Collage in Text and Image:
Dissecting the Exquisite Corpse*, 1998). Many of Styrsky's collages from this series
depict predominantly female bodies as curious compositions of anatomical parts,
contrasting hard skeletal forms with the softness of flesh and organs. This is one
of several variations on the figure of the Statue of Liberty and has an erotic character
that underlies much of Styrsky's collage and photomontage work.

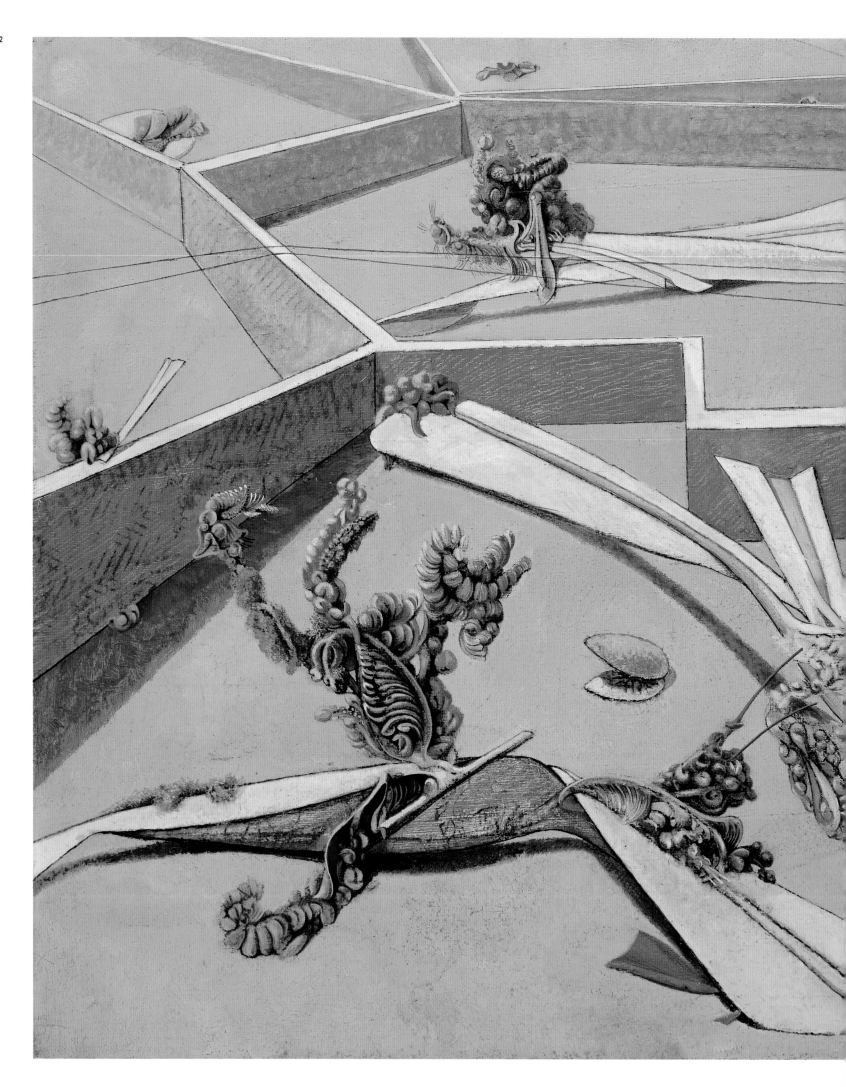

Max ERNST
Garden Aeroplane Trap
Jardin gobe-avions
1935
Oil on linen
58.5 × 73 cm [23.5 × 29 in]
Collection, The Art Institute of Chicago

Between 1934 and 1936 Ernst made a series of around twelve paintings on this theme.
This example was reproduced in *Cahiers d'art* in 1935, another in *Minotaure*, 8 (1936).
In his book *Beyond Painting* (1948) he describes these scenes as 'voracious gardens
devoured by a vegetation springing from the debris of trapped aeroplanes'. This may
bring to mind the anonymous photograph of a train engulfed by vines described by
André Breton in *L'Amour fou* (1937) as part of his portrayal of 'convulsive beauty'.
Yet this earlier image is more intricate. The irregularly divided enclosures of the
'traps' seem to follow no system; scale is impossible to determine. In what could be
a vast plain or a miniature children's game, the 'aeroplanes' and the excrescences
emerging from them are indeterminate, hybrid forms. Ernst's frottage images in
Histoire naturelle (1925) often combine the traits of both flora and fauna; here the
natural becomes inextricably mixed with the artificial. Some of the forms might evoke
creatures such as leaf and stick insects whose capacity for mimicry of surrounding
plants merges animate and inanimate nature. Roger Caillois discussed these in his
text '*Mimétisme et psychasthénie légendaire*', *Minotaure*, 7 (June 1935).

René <u>MAGRITTE</u>
The Key of Dreams
La Clé des songes
1930
Oil on canvas
81 × 60 cm [32.5 × 24 in]
Private collection

This work exists in several versions with different objects pictured and labelled. In this example, the most frequently reproduced in surrealist literature, none of the images and labels correspond to each other as the arbitrary visual and verbal signs for the same thing, whereas in the others some of them do. This series of paintings, like the one reproduced below, draw attention to the arbitrary nature of language games by which we apprehend the world. However, as the title suggests, here Magritte is being more expansive. In his notes to accompany a slide of this work for his 1938 lecture, '*La ligne de vie*' ('The Lifeline'), he wrote: 'Is it a list of things some of which are indicated by their image, others by their name? Is it a melody of music which consists of objects, while the words remain words? Is it a poetic machine working in favour of deliberate misnaming? Is it a subversive demonstration against speech? It is a picture which prompts serious thought. It sometimes happens that we are presented with something unknown simply by means of its name; we are faced with an obvious truth: the word can never replace the object, is foreign to it, seems to have nothing to do with it. But it can also happen that the unknown name projects us into a world of ideas and images, draws us towards a mysterious point on the horizon of the mind, where we encounter strange marvels and come back loaded with them.'

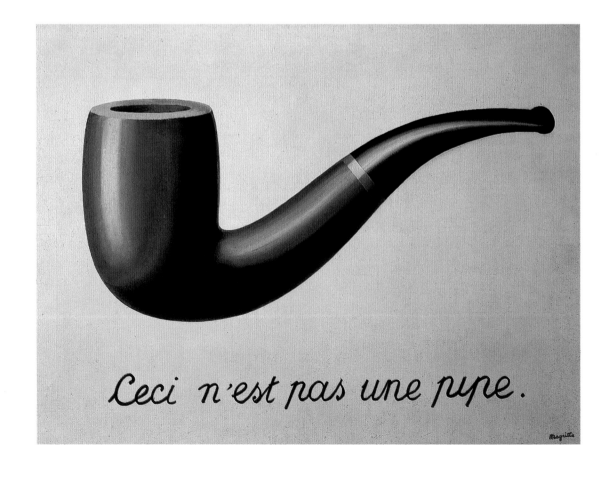

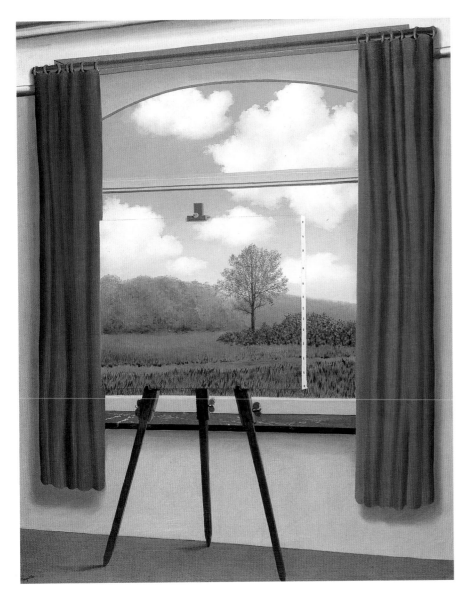

René <u>MAGRITTE</u>

The Human Condition

La Condition humaine

1933

Oil on canvas

100 × 81 cm [39.5 × 32 in]

Collection, National Gallery of Art, Washington

Magritte wrote of this work: 'I placed in front of a window, seen from inside a room, a painting representing exactly that part of the landscape which was hidden from view by the painting. Therefore, the tree represented in the painting hid from view the tree situated behind it, outside the room. It existed for the spectator, as it were, simultaneously in his mind, as both inside the room, in the painting, and outside in the real landscape. Which is how we see the world: we see it as being outside ourselves even though it is only a mental representation of it that we experience inside ourselves.' ('*La Ligne de vie*', 1938.) As well as raising philosophical questions about the location of our consciousness of the world and the role of pictorial illusion and objecthood, the painting within the painting might also be read in terms of the object-relations theory of the psychoanalyst D.W. Winnicott: 'By both negating and affirming the opacity of the picture plane, perspective transforms the painting into a transitional object that is both "there" and "not there" simultaneously.' (Eric Wargo, 'Infinite Recess: Perspective and Play in Magritte's *La Condition Humaine*', *Art History*, 25, 2000.)

opposite

René <u>MAGRITTE</u>

The Treachery of Images

La Trahison des images

1929

Oil on canvas

60 × 81 cm [23.5 × 32 in]

Collection, Los Angeles County Museum of Art

This work was initially presented untitled. In the same year as the painting, a similar drawing was published in the Belgian surrealist group's review on contemporary culture, *Variétés*, 9 (January 1929). The title for this particular work, 'The Treachery of Images' appeared in a letter from the artist to Paul Éluard in 1935 (*Magritte Catalogue Raisonné*, 1, 331). Magritte often returned to this image and its inscription, drawing and painting new variations with different titles. Of one of these he wrote, 'it would be good for such a thing to be found in as many "households" as possible' (Letter to André Bosmans, October 1964). Also resembling the type of illustration used by primary school teachers, it 'demonstrates' that neither the picture nor the words are a pipe; they are no more than arbitrary signs. This realization, however, provides no reassurances, only opening up further questions such as those Magritte explored in the same year in '*Les Mots et les images*' ('Words and Images'), *La Révolution surréaliste*, 12 (December 1929).

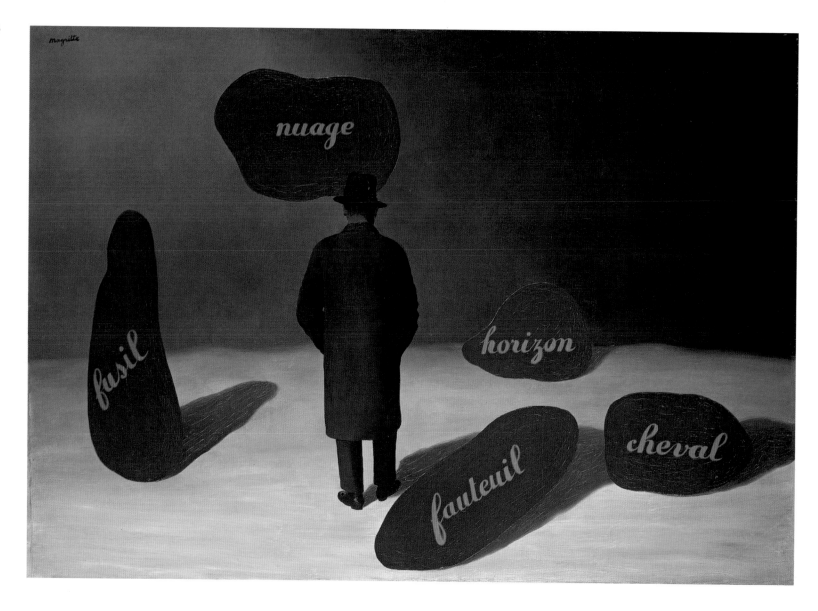

René MAGRITTE
The Apparition
L'Apparition
1928
Oil on canvas
80 × 117 cm [31.5 × 46 in]
Collection, Staatsgalerie, Stuttgart

Also sometimes known as *Figure Walking Towards the Horizon*, this is one of several paintings in which words or phrases are attached to biomorphic shapes. As one of Magritte's propositions – often compared with those of the philosopher Wittgenstein – states: 'Sometimes names written in a painting designate precise things and the images indefinite things, or else the contrary.' ('*Les Mots et les images*', *La Révolution surréaliste*, 12, 1929.) There are variations, however, in the status of these words and forms. The cloud, at least, is in the right place, and looks as if it could even be a cloud; the word 'horizon', too, is at least level with the 'horizon line'; whereas the words 'gun', 'armchair' and 'horse' are stranded out of place on the boulder-like shapes, made more puzzling by the object-like solidity conferred on them pictorially by their shadows. In their midst the bowler-hatted man faces away from us, as a stand-in for the viewer, the artist or someone else. He seems immersed in the centre of the confusion, a sign among signs.

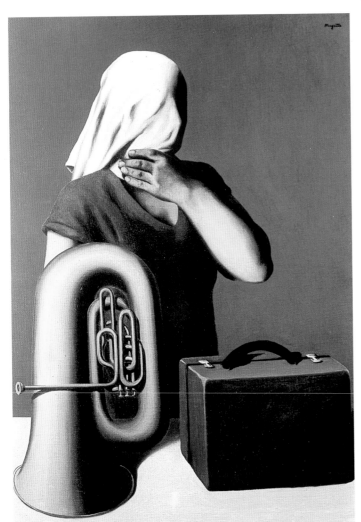

René MAGRITTE

The Central Story

L'Histoire centrale

1928

Oil on canvas

116 × 81 cm [46 × 32 in]

Private collection

Magritte's painting mysteriously juxtaposes a veiled woman, a tuba and an attaché case: three recurring motifs in his work of the late 1920s. According to David Sylvester, the artist first referred to this work as *La Femme voilée* (*The Veiled Woman*), and both this provisional title and the final one have been read as having highly personal significance for Magritte. (David Sylvester and Sarah Whitfield, *René Magritte. Catalogue Raisonné*, 1, 1992.) From biographical information passed on by the artist to Louis Scutenaire, it is known that the image of the veiled woman relates to his mother's apparent suicide by drowning when he was twelve years old. In a psycho-analytic reading, the central story is that when her body was recovered after many days, her face was covered by her nightdress. As a motif in Magritte's repertory of images, the veiled woman was described by Sylvester as 'an inspired mixture of the complacently romantic and the shockingly erotic', which gives to this work an 'Oedipal and necrophilic' frisson. He proposes another, less personal source for the image in Magritte's fascination with pulp fiction, referring to an illustration of a veiled woman in a Nick Carter detective story and a scene in Louis Feuillade's film *Judex* (1917) where 'the heroine is dragged from the water with her head covered by her clothing'. (David Sylvester, *Magritte: The Silence of the World*, 1992.)

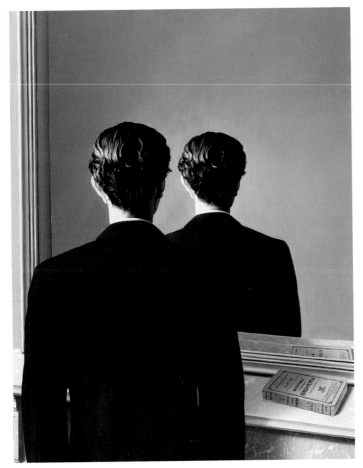

René MAGRITTE

Reproduction Forbidden

La Reproduction interdite

1937

Oil on canvas

81.5 × 65 cm [32 × 25.5 in]

Collection, Museum Boijmans Van Beuningen, Rotterdam

The figure in this painting is the collector and writer on Surrealism, Edward James, whom Magritte visited in London in 1937. He is looking into a mirror, 'so we would expect to see his face reflected back to us, but instead it recedes into the depths, still turned away, with the mysteries of Edgar Allan Poe's *Adventures of Arthur Gordon Pym* on the mantelpiece to the right … Something is watching and we are watching it watching … It is looking at us, into our own private space, through just the opening that we use, usually, to look out. We are rendered nervous by the intrusion.' (Mary Ann Caws, *The Surrealist Look*, 1997.) Poe's narrative, well known to Magritte, is full of such anxious encounters with mirrors and mirrorings of all kinds, as parables of the distance between sight and vision, in which perception appears as distorted and unreliable. Rather than affirming the gazer's image of selfhood and completeness, the uncanny doubling negates such assurance.

Yves <u>TANGUY</u>

Tes bougies bougent
Your Tapers Taper
1929
Oil on canvas
73 × 92 cm [29 × 36 in]
Private collection

This much admired painting was reproduced in the final issue of *La Révolution surréaliste* (December 1929). It dates from the latter part of what became known as Tanguy's 'smoky' period, referring to the vaporous formations of the biomorphic forms. In contrast to most works of the previous two years, the atmospheric charge is conveyed through a unified, vividly coloured background; the shapes have taken on a greater delineation and an apparently three-dimensional solidity, enhanced by the use of shadow. Yet they have a lightness, an uncharacteristic symmetrical arrangement, and a dance-like rhythm, suggesting that the title Tanguy chose might echo one of the traditional Breton songs that the painter Gordon Onslow Ford recalled him singing during these years (*Yves Tanguy and Surrealism*, 2001). Increasingly from this point onwards Tanguy creates a world of fluid ambiguity: these '*bougies*' (tapers, or flares) might be hot or cold, wet or dry, rising from surface to air or floating under water.

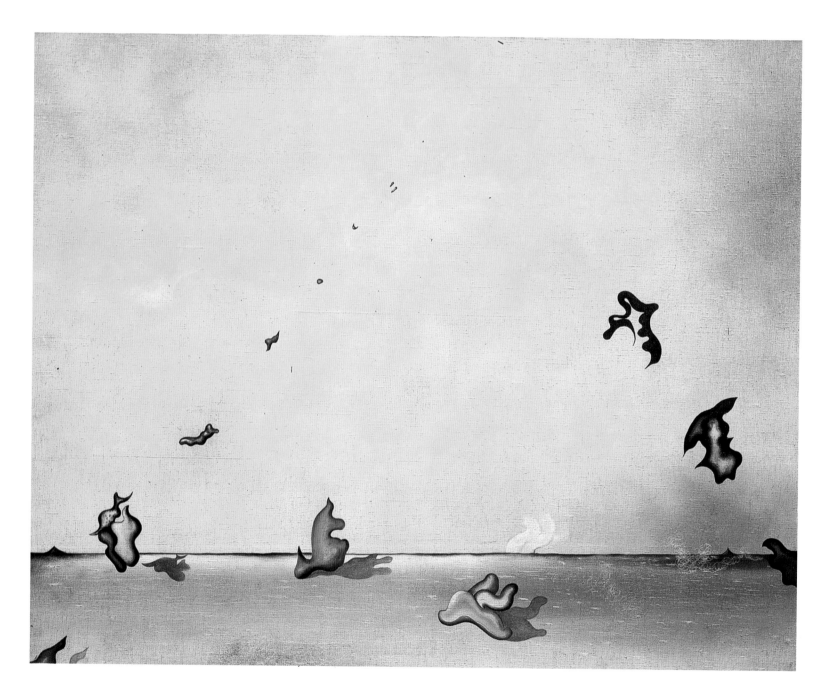

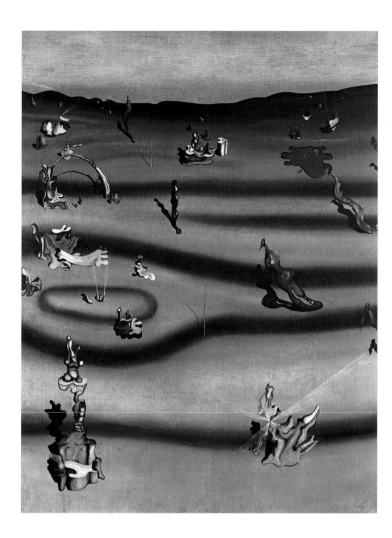

left

Yves TANGUY

Title unknown

1931

Oil on canvas

117 × 89 cm [46 × 35 in]

Private collection

This painting marks the beginning of a transitional period during 1931–32 in which Tanguy moved away from the demarcation of a horizon between 'earth' and 'sky' towards the horizontal, softly graduated bands of colour indicating an undifferentiated receding space that would characterize his later paintings. Here there is still a 'sky' area but it is now empty. The horizon has become hilly and the bands of darker colour resemble formalized contour lines, not quite succesfully indicating a receding plane. The biomorphic forms have gravitated together in what seem to be meaningful groups, while remaining enigmatic; some of them are suggestive of identifiable subjects: hands, human figures, rock formations, birds. They differ from Miró's forms in their three-dimensionality, emphasized by painted shadows. Some emerge from the edges as if this is a section of a larger continuous image. In the following year Tanguy made two painted folding screens which share some of the characteristics of this work and show his familiarity with Asiatic screens and scroll paintings.

right

Yves TANGUY

Untitled

1940

Oil on canvas

91 × 71.5 cm [36 × 28 in]

Collection, The Art Institute of Chicago

Tanguy left France for the United States in November 1939. Some of the features of his French compositions of the late 1930s linger in this work, such as the subtle, dark and misty colouration of the background, the grouping of a cluster of anthropomorphic forms to the left, and the thread-like connections between some of them. The horizon can only be guessed at from the gradual transition of colour between ground and sky. Of such scenes Breton wrote: 'The tide ebbs, revealing an endless shore where hitherto unknown composite shapes creep, rear up, straddle the sand, sometimes sinking below the surface or soaring into the sky. They have no immediate equivalent in nature and it must be said that they have not as yet given rise to any valid interpretation.' (*Le Surréalisme et la peinture*, 1945.) The work differs from its predecessors in its larger scale and increased legibility. By 1942 Tanguy would be using much brighter, contrasting hot and cool colours, less organic, more 'technoid' forms, and almost metallic, shimmering effects. From this time on his scenes increasingly evoke an atmosphere of the infinite and uncertain.

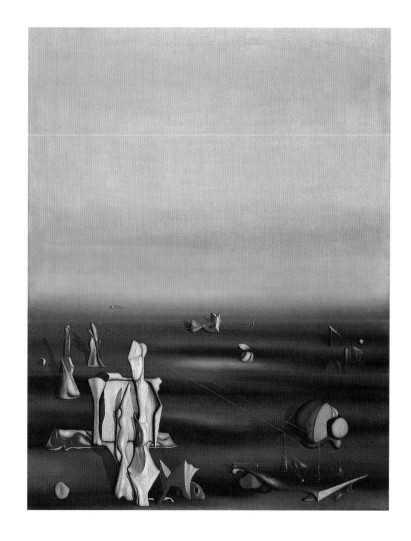

opposite

Joan MIRÓ

Painting [Composition]

1933

Oil and aqueous medium on canvas

130.5 × 163 cm [52 × 64 in]

Collection, Philadelphia Museum of Art

Between 26 January and 11 February 1933 Miró began a systematic experiment.
He made eighteen collages, completing on average one per day, on uniformly sized
sheets of paper. He then painted a sequence of eighteen canvases, to which this
example belongs, each composition being derived from one of the collages in
chronological sequence. Each collage was inscribed with the canvas size of its
related painting and its date of completion. The collages have only the most germinal
relationship compositionally to the forms in the paintings. Here, the central yellow
ochre form near the base and the black outline form that looms over it are derived
from the encounter in the source collage between a section of u-bend pipe and part
of an aeroplane propeller. The small collage elements surrounded by large expanses
of paper came from advertisements, trade catalogues and newspapers and most
frequently depicted such things as tools, machines and plumbing as in the example
described. Miró exhibited the paintings alone but acknowledged the idea behind the
experiment as integral to their meaning. The utilitarian, rational world was first
displaced in the arbitrary and nonsensical collages, then stretched, rounded, rotated
and quixotically reconfigured in the paintings to create a new kind of imaginary world.

below

Joan MIRÓ

Wounded Personage, from Constellations

1940

Gouache and oil wash on paper

38 × 46 cm [15 × 18 in]

Private collection

On 21 January 1940 Miró made the first small gouache and oil wash painting on paper,
Sunrise, in the series of 23 he named *Constellations*, completed on 12 September
1941 by *The Passage of the Divine Bird*. Between these dates he and his family
experienced the most harrowing period of their life, fleeing across France from the
German occupation to Mallorca. *Wounded Personage* is the seventh in the series,
completed on 27 March 1940, two months before these events. In his 1970 monograph
on Miró, Roland Penrose recorded the artist's description of dipping his brushes in
turpentine, after making an oil painting, and wiping them across the paper, with no
preconceived ideas, the blotchy surface provoking 'the birth of forms, human figures,
animals, stars, the sky, moon and sun'. With their lyrical intensity, the sense of both
intimacy and immensity, and all-over articulation of surface, these works made
a strong impression on younger New York painters when shown at Pierre Matisse
Gallery in 1945. In 1958 Breton wrote poetic texts to accompany each of them.

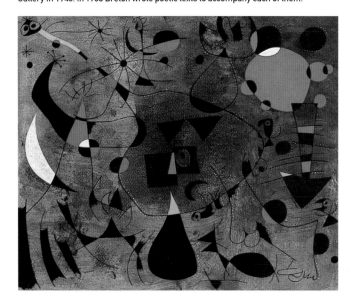

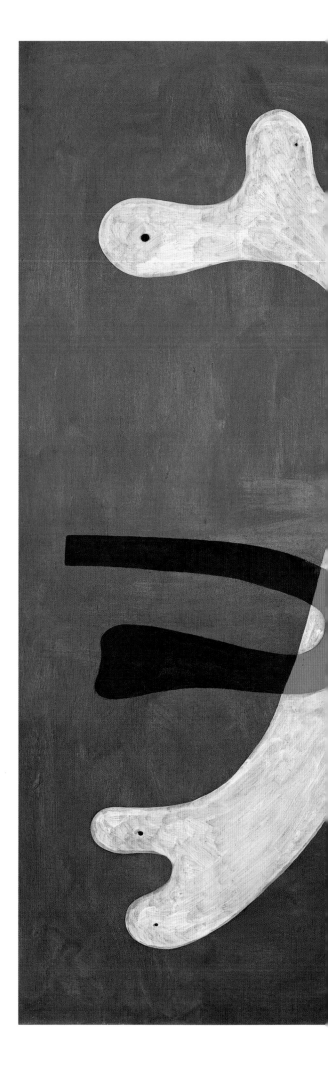

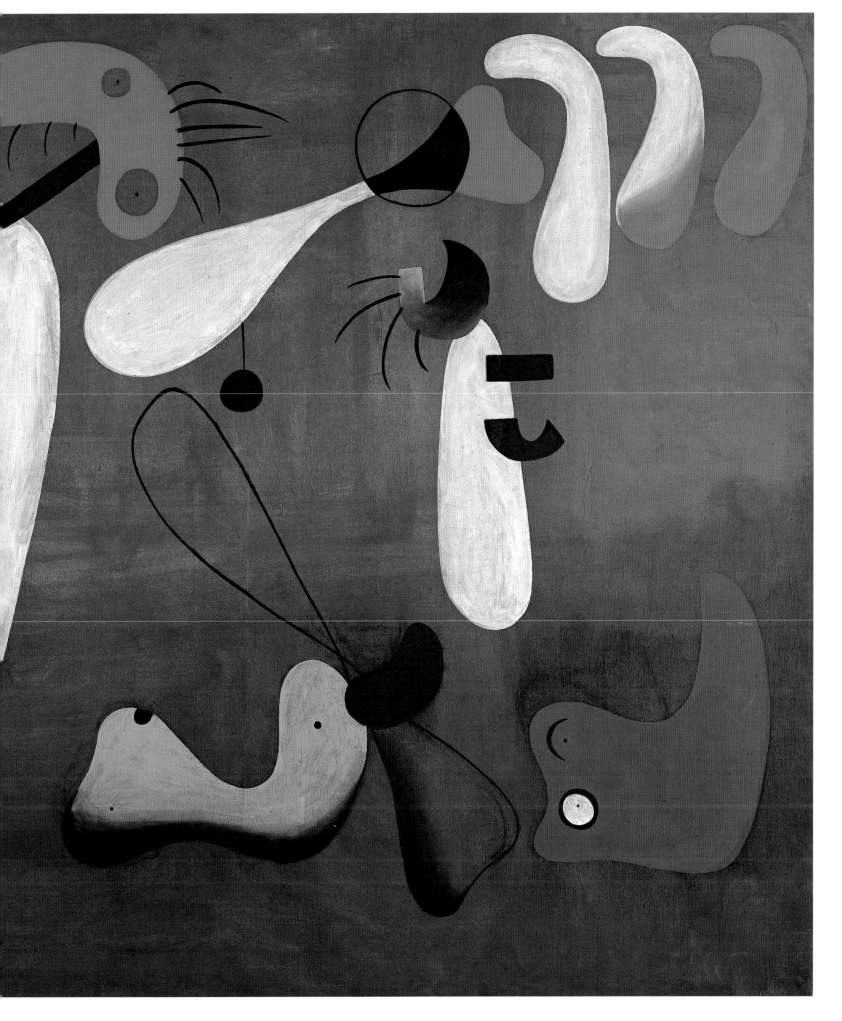

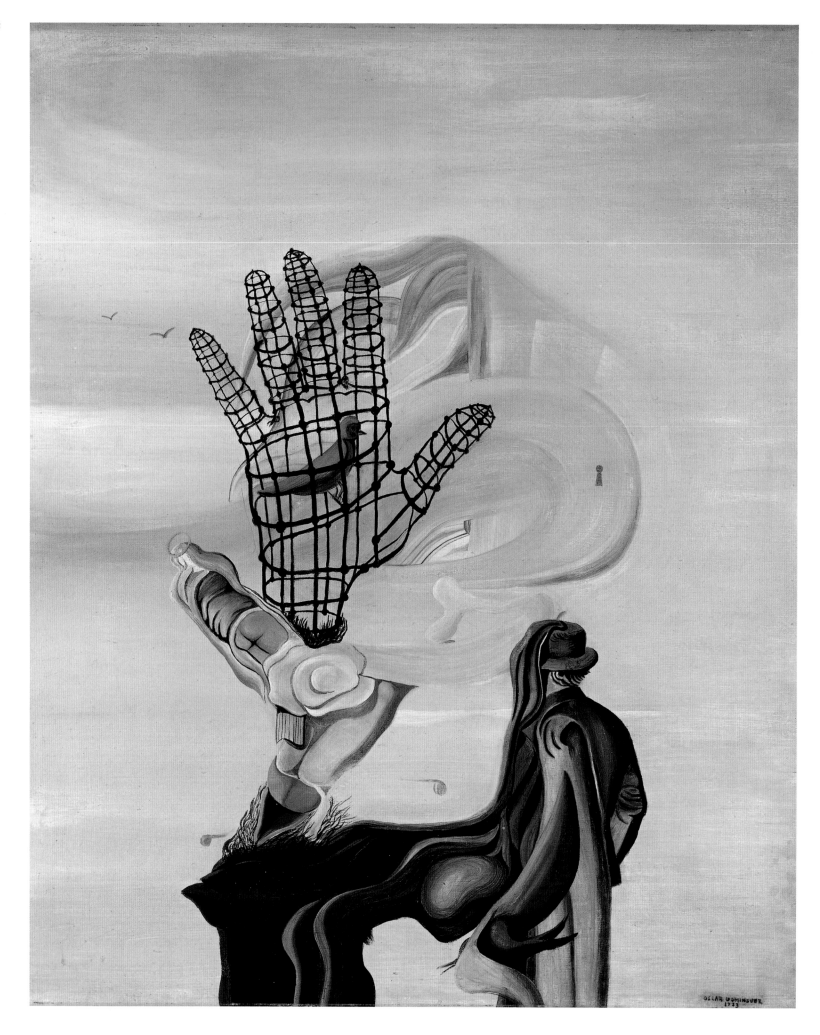

Óscar DOMÍNGUEZ

The Hunter

El Cazador

1933

Oil on canvas

61 × 50 cm [24 × 20 in]

Collection, Museo de Bellas Artes, Bilbao

Domínguez at first absorbed Surrealism from publications when he began making and exhibiting work in his native Tenerife several years before officially joining the surrealist group and going to Paris. As a result his works of the early 1930s combine different surrealist approaches together in interesting ways. A string of associations is depicted in a line, one thing leading to another as in an automatic text or an 'exquisite corpse' drawing. The juxtaposition of unrelated things suggests collage. Like Dalí, Domínguez explores the visceral associations of objects and living things, the combination of realistic detail and 'soft' biomorphic forms. The ensemble also suggests sculpture. Domínguez made surrealist objects which are closely related to the paintings. In one lost example, *Exact Sensibility* (1935), a string of three-dimensional forms actually emerged from a painting (Marcel Jean, *The History of Surrealist Painting*, 1959, 245). Here a man in coat and hat facing away from the viewer points to the unfolding constellation of images. His clothing melts into a viscous dark mass joining with a giant bird's beak, followed by the suggestion of a cocooned and shrouded body from which sprouts a cage shaped like a hand wherein a bird is claustrophobically trapped. Beyond, the outline shapes are disrupted by an unambiguously realistic painted keyhole.

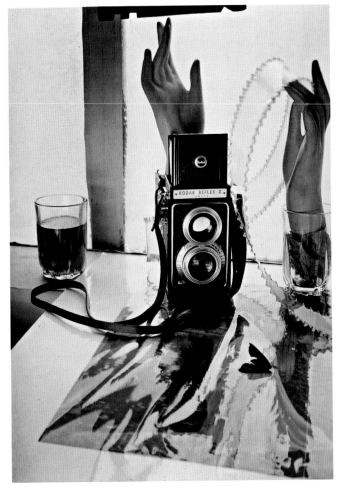

Maurice TABARD

Composition

1950

Gelatin silver print

In this 1950 composition Tabard seems to refer to both his fashion photography and his surrealist experiments. The camera points almost towards the viewer but looks out, somewhere to the side and beyond. Perhaps it stands in for the photographer, in a kind of self-portrait. Evoking the elegant subjects of his fashion photographs, the disembodied mannequin-hands are playing. One springs up like a jack-in-a box behind the camera, poised as if about to take a photo. The other unravels the 'film', which looks more like a translucent piece of ribbon, with its crimped edges. A moth-like shape casts its solid silhouette against the reflective surface of what might be one of Tabard's prints, indecipherable with its shadowy forms. In another composition of the same year, the hands reappear, this time solarized, and caressed by soft beams of light, still emerging from glasses atop the table with its mysterious reflections. Camera, film, drink and moth are gone and the hands now face towards each other as if in dialogue.

ELUSIVE OBJECTS

Breton once defined 'objective chance' as a response in the external world to a question we didn't know we had. The objects of Surrealism, included in such notions of the objective, are the most elusive, for in some sense they have yet to be materialized. Their potentiality is magnified by the surrounding aura that Surrealism confers upon unlikely convergences.

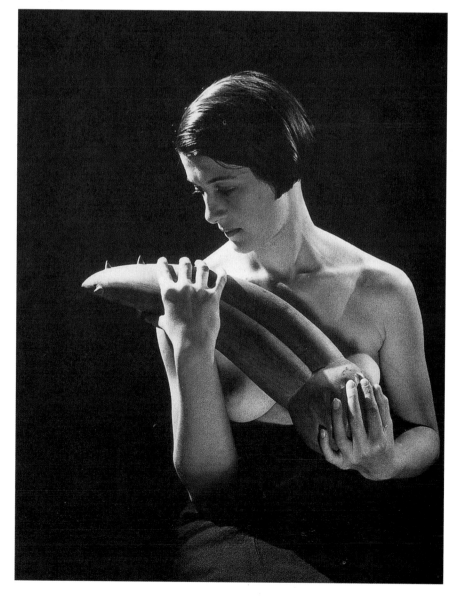

MAN RAY
Model with Alberto Giacometti's *Objet désagréable*
1930-31
Uncropped gelatin silver print from Man Ray archive
Collection, Musée national d'art moderne, Centre Georges Pompidou, Paris

Several versions of what he titled 'disagreeable objects' were conceived by Giacometti according to the procedure he used in the making of *La Boule suspendue*, described opposite. While the suspended ball is held within the fixtures of its surrounding structure, the disagreeable objects are free-standing. They might be encountered on a table or picked up and held, as in this photograph by Man Ray. The photographer has chosen to emphasize a phallic, totemic quality in the object, which the model is cradling at a diagonal angle, as if it were substituting for an infant or a small creature. If it were seen resting on a surface, however, a horizontal axis, connected with Georges Bataille's notion of 'base' matter, would be emphasized, as discussed by Rosalind Krauss ('No More Play', 1984). The object also has different features according to which side is viewed. On one side of the unpointed end, two indentations in the rounded form resemble eyes in a face, reversing the tendency to see the tusk-like point of the object as its 'top' and suggesting instead a 'tail'. Its small thorny spikes disrupt its otherwise smooth form. Designed to be manipulated, positioned and interpreted in a number of ways, it is disagreeable most of all to the fixity traditionally associated with sculpture.

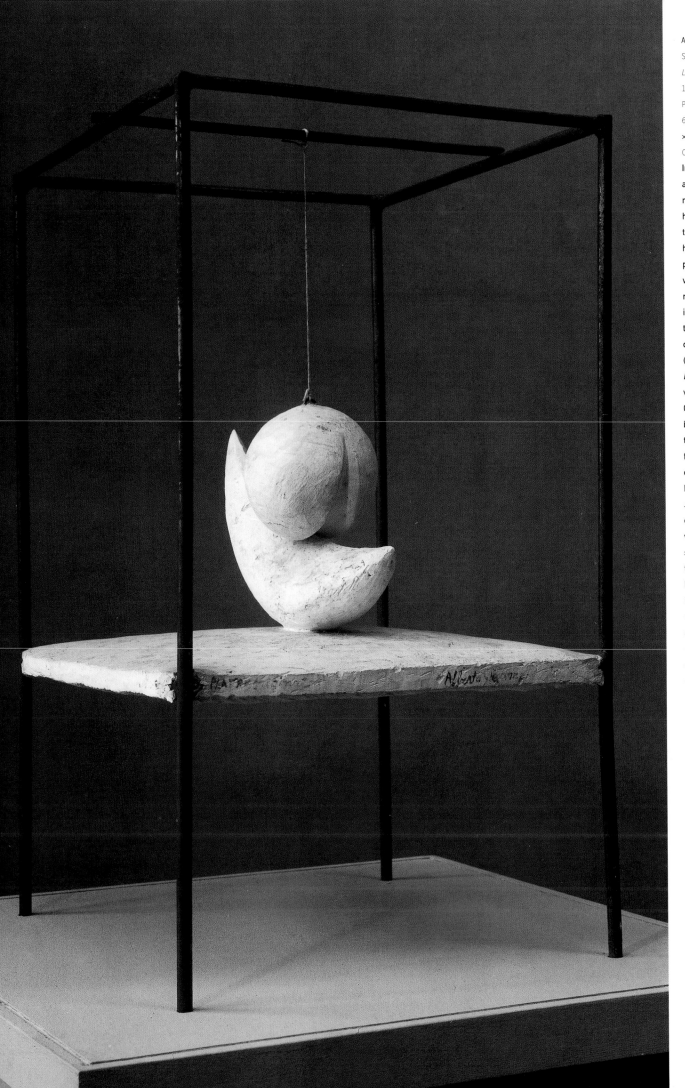

Alberto <u>GIACOMETTI</u>
Suspended Ball
La Boule suspendue
1930-31
Plaster and metal
61 × 37 × 35.5 cm [24 × 14.5
× 14 in]
Collection, Kunstmuseum, Basel

In the early 1930s Giacometti followed
a procedure something like this: he
recalled objects and structures which
had come to his mind; they 'presented
themselves' to him 'fully accomplished';
he sketched them and made rough
plaster versions of them; finally a version
would be made in wood by a cabinet
maker, so that it would retain its
independence from any manipulation by
the artist's hand, 'like a projection' of the
original unconsciously formed idea.
(Interview, 1959, quoted in William Rubin,
Dada and Surrealist Art, 1968.) A wooden
version of this object was shown at the
Galerie Pierre Loeb, Paris, in 1930 and
bought by Breton, who invited Giacometti
to join the group. The Surrealists were
fascinated by the indefinable sense of
eroticism it conveyed, elucidated by
Rosalind Krauss (*Passages in Modern
Sculpture*, 1978): the sense of union
endlessly delayed due to the short wire
which prevents the two enigmatic
shapes from ever meeting; the sugges-
tion of many different bodily forms, each
hovering between male and female
identity; the way the possibility of actual
movement locates the object in the here
and now, while its individual space,
due to its cage-like support, opens up
a discontinuity in the surrounding space
of the real.

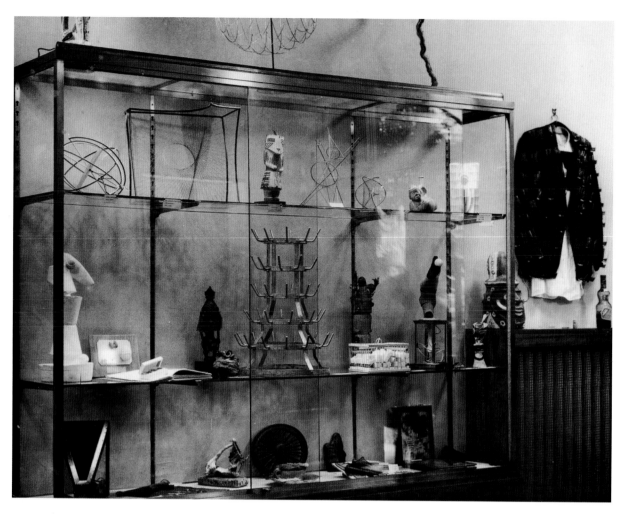

View of 'L'Exposition Surréaliste d'Objets', Galerie Charles Ratton,
Paris, 22-29 May, 1936
Photograph by Man Ray
Gelatin silver print
22 × 30 cm [9 × 12 in]
Collection, Musée national d'art moderne, Centre Georges Pompidou,
Paris

The 1936 'Exposition Surréaliste d'Objets', presented in the Paris gallery, house and
garden of Charles Ratton, the dealer in non-western art, was the first major show
devoted to surrealist objects. Although a number had appeared earlier and been
included in shows such as the one at Galerie Pierre Colle in 1933, this was the year
when theoretically and actually the object became the focus of interest. The catalogue
lists 'natural objects' (animal, vegetable and mineral); 'interpreted natural objects';
'incorporated natural objects'; 'perturbed objects' (such as a melted wine glass found
after a volcanic eruption); 'found objects'; 'interpreted found objects'; 'American
objects (such as Eskimo masks, Hopi dolls, Peruvian pots); 'Oceanic objects';
'mathematical objects', such as the stringed constructions on the top shelf of the
vitrine shown above; a readymade (Duchamp's *Bottle Rack* seen on the middle shelf
of the vitrine); an 'assisted' readymade (*Why Not Sneeze, Rose Sélavy?*, also on the
middle shelf, and shown on the opposite page); and finally a looser category of
'surrealist objects', which ranged from small sculptural objects by Giacometti and
Ernst, such as Ernst's figure on the far left of the middle shelf (*Habakuk*, 1934, shown
large on page 4) to the diverse assemblages of Breton, Cahun, Dalí, Domínguez,
Hugo, Miró and others. 'This diversity underlines the role that the object in its widest
sense took in erasing aesthetic hierarchies and encouraging a radical mixture of
western and non-western cultures. Distinctions between utilitarian and ritual, found
and made, collective and individual are blurred. Like Dada, Surrealism embraced the
anti-art aspect of the object, but went on to uncover its potential both to crystallize and
to perturb "the real".'
– Dawn Adès, *Surrealism: Desire Unbound*, 2001

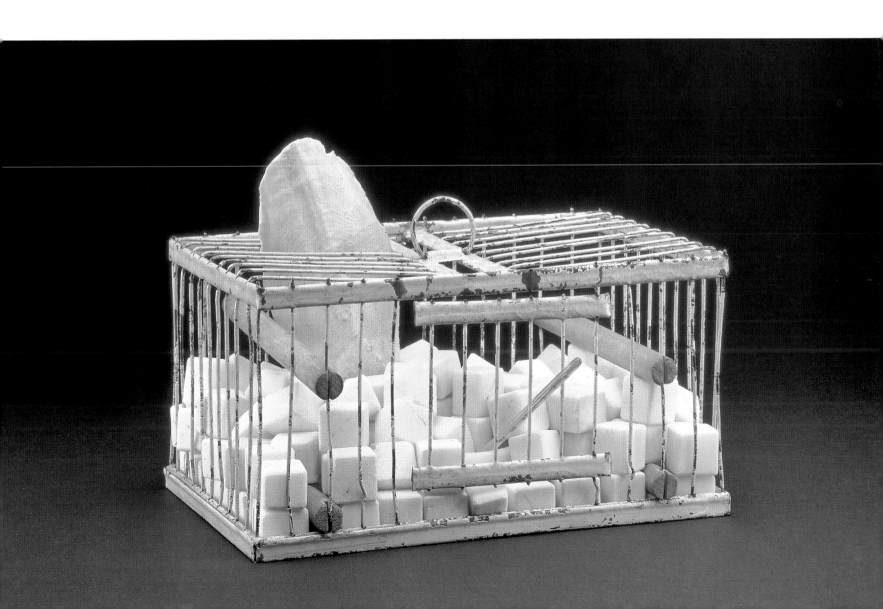

Marcel <u>DUCHAMP</u>

Why Not Sneeze Rose Sélavy

1921

Painted bird cage containing 152 white marble 'sugar' cubes, 4 wooden
perches, thermometer, cuttlefish bone; title affixed to base, with each
word placed on a separate line

12.5 × 22 × 16.5 cm [5 × 9 × 6.5 in]

Collection, Philadelphia Museum of Art

This 'assisted readymade' by Duchamp – a close collaborator but not an official
member of the group – was considered to have a close affinity with surrealist objects.
In 1936 it was included in the Exposition Surréaliste d'Objets at Galerie Charles
Ratton, Paris, and later that year was loaned for 'Fantastic Art, Dada and Surrealism'
at The Museum of Modern Art, New York. In 1920 Duchamp had devised the name
Rose Sélavy to represent an alter ego. During 1921 he added an extra 'r' to make
a phonetic pun on 'eros c'est la vie': love/desire is life. In 1963 he commented that
'the answer to the question "Why not sneeze?" is simply that you can't sneeze at will'.
Such indications have been interpreted by most critics to suggest that the implied
state of anticipation can be compared to the conditions of desire. Scholars have
discussed possible connections between the elements in the work and Duchamp's
notes for the 'Large Glass': *The Bride Stripped Bare by Her Bachelors, Even* (1915–23).
Confining himself to noting the coldness of the marble, Duchamp went on to say that
'all the associations are permissible'.

– Marcel Duchamp, French television interview, 1963, cited in Arturo Schwarz,
The Complete Works of Marcel Duchamp, 1969

BILLET D'AUTOBUS ROULÉ " SYMÉTRIQUEMENT ", FORME TRÈS RARE D'AUTOMATISME MORPHOLOGIQUE AVEC GERMES ÉVIDENTS DE STÉRÉOTYPIE.

NUMÉRO D'AUTOBUS ROULÉ, TROUVÉ DANS LA POCHE DE VESTON D'UN BUREAUCRATE MOYEN (CRÉDIT LYONNAIS) ; CARACTÉRISTIQUES LES PLUS FRÉQUENTES DE " MODERN'STYLE ".

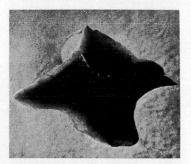

LE PAIN ORNEMENTAL ET MODERN'STYLE ÉCHAPPE A LA STÉRÉOTYPIE MOLLE.

MORCEAU DE SAVON PRÉSENTANT DES FORMES AUTOMATIQUES MODERN'STYLE TROUVÉ DANS UN LAVABO.

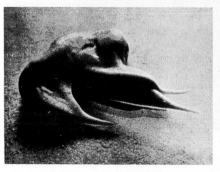

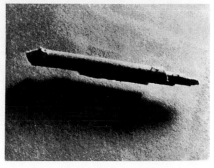

LE HASARD MORPHOLOGIQUE DU DENTIFRICE RÉPANDU N'ÉCHAPPE PAS A LA STÉRÉOTYPIE FINE ET ORNEMENTALE.

ENROULEMENT ÉLÉMENTAIRE OBTENU CHEZ UN " DÉBILE MENTAL "

SCULPTURES INVOLONTAIRES

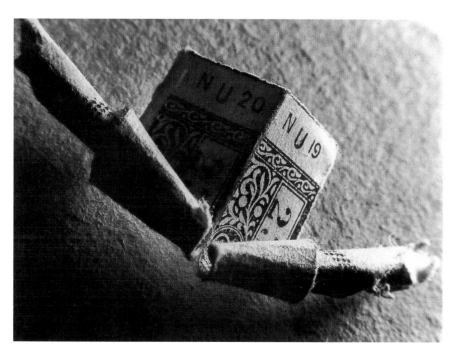

<u>BRASSAÏ</u>

Involuntary Sculptures
Sculptures involontaires
1933
Published with texts by Salvador
Dalí in *Minotaure*, 3-4, December
1933
below, Gelatin silver print from
the series ['Rolled-up bus
ticket', 1932]
Collection, Brassaï Archives,
on deposit, Musée national d'art
moderne, Centre Georges Pompidou,
Paris

These photographs by Brassaï with titles by Dalí appeared in *Minotaure*, 3–4 (December 1933). They include a torn and rolled bus ticket, a piece of ornamental bread roll, a used sliver of soap and a blob of toothpaste, all dramatically lit and enlarged in the prints. The idea of 'involuntary' sculpture suggests objects which have simply arisen or been found, and which are thus unpremeditated, in contrast to conventional sculpture which arises from the skilled manipulation of 'sculptural' material such as wood, stone or metal. Yet these lowly, castaway objects have also been shaped by the hand and therefore the imagination, even if unconsciously, may play some part in their forms and significance. Dalí's interest in the irrational aspects of the concrete world is reflected in the dramatized but documentary style of the photography. As Brassaï later recalled: 'People thought my photographs were "surrealist" because they showed a ghostly, unreal Paris, shrouded in fog and darkness. And yet the surrealism of my pictures was only reality made more eerie by my way of seeing.'
– Brassaï, Interview with France Bequette, *Culture et Communication*, 27, May 1980

BRASSAÏ

Photographs of the Paris Metro

1933

Published in *Minotaure*, 3-4, December 1933, to illustrate Salvador
Dalí's article '*De la beauté terrifiante et comestible de
l'architecture Modern style*'

Gelatin silver prints

Collection, Brassaï Archives, on deposit, Musée national d'art
moderne, Centre Georges Pompidou, Paris

left to right, from top: 'As opposed to the functionalist ideal here
is the symbolic-psychic-materialist function'; 'This is another
atavism in metal from the Angelus of Millet'; 'Eat me!'; 'Me too';
'Have you seen the entrance to the Paris Metro?'

Brassaï's photographs accompanying Dalí's '*De la beauté terrifiante et comestible de l'architecture Modern style*' ('On the terrifying and edible beauty of Modern style architecture') immediately follow the involuntary sculptures in the same issue of *Minotaure*. They show close-up details of the wrought ironwork in the art nouveau architect Hector Guimard's entrances to the Paris Metro. Other photographs by Man Ray focused on details of Antoni Gaudí's buildings in Barcelona. For Dalí the dramatic curves of the art nouveau decorative style conveyed simultaneously erotic and agitating, disturbing qualities. Here the photographs evoke Dalí's personal symbols of terror and voracious consumption. The image at top right resembles an insect such as a locust or praying mantis, the latter associated with the eating of her partner after mating. In his title, Dalí relates it, through his 'paranoid-critical method', to Millet's well-known painting, *L'Angélus* (see page 150). The image at lower left, captioned 'Eat me!', suggests an edible object, similar perhaps to the moulded and twisted morsel of bread among the 'involuntary sculptures'.

Jean ARP

Disagreeable Objects on a Face

Objets désagréables sur une figure

1930

Plaster

37 × 29.5 × 19 cm [14.5 × 11.5 × 7.5 in]

Collection, Kunstmuseum, Silkeborg, Denmark

In the years 1929–30, Arp began to turn from making painted wooden reliefs to his earlier practice of making works in the round. Like Giacometti, at first he described these as objects, not sculptures. One of the first of these to appear, this work shares the interest in ambiguous forms that characterized the earlier reliefs. Here, however, instead of a plane surface facing towards the viewer, who might interpret the shapes in different ways but always by taking in the whole composition visually at once, this three-dimensional object involves apprehending it as such: a movable object that can be situated in the world, in real space. It cannot satisfactorily be taken in by one glance but must be circled around to view its changing aspects. Furthermore, the parts can be picked up and rearranged. This work was shown in 1933 at Galerie Pierre Colle, Paris, the first significant exhibition to include a number of surrealist objects. In the catalogue the disagreeable (or 'annoying') objects were identified as a mandolin, a moustache and a fly.

Yves <u>TANGUY</u>

The Certitude of the Never Seen
La Certitude du jamais vu
1933
Oil on board in carved, free standing wood and gesso frame, with five carved objects in wood, one with fine hair
22 × 26 × 7 cm [8.5 × 10 × 3 in]
Collection, The Art Institute of Chicago

This is one of several rare works in which Tanguy combined a painting with three-dimensional objects and a specially shaped frame which becomes part of the work. With its ledge on which the small objects appear, echoing similar counterparts in the terrain depicted in the painting, the frame, rather than marking a division between pictorial and 'real' space instead extends the former into the latter. As in many of Tanguy's works of the mid 1930s, the objects depicted and sculpted here seem to evoke the rocks and standing stones of the Breton coast where he grew up, even as they are transformed into shapes whose otherworldliness is heightened by the uncertainty of this interchange between real and represented objects. This work was included in 'Exposition surréaliste: Peintures, dessins, sculptures, objets, collages', at Galerie Pierre Colle, Paris, in 1933, possibly under another title. The present title was first used when it was reproduced in *Minotaure* the following year. (Jennifer Mundy, 'Tanguy, Titles and Mediums', *Art History*, 6, June 1983.)

Pablo <u>PICASSO</u>

Woman in a Red Armchair
Femme au fauteuil rouge
1932
Oil on canvas
130 × 97 cm [51.5 × 38 in]
Collection, Musée Picasso, Paris

Against the black background and stately red of the chair, a fragmentary image of a female body is depicted as individually moulded sculptural forms. This is an example of the close relation between sculpture and painting in Picasso's work of the early 1930s. Elizabeth Cowling likens its solid forms to the remains of prehistoric creatures, and its gloomy setting and ghostly lighting to the gallery of palaeontology in the Musée national d'histoire naturelle, Paris, where such remains would have been seen by the artist. (Elizabeth Cowling, *Picasso: Style and Meaning*, 2002.) She suggests another possible source for the forms, more directly drawn from surrealist art. A few weeks before Picasso completed this painting at the end of January 1932, Giacometti's *La Boule suspendue* was reproduced in *Le Surréalisme au service de la révolution* (December 1931). A visual analogy can be drawn between the figurative elements, including spheres and crescents, apparent in both works. Suggesting that Picasso 'consciously positioned himself between the realist art of the past and the Surrealism of the younger generation', Cowling also draws attention to the way the image recalls the Spanish tradition of vanitas painting.

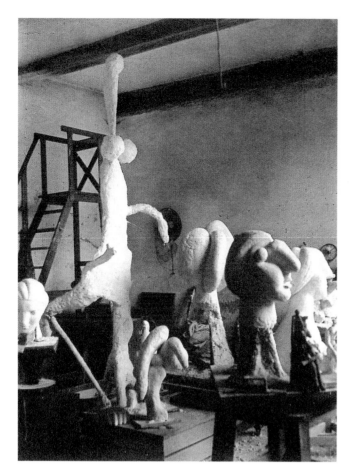

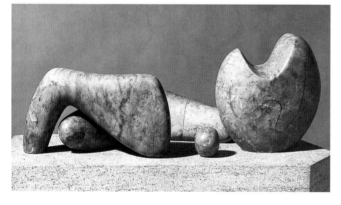

Henry MOORE
Four Piece Composition: Reclining Figure
1934
Cumberland alabaster
l. 51 cm [20 in]
Collection, Tate Gallery, London

Moore's division of a reclining figure into parts recalls surrealist precedents of which
he would have been aware from Paris visits since 1923, such as the floating shapes
resembling body parts in Arp's reliefs; Arp and Giacometti's 'disagreeable objects';
and Picasso's sculptures of the preceding years. To such ideas Moore introduces
a more overt reference to nature – carved in stone, each part resembles a natural
form such as a sea-worn boulder, bone or pebble. The group could be a beach-
comber's arrangement or evoke dramatic rocks and promontories in a landscape.
Also evoking a human figure, each part is singled out in its curved smoothness and
harmonious rapport with the others. Moore described how he moved from a single
static unit to the combination of 'forms of varied sizes, sections and directions into
one organic whole'. Although the stress on unity would soon distance his work from
Surrealism, here the viewer may circle the composition, trying to arrive at a complete
image, but as one angle or perspective supplants another, the imaginative
reconstruction of real forms, spaces and relations is endlessly suspended.

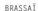

BRASSAÏ
The Large Statue in Picasso's sculpture studio at Boisgeloup
1932
Gelatin silver print
Collection, Brassaï Archives, Paris

This photograph is one of a series taken by Brassaï of Picasso's studio at the Château
de Boisgeloup and published in *Minotaure*, 1 (1933) alongside a text by Breton titled
'Picasso in his Element'. To the right and far left of the photograph are a number
of sculpted heads, modelled on Picasso's lover, Marie-Thérèse Walter, behind which
stands *The Large Statue* (1930). The photographer writes of his first visit to the
Boisgeloup studio in his *Conversations with Picasso* (1999), describing how Picasso
opened the door of the studio onto 'the dazzling whiteness of an entire people of
sculptures'. The sculptural works in the photograph were influenced by prehistoric
fertility goddesses, specifically the Venus of Lespugne, discovered in 1922. Elizabeth
Cowling describes how *The Large Statue* was 'conceived as a giant fertility totem
of prehistoric type', which took on the form of 'a three-metre high plaster sculpture
of a running bather', with the head and breasts doubling into a phallic form.
(*Picasso: Style and Meaning*, 2002.) Picasso's fascination with the swelling forms
of the prehistoric Venus is also evidenced in the heads inspired by Marie-Thérèse,
described by Brassaï as 'barbarian goddesses' (*Conversations with Picasso*, 1999).

F.E. MCWILLIAM
Eye, Nose and Cheek
1939
Hoptonwood Stone
h. 90 cm [35 in]
Collection, Tate Gallery, London

In the late 1930s McWilliam rejected pure
forms in favour of a surrealist-derived
questioning of the rules of anatomy,
vision and rationalism. This work is from
a series titled collectively *The Complete
Fragment*: 'These carvings are mostly
part or parts of the head, greatly
magnified and complete in themselves.
They concern the play of solid and void,
the solid element being the sculpture
itself while the "missing" part inhabits
the space around the sculpture.' (Letter
to the Tate Gallery, London, June 1963.)
As Michel Remy observes (*Surrealism
in Britain*, 1999), as we try to reconstruct
the missing parts of the face, 'the snag
is that they will always remain missing,
except in our minds. In other words,
mind turns into matter, and the
fragments we are supplied with, an eye,
a nose, a cheek, are situated between
our perception of them and the percep-
tion of what is absent but necessary
to make them mean, to make them
functional as a human face. As happens
with Moore's sculptures, the distinction
between inside and outside, presence
and absence, is abolished, but, far from
creating a lyrical, almost spiritual
revelation, it provokes a devastating
foundering of reason.'

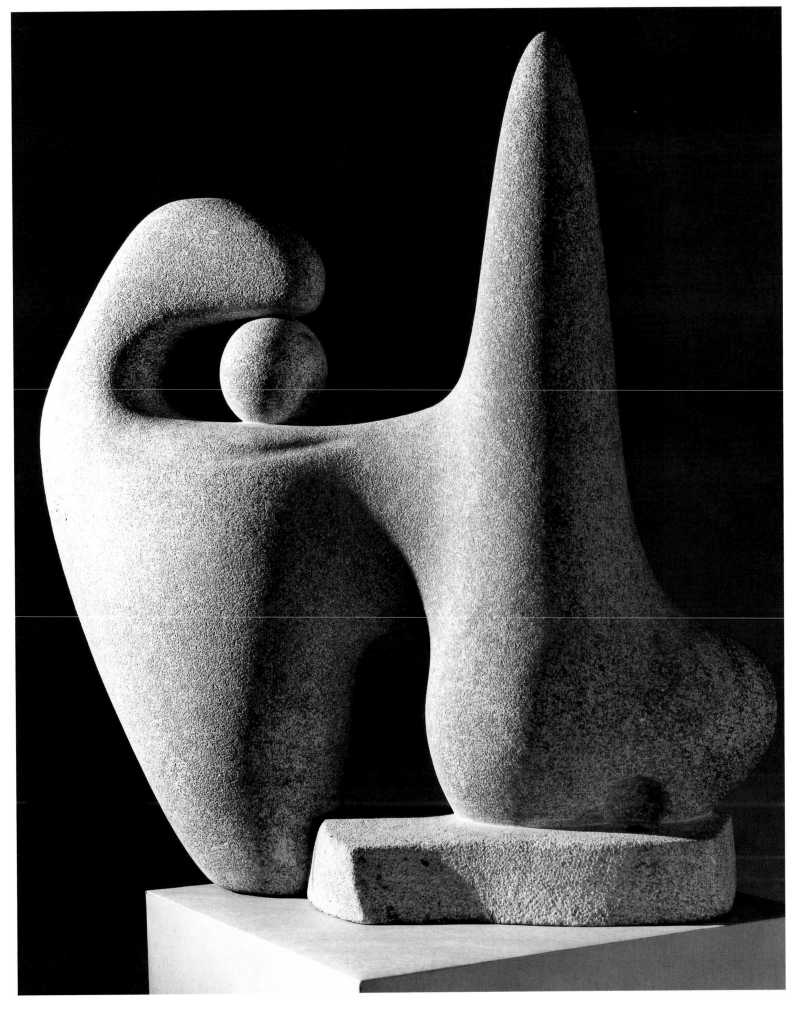

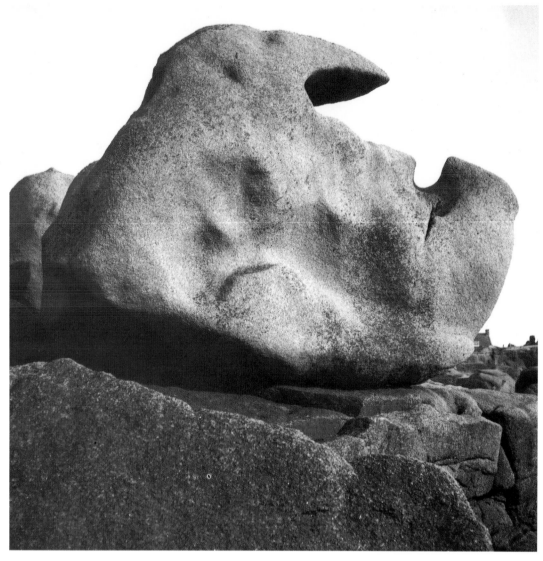

Eileen AGAR
Rocks, Brittany
1936
Gelatin silver print
Estate of Eileen Agar; Tate Gallery Archive, London

Although the photographer Raoul Ubac had made an important series of studies of rocks (*Stones of Dalmatia*, 1932–33), and the Parisian group were interested in Eastern traditions of collecting and contemplating stones, continental European found objects are usually urban in origin, retrieved from junk-shops and flea-markets. English artists such as Agar and Paul Nash, whom she first met in 1935, tended more to discover surreal associations on the beach or the wayside in natural forms such as rocks and pebbles, bones, driftwood, tree-trunks and fungi. When Agar visited Brittany in 1936 she was struck by the marine rock formations at Ploumanach and Perros-Guirec which were locally renowned for their resemblances to giant faces and monstrous beings. While Ubac mainly used dramatic sculptural compositions and lighting, Agar worked economically, using the camera angle and framing of the large central rock to isolate it as a singular, ambiguously featured object of indeterminate scale. This photograph has its own status but was also used as a study for a water-colour painting in which the face-like aspects of the rock are emphasized.

opposite
Lee MILLER
'Cock Rock', Egypt, near Siwa
1939
Gelatin silver print
Lee Miller Archives, Sussex, England

Miller's photographs of the Egyptian landscape are generally unpopulated. As in Agar's image, this creates an uncertain sense of scale: the rocks could be towering above or could be of more human proportions. The informal title 'Cock Rock' refers to the bird-like character of the rock formation in the centre. This suggestion of an image in a landscape form, combined with the mirage-like effects of the play of shadows, recalls Dalí's depiction of soft forms derived from the extraordinary rocks at Cadaqués. In her Egyptian series, Miller moved away from the darkroom mani-pulations of her earlier work to the creation of images that Jane Livingstone has described as 'fundamentally transparent, descriptive, strangely uneventful', relying on a 'relatively simple yet crucial framing decision' (*Lee Miller*, 1989).

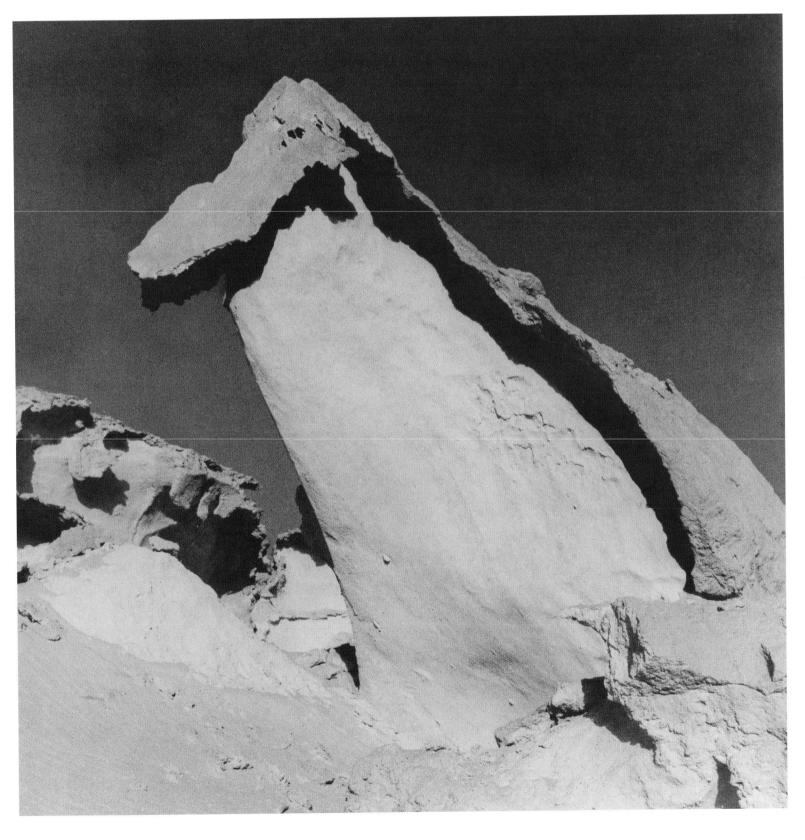

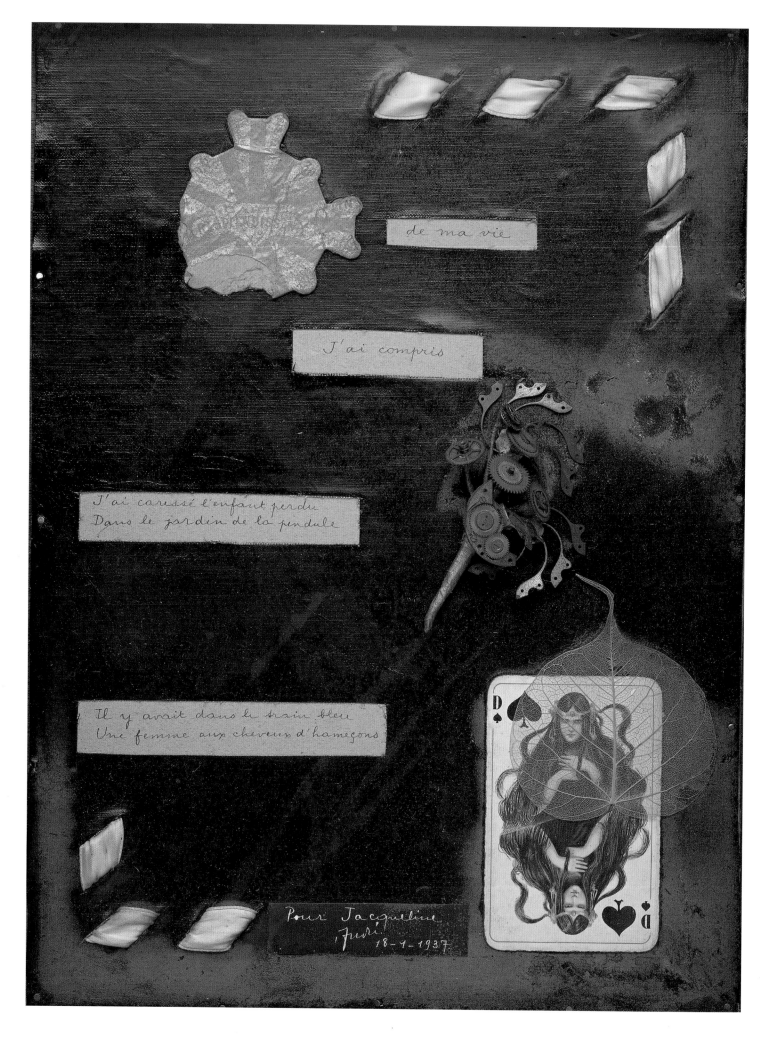

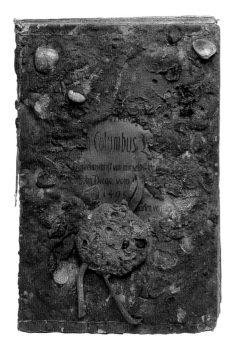

Léonor FINI
Cover of a book which has dwelled in the sea
Couverture d'un livre ayant séjourné dans la mer
1936
Object
Private collection

Fini's object is an old leather book cover encrusted with shells, seemingly mineralized by a submarine existence. The text on the cover is in German, but the only fully visible word is the name Columbus, with the date 1499. The name implies marine voyage and discovery, the date suggesting that the book may have lain undersea for centuries. During her stay on the island of Giglio off the coast of Tuscany in 1943, Fini collected debris washed up on the shore: objects which had found their way back to land, having undergone an unseen transformation under the sea. Fini was fascinated by decay – seen elsewhere in her work in imagery of bones and ossification – and the metamorphoses natural processes effect over time. This work has affinities with Eileen Agar's *Marine Object* (1939), the main body of which is a found Greek amphora. It also recalls some of Joseph Cornell's works, with its romantic connotations of voyage and adventure.

opposite
André BRETON
Untitled [poem-object, for Jacqueline]
1937
Collage; oilcloth on card, with woven ribbon, leaf, tarot card, metal mechanism, die-cut card, ink; in shallow box [not shown]
39.5 × 30.5 cm [15.5 × 12 in]
Collection, The Art Institute of Chicago

In the early 1930s Breton began to make works which integrate objects and poetry. This example was reproduced untitled in *Minotaure*, 10 (Winter 1937). It was dedicated to Jacqueline Lamba, who becomes Ondine, the object of his 'mad love' in the novel *L'Amour fou* of the same year. Dawn Adès has described how it conveys the idea that meeting Lamba was the result of a fated, occult prediction (*Surrealist Art: The Bergman Collection*, 1997). The Parisian night, suggested by the black ground, is magically lit with flashes of white silk ribbon. The '*Carte resplendissante*' may have come from a fairground fortune teller. The leaf skeleton covers like a veil the upper half of a Queen of Spades card. Her long, trailing hair is echoed in the line '*Une femme aux cheveux d'hameçons*' – a woman whose 'fish hook' hair has drawn him to her. *Le train bleu* was the luxurious overnight train from Paris to the Côte d'Azur, suggesting embarkation on a long, romantic journey.

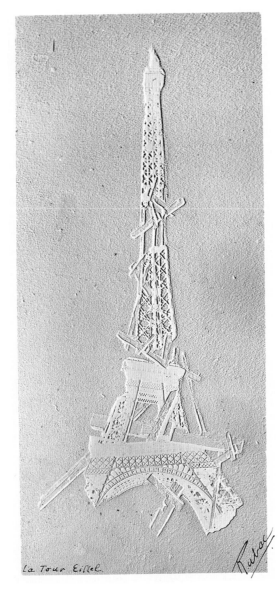

La Tour Eiffel

Raoul UBAC
Fossil of the Eiffel Tower
Fossile de la Tour Eiffel
c. 1938-39
Gelatin silver print
24 × 12.5 cm [61 × 38 in]
Private collection

Ubac explored relationships between objects, photography and perception through various techniques, one of the most radical being 'inversion'. Reviving a process described as a curiosity in early manuals of photography, when making a print he placed the negative and positive of the same subject on top of one another, very slightly out of alignment. The resultant image simultaneously cancels out the usual illusionistic attributes of photography and adds a new, counter-intuitive effect of three-dimensional relief, turning the subject into an object that seems imprinted or embedded in a surface textured like stone or sand. Three of the fossil-like images Ubac thus constructed from fragments of views of monumental Paris buildings – the Eiffel Tower, the Bourse and the Opéra – were reproduced in *Minotaure*, 12–13, May 1939, to accompany Benjamin Péret's text '*Ruines: ruines des ruines*'.

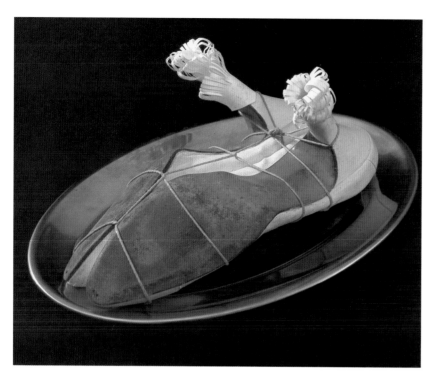

Meret OPPENHEIM

My Nurse

Ma gouvernante/mein Kindermädchen

1936

Metal plate, shoes, string, paper

14 × 21 × 33 cm [5.5 × 8 × 13 in]

Replica of the original made by the artist, 1967

Collection, Moderna Museet, Stockholm

A pair of elegant, pure white leather high-heeled shoes are upturned, presenting their worn and soiled soles. Tightly trussed up together with string they are arranged on a serving dish like a cooked goose or chicken ready for the table. Several decades after it was made Oppenheim commented: 'it evokes for me the association of thighs squeezed together in pleasure. In fact, almost a "proposition". When I was a little girl, four or five, we had a young nursemaid. She was dressed in white (Sunday best?). Maybe she was in love, maybe that's why she exuded a sensual atmosphere of which I was unconsciously aware.' (Interview with Henri-Alexis Baatsch, 1982.) Interpreting this object in the light of Oppenheim's strong awareness of patriarchal discrimination, which led to a period of severe depression and temporary inability to continue making art not long after she completed it, Thomas McEvilley aligns this work with her later object *The Couple* (1956). Here 'two old-fashioned, almost sadistic-looking, women's shoes are joined at the tip. Among other implications is the suggestion that women are not supposed to move …' (*Meret Oppenheim: Beyond the Teacup*, 1996.)

Salvador DALÍ

Scatological Object Functioning Symbolically

Objet scatologique à fonctionnement symbolique

1931

Assemblage of found and fabricated objects

48 × 28 × 14 cm [19 × 11 × 5.5 in]

Original destroyed; re-edition, 1974

Private collection

This object was reproduced in *Le Surréalisme au service de la Révolution*, 3 (December 1931), where Dalí gave the following description in his short text on surrealist objects: 'A woman's shoe inside which has been placed a cup of luke-warm milk in the middle of paste of ductile form and excremental colour. The mechanism consists of lowering a piece of sugar, on which has been painted the image of a shoe, in order to observe its dissolution – and consequently the image of the shoe – in the milk. Many accessories (pubic hairs glued to a sugar cube, a small erotic photo) complete the object, which is accompanied by a reserve box of sugar and a special spoon to stir the lead pellets inside the shoe.' He divided surrealist objects into different categories and in the first, 'Symbolically functioning object (automatic origin)', he placed 'shoe and glass of milk' in a lineage which begins with Giacometti's *La Boule suspendue* (1930–31) but moves away from its residues of sculptural form. For Dalí, 'symbolically functioning objects leave no room for formal preoccupations. They depend only on the amorous imagination of each person and are extra-plastic'.

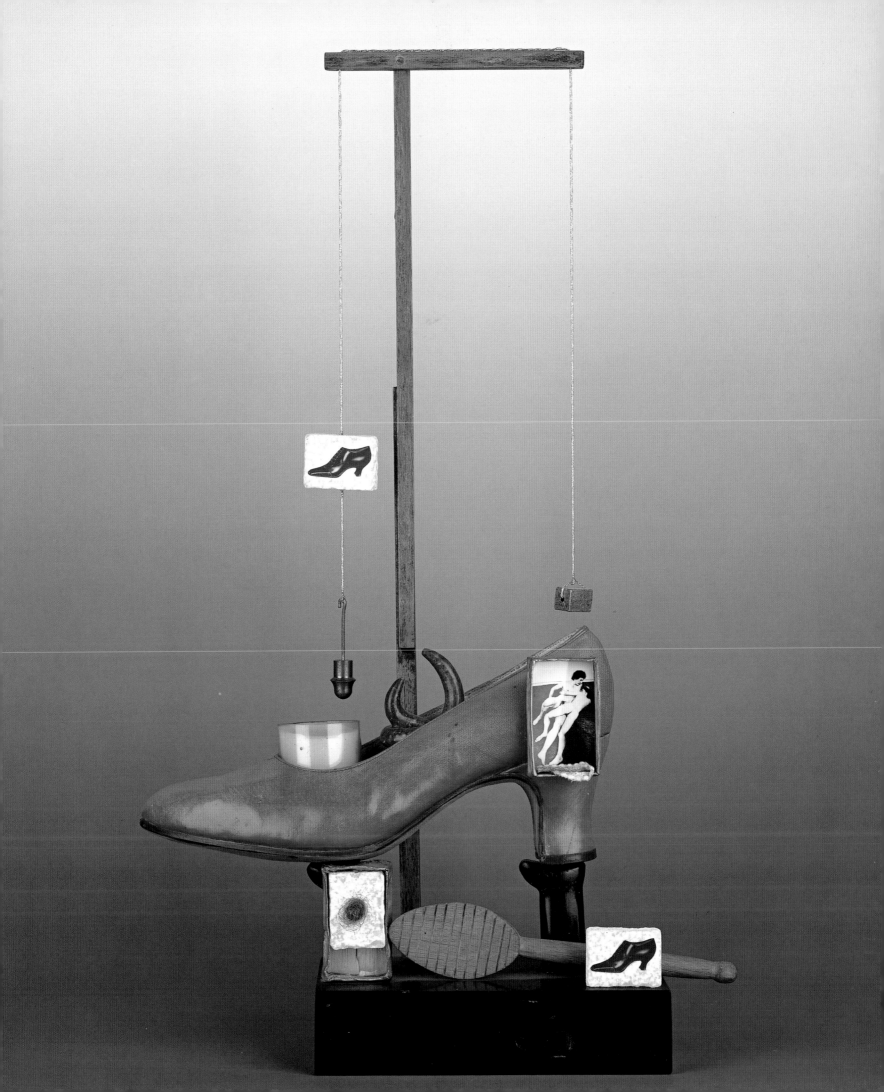

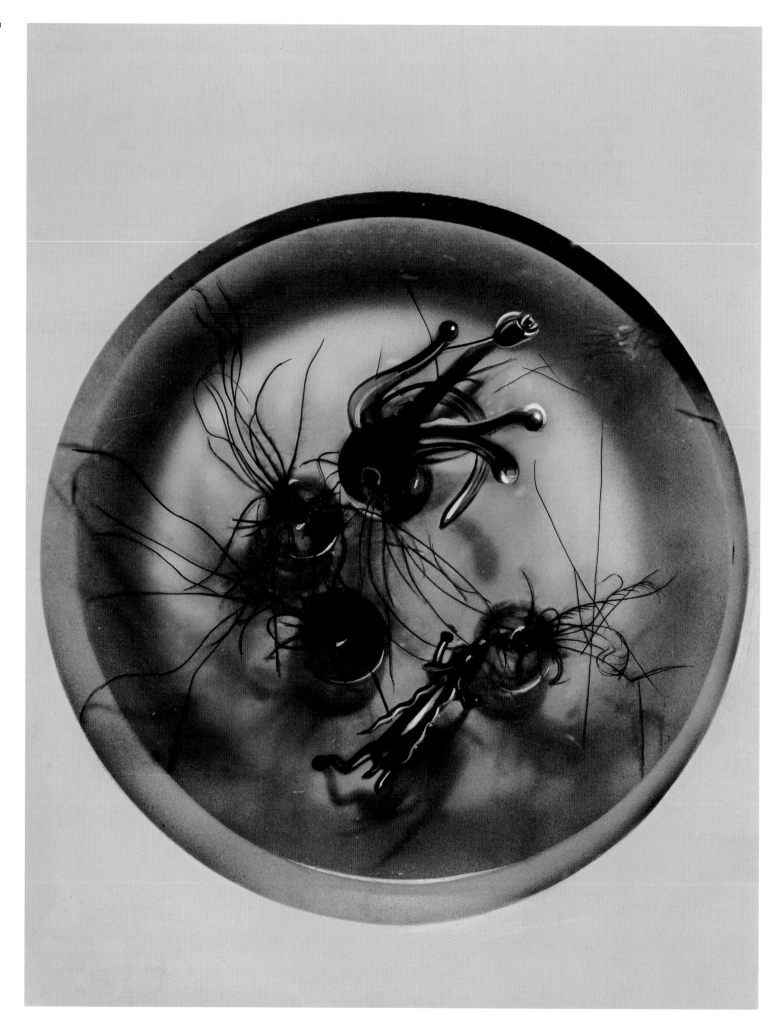

Claude <u>CAHUN</u> and Marcel <u>MOORE</u> [Suzanne Malherbe]
Cotton Grass
Linaigrettes
1936
Vintage gelatin silver print and mixed media
24 × 18 cm [9.5 × 7 in]
Original artwork for an illustration in *Le Coeur de pic* by Lise
Deharme, Éditions José Corti, Paris, 1937
Private collection

This photograph was one of 22 made to illustrate a book by Lise Deharme titled *Le Coeur de pic* (*The Pick-Axe Heart*), published in 1937 with a preface by Paul Éluard. Cahun's images depict small objects, such as dolls, flowers, playing cards, cloth, and tiny dolls' hands, arranged in visually poetic ensembles. *Le Coeur de pic* has been described as 'a book of children's stories that gives a dreamy, tortured vision of childhood, packed with melancholy'. (Juan Vincenti Aliaga, *Claude Cahun*, 2001.) In François Leperlier's monograph on Cahun, this photograph is reproduced in its original format along with annotations and ink markings around the edge of the circular object. In the original photograph the identity of the large round object is more obviously that of an enamel basin filled with water. (*Claude Cahun: L'Écart et la métamorphose*, 1992.) Leperlier records how Cahun sometimes called on the assistance of another photographer for the final print process. The annotations on the original photograph indicate that Cahun gave directions for the image to be cropped along the sketchy lines she has drawn onto the image: 'print with circular masking in order to hide the edge of the basin, and as large as the format permits.' This manipulation of the image, combined with retouching by hand, has the effect of making the objects' identity, already ambiguous, more indecipherable.

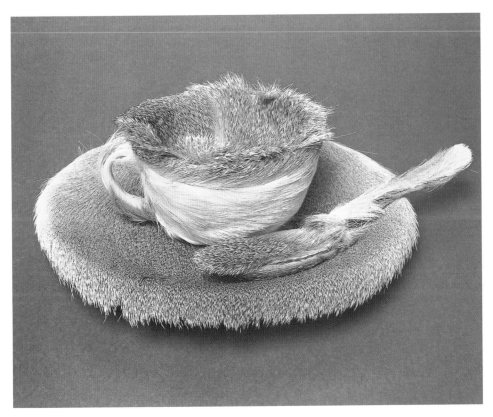

Meret <u>OPPENHEIM</u>
Object (Breakfast in Fur)
Objet (Déjeuner en fourrure)
1936
Fur-covered cup, saucer and spoon
cup, 11 cm [4.5 in], saucer, 24 cm [9.5 in], spoon, 20 cm [8 in]
Collection, The Museum of Modern Art, New York

Shortly after it was made, this object was exhibited and acquired by Alfred H. Barr for The Museum of Modern Art, New York, soon becoming one of the icons of Surrealism. However the identity, diverse work and even gender of its maker were largely ignored. Without deprecating the work but drawing attention to the irony of its fate, like Duchamp's readymades, once it entered the art institution, Oppenheim often recounted its story: 'In 1936, sitting at the Café Flore one day with her friends Dora Maar and Pablo Picasso, she happened to be wearing one of the bracelets she had been making for Schiaparelli out of lengths of fur-lined, polished metal tubing. Talking and joking about the bracelet, Picasso quipped that one could actually cover anything with fur, to which Meret replied, "Even this cup and saucer …" Shortly afterwards, when André Breton invited her to contribute to the exhibition of surrealist objects at the Galerie Charles Ratton, she recalled the conversation and, without further ado, bought a large cup and saucer with spoon at the Parisian department store, Uniprix, and lined the three objects with the fur of a Chinese gazelle. It was André Breton who then named the work *Déjeuner en fourrure*, a title with echoes of Manet's *Déjeuner sur l'herbe* and the book *Venus im Pelz* (*Venus in Furs*) by Sacher-Masoch.'
– Bice Curiger, from conversation with the artist, in *Meret Oppenheim: Defiance in the Face of Freedom*, 1989

René MAGRITTE

The Imp of the Perverse

Le Démon de la perversité

1927

Oil on canvas

81 × 116 cm [32 × 46 in]

Collection, Royal Museums of Fine Art of Belgium, Brussels

This work is the culmination of a series of smaller paintings of 1927 which depict
a dark biomorphic object through which suggestively organic holes have been cut
to reveal, in part, the grainy texture of wooden boards. Although several of the works
from this series reveal a blue sky through their holes, *The Imp of the Perverse* is far
darker in tone and more dense in structure, leading David Sylvester to refer to it as a
'nocturnal' work: 'The uncanny feeling this ominous presence over the dark water
gives and the density of its reality make it one of the most mysterious – and one of the
most mysteriously mysterious – of all Magritte's images.' (*Magritte: The Silence of the
World*, 1992.) According to Sylvester, the form of the image is 'a highly oblique and
schematic transposition' of the Symbolist artist Arnold Böcklin's influential painting,
The Island of the Dead (1880). The title of the work is taken from a short essay by
Edgar Allan Poe, a writer often quoted by Magritte, which discusses the notion of the
perverse as an irresistible, primitive impulse that drives us to act outside the dictates
of reason, often against our instincts of self-preservation.

Paul NOUGÉ

From the series *Subversion des Images*

1929-30

5 from the series of 19 photographs published in *Subversion des
Images*, Éditions Les Lèvres nues, Brussels, 1968

Clockwise, from top, The Juggler; Woman Frightened by a Knot
of String; The Birth of the Object; Coat Suspended in the Void;
The Drinkers

These photographs come from a group of nineteen which Nougé made between
December 1929 and February 1930. They did not become widely known outside of his
immediate circle of Belgian surrealists until 1968 when they were published by Marcel
Mariën in the book *Subversion des Images* (*Subversion of Images*), with Nougé's
accompanying text, which is a form of surrealist critical theory. In everyday interiors,
reminiscent of Magritte's settings, his collaborators enact scenarios suggested in
his text, which goes on to examine the propositions and questions provoked by the
images. For example, a series of different reactions by viewers to 'Woman frightened
by a knot of string' are considered: 'A. We sympathise with this person; we substitute
ourselves for her; the string becomes terrible; we are plunged into terror.

'B. We sympathise just enough to acknowledge the terror but without really feeling
it; discomfort; an equivocal feeling; curiosity. Why this terror? So string is a terrible
thing? Inventions. Poetry. How to make string an object of terror? Excitation.
Discoveries. Changes of perspective, etc.

'C. Sympathy nil. We don't admit the feeling of terror. Ridicule. Comic. Indifference
… So, taking all precautions in order that the spectacle presented cannot be
discussed, is refused; what precautions to take so as not to discourage the goodwill,
the sympathy of the spectator?

'In this spectacle one must safeguard the maximum of familiar elements,
presenting an everyday image which doesn't convey any more than the strictly
necessary subversions. Photo 1 allows us to push the research further. Effectively,
to what proposition, what order of facts does one connect the 'woman terrorized by
a string', this exceptional effect provoked by a familiar object? …'

– Paul Nougé, *Subversion des Images*, 1968

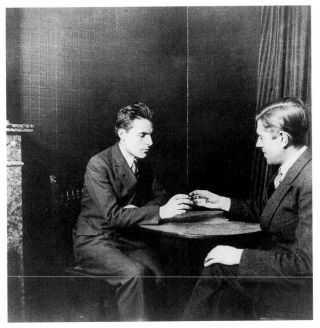
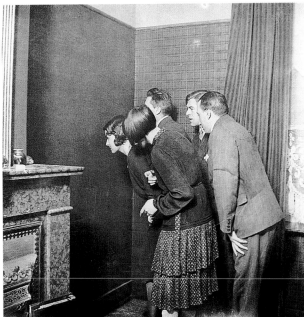

MAN RAY
Indestructible Object
Objet indestructible
1923
Metronome with photograph of eye
1966 re-edition
23.5 × 11 × 11 cm [9.5 × 4.5 × 4.5 in]
Private collection

This object was conceived in a Dada spirit and later acquired a more surrealist inflection. In 1922–23 Man Ray made the first version, calling it *Object to be Destroyed* (*Objet à détruire*). 'I had a metronome in my place which I set going when I painted … its ticking noise regulated the frequency and number of my brushstrokes. The faster it went, the faster I painted; and if the metronome stopped then I knew I had painted too long, I was repeating myself, my painting was no good and I would destroy it. A painter needs an audience, so I also clipped a photo of an eye to the metronome's swinging arm to create the illusion of being watched as I painted. One day I did not accept the metronome's verdict, the silence was unbearable and since I had called it, with a certain premonition, *Object to be Destroyed*, I smashed it to pieces.' (Man Ray quoted in Arturo Schwarz, *Man Ray*, 1977.) In response to exhibition requests he remade it in 1933, the year after his photographic collaborator and lover Lee Miller left him, using a photo of her eye. He then retitled it *Indestructible Object*. In *This Quarter*, 1 (September 1932) next to a working sketch he wrote: 'Cut out the eye from a photograph of one who has been loved but is seen no more. Attach the eye to the pendulum of the metronome and regulate the weight to suit the tempo desired. Keep doing to the limit of endurance. With a hammer well-aimed, try to destroy the whole at a single blow.'

Marcel JEAN
The Spectre of the Gardenia
Le Spectre du gardénia
1936
Plaster, wool flakes, zips, celluloid film and suede on wood
1972 re-edition
34.5 × 18 × 23 cm [13.5 × 7 × 9 in]
Private collection

A reel of film wrapped around the neck of this surrealist transformation of the classical sculpted head lends it an enigmatic suggestion of narrative, as if the ghostly celluloid images carry a message that might answer the riddle of the work's meaning. The reel contains images taken by Louis Chavance featuring the artist and muse/lover of Picasso, Dora Maar (Mary Ann Caws, *Dora Maar: With or Without Picasso*, 2000). Characteristic of the surrealist themes of living statues and sightless vision, the eyes are closed, while the zips add an element of participation, suggesting the eyes can be opened. The slightly sadistic overtones prefigure the treatment of some of the shop mannequins by various members of the group in their display for the *Exposition Internationale du Surréalisme*, Paris, in 1938.

Salvador <u>DALÍ</u>
Venus de Milo with Drawers
Vénus de Milo aux tiroirs
1936
Painted bronze, fur
1964 re-edition
98 × 32.5 × 34 cm [38.5 × 13 × 13.5 in]
Private collection

Venus appears in a number of Dalí's works, echoing the classical personification of love in various ways connected with the effects of desire on perception, both visual and tactile. He collaborated on this sculpture with Duchamp and it develops several of Duchamp's ideas. It plays on the notion of the readymade, since reproductions of the famous Venus de Milo had become mass-produced artefacts and the statue has furthermore been transformed into an everyday utilitarian object, as a chest of drawers. It also invokes Duchamp's ideas for 'reverse readymades', such as using a Rembrandt painting as an ironing-board. As with the marble cubes in Duchamp's *Why Not Sneeze Rose Sélavy* (1921), Dalí intended the same surprise when the small sculpture was picked up: it is painted to look like plaster but cast in bronze. The fur adds a contrasting tactile dimension and invites fetishistic associations. Dalí's writings on objects at this time include 'Aerodynamic Apparitions and Being-Objects', *Minotaure*, 6 (1935) and 'Tribute to the Object', *Cahiers d'Art*, II, 12 (1936).

Jean ARP
Torso
1931
Marble
h. 36 cm [14 in]
Private collection

This was among the first of Arp's sculptures of the early 1930s to be based on an identifiably human figure. A version of *Torso* was also made in plaster and another in dark patinated bronze. Some of Arp's bronzes were later polished by art dealers, giving them a resemblance to the finish of works by Brancusi which he had not wanted, preferring an 'earthy concreteness'. (Margherita Andreotti, *The Early Sculpture of Jean Arp*, 1989.) Although he admired Brancusi, rather than wishing to arrive at a singular, essential form, he emphasized analogies which connect one form with others in nature – the kinds of 'correspondence' which fascinated Breton's group and some of Bataille's circle such as Roger Caillois. The shaping of the smooth, curvaceous surfaces confers on this object an intense eroticism, a quality which Arp admired in Rodin's series of sculptures based on classical torso-fragments. This carefully lit photograph emphasizes how Arp departs from Rodin's humanism, evoking an amorphous, 'cosmic' erotic energy. A year after this work was made he became a founder-member of the more formalist *Abstraction-Création* group. However, he continued to be allied with the Surrealists throughout the 1930s, participating in the exhibitions at Galerie Pierre Colle (1933), Galerie Charles Ratton (1936), and the Exposition Internationale du Surréalisme in Paris (1938).

MAN RAY
Mathematical Object
Objet mathématique
1934-36
Gelatin silver print
24 × 30 cm [9.5 × 12 in]
Collection, Musée national d'art moderne, Centre Georges Pompidou, Paris

In 1936 the director of *Cahiers d'Art*, Christian Zervos, commissioned Man Ray to photograph the dusty 'mathematical objects' at the Institut Henri Poincaré in Paris, which Ernst had drawn to his attention. Some of the photographs appeared in *Cahiers d'Art* alongside an essay on mathematics and abstract art by Zervos. The objects had evolved from the co-ordinate geometry developed by Descartes and others in the seventeenth century. This allows points in a plane to be represented by an algebraic list of numbers. Using co-ordinates, mathematicians can consider the set of solutions to an algebraic equation as a geometric form. In the eighteenth century these became more complex: surfaces suspended in three-dimensional space. By the end of the nineteenth century models of these surfaces were widely used in teaching, at a time when Euclidian geometry was being abandoned and supplanted by the non-Euclidian theories which fascinated Duchamp and others, with their interest in the possibility of a fourth dimension. Models based on both systems existed side by side. The Surrealists were attracted to the contradictory quality of these mysterious forms which derived from rational principles.

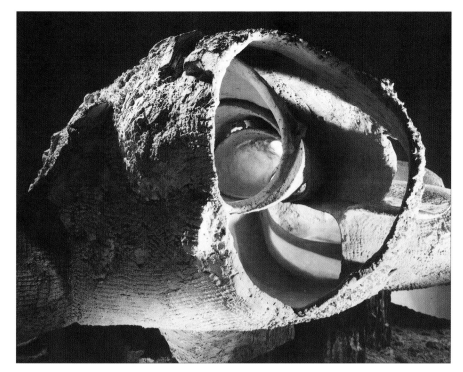

Frederick <u>KIESLER</u>
Model for the Endless House
1959
Wire mesh, cement, Plexiglas
96.5 × 247 × 107 cm [38 × 97 × 65.5 in]
Collection, Whitney Museum of American Art, New York

Kiesler's first, single, egg-shaped model and drawings for the *Endless House* were exhibited alongside work by five other architects and artists in 'The Muralist and the Modern Architect', organized by the sculptor David Hare at Kootz Gallery, New York, in 1950. By 1959 this had become a complex articulation of three interconnected cave-like spaces. From 1937–42 he had experimented with optical 'vision machines' which explored the shared surrealist and psychoanalytical notions that 'vision is not a separate faculty but deformed and determined by total experience which, in turn, sees not a real object but rather an invented or symbolic image … The subsequent development of the space of the *Endless House* would then be an attempt to house this subject in a container where outside and inside were endlessly ambiguous … where the topology of the house space was of parallel construction to the subject's own experiential vision. Here Kiesler takes direct issue with Le Corbusier's idea of the house as a machine for living.' (Anthony Vidler, 'Rethinking Kiesler', *Frederick Kiesler: Endless Space*, 2001.) As Kiesler wrote in his *Manifesto of Correalism* (1949): 'The house is a living organism … the skin of the human body … Form does not follow function. Function follows vision. Vision follows reality.'

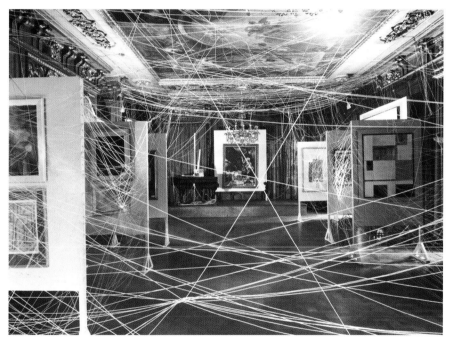

Marcel <u>DUCHAMP</u>
'Mile of string' exhibition installation, 'First Papers of Surrealism', New York, 1942
Photograph by John Schiff

'First Papers of Surrealism', the first show of the exiled Surrealists in New York, organized by the Co-ordinating Council of French Relief Societies, was held at the Reid Mansion, 451 Madison Avenue, from 14 October to 7 November 1942. Breton invited Duchamp to design the installation, as he had for the 1938 international exhibition in Paris. With scant resources, Duchamp obtained what he recalled as 16 miles of thin white string. Only a fraction of this was finally used, and the anecdotal title 'mile of string' is believed to be approximately accurate. The web- or maze-like effect he devised (strung collaboratively, with Breton, Ernst, Jacqueline Lamba and others) occupied and delineated the space between the gilded mouldings of the old-fashioned interior and the paintings exhibited on free-standing screens. In his detailed analysis of this work Lewis Kachur (*Displaying the Marvellous*, 2001) notes that although in places the string prevented closeness to some of the paintings, it did not block vision: 'It is as if Duchamp wished to split the bodily experience of the spectator from the optical one'. The 'twine rigging', as it was also called, was reproduced upside-down in Breton and David Hare's surrealist journal *VVV* in March 1943 so that the ceiling becomes the floor, further emphasizing its disorientation of the relations between vision and objects in space.

DESIRE

A constant longing for the eroticism of encounters motivates much surrealist work: the unaccustomed meeting of images is intended to provoke an enduring excitement, which transpires against rationality to enable its powerful effect. Everything about *l'amour fou*, the obsessive, frenzied love emulated by the Surrealists, haunts the reader of the texts and images as well as the lovers: the desire spreads from each to the other. The event, the place and the feeling are entirely beyond the bounds of normal living. These encounters reveal new domains of vision, indicated through reflections, shadows, reversals, doublings; in Breton's phrase, the 'systematic derangement' of the senses.

MAN RAY

Return to Reason

Retour à la raison

1923/34

Gelatin silver print

Collection, Musée national d'art moderne, Centre Georges Pompidou, Paris

This image was reproduced in the first issue of *La Révolution surréaliste* (December 1924) alongside an account of a dream by Breton. Although unrelated to the text, it suggests an erotic, dream-like atmosphere. The photograph is a still from Man Ray's film *Retour à la raison* (*Return to Reason*, 1923), depicting stripes of shadow crossing the body of his favourite model of the time, Kiki de Montparnasse, who stands before a net-curtained window. 'The sense is both natural, like an animal – tiger-striped – and cultural, since the reflection reveals a constructed object. The woman is made animal by the imposition of the photographer's design.' (Mary Ann Caws, *The Surrealist Look: An Erotics of Encounter*, 1997.) The image later appeared in Man Ray's album of photographs, *The Age of Light* (1934). A similar device was repeated in a series of photographs of Lee Miller standing in front of a curtained window, taken between 1929 and 1931. The film was an early imagistic exploration of automatism and the unconscious. It had no pre-written scenario, prompting Man Ray to describe it as 'automatic cinema' ('*Tous les films que j'ai réalisés*', 1965). Ironically, it signals 'a return to unreason' in its substitution of unrelated images for narrative structure and poetry for logic. (Arturo Schwarz, *Man Ray*, 1977.)

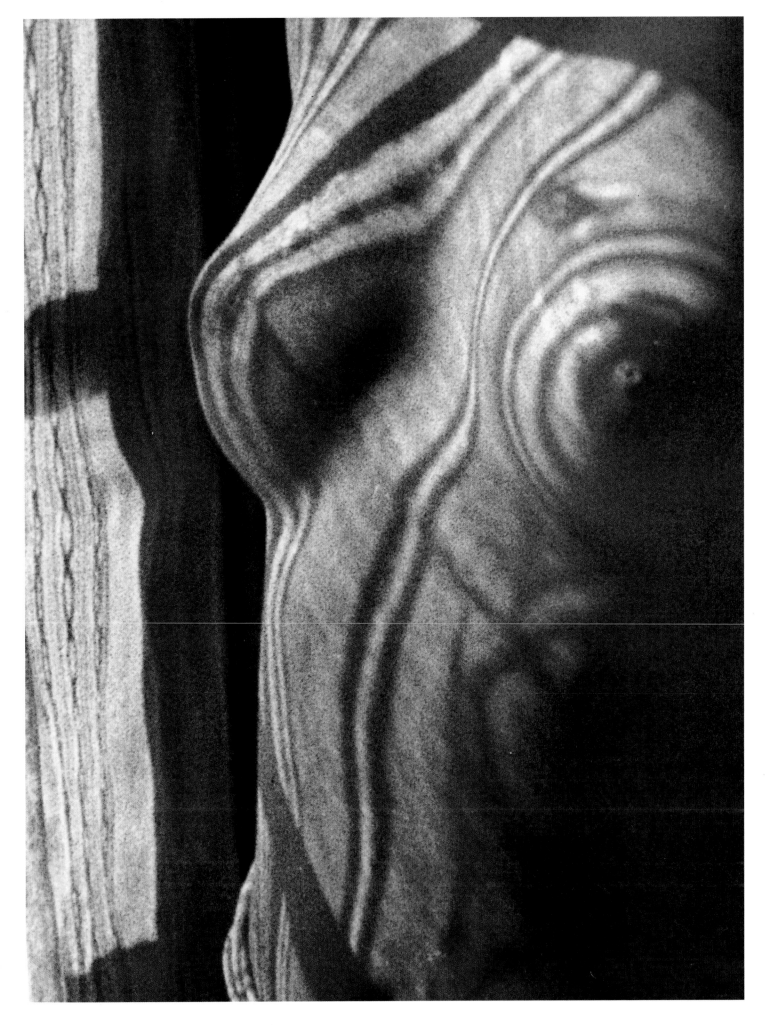

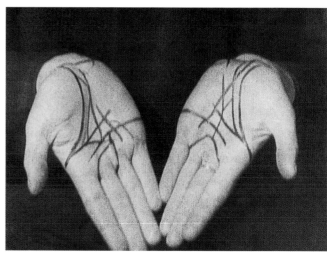

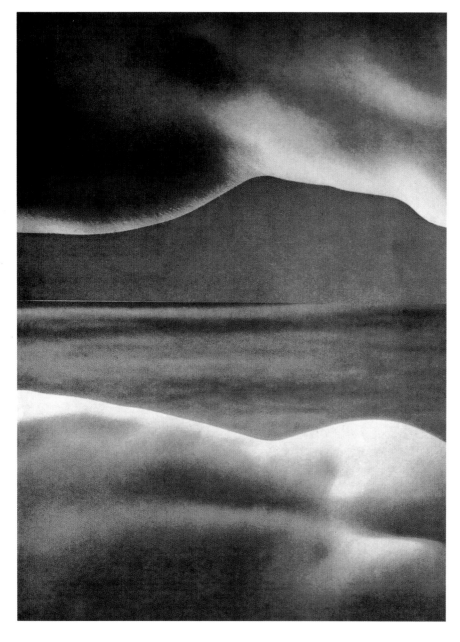

BRASSAÏ
False Sky
Ciel postiche
1934
Photograph published in
Minotaure, 6, Winter 1934-35

In this image, reproduced in *Minotaure*, 6 (Winter 1934–35), two photographs of the front and back of a woman's torso are superimposed over a view of the point where sky and sea meet on the horizon. Together, the bodies have a bilateral symmetry which suggests a mirror reversal. The curvilinear shape of the upper torso creates an outline like that of hills, echoed in the outline of the lower torso, which seems to form the contour of the shore. The shadowed undulations of the bodies and the effect of cropping by the frame render the female form unfamiliar; both bodies create a double image which is the effect of an optical illusion. Through the play of shadow the upper body takes on the form of a dramatic sky, and the brightly lit edge of hip and breast dissolves into an impression of rays from the rising or setting sun. If rotated through 180 degrees, the photograph creates a similar illusion. Negative and positive, space and substance, foreground and background alternate in a game of shifting perception. *Postiche*, in the French title, is a term often used to describe something added which 'falsifies' an image or composition.

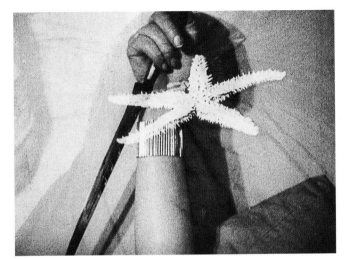

Robert <u>DESNOS</u> and <u>MAN RAY</u>
Étoile de mer
Sea Star
1928
Photograms from film, 15 min., black and white

This film was developed from a poetic text by Robert Desnos, who appears in the last scene. The other actors are Man Ray's model, Kiki, and a neighbour of Desnos, André de la Rivière. Man Ray saw the text as analogous to a film scenario and constructed from it a dream-like narrative. It was written, Desnos recalled, under the haunting influence of a starfish he bought in a second-hand shop in Paris, which seemed to him 'the very embodiment of a lost love' (Arturo Schwarz, *Man Ray*, 1977). The starfish first appears in the film as a marvellous object and develops into a dream-like motif which, according to Schwarz, symbolizes a 'primitive sexual force'. The film was innovative in technique, using titles which do not comment on the given scene but enhance the poetic effect of the film through juxtaposition.

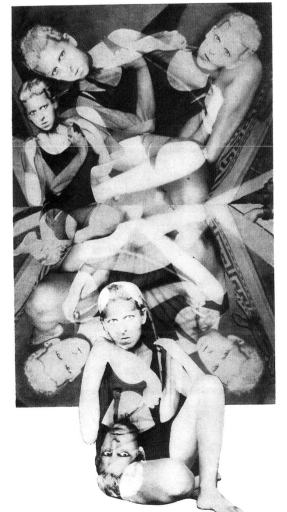

Claude <u>CAHUN</u> and Marcel <u>MOORE</u> [Suzanne Malherbe]
Untitled [plate IX, *Aveux non avenus*]
1929-30
Photomontage
Éditions du Carrefour, Paris

Aveux non avenus, roughly translated as 'Unavowed Confessions', is Cahun's autobiography of a highly protean self which emerges visually in the accompanying photomontages by Marcel Moore (her partner Suzanne Malherbe). A graphic artist, Moore included many images from Cahun's photographs to illustrate her text, which comprises a heterogeneous mixture of dreams, letters, poems, dialogues, polemic and fable. François Leperlier draws attention to the work's 'poetic of the metamorphosis of self' through the 'theatricalization of genders (male/female/androgynous) and the *mise-en-scène* of identities (I/the other).' (*Claude Cahun*, IVAM, Valencia, 2001.) This image shows the artist posing in a bathing suit, her transparent body revolving kaleidoscopically in a multitude of repetitions. Her cropped blond hair gives her a boyish look, one of many androgynous personae in this series. Cahun's accompanying text recalls a dream: 'I was on the shore of a beach at high tide. The waves in the dream did not want to have anything to do with me and they threw me, broken, onto the reefs of life. I shall remain standing on the dune, rigid with the wish to fall down, but dazzled by the whiteness of a night of foam and sand.'

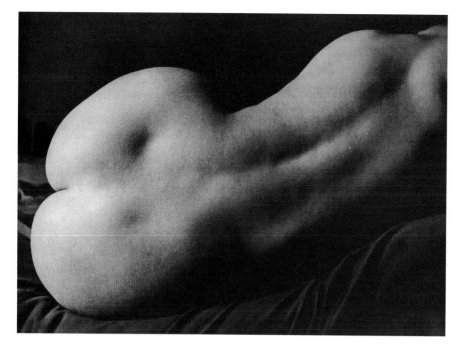

BRASSAÏ
Nude
1931-32
Gelatin silver print
Private collection

Three similar images from this series, shown in a vertical sequence on a single page, illustrated an article by Maurice Raynal titled '*Variété du corps humain*' ('Variety of the Human Body'), in the first issue of *Minotaure* (1933). Also illustrated are nineteenth-century studio photographs of nude models and two nude drawings, one by Seurat, the other by Renoir. Brassaï's cropped, headless bodies contrast starkly with the academic compositions; Raynal compares the former's vitality with the moribund state of the latter. He refers to the modern nude as a 'deformation' of the academic, arguing for the liberation of artistic treatments of the body from the strictures of a 'pre-ordained architecture'. Instead, artists should enable the body's 'instinctive omnipotence' to allow its own potential for transformation to emerge. Brassaï's group of photographs has been interpreted as an example of the Surrealists' fetishization of the female body, enacting a collapse of sexual difference. Through pose, cropping and lighting the female torso takes on a phallic form, thereby creating an image 'in which the female body and the male organ have each become the sign for the other'. (Rosalind Krauss, 'Corpus Delicti', *L'Amour fou: Photography and Surrealism*, 1986.)

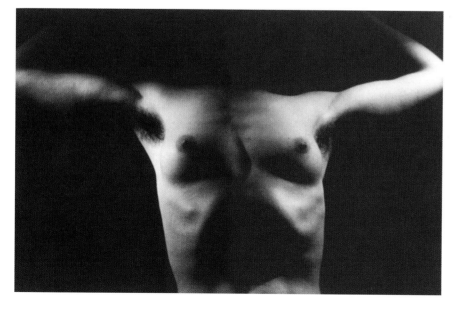

MAN RAY
Untitled
1934
Gelatin silver print
Collection, Musée national d'art moderne, Centre Georges Pompidou, Paris

This image was published on the opening page of *Minotaure*, 7 (1935). Depicting an androgynous torso which, through cropping and dramatic lighting, takes on the appearance of a bull's head, it can be related to certain theoretical preoccupations in Surrealism in the 1930s. The image reflects the move away from automatism towards the notion of the concrete irrational, as demonstrated by Dalí through his paranoid-critical method, which was based on a form of hallucinatory perception. It can also be read through Breton's category of the 'veiled erotic', expounded in what would be the preface to *L'Amour fou* (1937), first published in *Minotaure*, 5 (1934). One of three categories of 'convulsive beauty', Rosalind Krauss has discussed how it invokes the occurrence in nature of representation, as one creature imitates another (*L'Amour fou: Photography and Surrealism*, 1986). For the Surrealists, the mythological figure of the Minotaur became emblematic of the transgression of rules and limitations.

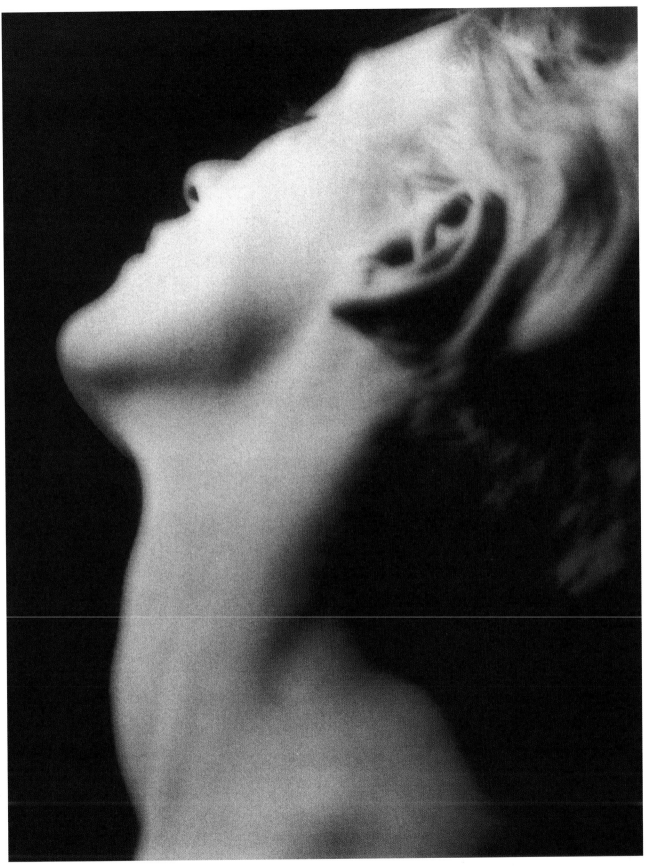

MAN RAY

Lee Miller

c. 1930

Gelatin silver print

23 × 18 cm [9 × 7 in]

Lee Miller Archives, Sussex, England

This photograph depicts the head and neck of model and photographer, Lee Miller. The head is isolated through the framing and the use of lighting which sharply defines the profile against the black background, at the same time blurring any delineation of the rear of the head, neck and shoulders. This gives the figure an androgynous appearance and renders the features unfamiliar, producing the effect of an abnormally elongated neck. The light on the surfaces creates a fluid effect, while conversely the starkness of the profile suggests taught, muscular rigidity. What may at first appear as an erotic and sensual image may, after longer observation, take on a grotesque and distorted form.

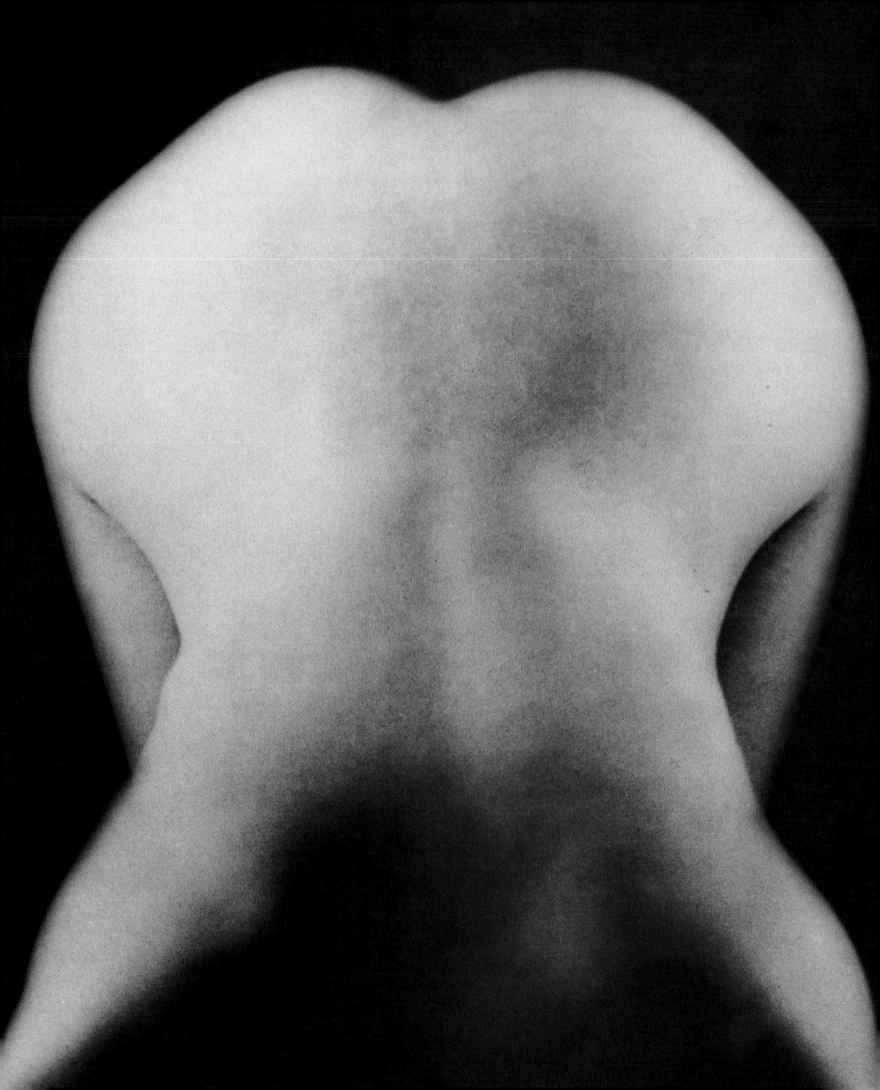

Lee <u>MILLER</u>

Nude bent forward

c. 1931

Gelatin silver print

Lee Miller Archives, Sussex, England

A female body is here inverted so that instead of the head appearing as the uppermost part, the curvature of hips and buttocks take its place. The form is recognizably human yet unfamiliar. This effect was produced by cropping the image at the point of the shoulder blades so as to eradicate the extension of the neck and head, thereby creating from the distinctly female curves an implicitly phallic form. The bright lighting conspires in this effect, blurring the receding angles of the body so that it seems to occupy a single vertical plane. The black background starkly outlines the curvilinear form, and the dark shadow across the shoulders has the disquieting effect of making the body appear gradually to be dissolving. In 1929, following three years of collaboration with Man Ray as his assistant in Paris, Miller moved back to New York where this image was produced. Although the photograph was not published in the surrealist context of *Minotaure*, it developed from similar interests in transforming the nude as those apparent in the work of Man Ray and Brassaï.

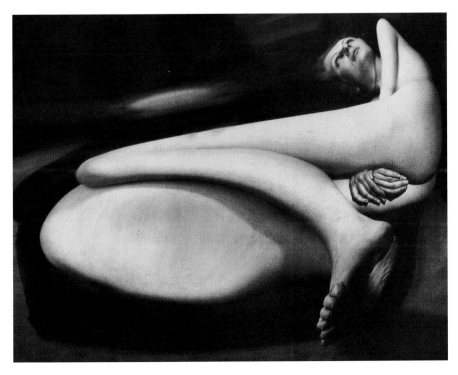

André <u>KERTÉSZ</u>

Distortion, No. 40

1933

Gelatin silver print

18 × 23 cm [7 × 9 in]

Collection, J. Paul Getty Museum, Los Angeles

In 1933 Kertész accepted a commission from a humour magazine, *Le Sourire* (*The Smile*), to photograph a female nude reflected in distorting mirrors from an amusement arcade. Earlier he had made several portraits using such mirrors and had a lifelong fascination with such optical effects. At first he used two mirrors and collaborated with two models, Nadia Kasine and Najinskaya Verackhatz. After several shoots he continued only with Verackhatz, using one mirror, extending the series to two hundred images. *Le Sourire* published twelve, alongside an article by A.P. Barancy: '*Fenêtre ouverte sur l'au-delà*' ('Open Window on the Beyond') in March 1933. In September Kertész succeeded in placing some of the images in the more serious context of *Arts et métiers graphiques*. (Pierre Borhan, *André Kertész*, 1994.) Although independent, he was close to Man Ray's circle and was admired by the Surrealists. The *Distortions* coincide with their interest in anamorphic images (such as the famous distorted skull which appears in the foreground of Holbein's painting *The Ambassadors*, 1533) and the disorientation of the viewer, cast loose from familiar reference points. The series was not published in book form until 1976.

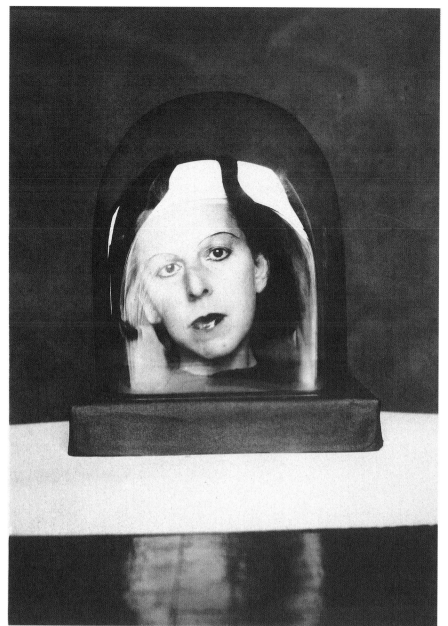

Claude <u>CAHUN</u>
Untitled Self-portrait
c. 1925
Gelatin silver print
10 × 7.5 cm [4 × 3 in]
Collection, IVAM, Centro Julio Gonzalez, Valencia

This self-portrait is one of a series of three photographs which depict Cahun's head, isolated from the rest of her body, in what at first glance might seem to be a mirror reflection before it is perceived, apparently, to be trapped within a glass bell jar. As if part of a macabre illusionist's trick the artist has concealed the rest of her figure, which otherwise in Cahun's self-portraits is displayed in countless guises. The stark lighting and cropping prefigure the manipulations of the female body performed by Man Ray and Brassaï, in particular a photograph attributed to the collaboration of Man Ray and Lee Miller, which also depicts a woman's head inside a bell jar (*Homage to D.A.F. de Sade*, 1930, published in *Le Surréalisme au service de la révolution*, 2, 1930). In 1925 Cahun published several stories from *Heroines*, which in total consisted of thirteen tales of women, historical, fictional, and mythical. One such tale was that of Salomé, who demanded the head of John the Baptist on a platter, and whose story Cahun would have been familiar with through Oscar Wilde's notorious play. In Cahun's tale, at the sight of the severed head, Salomé cries: 'Why did I ask for that? That head is still uglier now it is cut off; it looks worse than in the theatre.' It could be that Cahun has cast her isolated head as the victim of Salomé in what would be another of the artist's many inversions of gendered roles.

Maurice <u>TABARD</u>
Untitled
c. 1928
Gelatin silver print
Private collection

The woman in this photograph at first appears to be standing before a window. Half of her face is in shadow, following the line of the apparent window frame, so that she occupies a space between light filtering through and a cast shadow. The lower part of her figure and the window-like form are bleached out by light. The superimposed image of her face, at least double size, rotated almost upside down, confers solidity on her body, as if it composed a mirror or screen for her own reflection. The silhouette of a face in profile, perhaps her own, appears at the foot of the image, looking upwards and to the right. Vague, insubstantial forms suggest something else floating, out of place, in the background. Also a fashion, advertising and portrait photographer, during the 1920s Tabard associated with Man Ray and Magritte, experimenting with solarization and double exposure to produce many complex images such as this one. 'The birth of the image in the developer is always a discovery, a surprise. At this moment ideas gel, analogies gather and suggest the *find* (*la trouvaille*) of a superimposition.'
– Maurice Tabard, statement, 1930, in *Maurice Tabard*, 1987

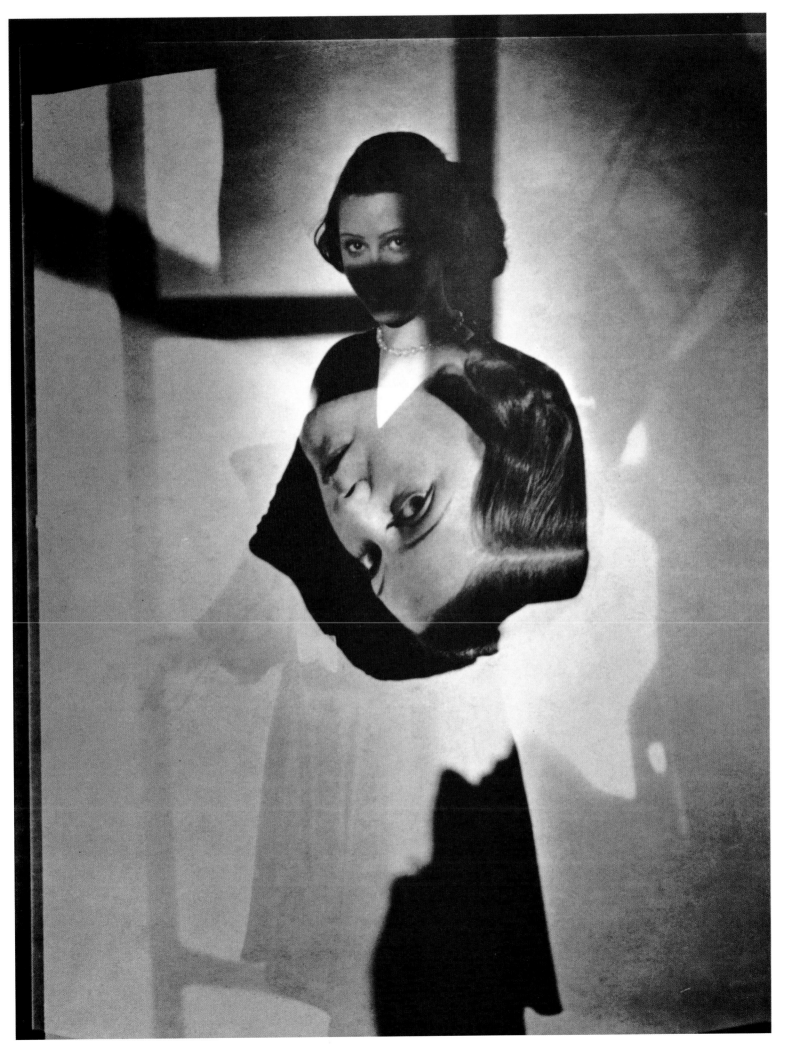

below

Georges HUGNET

Parce que, from *La Septième Face du dé*

c. 1933-36

Collage-poem

32.5 × 25 cm [13 × 10 in]

Private collection

Published in *La Septième Face du dé* [*The Seventh Face of the Dice*], limited edition book of poems and collages with cover designed by Marcel Duchamp; quarto, black and white photo collages, several hand-coloured, Éditions Jeanne Bucher, Paris, 1936

This image is typical of a number of Hugnet's photo-collages or what he called '*découpages*', which he often juxtaposed with his similarly conceived poetic texts, as here, made from lines cut out from various found sources such as magazines, newspapers and advertisements. *La Septième Face du dé* was Hugnet's first book of *poème-découpages*. The title echoes the poet Stéphane Mallarmé's *Un coup de dés n'abolira jamais le hasard* (*A Throw of Dice Will Never Abolish Chance*, 1895), the influential poem in which the text is arranged typographically in a way which affects the response of the reader. Unlike Ernst, Hugnet rarely integrates the images in his collages into an appearance of pictorial unity. Rather, as with the texts, new relationships and meanings, usually erotic, are suggested through disjunctive juxtapositions. The magazine sources he used for his images included *Allo Paris* and *Paris Sex-Appeal*. From the left, the poem translates: *1/Because/it's the sun/who is wrong/ 2/Because/A SHOE HEEL/could be compared to/THE YOUNG GIRL WHO DREAMS OF LOVE/oval so pure/liquid/phenomenon/WITH A WAIST/OF TULLE/seem to say these two/shoulders/You resign yourself always to/weeping for a naked man/night on a bench/stir up the fire/of your/DOUBLE/It's the secret of trysts/She lies, today/ but has not entirely disappeared/Then she will scream:/THREE SHINING/nude girls/with pink knees in lace/discover themselves stained with/I am the obvious prey/And life continues*

opposite

MAN RAY and Paul ÉLUARD

Facile

1935

Limited edition book of poems by Paul Éluard with photographs by Man Ray

Small quarto, gravure plates, unbound signatures

Éditions G.L.M. [Guy Levis-Mano], Paris

The imagery and construction of surrealist love poetry is often echoed in a series of corresponding forms played out in the artists' visual creations. A beloved part of the body, or a reminder such as a glove or shoe is singled out; images of the loved one merge, fold, interlace, reflect or double each other, according to the lover's vision. This collaboration between the poet and photographer is celebrated as a unique example of these two forms coming together in a remarkable integration. The subject of the photographs and the poems, Nusch, was already one of Man Ray's most important models. She had married Éluard the previous year. Man Ray uses a series of techniques and effects such as superimposition and solarization, combining the images with Éluard's poems on the page in such a way that they seem to embrace.

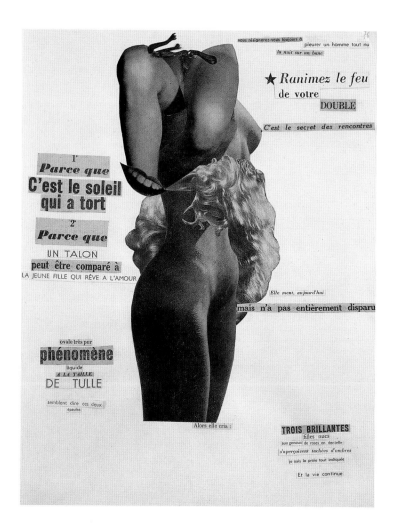

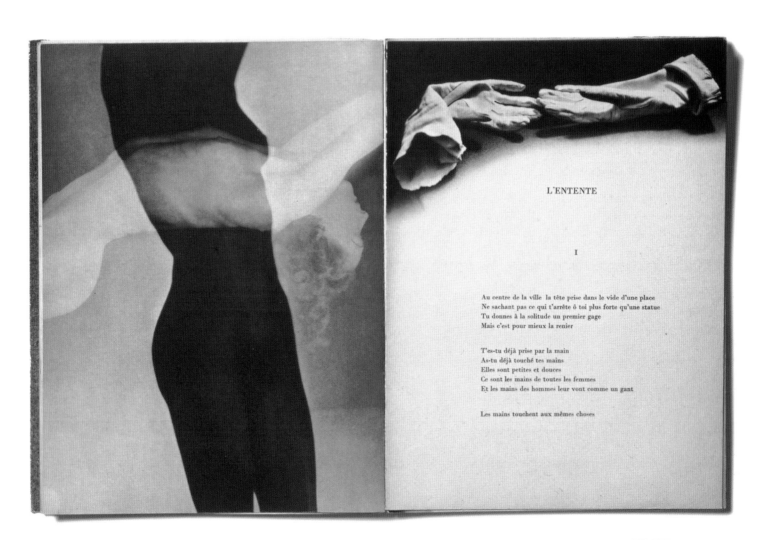

L'ENTENTE

I

Au centre de la ville la tête prise dans le vide d'une place
Ne sachant pas ce qui t'arrête ô toi plus forte qu'une statue
Tu donnes à la solitude un premier gage
Mais c'est pour mieux la renier

T'es-tu déjà prise par la main
As-tu déjà touché tes mains
Elles sont petites et douces
Ce sont les mains de toutes les femmes
Et les mains des hommes leur vont comme un gant

Les mains touchent aux mêmes choses

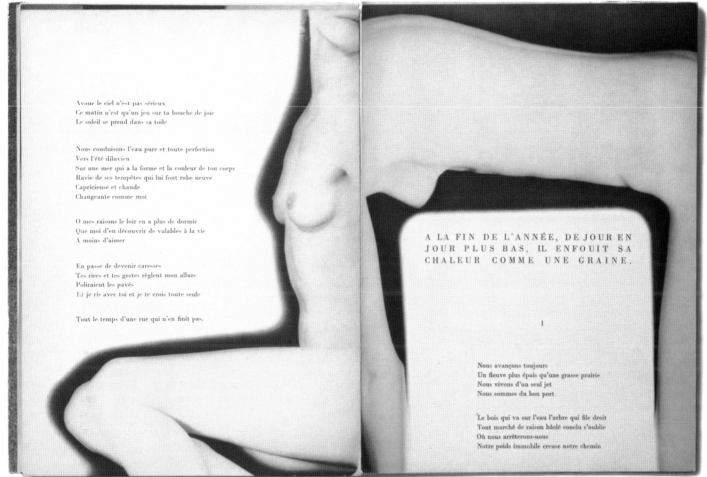

Avoue le ciel n'est pas sérieux
Ce matin n'est qu'un jeu sur ta bouche de joie
Le soleil se prend dans sa toile

Nous conduisons l'eau pure et toute perfection
Vers l'été diluvien
Sur une mer qui a la forme et la couleur de ton corps
Ravie de ses tempêtes qui lui font robe neuve
Capricieuse et chaude
Changeante comme moi

O mes raisons le loir en a plus de dormir
Que moi d'en découvrir de valables à la vie
A moins d'aimer

En passe de devenir caresses
Tes rires et tes gestes règlent mon allure
Poliraient les pavés
Et je ris avec toi et je te crois toute seule

Tout le temps d'une rue qui n'en finit pas.

A LA FIN DE L'ANNÉE, DE JOUR EN
JOUR PLUS BAS, IL ENFOUIT SA
CHALEUR COMME UNE GRAINE.

I

Nous avançons toujours
Un fleuve plus épais qu'une grasse prairie
Nous vivons d'un seul jet
Nous sommes du bon port

Le bois qui va sur l'eau l'arbre qui file droit
Tout marché de raison bâclé conclu s'oublie
Où nous arrêterons-nous
Notre poids immobile creuse notre chemin

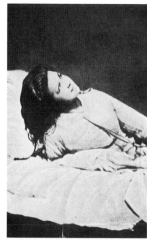
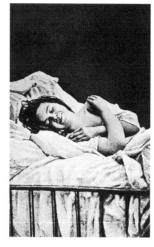
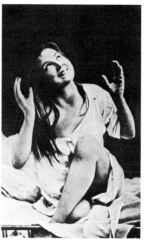
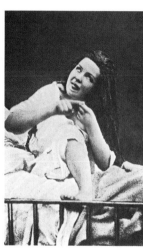
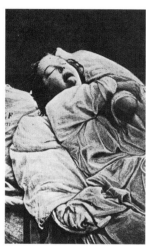
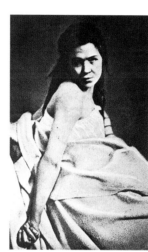

Photographs by Régnard from J-M. Charcot, *Iconographie photographique de la Salpêtrière*, volume II, 1878, published in Louis Aragon and André Breton, 'Le Cinquantenaire de l'hystérie' (The Fiftieth Anniversary of Hysteria), *La Révolution surréaliste*, 11, 1928

These images were selected from the 'photographic iconography' of the psychiatric doctor Jean-Martin Charcot of the Salpêtrière hospital in Paris, compiled between 1875 and 1918. They come from a sequence published in 1878, titled *Attitudes passionelles* (attitudes, or postures, due to passion). The subject was a woman named Augustine who was being treated for symptoms of hysteria. The photographs depict distinct stages of a 'hysterical attack': (*top, left to right*) 'the call'; 'erotism'; 'ecstasy'; (*below, left to right*) 'mockery'; 'onset of an attack: the cry'; and 'contracture'. Aragon and Breton ommitted the first stages: 'threat' and 'aural hallucinations'. These would have indicated Augustine's intense distress which originated in traumatic abuses. In their re-presentation the images could be read as non-pathological and purely erotic. Unethical as this use of the material seems, it was intended partly as a reclamation of female desire and its expression from its pathologization by the medical establishment. Hence the celebratory tone of the text by the two Surrealists, who before abandoning psychiatry had both been trained by students of Charcot; like many such institutions in that period, Salpêtrière had abused the freedom of its patients. A further fascination these images may have held for the Surrealists is suggested in Georges Didi-Huberman's study of Charcot's photographs, *Invention de l'hystérie* (1982) where he describes their paradoxical fusion of contrary states: '... every *attitude passionelle* is profoundly "illogical". A coherent body was only dreamed of, always diverted from rhythms and disasters – and then re-embarking from metonymies, desires and dreams of an other, coherent and inhabitable body. This body, delivered to its exacerbations, inhabited an imaginary space ...'

opposite
Salvador DALÍ
The Phenomenon of Ecstasy
Le Phénomène de l'extase
1933
Photomontage
27 × 18.5 cm [11 × 7 in]
Private collection
Published in *Minotaure*, 3-4, December 1933

This image followed several erotic photomontages of women in states of rapture that Dalí had made in the early 1930s. It was reproduced in *Minotaure*, 3/4 (December 1933), next to his text on 'the terrifying and edible beauty of modern style architecture'. His discussion of the irrationality of forms in art nouveau architecture and its capacity for the realization of unconscious desires is linked with Aragon and Breton's earlier homage to hysteria. Included in the photomontage are details from one of Gaudí's buildings showing carved heads of girls, and a typically fluid, sensuous art nouveau decorative form. In place of clinical photographs of 'ecstasy', most of the images here come from fin-de-siècle erotica; the largest central image, however, is from a photograph Brassaï made for this work. These individual moments experienced by different people have been caught in the frame of single still images and laid side by side to be apprehended simultaneously. While men, except for the two figures on the left, are reduced to uniform sized grids of anonymous ears, suggesting the sounds which could be heard at those expired moments, the women's experience is conveyed through the individuality of their faces and different expressions and poses, some of which are altered through rotation of the image. Disrupting the formulaic styles of both medical and erotic photography, the image suggests a reclamation of the idea of ecstasy for veneration in a secular icon.

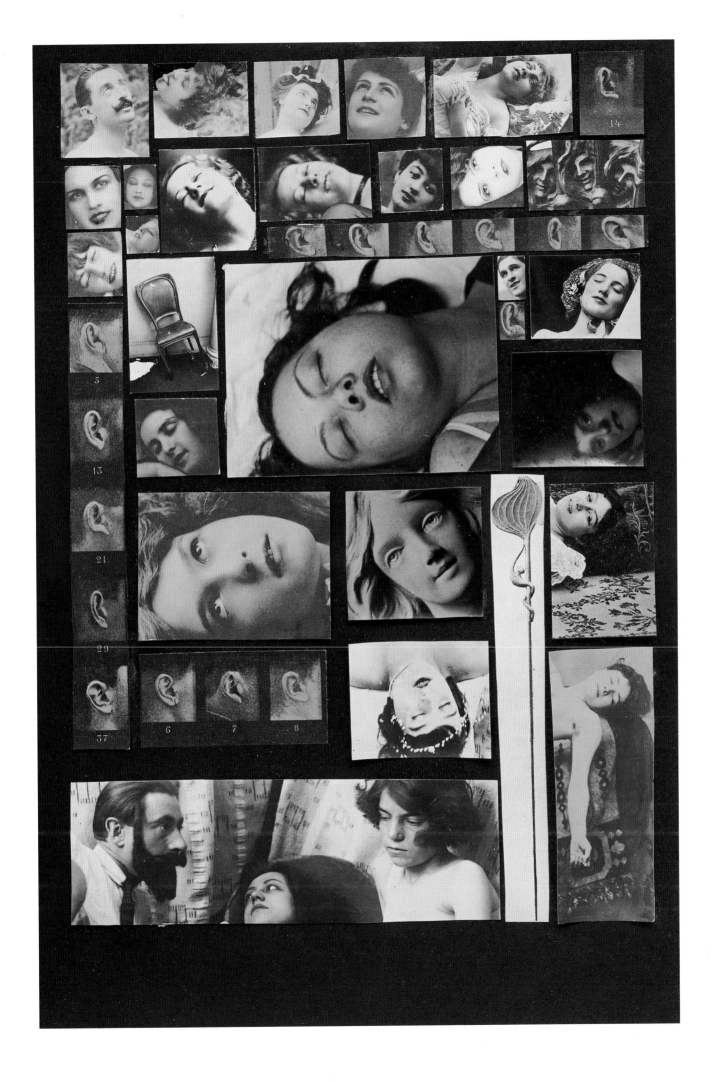

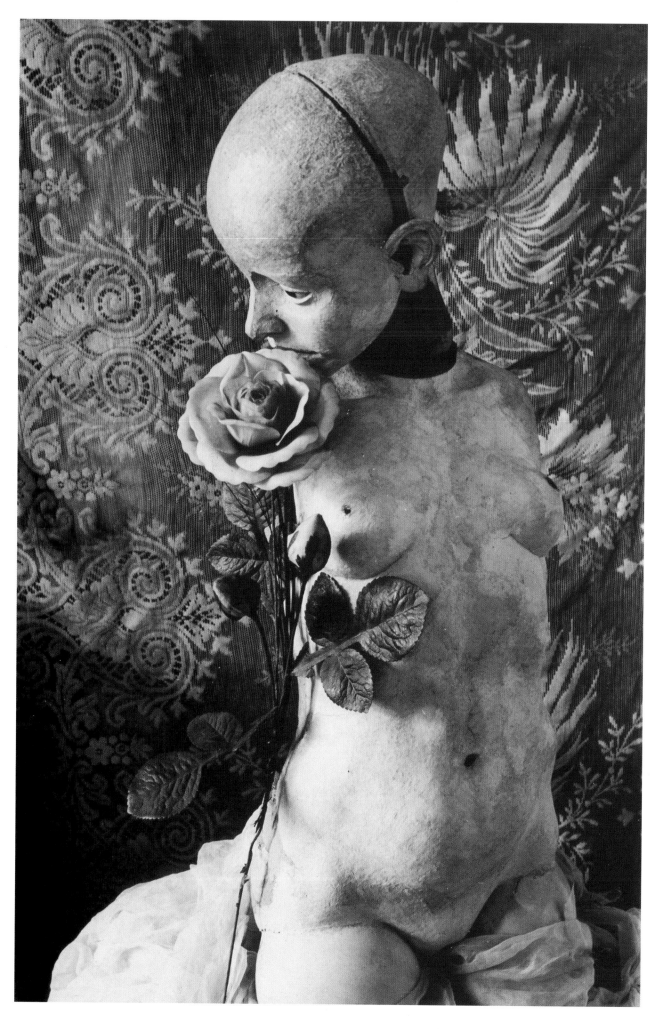

Hans **BELLMER**
Die Puppe
The Doll
1934
Vintage gelatin silver prints
Various dimensions, each approx.
29.5 × 19 cm [12 × 7.5 in]
Private collections
From the sequence published in
Die Puppe, 1934

In *Die Puppe*, a small deluxe edition published privately in Karlsruhe, Germany, in 1934, Bellmer presented ten small photographs of his first doll. They were prefaced by his short text, 'Memories of the Doll Theme', which sets a tone of nostalgic reverie: 'Pulp writers, magicians and confectioners used to have that secret something, that beautiful sweet which was called nonsense and brings joy …' In the first three images the doll is introduced in different stages of construction: a wooden skeleton with metal joints; then a torso, face and limbs sculpted in papier mâché; a wig, a shoe, a fallen stocking and a pose. In the fourth photo all the parts are completely disassembled, pinned to a kind of drawing board. In the fifth the doll is no longer just a doll but the subject of an intense, haunting portrait. From the sixth onwards, this personage and/or dismembered parts of it are posed, atmospherically lit and arranged, on a mattress or emerging from swirls of fine cotton or gauze, resting against lace, or with a single stiletto shoe or a rose. The close-up views draw the spectator into the world of the creator and his subject/object, repeatedly being played with, put together and pulled apart, fantasized, fetishized, recalled and preserved.

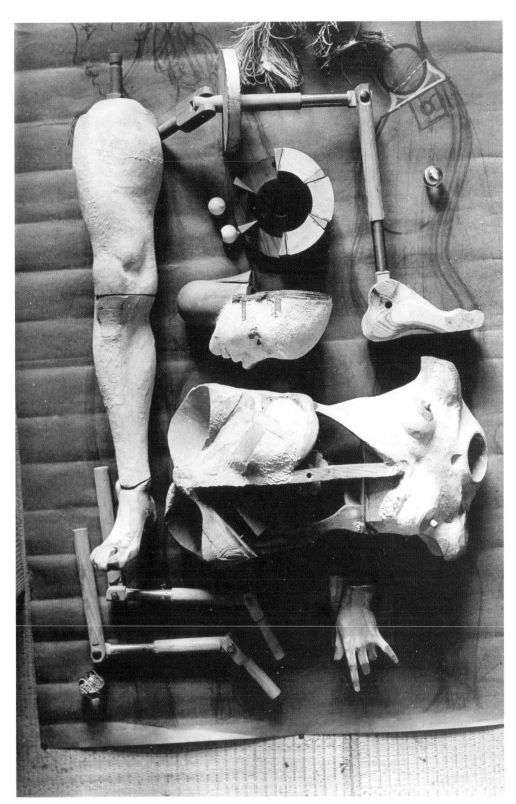

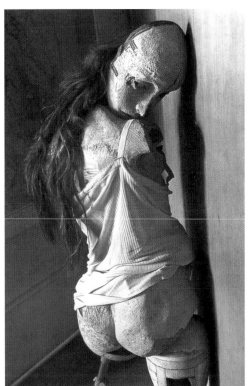

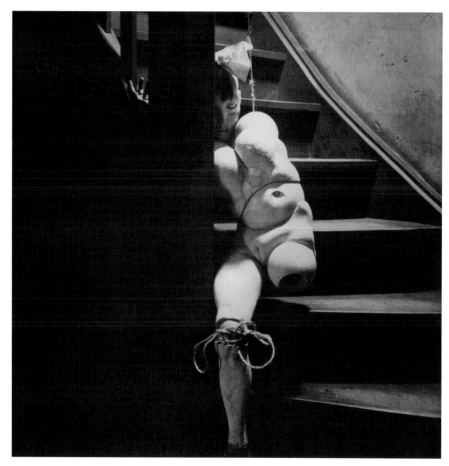

Hans BELLMER
La Poupée [maquette for the book
Les Jeux de la poupée]
1938
Hand-coloured vintage gelatin
silver contact print on original
mount [not shown]
5.5 × 5.5 cm [2 × 2 in]
Private collection

Hans BELLMER
La Poupée
1935/49
Hand-coloured vintage gelatin
silver print
14.5 × 14.5 cm [6 × 5.5 in]
Private collection

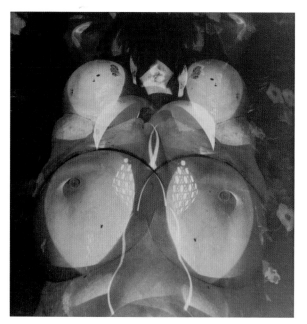

Hans BELLMER
La Poupée
1938
14.5 × 14.5 cm [6 × 6 in]
Vintage gelatin silver print
Private collection

Bellmer began work on his second doll in 1935. It differs from the first doll by being more flexible as well as integrating its armature with its surface. This was achieved with articulated ball-joints, based on a pair of beautifully constructed wooden dolls made by a contemporary of Albrecht Dürer, which Bellmer discovered in the Kaiser Friedrich Museum in Berlin. His photographs of the second doll are often hand-tinted, predominantly in pale, sweet-sickly shades of yellow, pink or blue/green. Aside from their ambiguous, disturbing ambience, many of these images demonstrate Bellmer's investigation of doubling and displacement: 'As in a dream, the body can change the centre of gravity of its images. Inspired by a curious sense of contradiction, it can add to one what it has taken from another: for instance, it can place the leg on top of the arm, the vulva in the armpit, in order to make "compressions", "proofs of analogies", "ambiguities", "puns", strange anatomical "probability calculations"'.
– Hans Bellmer, 'Notes on the Ball Joint' (1938), *Les Jeux de la poupée*, 1949

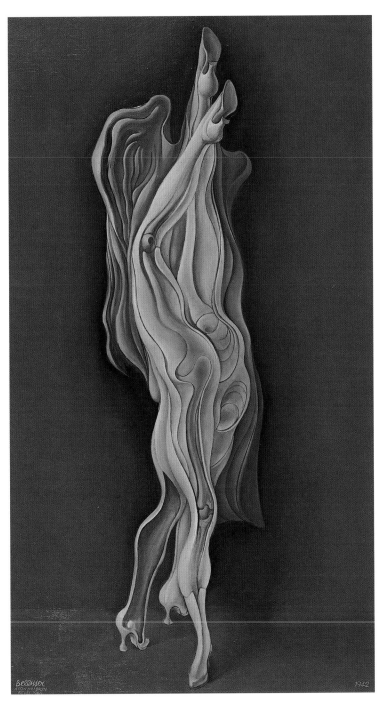

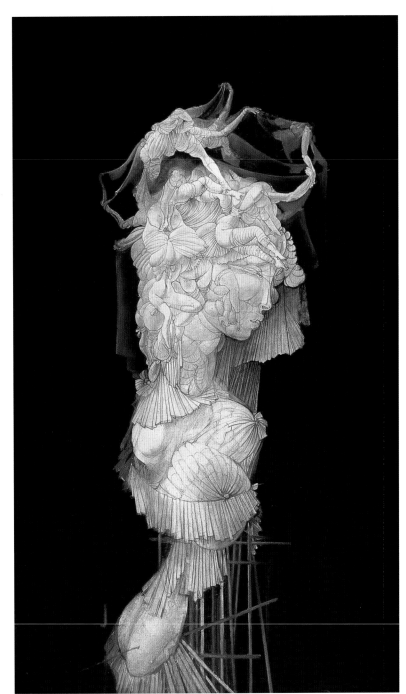

Hans <u>BELLMER</u>

Legs and Feet

Jambes et pieds

1942

Oil on board

47.5 × 26.5 cm [19 × 10.5 in]

Private collection

Bellmer painted and drew in a variety of different styles, sometimes reminiscent of the art-historical sources he studied, such as German Renaissance painting and engraving, at others sharing affinities with turn-of-the-century children's book illustrations, or, as here, a vaguely art deco style associated with the commercial illustration which had been his profession in the pre-Nazi years. Here the multiplication of limbs around a central core which characterized his second doll, with its ball-joints, is transformed into an image that could perhaps be read as more deliriously erotic, less abject in its overtones. Though hollow, skeletal and wraithlike, these chic, interlaced stiletto shoes, legs and veils seem swept up in an ecstatic dance. While a chorus-girl's kicks might spring to mind, the trio of supporting legs may also echo, in superb discordance, the classical Three Graces.

Hans <u>BELLMER</u>

Les Mille Filles

A Thousand Girls

1939

Oil on board

48.5 × 30 cm [19.5 × 12 in]

Private collection

With its title suggesting a pun on *Millefeuilles*, that elaborate type of patisserie constructed of layer upon layer of wafer-thin pastry, this fantastical female figure, emerging from multiple accretions of limbs and draperies, seems to require the scaffolding-like structure in the background to stop it from teetering over and crumbling apart. Its curiously vegetal appearance recalls the paintings of the sixteenth-century artist Giuseppe Arcimboldo, whose 'portraits' of faces made out of animal, vegetable and mineral elements fascinated the Surrealists. Something of what Bellmer wished to explore in such images is indicated in his '*Anatomies de l'image*' ('Anatomies of the Image', 1947): 'What do you wish me to call you when the inside of your mouth ceases to resemble a language, when your breasts kneel behind your fingers and your feet reveal or hide the armpit, your beautiful blushing face.'

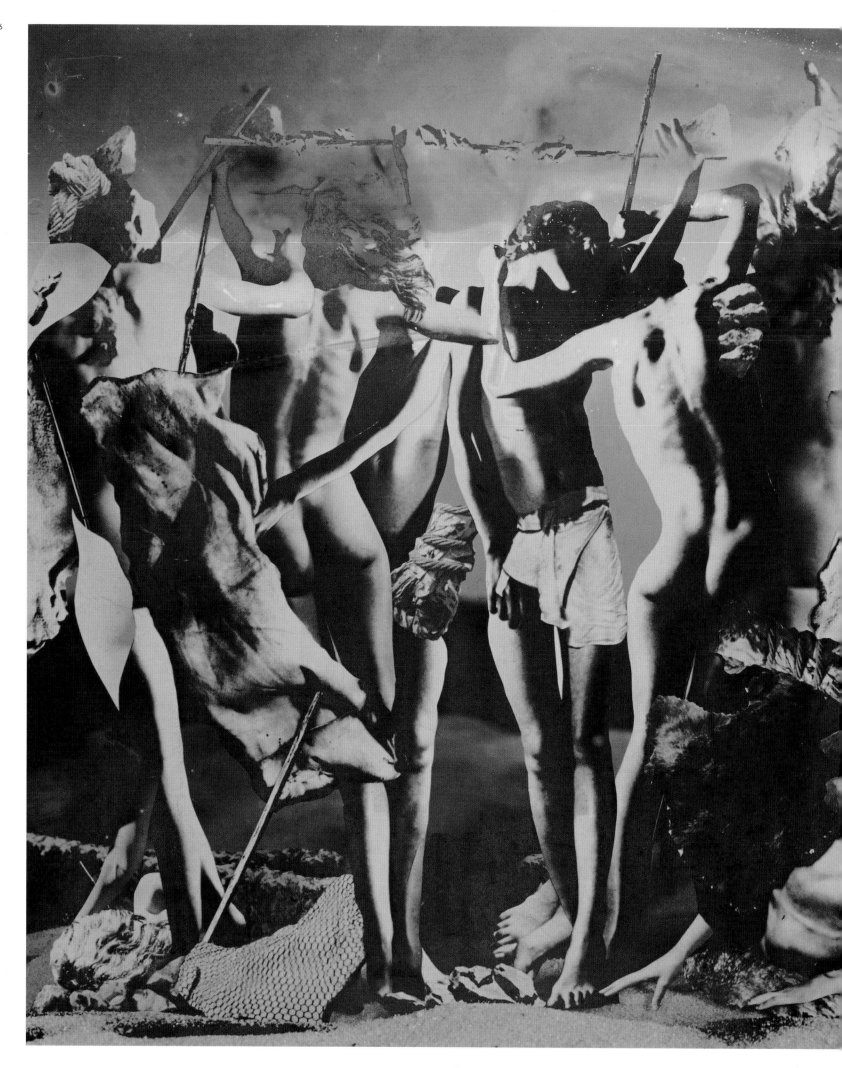

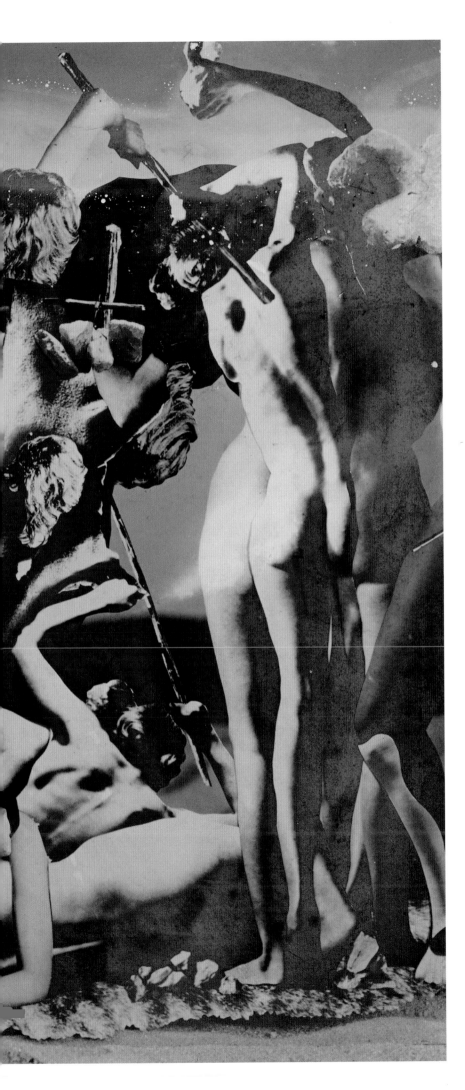

Raoul UBAC
Battle of the Amazons
Le Combat des Penthésilées
c. 1938-39
Toned gelatin silver print
29 × 39 cm [11.5 × 15.5 in]
Private collection

'An image, and above all a photographic image, gives us no more of the real than an instant of its appearance. Behind this thin film on which has been cast an aspect of whatever is there, at the very heart of this image there exists in a latent state another, or many others superimposed, which time and the frequent operations of chance unexpectedly reveal.'

– Raoul Ubac, 'L'envers de la face' (Reverse Face), *Exercice de la pureté*, 1942

In the late 1930s Ubac worked intensively on a series of these complex, frieze-like compositions, alongside several related studies comprised of smaller groups of subjects, in various horizontal or vertical formats. First he assembled a montage, grouping together different photographic views of the same female nude subject. Then the montage was photographed and the print exposed to solarization. The resulting positive image was recombined in a montage with other photographic fragments and then again rephotographed and resolarized. Optically reorganizing the boundaries that normally separate our perception of bodies and their surrounding space, the image sustains an enduring tension. It evokes the dynamic movement traditionally striven for in depictions of battle and conveyed by cinema but also the frozen, arrested characteristics of still photography. What one may read as the erotic merging of bodies, space and light is counterposed with corrosion, fragmentation and discord. The colouration of the image was achieved through a *virage* (toning) technique, in which varying quantities of different chemicals are substituted for the silver salts either during or after development. Between 1937 and 1939 Ubac produced many different versions of this image, using a wide range of experimental techniques.

opposite

Raoul UBAC

Agui in the Mirror With Damaged Silvering

Agui au miroir au tain endommagé

1932-33

Gelatin silver print

24 × 18 cm [9.5 × 7 in]

Private collection

This image, later known as *Portrait in a Mirror*, accompanied Pierre Mabille's text 'Miroirs', in *Minotaure*, 11 (Spring 1938). It depicts Ubac's wife Agui, the model for many of his photographs, whom he found adjusting her hair before the old mirror; he asked her to hold the pose (Christian Bouqueret, *Raoul Ubac*, 2000). Later he recalled: 'Like Mabille I considered the mirror as the best way of gaining an awareness of Self. The mirror by its very nature prompts us to question the true features of reality.

'The *Portrait in a Mirror* is that of my wife. The effect of mystery and unreality is conveyed by the damaged looking-glass. The disappearance of the silvering in some places conceals the face and hair, while one side of the reflection appears by contrast in full light. No montage here. What is unusual is the outcome of sheer realism, for as Mabille said: the mysterious and the marvellous are not outside but inside things and people.

'I depersonalized the model by showing her hair falling down over her face, and her form being destroyed by effects of light and shade. Objective photography was of no interest to me …'

– Raoul Ubac, interview with Jeanine Warnod, December 1983

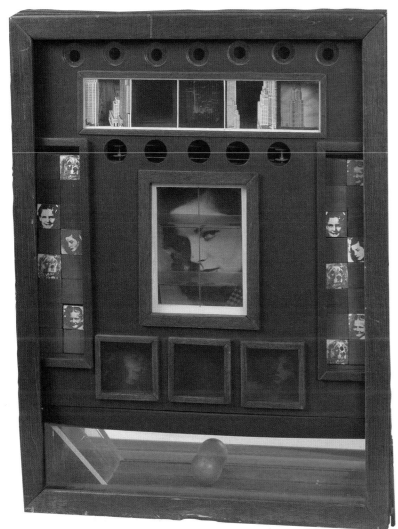

Joseph CORNELL

Untitled (Penny Arcade Portrait of Lauren Bacall)

1945-46

Box construction

52 × 36 × 14 cm [16 × 14 × 6 in]

Private collection

'The feeling of creation that so often only seems to come with leaving home and is invariably lost on returning. "To Have and Have Not" Hemingway's story. H. Bogart and Lauren Bacall. Interesting portraiture at times from good photography of close-ups. Her profile in one shot absolute vertical. Bought icinged rum treat. Better than average feeling.'

– Joseph Cornell, Diary, 20 February 1945

Holding onto a childlike sense of marvel, Cornell placed Bacall here in this early example of his penny arcade series, with its beautiful blue interior. Like a real penny arcade machine it includes a ball to be inserted in the top, which rolls past the collage of New York's skyline, then past Bacall at various stages of her life and career from childhood onwards, including her beloved pet dog. The ball's journey past these images brings actual time into dialogue with recollected, imagined and perhaps eternal time, in this revered, icon-like object. Cornell dedicated many artworks to women he admired, from a Medici princess or a nineteenth-century ballet dancer to the iconic women of his day – Bacall, Greta Garbo, Hedy Lamarr and Marilyn Monroe.

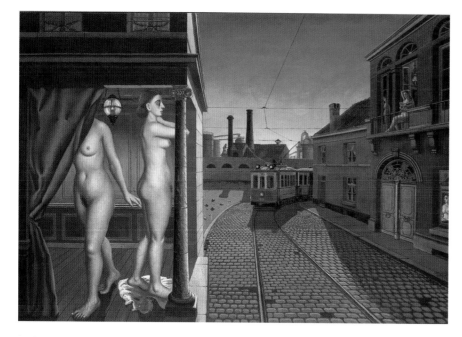

Paul DELVAUX

Street of Trams

La Rue du tram

1938-39

Oil on canvas

90.5 × 130.5 cm [35.5 × 51.5 in]

Collection, Scottish National Gallery of Modern Art, Edinburgh

Delvaux joined the Belgian Surrealists in the mid 1930s. His vision is in some respects closer to Dalí than, for example, Magritte, in that he wished to create a dialogue with certain historical genres of painting, 'surrealizing' them, as David Scott has written (*Paul Delvaux: Surrealizing the Nude*, 1992); he also explored highly personal, often erotic associations triggered by real objects and scenes. Many of his settings take the form of a city which he sometimes referred to as *La Ville inquiète* (the uneasy city), although in this painting the atmosphere seems tranquil. Trains, trams, stations and waiting rooms had a strong personal significance for him as places of transit, suggesting a space where the normal realities of everyday life can be suspended. Here the lines of perspective, the factory chimneys and columns have a more overtly sexual import than in the works of de Chirico. The blue of the tram and the hues of the dusk or dawn sky are romantically suggestive; no less so the nude women transported from the realms of academic painting to appear here, as in a dream.

Paul DELVAUX

Echo

1943

Oil on canvas

105.5 × 129.5 cm [41.5 × 51 in]

Private collection

In paintings such as *Echo*, where the same woman seems repeated, Marcel Jean saw an effect of 'several fractions of time existing at the same moment in the same space'. (*The History of Surrealist Painting*, 1959.) Ruins or ancient buildings appear in the background of a series of works such as this one which both reflect upon the legacy of classical history painting and draw attention to the past of civilization. In the context of the war in Europe the scene evokes concerns about destruction and survival but can also be read as a metaphor for the buried layers of memories, desires and drives in the unconscious mind, as described by Freud in a number of comparisons he made between psychoanalysis and archaeology. Dawn Adès has noted how in such images Delvaux's sleepwalkers, moving across and away from the viewer, depart from the conventional female nude as passive subject in Western painting. He confers on the luxurious bodies of Ingres' period the agency of modern, active subjects. (*Surrealist Art: The Bergman Collection*, 1997.) The moonlight setting of this painting is related to an earlier series, *Phases of the Moon* (1939–42), which derives imagery from Jules Verne's *Voyage to the Centre of the Earth* (1867). Here 'the moon influences phenomena underground (that is to say, in the unconscious) as well as those on the earth's surface'. (David Scott, *Paul Delvaux: Surrealizing the Nude*, 1992.)

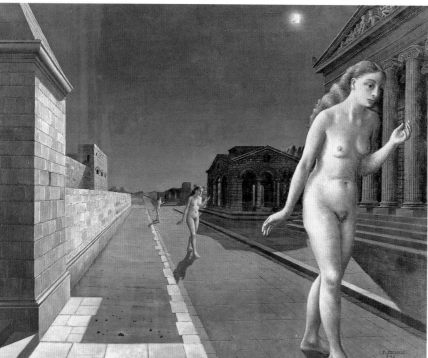

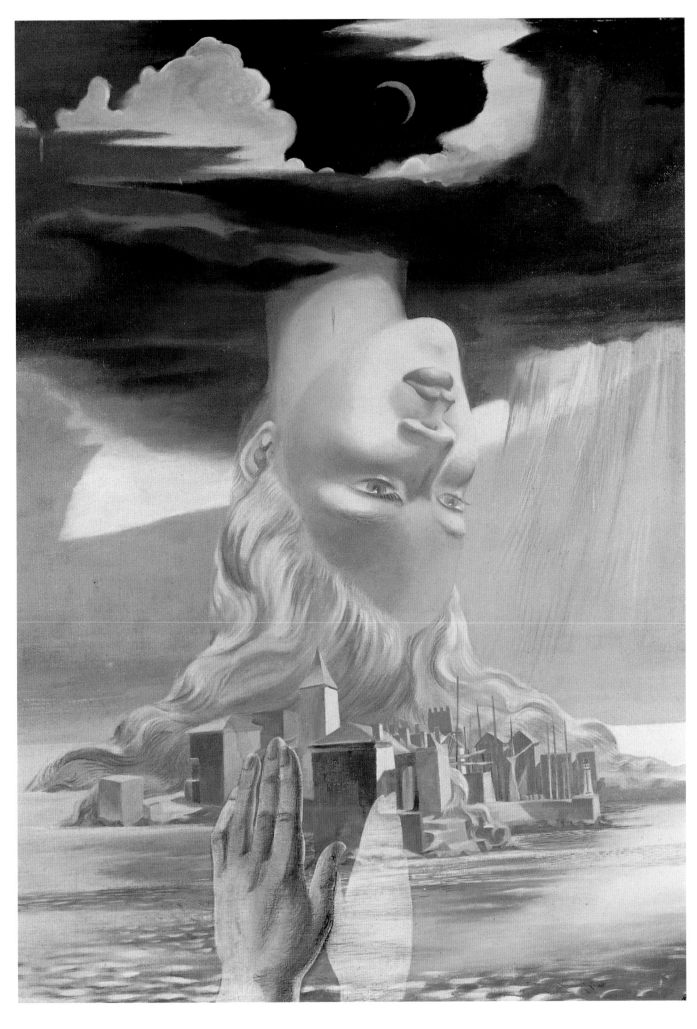

Roland PENROSE
L'Île Invisible (Seeing is
Believing)
1937
Oil on canvas
100 × 75 cm [39.5 × 30 in]
The Roland Penrose Collection,
Sussex, England

The upturned head of a woman is
depicted emerging from a moonlit sky,
her auburn hair cascading down to form
a glowing mass behind a coastal town.
At the base of the image is a male hand
reaching up as if to caress the woman's
hair. The hand is echoed in a ghostly
form to its right. Like much of Penrose's
work of this time the painting was
inspired by the artist's new lover Lee
Miller. Michel Remy (*Surrealism in
Britain*, 1999) describes the painting
as an example of Penrose's strategy
of 'retinal inversion', further explored
in his surrealist object of the same year,
The Dew Machine, which suspends
a mannequin's head upside down,
hair flowing in an identical manner
to *L'Île invisible*. Remy suggests the
presence of mythological allusions to
'cities in ancient Greece protected by
goddesses linked to the moon' and also
to the mythological Breton town of Ys:
'According to Breton mythology, this town
was covered by the tide, on account of
the king's daughter's immorality, while
the beautiful but dissolute girl, pledged
to the gods of the sea, drowned in the
waves to become 'Morgane' – in Breton
language a mermaid'.

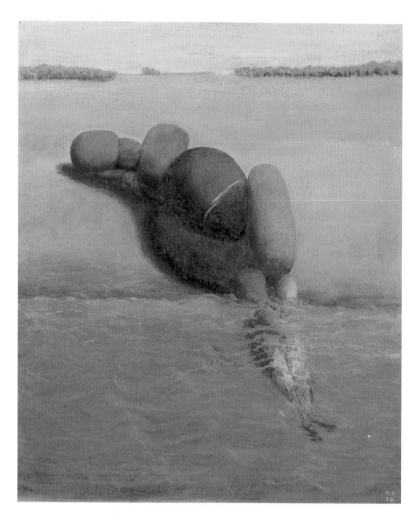

Meret <u>OPPENHEIM</u>
Stone Woman
Steinfrau
1938
Oil on cardboard
59 × 49 cm [23 × 19 in]
Private collection

This was painted in Basel following Oppenheim's return to her native Switzerland from Paris in 1937: a year marked for her by a serious depression that she later described as 'a destruction of self-esteem' which would last until 1954. In Basel, she enrolled in the School of Arts and Crafts, where she took lessons in painting and life drawing. Her experimental approach to materials, represented in her surrealist objects, is replaced by deliberate reference to traditional media. *Stone Woman* reflects the recurrent subject in her work of the female body in relation to female creativity. In an interview Oppenheim was asked if this was an image of 'an archetypal woman'. She replied: 'Yes and no. A stone woman is prevented from action but her legs are immersed in the stream. Which is to say it is a picture of contraries: sleeping stone and living waters. But she is not some ideal woman.' (Interview, 1984, reprinted in *Surrealism and Women*, 1991.) *Stone Woman* has been interpreted as an image of petrified female creativity struggling to life within a patriarchal world or, by Thomas McEvilley, as a poetic image of metamorphosis, depicting woman as empowered through her protean nature (*Meret Oppenheim: Beyond the Teacup*, 1996).

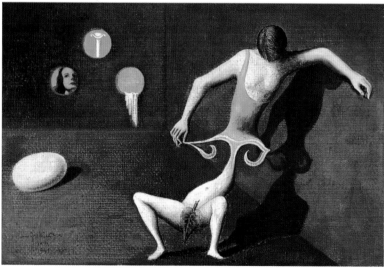

Wilhelm <u>FREDDIE</u>
Portable Garbo
Garbo mobile
1941
Oil on canvas
21.5 × 33 cm [8.5 × 13 in]
Collection, The Art Institute of Chicago

Redolent with provocative sexual symbolism, this Danish artist's work focused in the late 1930s and 1940s on graphically rendered figures within enclosed spaces or open landscapes. *Portable Garbo* reflects the stylistic influence of Magritte, whom he met in Belgium in 1937. Through the left-hand opening of an enigmatic triptych arrangement of portholes can be seen the face of the Swedish film star Greta Garbo. She mysteriously retreated from acting in 1941 and her sex appeal had been famously termed 'phantasmal' by Dalí several years before. The extraordinary divided figure in the foreground hovers indeterminately between male and female attributes, a conflation which frequently appears in Freddie's paintings and sculptures.

Pierre <u>MOLINIER</u>

Victory

La Victoire

c. 1970

Gelatin silver print

16.5 × 20 cm [6.5 × 8 in]

Collection, Maison Européenne de la Photographie, Paris

Molinier's earlier work as a painter attracted Breton's attention in 1955. He found the canvases 'magical', seeing in them a vertiginous eroticism he identified with Symbolist art and literature. By the mid 1960s Molinier was working primarily with photography, through which he expressed his highly transgressive sexuality. Photographs like *La Victoire* depict an orgiastic entanglement of legs, buttocks and breasts. They were made from a combination of self-portraiture – of himself in black stockings – and dolls: 'To create the extraordinary images of multiplied bodies and legs (he was a leg fetishist), Molinier carefully cut up his photographs, creating a store of elements that he would then assemble and rephotograph. The elements might include photographs of the head of the doll, but other body parts were in almost all cases his own. His skill in composing these montages and in developing the prints obscured remaining traces of his masculinity and, as strikingly, his age.'
– Jennifer Mundy, *Surrealism: Desire Unbound*, 2001

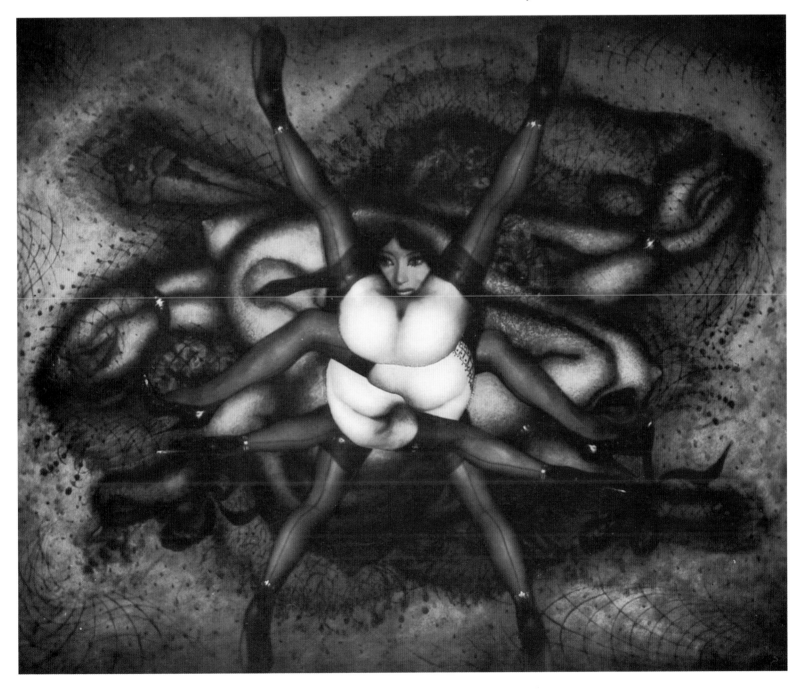

DELIRIUM The frenzied, liberated desire celebrated by the Surrealists often bordered on terror. Surrealism cherished the transgressive action, the violent impulse, as a positive and critical assault on the norms of a society against which it was in open revolt. As the nightmarish political climate of the 1930s unfolded such scandalous and ironic precursors as the Marquis de Sade increasingly figured in surrealist thought, as did contemporary figures, both real and fictional, from the worlds of the criminal and the insane. Officially joining the group in 1929, Salvador Dalí conveyed a panoply of new meanings to the surrealists' exploration of extreme psychological states, through his depiction and interpretation of subjective, paranoiac visions. From their different perspectives, Dalí and the writer Georges Bataille investigated the 'base' and scatalogical, domains of putrefaction and dissolution, the unformed and formless.

Salvador DALÍ and Luis BUÑUEL
Un chien andalou
An Andalusian Dog
1928
17 min., black and white, silent

This collaboration between the artist Dalí and the filmmaker Buñuel was filmed over six days in Paris and Le Havre in March 1929. When first screened its silent narrative was accompanied by records of an Argentinian tango followed by the *liebestod*, or 'love-death' song of Isolde as she collapses onto Tristan's lifeless body in Wagner's opera *Tristan and Isolde*, after seeing an apparition of him ascending to heaven. By contrast, in the finale of *Un chien andalou* a blind and destitute man and woman appear buried up to their heads in sand, being burned by the sun and eaten alive by swarms of insects. Ants have earlier appeared swarming on a man's hand, as have the corpses of rotting donkeys stretched out on grand pianos, among the products of black humour and macabre obsession which appear in a dreamlike sequence of abrupt transitions and disquieting scenes. These attempt to portray the irrational logic of the unconscious, using such filmic techniques as montage, double exposure and dissolve. In the opening scene a man, played by Buñuel, stares at the moon. Instead of the camera then moving towards the moon as the object of his gaze, the next frame suddenly cuts to a woman's face, staring; the moon is bisected by a razor thin cloud, followed by the notorious slitting and spilling of the woman's eye, an effect created using an ox's eye. This moment has been interpreted as an iconoclastic use of the eye as a surrealist symbol of inner vision, and as a confrontational assault on the moral detachment of spectatorship.

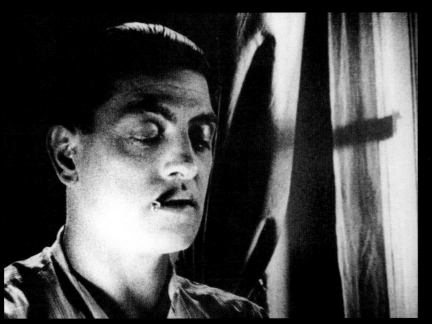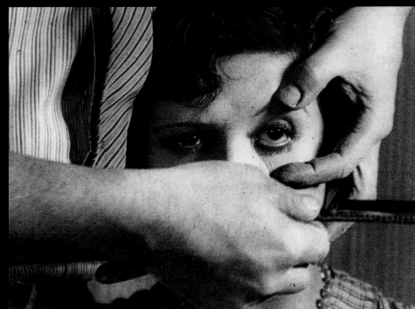

Luis **BUÑUEL**

L'Âge d'or

The Golden Age

1930

63 min., black and white, silent
dialogue with titles and musical
soundtrack

With Buñuel's anti-clerical imagery, this film provoked an even greater scandal than *Un chien andalou*. It was first shown privately at the home of the Vicomte de Noailles, who financed it, then screened several times to small public audiences. When passed by the Paris film censor it was shown from 28 November 1930 at Studio 28. On 3 December the cinema was vandalized by fascists. After a right-wing media campaign the censor's sanction was revoked on 10 December. The film was not shown again publicly in France for almost fifty years. As the Surrealists declared in their *Manifesto Concerning L'Âge d'or*: 'Love demands the sacrifice of every other value: status, family and honour. And the failure of Love within the social framework leads to Revolt. The process can be seen in the life and works of the Marquis de Sade, who lived in the golden age of absolute monarchy ...' Hence the film's title and the reference to Sade's *120 days of Sodom* in the final scene, as the survivors of the libertines' orgy emerge from the château, led by a figure who, blasphemously, resembles Christ. Throughout the film love and desire are frustrated and betrayed by bourgeois convention and repression, its irrationalities parodied to the point of absurdity. The social and religious satire seems to have derived mainly from Buñuel, while Dalí's influence can be seen in images such as these two stills. The title for the image of the woman ecstatically sucking the statue's toe reads: 'I've been waiting such a long time for this moment. Ah! What joy to have assassinated my children!'

Jacques-André BOIFFARD

Untitled [The Big Toe]

Sans titre [Le Gros Orteil]

1929

Gelatin silver prints

above, Collection, Musée National d'Art Moderne, Centre Georges
Pompidou, Paris; *above, right*, Private collection

In *Documents*, 6, 1929, several of Boiffard's photographs, captioned 'Big toe, subject
male, 30 years', accompanied Bataille's article '*Le Gros Orteil*' ('The Big Toe'). In each
the toe is greatly enlarged in close-up and dramatically isolated by surrounding
blackness. In one image just the end of the toe is singled out; in another the whole
length of the toe is shown, diagonally; in another the toe is photographed from above
and presented hanging down from a vestigial part of the foot in the side of the frame.
This suggestion of the phallic and fetishistic contrasts with the similarity to medical
photographs. In his article Bataille developed his idea of 'base materialism', which
he would use to redress the dialectical materialism, and thus the idealism, of Breton's
surrealist group. With irony he suggests that the big toe is the most 'human' part of
the body in that it is the least like the coresponding digit of the ape; it brings us closest
to the mud; it exercises a 'low seduction', confronting us with our proximity to the non-
human. Bataille's notion conveys the message that while certain objects, scenes,
bodily parts and functions disgust us, we are nevertheless also seduced by them.

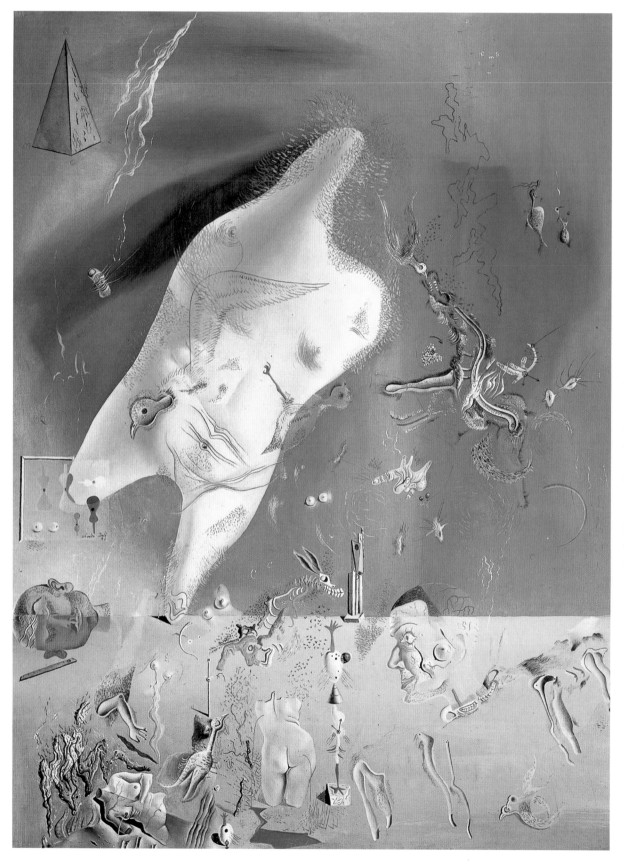

Salvador <u>DALÍ</u>
Little Cinders [Summer Forces,
or Birth of Venus]
*Senicitas [Forces estivales,
ou Naissance de Vénus]*
1927
Oil on wood
64 × 48 cm [25 × 19 in]
Collection, Museo Nacional Centro
de Arte Reina Sofía, Madrid

This was the most ambitious of Dalí's early attempts at arriving at a surrealist language for his paintings. The thin composite creature in the lower centre, topped by an egg surmounted by a red hand, resembles an 'exquisite corpse' drawing. Other personages resemble the symbolically abstracted figures in Miró's paintings such as *Catalan Landscape (The Hunter)* of 1923–24. An intense blue, which evokes the dream world in a number of Miró's other paintings of the period, is invaded, in Dalí's vision, with dismembered parts of bodies and other deliriously flying objects, some schematically indicated, others painted with a degree of realism. All this transformative activity seems to indicate Dalí's interest in testing out an equivalent to film effects such as dissolves and montage. It also reflects the widely held notion that the contents of dream must be noted down as fast as possible to avoid the intervention of memory and rational reconstruction.

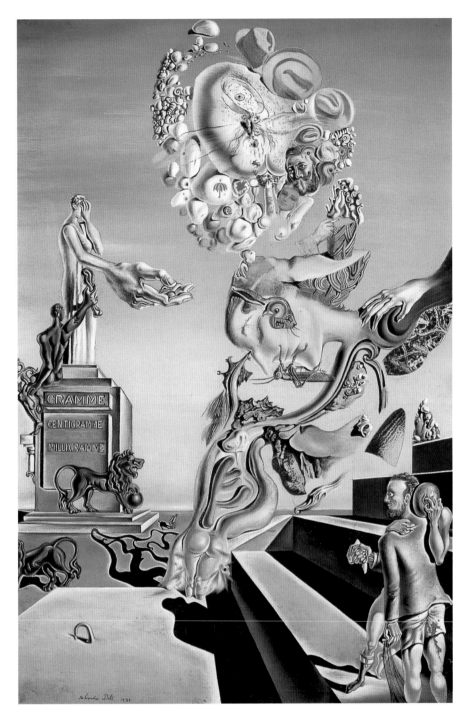

Salvador <u>DALÍ</u>

The Lugubrious Game
Le Jeu lugubre
1929
Oil and collage on card
44 × 30 cm [17.5 × 12 in]
Private collection

The Latin-derived word 'lugubrious' can often mean not just 'dismal' or 'mournful' but excessively so. Here it indicates Dalí's immersion in matters which are more individually personal than the experimental word and image play and automatism of most of the Paris Surrealists. Just as the words 'game' and 'lugubrious' seem strange companions, so, in this work and others of the period Dalí forces a psychological convergence, as does Bataille in many of his writings, of sexual desire with a simultaneous fear and repulsion. Images that emerged from his own anxieties and memories mingle with others derived from his informed use of symbols described in psychology textbooks. As Dawn Adès observes in *Dalí and Surrealism* (1982), these paintings seem to use 'the iconography of the science of psychoanalysis as though it were common property, in the way that religious iconography was common property in the Middle Ages'. Among the symbols that are personal to Dalí are the grasshopper, an insect that he had a terrifying encounter with as a child, represented here clinging to his face. Rather than using them as givens with a single meaning, Dalí introduces ambiguities in the textbook-derived signs of sexual anxiety, such as the large looming staircase, integrating them with the constellation of his own symbols.

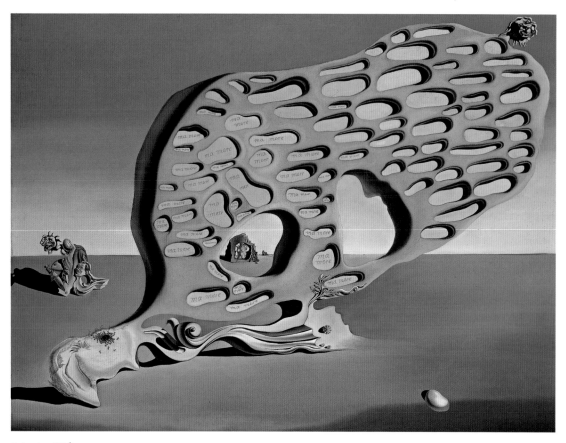

Salvador <u>DALÍ</u>

The Enigma of Desire

L'Énigme du désir

1929

Oil on canvas

110 × 150 cm [43.5 × 59 in]

Collection, Bayerische Staatsgemäldesammlung, Munich

When Dalí joined the Surrealists in 1929 he departed from his usual miniature scale to make two large paintings, this and *The Great Masturbator*, with which it shares some characteristics. Central to each are similar large biomorphic shapes which echo those of the strange rock formations that preside over the Cadaquès peninsula where he lived. Here the structure is full of cavities, like a sponge, perhaps, or a loaf of bread, or the recesses of the mind, in which the phrase 'my mother' repeats again and again. The whole structure emerges from Dalí's own molten head, plagued by ants, and is further supported by furniture scrollwork in the art nouveau style. In the poem 'The Great Masturbator' (1930), Dalí associates this 'Modern style' with 'interiors in which a very beautiful woman with wavy hair a terrifying look an hallucinatory smile and a splendid throat is seated at a piano …' As with a number of Dalí's paintings, there is an almost undetectable small area of collage which, if discovered, adds a further anti-pictorial element within this scene of the 'concrete irrational'.

Salvador <u>DALÍ</u>

The Architectonic *Angélus* of Millet

L'Angélus architectonique de Millet

1933

Oil on canvas

73 × 61 cm [29 × 24 in]

Collection, Museo Nacional Centro de Arte Reina Sofía, Madrid

The well-known painting *L'Angélus* (1858–59) by Jean-François Millet was an obsessional theme for Dalí from 1932 until about 1935. It shows a peasant man and woman in a field, he standing, looking downward, holding his hat in front of him, pitchfork planted in the ground alongside; she, a basket of gathered produce at her feet, standing in an attitude of 'grace' or blessing. In popular reproductions and postcards it became an emblem of rustic idyll and piety. Dalí had been familiar with the image since childhood. In 1932 it appeared to him transformed by a 'delirious phenomenon'. Latent in the image he saw 'the maternal variant of the immense and atrocious myth of Saturn, of Abraham, of the eternal Father with Jesus Christ and of William Tell himself, devouring their own sons'. Thus he determined that the painting's concealed subject was the castration of the husband and the killing of the son. In a series of 'secondary' paranoiac visions he began to see references to this scene in objects he encountered in fantasy and actuality, such as a daydream of playing on the beach with two peculiarly shaped pebbles which reminded him of the figures. Here they are transformed into spectral 'soft forms' which seem halfway between rocks and clouds, rising up in the midst of a landscape full of childhood memories for the artist. Referring to soft forms supported, as here, by crutches, Dalí wrote: 'I have often imagined the monster of sleep as a heavy, giant head with a tapering body held up by the crutches of reality. When the crutches break we have the sensation of "falling"'. (*The Secret Life of Salvador Dalí*, 1942.)

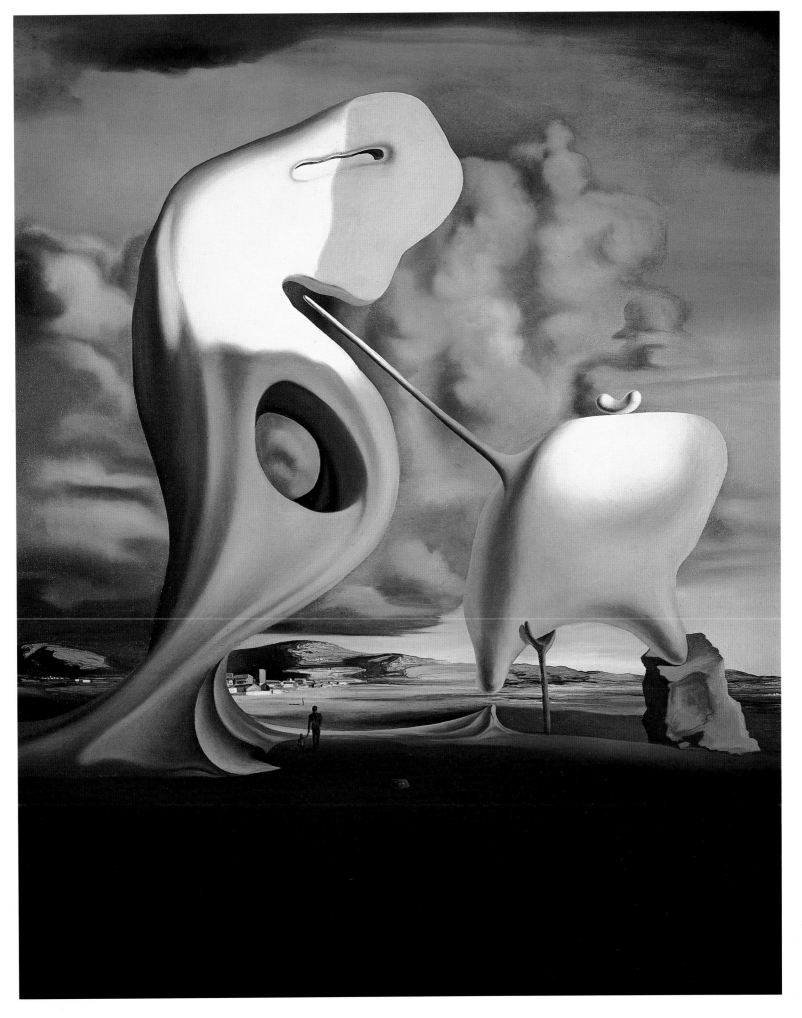

Salvador DALÍ

Invisible Lion, Horse, Sleeping Woman

Lion, cheval, dormeuse invisibles

1930

Oil on canvas

50 × 65 cm [20 × 25.5 in]

Collection, Musée national d'art moderne, Centre Georges Pompidou, Paris

Dalí's closeness to cinema can be seen in several paintings he made of this triple subject at the beginning of the 1930s, in which experiments with multiple images establish the links between cinematic techniques, such as dissolves and multiple exposures, and his theory of paranoiac imagery. He also wrote and sketched out a scenario for a film which was never realized : 'The paranoiac activity offers us the possibility of the systematization of delirium. Paranoiac images are due to the delirium of interpretation. The delirium which, in the dream, is wiped out on waking, really continues into these paranoiac images and it is directly communicable to everybody. In effect we are going to see how the paranoiac delirium can make it so that an odalisque is at once a horse and a lion. The odalisque arrives, she lies down lazily. Notice the beginning of the movement of the horse's tail; it becomes odalisque again and now it is a lion which appears in the distance. There again is a real phantom.'

– Salvador Dalí, manuscript of film scenario, undated, early 1930s

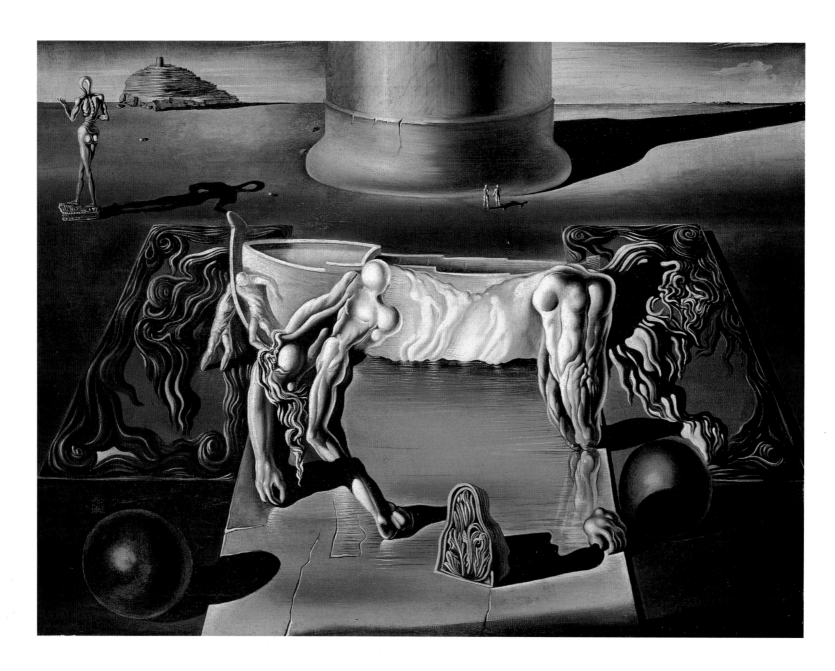

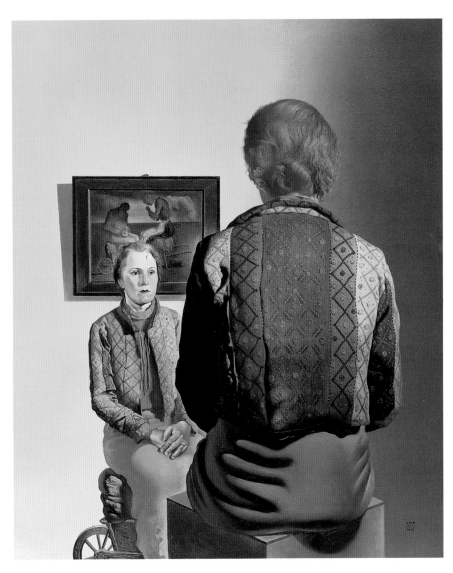

Salvador <u>DALÍ</u>

The *Angélus* of Gala

L'Angélus de Gala

1935

Oil on panel

32.5 × 27 cm [13 × 10.5 in]

Collection, The Museum of Modern Art, New York

The minute realism of this painting, as well as its main subject, setting and lighting, recall seventeenth-century portraits such as those of Vermeer. However the first impression of realism is soon dispelled: 'Exposing the viewer to the kind of visual paradox most usually associated with Magritte … in this double image of Gala the painting is presented to us as if it were performing as a mirror – an impossible or missing mirror, of course, because it is only a mirror from the point of view of the subject inside the picture, which leaves no rational space for us to occupy as viewers.' (Robert Radford, *Dalí*, 1997.) Furthermore, Dalí's wife is seated in a wheelbarrow, which echoes the wheelbarrow in his altered version of Millet's painting *L'Angélus* which hangs above, signifying the 'paranoid critical' dimension of this portrait.

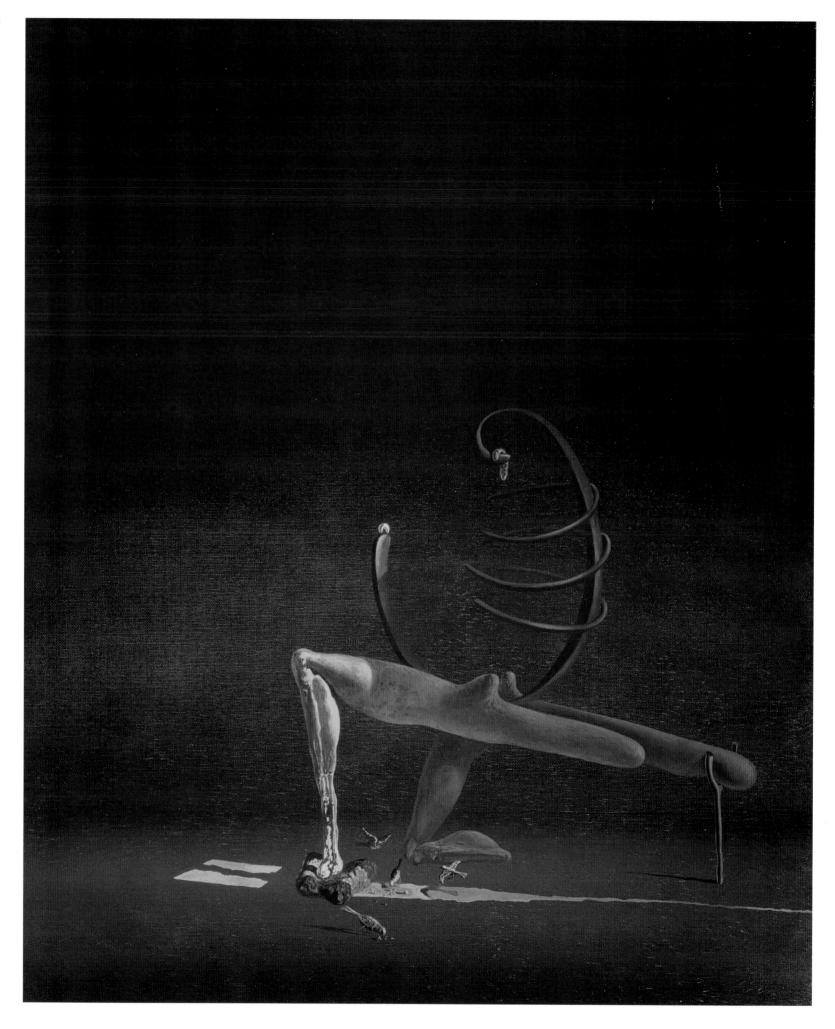

Salvador <u>DALÍ</u>

The Javanese Mannequin

Le Mannequin javanais

1934

Oil on canvas

65 × 54 cm [25.5 × 21.5 in]

Collection, Salvador Dalí Museum, St Petersburg, Florida

This painting is closely related to the series of etchings which Dalí made in 1933–34 to illustrate Lautréamont's *Les Chants de Maldoror*. As David Lomas has described them: 'Tottering monuments cobbled together from bits of bentwood furniture, bones, formless lumps of decomposing flesh, and abstracted Tanguyesque forms lean on crutches in order simply to stay upright.' (*The Haunted Self*, 2000.) *The Javanese Mannequin* shares these spectral, hybrid qualities. Suggesting that it exhibits the haunting of the subject by the death drive which can be detected as a theme in the etchings, Lomas quotes Maldoror's fourth chant: 'From my neck, as from a dung heap, an enormous toadstool with umbelliferous peduncles sprouts. Seated on a shapeless chunk of furniture, I have not moved a limb for four centuries.' This recalls the delusions of Freud's patient, Schreber, who at one point believed that his body was starting to rot and decompose, as if he were a corpse. Dalí's soft forms inevitably contain an implicit reference to death and decomposition, as well as to bodily secretions of a viscous or abject nature.

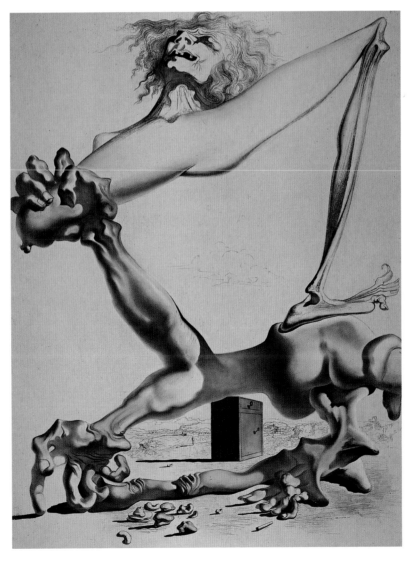

Salvador <u>DALÍ</u>

Study for Premonition of the Civil War

Étude pour Prémonition de la guerre civile

1936

Charcoal on paper

105 × 80 cm [41.5 × 31.5 in]

Collection, Museo Nacional Centro de Arte Reina Sofía, Madrid

Dalí described how in the painting for which this is a study, he 'showed a vast human body breaking out into monstrous excrescences of arms and legs tearing at one another in a delirium of auto-strangulation. As a background to this architecture of frenzied flesh devoured by a narcissistic and biological cataclysm, I painted a geological landscape, that had been uselessly revolutionized for thousands of years, congealed in its "normal course". The soft structure of that great mass of flesh in civil war I embellished with a few boiled beans, for one could not imagine swallowing all that unconscious meat without the presence (however uninspiring) of some mealy and melancholy vegetable.' (*The Secret Life of Salvador Dalí*, 1942.) While recalling Goya's depictions of war's horror from the 1820s, Dalí's retrospectively titled image presents the body of Spain as both victim and aggressor, an outcome of inevitable processes.

opposite

Victor BRAUNER

Fantômas

1932

Oil on canvas

73.5 × 93 cm [29 × 36 in]

Collection, Musée d'art moderne, Saint-Etienne

This work was painted when Brauner made contact with the surrealist group in Paris, although he was not to meet Breton until the following year. The title refers to the popular crime novels written by Pierre Souvestre and Marcel Allain between 1911 and 1913, which were adapted into a film in 1913 by Louis Feuillade, followed by many other subsequent productions. Both the books and the films held a marvellously macabre fascination for the Surrealists, and are frequently referred to in their art and writings. Fantômas was personified by a mysterious and deadly character in nineteenth-century attire, and most famously a top hat, who can be seen right of centre in Brauner's painting. Here he appears as the ghoulish coachman of a strange mechanical contraption, seemingly yoked to a bull. This construction appears in other works from the early 1930s; as here, it occasionally forms a conduit between man and beast. The machinery possibly relates to Brauner's dadaist work of the 1920s, when he contributed to the Romanian Dada magazines *Integral* and *Unu*. In his later works it evolves into forms which allude to the communicating vessels of alchemy.

Victor BRAUNER

The Strange Case of Mr K

L'Étrange cas de Monsieur K

1934

Oil on canvas

81 × 100 cm [32 × 40 in]

Private collection

This painting was exhibited at Brauner's first solo show in Paris (Galerie Pierre, 1934). In his catalogue preface, Breton identified the persona with Ubu, the central satirical figure in the writings of Alfred Jarry (1873–1907). The title might also allude ironically to the everyman figure, Josef K, in Franz Kafka's novel *The Trial* (1925). Breton felt it appropriate that this painting should confront the viewer at the exhibition's entrance: 'It is not without reason that Mr K, criss-crossed by medals, masses, prostitutes and machine guns, displays at the entrance to this exhibition a belly comparable to the one that Alfred Jarry had already tattooed to represent a target. This explicit image long ago ceased to make us laugh. Brauner's vision scores a bull's-eye on it each time.' ('Victor Brauner', *Surrealism and Painting*.) Forming a grid of morphological transformations of this character, the various incarnations imply an attack on bourgeois roles that recalls German Dada. Despite the figure's ostensibly European appearance, Evan Maurer has drawn attention to its similarity to a Polynesian statuette ('Dada and Surrealism', in *Primitivism in Twentieth Century Art*, 1984).

above

Alberto GIACOMETTI

Woman with Her Throat Cut

Femme égorgée

1932.

Bronze

21.5 × 82.5 × 55 cm [8.5 × 32.5 × 22 in]

Collection, Scottish National Gallery of Modern Art, Edinburgh

This outstretched, sprawling body, part of which is jointed and can be repositioned, combines the appearance of a creature halfway between a scorpion and an unspecified type of insect with the representation, conveyed by the title, of a woman with her throat cut. Unsettlingly ambiguous, the arching of its back has been seen as an evocation of sexual ecstasy as much as an expression of extreme pain. Giacometti's text '*Hier, sables mouvants*' ('Yesterday, the Quicksands') published in *Le Surréalisme au service de la révolution*, 5, in May 1933, culminates in a disturbing fantasy of rape followed by murder. The image of a scorpion might have been suggested by the found footage of a nature documentary on these creatures which opens Buñuel and Dalí's film *L'Âge d'or* (1930). The castration-like wounding of the exaggeratedly long neck suggests an inversion of the trait observed in a species of praying mantis when in captivity, where the female bites off the neck of the male after mating. The symbolic significance of these insects' forms and behaviour fascinated the Surrealists (at this time Breton had several caged specimens), and was later discussed by Roger Caillois in his article '*La Mante religieuse*' ('The Praying Mantis'), *Minotaure*, 5, February 1934.

opposite

Hans BELLMER

Machine-Gunneress in a State of Grace

La Mitrailleuse en état de grâce

1937

Hand-tinted gelatin silver print, paint

65 × 65 cm [25.5 × 25.5 in]

Collection, San Francisco Museum of Modern Art

Unlike Bellmer's series of dolls, which were repeatedly reassembled and photographed, this is a singular creation but its articulated joints allow for endless manipulation and variations of pose. Bellmer posed it for this photograph which he worked on with paint in addition to dye tints. Here the figure is seen in a tightly composed, vertical posture, differing from other photographs of it by the artist and others. The nippled breast forms are not immediately apparent as such, appearing more like echoes of the central ball-joint, and through angle, foreshortening and perhaps some overpainting, the crevassed buttocks which form the top of the head have become no more than a soft curve, making a heart shape. Also particular to this image, a part of the wooden limb structure has been placed, phallus-like, between the 'legs'. The sinister figure combines the associations of fragmented body parts; a kind of robot, automaton or military armature; and a stick insect or mantis-like creature. Rosalind Krauss draws attention to its frozen posture, referring to Roger Caillois' influential text '*La Mante religieuse*' (*Minotaure*, 5, 1934) where his description of the mimicry by the praying mantis of its dead state suggests 'a chilling portrait of life's mechanical double, the android simulation of the living being.' (*The Optical Unconscious*, 1994.) Hal Foster connects this work with a critique of fascistic, sado-masochistic idealizations of the armoured body. At the exhibition of 'degenerate art' in 1937, the greatest condemnation was reserved for images that 'disfigured' the body. 'Had they known them, the Bellmer dolls would have provoked the Nazis even more profoundly, for not only do they shatter all sublimatory idealisms, but they also attack fascist armouring with the effects of sexuality.' (*Compulsive Beauty*, 1993.)

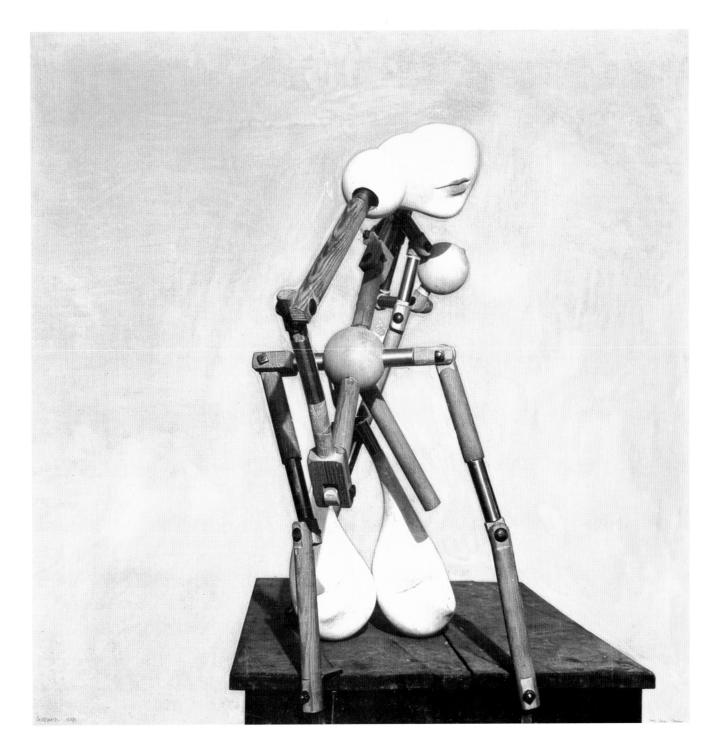

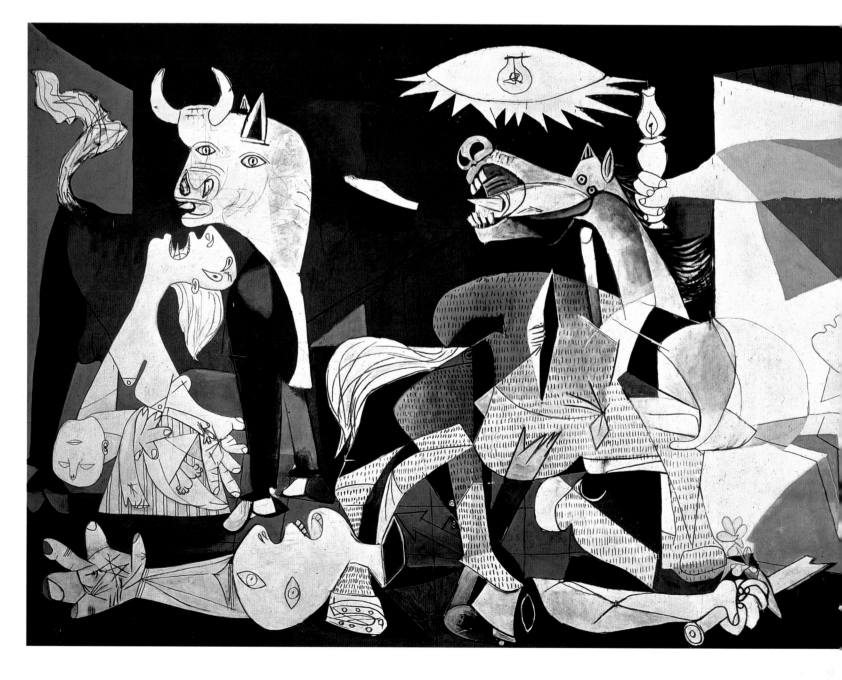

Pablo PICASSO

Guernica

1937

Oil on canvas

349.5 × 776.5 cm [137.5 × 306 in]

Collection, Museo Nacional Centro de Arte Reina Sofía, Madrid

Guernica portrays the horrific devastation of the Basque town of Guernica, the first mass bombing of a peaceful civilian target, perpetrated by Nazi allies of the anti-republicans on 27 April 1937 during the Spanish Civil War. That January, Picasso had been commissioned to paint a mural for the Spanish Pavilion at the forthcoming International Exhibition in Paris, intended as a celebration of modern technology. When the news of the atrocity was reported in Paris, he began the first sketches for the huge mural, completed in three weeks and exhibited at the Spanish Pavilion in June. Afterwards, *Guernica* was exhibited in Scandinavia, England and the United States to warn of the threat of Fascism. In 1939 Picasso requested that it be held on extended loan at the Museum of Modern Art, New York, not to be returned to Spain until democracy was restored. It was returned on the centenary of his birth in 1981. In a composition that echoes great religious and historical paintings of the past, Picasso depicts the chaos and horror of the market day bombing through imagery which fuses the brutality of the event with symbols from other dimensions of experience. From the right, terrified women rush into the central violence of the street from burning houses, and on the far left a mother holds her dying child. Picasso's recent incorporation of Mithraic mythological symbols into his art is evident here in the images of the bull, the sun and the horse; allusions to sacrifice that echo the symbols of Spain. The monochrome grisaille effect of the painting evokes the black and white photographs and newsreels which were the sources of information. Elizabeth Cowling analyses the influence these may have had on the narrative structure of the work (*Picasso: Style and Meaning*, 2002). In the summer of 1937, Christian Zervos devoted a complete issue of *Cahiers d'Art* (Vol. 12, No. 4–5) to the development of the painting, documented by Picasso's lover, the photographer Dora Maar. Zervos wrote of 'the violent reaction of a man when events make him suspect some scheme that undermines and questions the very order of humanity'.

Dora <u>MAAR</u>

Le Simulateur

The Simulator

1936

Gelatin silver print collaged on card, photomontage

49 × 35 cm [19.5 × 14 in]

Collection, Musée national d'art moderne, Centre Georges Pompidou, Paris

Dora Maar's surrealist compositions frequently place enigmatic figures in desolate or disrupted architectural settings. *Le Simulateur* is a composite image: the figure of the boy was taken from a contemporaneous photograph by Maar of children playing in the street, in which the boy is seen performing a one-handed handstand against a wall. The dark architectural setting of the photograph has been identified as either the vaulted ceiling of the Orangerie at Versailles or the cloister at Mont Saint-Michel. The image of the vault has been upturned so that the curvature of the ceiling creates a spiralling, sewer-like space, the contour of which is echoed in the contorted body of the boy, who appears to be smiling demonically, adding to the sinister ambience. Through the subtle revolving of the two images 'Maar achieved a curiously stable appearance of the unstable'; the 'blind windows and the curved floor created by the reversed image may cause a certain vertiginous feeling, a sense of a disturbing dream-like space'. (Victoria Combalía, 'Dora Maar: Life and Work', *Dora Maar Fotógrafa*, 1995.)

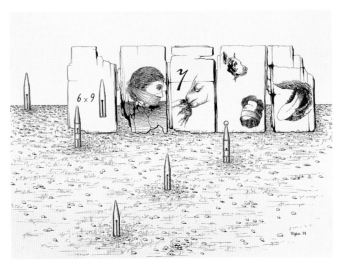

<u>TOYEN</u>

Shooting Gallery

Strelnice

1939-40

India ink on paper

2 from the series of drawings, 28 × 42.5 cm [11 × 17 in] each

Private collection

Toyen's series of drawings, collectively titled *Shooting Gallery* (or *The Rifle Range*) was made during the Nazi occupation of Czechoslovakia, which brought the public activity of the Prague Surrealists to a standstill. *Shooting Gallery* was followed by another series, *Hide! War*. They were published together in 1946 accompanied by Jindrich Heisler's poetic texts. In one drawing, the solitary figure of the child, reminiscent of Lewis Carroll's Alice, is depicted surrounded by the torn fragments and feathers of a bird, a recurring motif in Toyen's work. In the other drawing shown here, a number of illustrations are transposed onto a ruined wall, giving the impression of a child's text-book or school manual. The series makes no explicit reference to war, yet is infused with the desolate atmosphere that reflected Toyen's response to the events tearing Europe apart. Here, as Karel Teige, the Prague group's leader, wrote in his preface to the 1946 edition, 'the world of childhood is confronted by the world of war'.

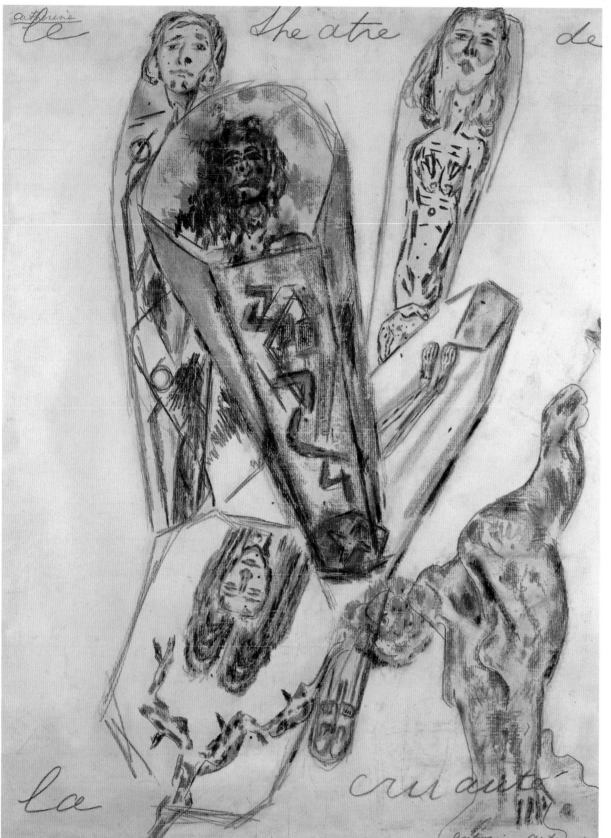

Antonin ARTAUD
The Theatre of Cruelty
Le Théâtre de la cruauté
c. March 1946
Graphite and wax crayon
63 × 46 cm [25 × 18 in]
Collection, Musée national d'art
moderne, Centre Georges Pompidou,
Paris

'My drawings are not drawings but documents. You must look at them and understand what's *inside* ... I have stippled and chiselled all the angers of my struggle in view of a number of totems of being, and these miseries, my drawings, are all that is left ... '
– Antonin Artaud, *'Mes dessins ne sont pas dessins'*, Rodez, April 1946

This work, in which what appear to be multiple self-portraits of the artist are imprisoned in centrally converging, coffin-like forms, is part of a series made at Rodez, a psychiatric hospital south of Paris, between January 1945 and May 1946. In 1938 Artaud had been diagnosed with 'incurable paranoid delirium', institutionalized and subjected to repeated electro-convulsive therapy. From 1943, encouraged by Dr Gaston Ferdière, he began to make drawings 'activated' by fragmentary texts. In a letter to Ferdière of 18 October 1943, he connected this project with his experimental work in 1930 at the Théâtre Alfred Jarry, where he had created photomontages of tableaux vivants in which sections of limbs and decapitated bodies were strewn across a theatrical space. Artaud's notion of a theatre of cruelty derived from his study of works such as the *Tibetan Book of the Dead* and non-western performance and ritual, in particular Balinese performers he saw in Paris in 1931 and Tarahumara ceremonies he witnessed in Mexico in 1936. This theatre would use 'the nervous magnetism of man to transgress the ordinary limits of art and speech, in order to realize actively, that is *magically in real terms*, a kind of total creation, in which man can only resume his place between dreams and events'.
– Antonin Artaud, *Selected Writings*, 245

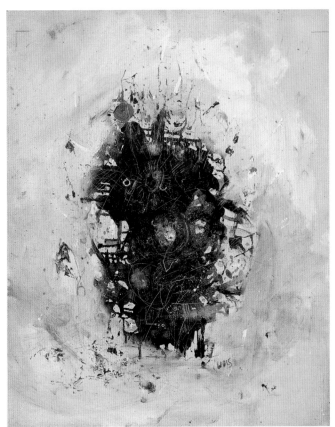

WOLS
Composition/Untitled
1946-47
Oil on canvas
81 × 65 cm [32 × 25.5 in]
Private collection

This work dates from Wols' first experiments with oil painting, encouraged by the Paris art dealer René Drouin who exhibited his first canvases in 1947. Wols' transition to this medium is marked by his heightened physical engagement in the process of painting, by means of a form of automatism. He became familiar with the Surrealists in 1930s Paris when he worked mainly as a photographer, at the end of that decade producing a number of Klee-like ink and watercolour drawings which he referred to as his 'surrealist' works. During the 1940s Wols was forced to remain in France. There he developed a highly personal style of drawing and painting which was crucial in the development of *informel* abstraction, and drew him closer to existentialism. Like Michaux, Wols was influenced by Taoism, both in his art and his aphoristic statements, such as 'To see means to close one's eyes'. This is further reflected in his contemplation of the microscopic and the macroscopic, the energy and flux of matter: 'The universe is a unity making itself manifest through an infinite number of relative phenomena in part accessible to our senses (in their relativity). Only through things do we sense the unity.'
– Wols, *Aphorisms and Pictures*, trans. Peter Inch and Annie Fatet, 1971

Henri MICHAUX
Mescaline Drawing
1957
India ink on paper
39 × 26 cm [15.5 × 10 in]
Private collection

On the periphery of Surrealism and critical of its methods such as automatism, Michaux was, like Artaud, a poet and writer who explored drawing and painting as a means of reaching towards a new language, unfettered by the limits of the verbal. From 1954–62 he worked under the influence of the hallucinogenic drug mescaline, experimentally recording its bodily and psychological effects in writings and drawings. The drawings communicate what he called the 'infinite turbulence' of the trance-like process, yet here, rather than the constellations of half-identifiable forms which characterized, for example, Masson's automatic drawings of the 1920s, what emerges is a rhythmic, repetitive field of randomly variable, indecipherable pen-strokes, spreading like an excrescence across the sheet of paper. Elated by a feeling of transcending the finite, an effect of the wave-like vibrations of consciousness induced by the drug, Michaux also became aware of the 'robotic', inhuman aspect of his suspension of will (*Misérable Miracle*, 1963) and the inadequacy of drawing to record his experience. What he felt the drawings did convey was a 'process of infinitization through the infinitessimal'. (*Henri Michaux*, 1959.) 'By concentrating the drawing hand and the eye down to minute strokes and dots' each drawn sheet seems suspended in a 'relative and arbitrary position between the scales of microcosm and macrocosm'. (Guy Brett, *Force Fields*, 2000.)

INFINITE TERRAINS

For the philosopher of science Gaston Bachelard the only limit to our perception of the world lay in the poetic potential of our imagination. Before him the poet Stéphane Mallarmé believed that the ideal *mise-en-scène* of any theatre was set just there: a theatre of the mind. These conceptions merge in the haunting terrains that characterize much of Surrealism from the late 1930s onwards – the visual rephrasings of places of encounter that have chosen us, as we think we have chosen them. Whether harbouring otherness, infused with longing, or charged with the energy of Eros, these 'inscapes' rush towards forms of self-realization.

Max ERNST
Capricorn
1947-48
Cement
h. 240 cm [94.5 in]
Partially destroyed; second version cast in bronze, France, 1964
Photograph by John Kasnetzkis of Max Ernst and Dorothea Tanning with *Capricorn*, Sedona, Arizona, 1948

Ernst situated this monumental group of figures, considered to be his most important sculpture, in front of a view of the landscape from the grounds of the home he shared with Dorothea Tanning in Sedona, Arizona. The eyeless, animal-headed, male central figure holds a totemic staff in his right hand, while two creatures perch at his left side. The moon-headed female is without arms; her legs fuse to form a mermaid-like fish tail. Their forms recall ancient styles of carving from various cultures. Ernst referred to the work as a 'family portrait', and in this photograph the artist couple seem to complete the ensemble, adding a further dimension to its symbolism. The sculpture is a synthesis of occult, mythological and astrological icons, as well as a development of Ernst's personal iconography. Images of king and queen appear in a number of his works and have been read as alchemical symbols of masculinity and femininity that become united into a single androgynous being. 'The male figure is not only the "king" of the chess game but also the symbolic bull and goat of the zodiac. Metamorphosis and rebirth are associated with Capricorn, as are fertility, Bacchus and rock (including cement) … Ernst used the astrological fish motif in the fish-tailed "dog" on the king's arm and in the mermaid form of the queen, whose "bone" head ornament is equally a fish.' (Lucy R. Lippard, 'Max Ernst and a Sculpture of Fantasy', *Art International*, XI, 1967.)

Max ERNST
Day and Night
Le Jour et la nuit
1941-42
Oil on canvas
112 × 146 cm [44 × 57.5 in]
The Menil Collection, Houston

This is among the first paintings Ernst completed after his arrival in New York the previous year. Its origins lie in occupied France, 1939–40, where between being interned twice in a prison camp he adapted the decalcomania technique to create fantastic landscapes with similar rock formations which are desolate yet teeming with half-emerging forms. Here for the first time the scene is nocturnal but pierced with 'daylight' sections which might equally evoke searchlight beams. The landscape 'is invaded by a multitude of framed images, some propped up on the flank of a rock, others suspended in mid-air against a mineral pillar, each seeming to propose possible transformations of the view. The play of perspective and transparency animates the painting like the rocking of a boat on a choppy sea – the viewer beckoned to, in turns, by these unequally disposed planes, and cast adrift by their disparities of scale.' (Patrick Waldberg, *Max Ernst*, 1958.) These framed pictures within the picture – a device used earlier within Ernst's collage novel *Une semaine de bonté* (1934) and the *Loplop* series – here disrupt any coherent optical navigation of this imaginary terrain.

TOYEN

La Dormeuse

The Sleeper

1937

Oil on canvas

81.5 × 101.5 cm [32 × 40 in]

Several of Toyen's paintings of the late 1930s depict a solitary figure in a desolate landscape. Here the image of a young girl holding a butterfly net is created through a collage-like assembly of forms. The hollow figure whose face cannot be seen is like a ghostly apparition, pointing towards a horizon darkened by the onset of night. With her net held aloft, she seems to wait in vain for butterflies in this empty, dreamlike terrain. Breton later described Toyen's work of this year as 'purely spectral' (*Toyen*, 1953). Karel Srp has noted a similar theme in a 1928 poem by Toyen's contemporary the Czech surrealist writer Vítěslav Nezval, titled 'The Chaser of Images' (*Toyen: une femme surréaliste*, 2002).

Frida KAHLO

What the Water Gave Me

Lo que el agua me ha dado

1938-39

Oil on canvas

88 × 69 cm [34.5 × 27 in]

Private collection

Kahlo's painting depicts her legs and feet in a bathtub of water from which an assembly of hallucinatory images drawn from her life and art rise up like steam before her; images of herself, her clothes, the flowers of Mexico, symbols of sexuality and death. Breton visited Kahlo and Diego Rivera's home in San Angel, Mexico, in the spring of 1938. He saw Kahlo's work as intuitively surrealist and was amazed that she could have reached such 'pure surreality' without having any awareness of the movement. *What the Water Gave Me* is referred to in Breton's essay on Kahlo in *Surrealism and Painting* as the work she was completing when he arrived in Mexico. It 'illustrated, unbeknown to her, the phrase I had once heard from the lips of Nadja: "I am the thought of bathing in a mirrorless room".' This work also illustrates Breton's 'The Most Recent Tendencies in Surrealist Painting', *Minotaure*, 10-12, May 1939. Kahlo opposed Breton's attempts to include her in the movement; however, 'although she insistently denied she was a Surrealist, her encounter with Surrealism in the late 1930s strengthened the psychological content of her painting and increased her reliance on symbolic imagery.' (Whitney Chadwick, *Women Artists and the Surrealist Movement*, 1985.)

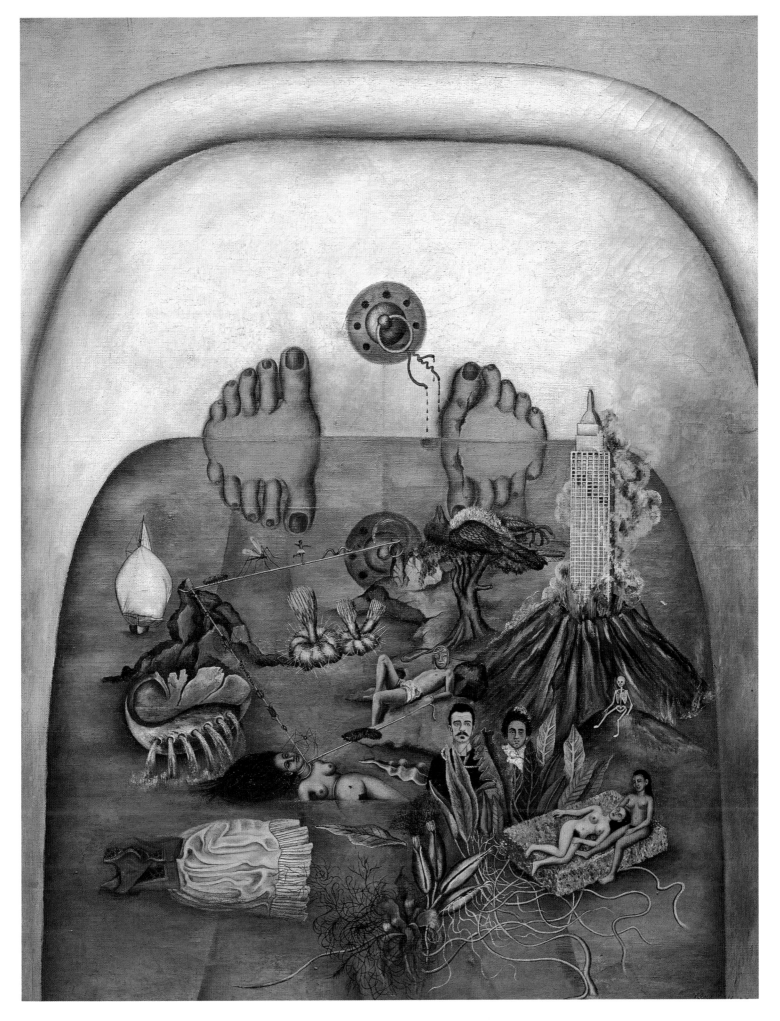

Roberto MATTA

Untitled

1938

Coloured crayon on paper

49.5 × 65 cm [19.5 × 25.5 in]

Private collection

Originally trained as an architect in Chile, Matta moved to Paris in 1933 and worked in Le Corbusier's office. He first became interested in surrealist ideas in 1936 and the following year was introduced to Breton, who included four 1937 drawings, similar to this one, at the *Exposition Internationale du Surréalisme* in 1938. They were given subtitles such as 'Elasticity of intervals' and 'Infusionary pulsions of the sun'. Matta continued making these drawings, viewed as a major development from automatism, throughout 1938. They are characterized by swirling masses which appear to wrap around, press against each other or interpenetrate, often resembling seeds and other biological as well as cosmic forms. These images arose from his theory of psychological morphology, presented to the Surrealists in autumn 1938. Using examples of transformation and metamorphosis in nature, such as the growth of a seed into a tree, in which forms constantly evolve under pressure until reaching maturity followed by decay, he related these processes to the psychological development of the individual throughout life. Matta's notion of morphology was all-encompassing and included language as well as visual forms. He frequently invented neologisms to describe what his drawings and paintings portrayed: 'The object, at each risk of interpenetration, may oscillate from pointvolume to moment-eternity, from attractionrepulsion to pastfuture, from lightshadow to mattermovement.'
– Roberto Matta, *Morphologie psychologique*, 1938

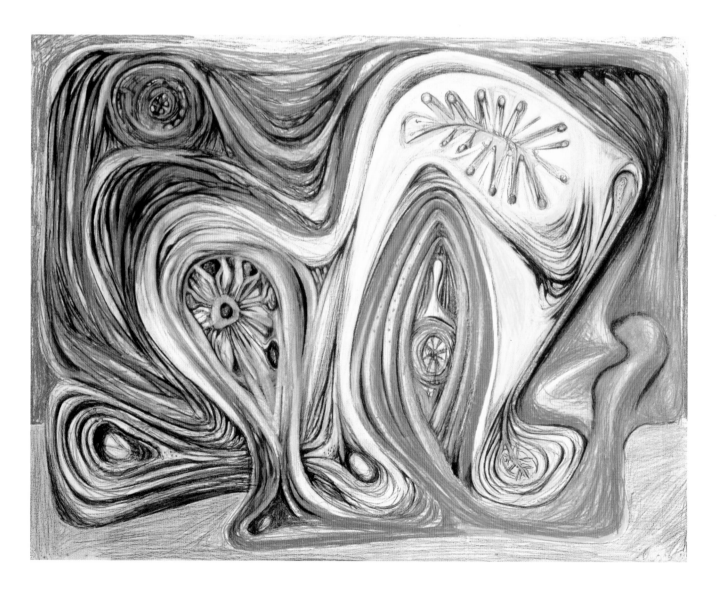

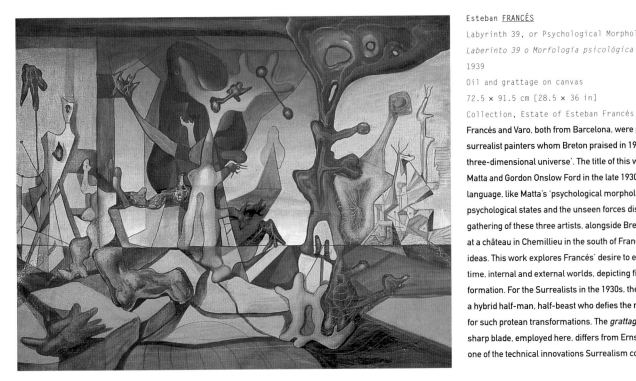

Esteban FRANCÉS

Labyrinth 39, or Psychological Morphology

Laberinto 39 o Morfología psicológica

1939

Oil and grattage on canvas

72.5 × 91.5 cm [28.5 × 36 in]

Collection, Estate of Esteban Francés

Francés and Varo, both from Barcelona, were part of the second generation of surrealist painters whom Breton praised in 1939 for their 'yearning to transcend the three-dimensional universe'. The title of this work reflects Francés' closeness to Matta and Gordon Onslow Ford in the late 1930s, and his exploration of a formal language, like Matta's 'psychological morphology', which would represent complex psychological states and the unseen forces discovered by modern physics. The gathering of these three artists, alongside Breton and Tanguy, in the summer of 1939 at a château in Chemillieu in the south of France, was crucial in the evolution of these ideas. This work explores Francés' desire to explode the boundaries of space and time, internal and external worlds, depicting figures in the process of a primordial formation. For the Surrealists in the 1930s, the labyrinth of the mythical Minotaur – a hybrid half-man, half-beast who defies the natural order – becomes a symbolic site for such protean transformations. The *grattage* technique of scraping paint with a sharp blade, employed here, differs from Ernst's technique of the same name and is one of the technical innovations Surrealism continued to generate during this period.

Remedios VARO

Vegetal Puppets

Titères vegetales

1938

Oil and wax on canvas

90 × 80 cm [35.5 × 31.5 in]

Private collection

Vegetal Puppets was created through Varo's experimentation with automatic techniques. First wax was dripped onto a surface. The forms suggested by the wax were then elaborated – in a similar way to the *fumage* works of Wolfgang Paalen which began as traces of smoke – by the working up of the image in paint, adding faces, stalks, leaves, hands, and so on, where they were suggested by the traceries of dripped wax. These hybrid forms recall Ernst's creatures which combine human with animal, plant and sometimes mineral forms, and these in turn echo the grotesques in earlier periods of art. Varo's version of biomorphism is informed by her researches into science, psychoanalysis and alchemy; subject matter which she explored more overtly in her later works. The animated world of metamorphosis in this painting suggests imagery such as Raymond Roussel described in his account of 'Bertha, the Child-Flower', a 'half-human, half-vegetal' child born of a woman impregnated with flower pollen' (manuscript for *Locus Solus, c.* 1918). Varo's work heralds the 'magical realism' in Latin American culture which emerged partly from surrealist origins.

Jacqueline <u>LAMBA</u>

C'est le printemps malgré tout
It's Spring, Despite Everything
1942
Oil on canvas
111 × 154.5 cm [43.5 × 61 in]
Private collection

Lamba was deeply involved with literature, from Symbolism to Surrealism. Her mystical approach to painting encourages at once the radiant optimism of this Spring painting and the later *Toujours Printemps* (*Still Spring*), with its ironic title: still now, and in spite of everything, and its darker half. She developed this form of painting in the late 1930s and early 1940s. In its creation of a kind of 'inscape', a term Matta borrowed from the poet Gerard Manley Hopkins, her work of this period shares some affinities with Matta's notion of psychological morphology, while arising from her own luminescent vision of budding, unfolding and crystallizing forms. Lucid always, she destroyed much of her early work she found not up to her standard, and in 1948 wrote in her journal that she was 'no longer painting surrealism' (quoted in Salomon Grimberg, 'Jacqueline Lamba: From Darkness, with Light', *Women's Art Journal*, 22: 1, Spring/Summer 2001).

André <u>MASSON</u>

Paysage Iroquois
Iroquoian Landscape
1942
Oil on canvas
77.5 × 101.5 cm [30.5 × 40 in]
Private collection

When Masson settled in Connecticut in the early 1940s he abandoned the almost sculptural modelling, harsh colours and overtly violent themes of his preceding paintings and returned to his earlier exploration of evolving, germinating forms, now in canvases reminiscent of 'a stained-glass window caked with mud through which only the most brilliant light can penetrate' (Otto Hahn, *André Masson*, 1965). The deep browns and blacks of the background evoke the earth as the source of growth and regeneration. The symbolic forms, suggesting growing plants, roots, tendrils, insects, are derived as much from observation as from the imagination, as Martica Sawin notes, citing Masson's descriptions of the rich, dark soil and, compared with their European counterparts, gigantic flora and fauna by which he was surrounded (*Surrealism in Exile*, 1995). In his description of *Meditation on an Oak Leaf* of the same year, which shares similar characteristics, William Rubin noted how 'the perfect jig-sawing of flattened shapes allows the eye to pass easily from one to the other' so that 'the imagery that suggests the way the artist's mind wanders' as it meditates on these forms is deeply integrated with the formal structure (*Dada and Surrealist Art*, 1968).

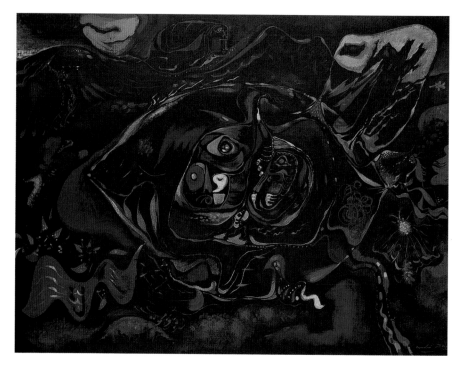

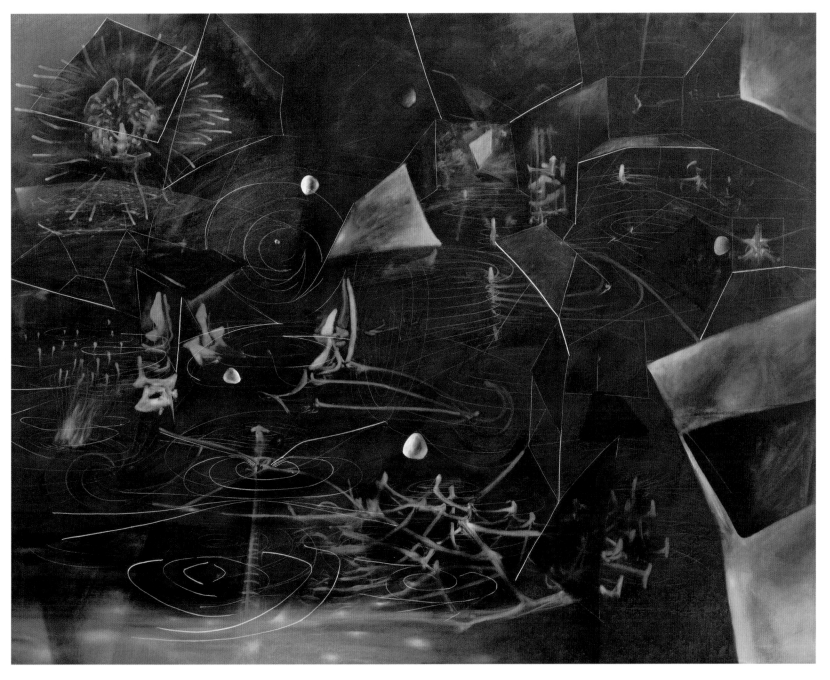

Roberto MATTA

The Vertigo of Eros
Le Vertige d'Eros
1944
Oil on canvas
195.5 × 251.5 cm [77 × 99 in]
Collection, The Museum of Modern Art, New York

In this painting's title Matta implicitly relates the erotic drives to vertigo, a condition associated with unconscious fears, manifested not by paralysis but an involuntary desire to fall. Vertigo is an example of our psychological condition manifesting itself in direct relation to our surrounding physical space, a central preoccupation for the artist which originated in his linking of architectural space and perspectival drawing with the spatial analogies of Freud and Kierkegaard. As Claude Cernuschi has written (in *Matta: Making the Visible Invisible*, 2004), Matta was well versed in Freudian theory and was introduced to Kierkegaard's ideas in the late 1930s through his friend Lionel Abel. Freud several times compared the psychoanalytic process with the excavation of a buried city; Kierkegaard made analogies between the human condition and the state of dwelling in different rooms in a house. In works such as *The Vertigo of Eros*, the spatial effects are highly complex and elusive. As Cernuschi observes, these 'warped spaces suggest the turbulence of emotions and the mutability of psychological states'.

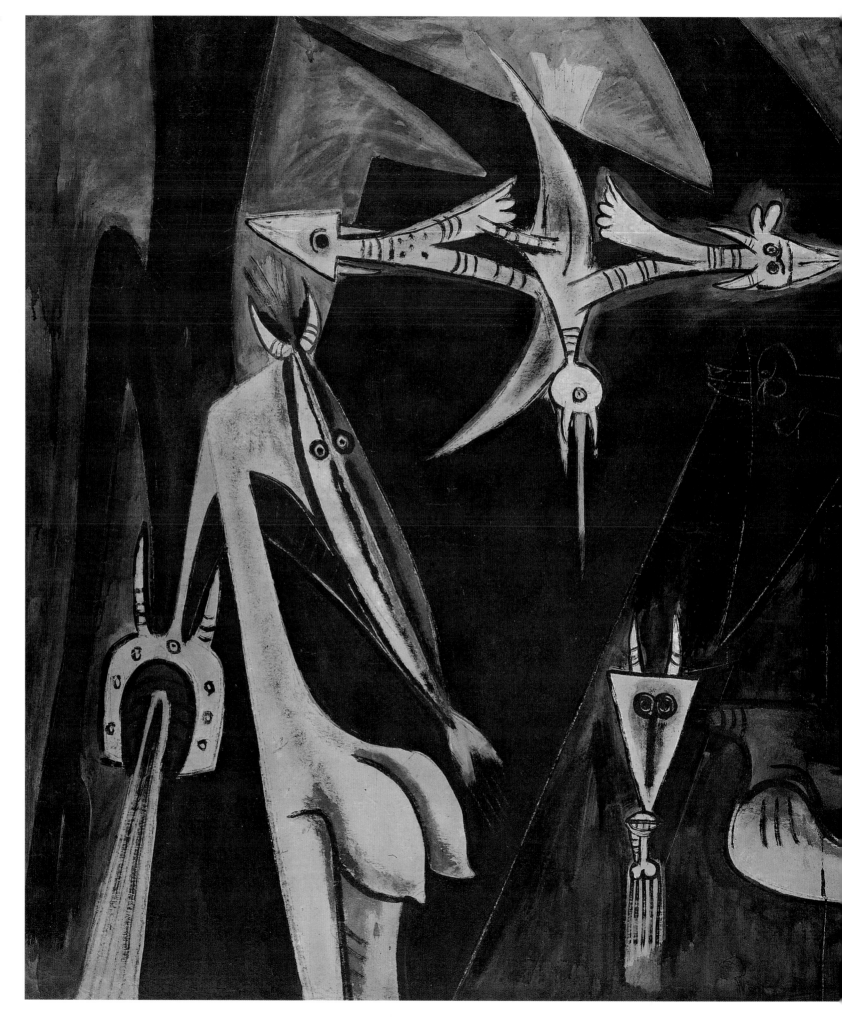

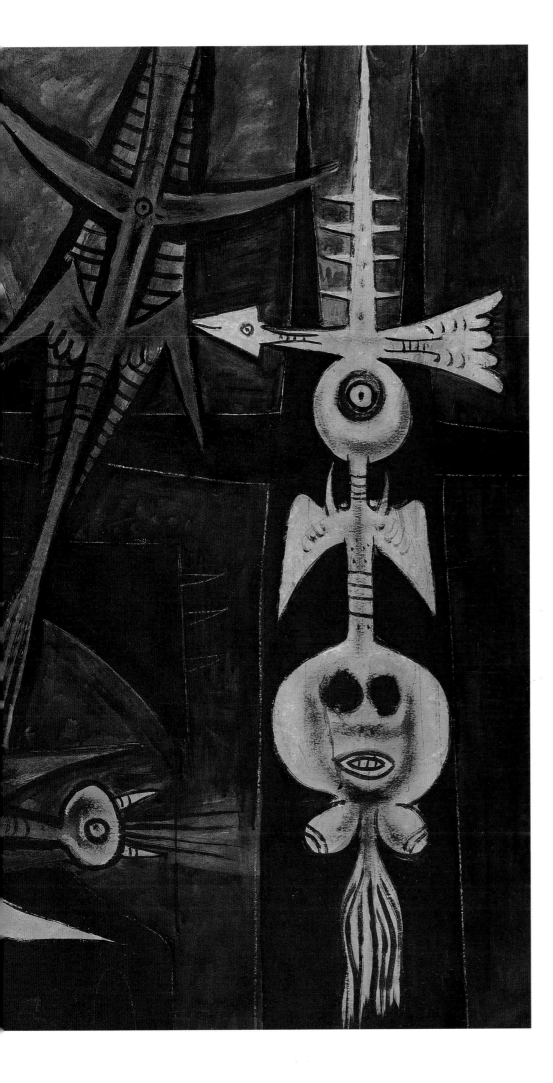

Wifredo LAM
The Gathering
La Réunion
1945
Oil and white chalk on paper
mounted on canvas
152 × 212.5 cm [60 × 84 in]
Collection, Musée national d'art
moderne, Centre Georges Pompidou,
Paris

Haïtian religion, ritual and magic began
to figure in Lam's work after his first trip
to Haïti with Breton in 1944. As a child
in Cuba, Lam had been initiated by his
godmother into the religious system
of Santería, a synthesis of African belief
systems and Catholicism. In Haïti he
encountered the Voodoo religion, which
influenced later works where he depicts
monstrous anthropomorphic forms,
beset by evil spirits. *The Gathering*
suggests a nocturnal, possibly ritual
meeting of people, animals and spiritual
entities in dense natural surroundings.
While the style of painting is close to that
of Lam's mentor, Picasso, it explores
a different world from his. Different
orders of reality appear united in the
scene; natural, magical, historical and
unconscious, creating an impression
of access to a secret order of things,
a world inhabited by the *Orisha*, or
ancestral spirits. Writing of his complex
position between native influences and
European modernism, Lam wrote of his
refusal to paint 'the equivalent of the
pseudo-Cuban music for nightclubs';
his desire to 'act as a Trojan horse that
would spew forth hallucinating figures
with the power to surprise, to disturb
the dreams of the exploiters.'
— Wifredo Lam, statement quoted in
Max-Pol Fouchet, *Wifredo Lam*, 1989

Joseph CORNELL
Toward the 'Blue Peninsula' (for Emily Dickinson)
1951-52
Wood, wire, paint, glass, in wooden box construction
38 × 27 × 10 cm [15 × 10.5 × 4 in]
Private collection

The wire mesh, the structure like a perch on the right, and another like a feeding bowl on the left, suggest a bird cage, as in Cornell's aviary series, but if the thought of a bird is evoked it is through absence. An opening in the mesh draws viewers and their thoughts towards the window which frames an expanse of blue. The white-washed interior has the atmosphere of Cornell's dovecotes, where the doves, as Walter Hopps describes them, may be 'carriers of spirit' (*Joseph Cornell: Shadowplay Eterniday*, 2003). Like Cornell, the poet Emily Dickinson worked reclusively in her family home. The title is drawn from the final stanza of Dickinson's poem no. 405 (*The Poems of Emily Dickinson*, 1958):

It might be easier
To fail
with Land in Sight
Than Gain
My Blue Peninsula
To perish
of Delight

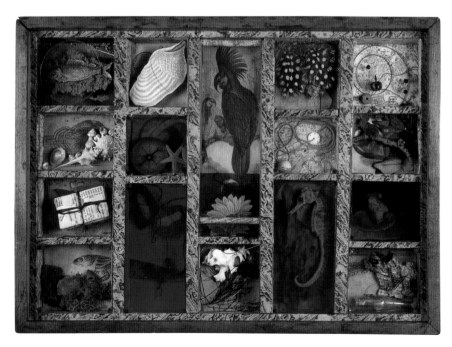

Joseph CORNELL
Solomon Islands
1940-42
Wood, collage, compasses, found objects, coloured glass, in wooden box construction
6.5 × 44.5 × 32 cm [2.5 × 17.5 × 12.5 in]
Private collection

left, interior with tray of compasses removed; *opposite*, open box
This belongs to the small group of works Cornell referred to as 'sailor's boxes'. It is backed by a map of the Solomon Islands in the South Pacific, named after the biblical king by the Spanish explorer Álvaro de Mendaña de Neira in 1568, due, it is thought, to the natural wealth and harmony he found there. The upper compartment contains twenty small compasses, each inscribed in Latin. The individual compasses and the whole compartment can be removed to reveal a further divided box below. Its sections, behind richly coloured panes of glass, contain objects and printed scenes which draw on Cornell's reveries of voyage and exploration, further evoked by the old maps and prints found in flea markets and dime stores, which become the frame and background of each gathering. The compasses allude to navigation by the stars, with its drawing together of the terrestrial and celestial spheres.

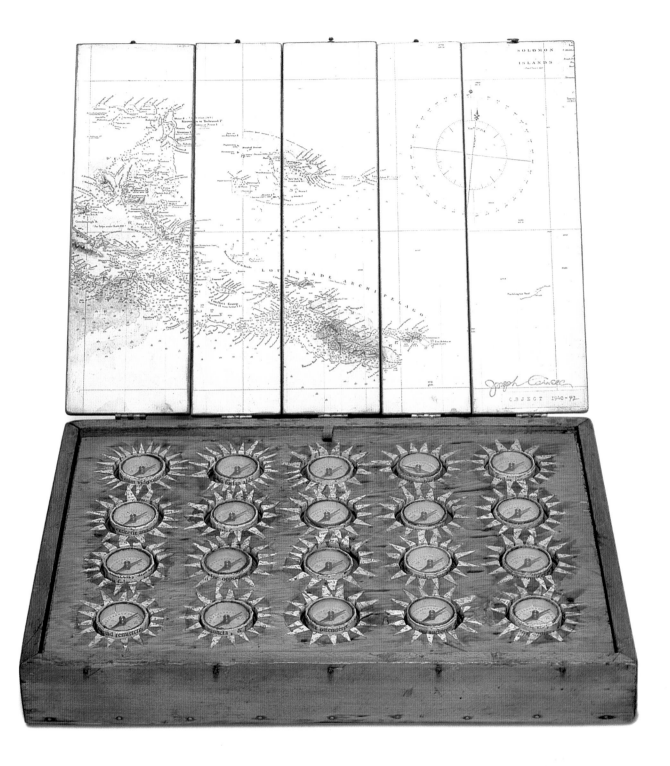

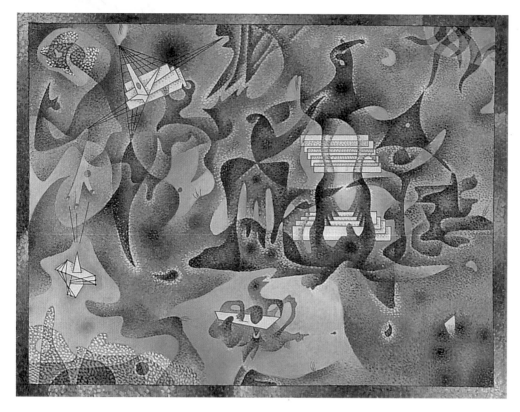

Gordon ONSLOW FORD
The Circuit of the Light Knight through the Dark Queen
1942
Oil on canvas
96 × 125 cm [38 × 50 in]
The Lucid Art Foundation, Inverness, California

This composition was painted in Erongarícuaruaro, Mexico, where Onslow Ford
moved in 1941. The experience of living there had a profound effect on his painting,
providing him with new inspiration after the previous year in New York, where he
had been giving lectures on Surrealism at the New School for Social Research.
The canvas took around six months to complete and is painstakingly executed in
a pointillist technique, layered to produce an intensely luminous effect. It reflects
the artist's immersion in both the natural landscape of Mexico and the pantheistic
thought of the native Tarascan Indians, depicting a world of organic and symbolic
forms in a state of elemental harmony. It also evokes the figures of artist and muse,
symbolized by the central forms.

Arshile <u>GORKY</u>
Garden in Sochi, II
1941
Oil on canvas
112.5 × 158 cm [44.5 × 62 in]
Collection, The Museum of Modern Art, New York

Between 1938 and 1943 Gorky returned to this theme many times. This example is the second of two paintings of this title from 1941 which The Museum of Modern Art, New York, acquired soon afterwards. The museum asked Gorky to write a statement about the series, which he described as alluding to childhood memories of his family's garden in Van, an Armenian province on the Eastern border of Ottoman Turkey. There, his mother and other local women often used to place their breasts against a rock from which grew a tree believed to be sacred. From its branches fluttered strips of cloth which passers-by had torn from their garments, tying them there. The first works in the series show discernible traces of these forms and bear signs of the influence of Picasso and Miró. As the series progresses, the compositions become more abstract. In later examples, such as a third painting dated 1943 also in the same collection, Gorky's abstract expressionist style emerges, affected by the automatism and biomorphic abstraction he encountered in the company of the exiled Surrealists. In his catalogue preface for Gorky's 1945 show at the Julien Levy Gallery, New York, Breton drew attention to the 'free and limitless play of analogies' emanating from the forms whose origins lay in direct observation of nature but which gravitated towards the freely gestural, 'capable of acting as springboards towards the deepening, in terms of consciousness as much as enjoyment, of certain spiritual states'.

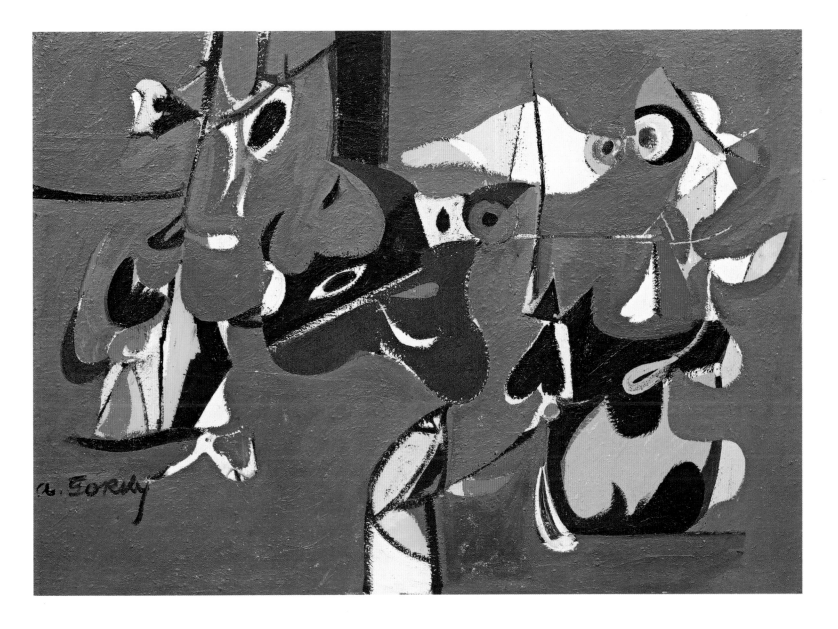

Wolfgang **PAALEN**

Tâches Solaires
Solar Flares
1938
Oil and fumage on canvas
129.5 × 99 cm [51 × 39 in]
Private collection

This painting arises from Paalen's technique of *fumage*, an automatic process he initiated in 1937, a year after joining the Surrealist movement. It involved passing a canvas over the smoke from a candle or oil lamp and then interpreting the forms suggested, often with the addition of painting. The wispy forms of *Tâches solaires* suggest a hallucinatory, skeletal horde floating across a crepuscular landscape. In 1937 Paalen had visited the forests of the Böhmer Wald, which revived childhood memories of his family home in that region, part of the former Prussian province of Silesia. This led to his work of that year, *Totemic Landscape of my Childhood*, echoed in his later text, 'Totemic Landscape', published in *Dyn*, the review he edited in Mexico, 1942–44. Here his recollected visions of the forest are evocative of *Tâches solaires*: 'I think of the fairy scene that happened overnight in my childhood. Between a single dawn and sunset of autumn a prodigious ascent of incalculable processions of "nones" laid waste a whole forest.' This image might also recall local folk traditions such as James Frazer described in his section on 'The Periodic Expulsion of Evil' in *The Golden Bough* (1922): 'In some parts of Silesia the people burn pine-resin all night long between Christmas and the New Year in order that the pungent smoke may drive witches and evil spirits far away from house and homestead.'

Kurt **SELIGMANN**

Melusine and the Great Transparents
Mélusine et les grands transparents
1943
Oil and tempera on canvas
74.5 × 61 cm [29.5 × 24 in]
Collection, The Art Institute of Chicago

The title of this painting reflects an absorption in mythology and occultism which intensified among the exiled Surrealists in the 1940s. Melusine is a figure from mediaeval French mythology: a beautiful mermaid-like woman with a serpent's tail. Her appearance in flight was considered an omen of misfortune. As a figure in surrealist texts and images Melusine often signifies transformations from one state to another. The idea of the 'great transparents' was first described by Breton in 1942 when in collaboration with Matta, Seligmann and others, he sought to develop a new cosmological concept, in defiance of the destructive times they were living in. In his 'Prolegomena to a Third Surrealist Manifesto, or not' (*VVV*, 1, June 1942) Breton suggested that 'man is perhaps not the centre, the focus of the universe'; there may exist 'above him, on the animal scale, beings whose behaviour is as strange to him as his may be to the mayfly or the whale'. It was possible, he speculated, that the structure of such beings could be likened to natural phenomena such as cyclones. Seligmann's quasi-automatic paintings of this period were described in an early exhibition of them as 'wrapped and cyclonic landscapes'. The forms in this and related paintings derive from a photographic technique he developed in which light is polarized through cracked glass. They might also recall the dramatic rock formations of the Grand Canyon, which he visited during this period.

Roberto MATTA

The Onyx of Electra

1944

Oil on canvas

127 × 183 cm [50 × 72 in]

Collection, The Museum of Modern Art, New York

The Onyx of Electra explores non-Euclidean geometry and the attempt to represent in a painting the environment hypothesized as four-dimensional space, where, for example, geometric forms such as a cube are extruded – in a way which is almost impossible to grasp intuitively – in yet another direction perpendicular to the first three (width, length and height), one of the four dimensions of this extruded form being neither width, length nor height. Breton discussed the spatial explorations in Matta's work in his 1941 essay 'The Most Recent Tendencies in Surrealist Painting' (*Surrealism and Painting*). In this period Matta abandoned the vibrant colours of the earlier works, adopting a more restricted palette as an adjunct to his complex linear depiction of space, form and motion, which suggests the dynamic interplay of both psychological and physical energy. Some of the forms in this painting recall the mathematical objects photographed by Man Ray and reproduced in *Cahiers d'Art* in 1936. In the classical Greek pantheon, Electra was the goddess of amber clouds. The work may also refer to the figure in Greek tragedy to whom Freud alluded in his classification of a female version of the Oedipus complex. Onyx derives from the Greek *onux* (fingernail). In one myth, Eros clipped the fingernails of Aphrodite while she was sleeping and scattered them onto the Earth below. The Fates transformed them into the veined chalcedony known as Onyx.

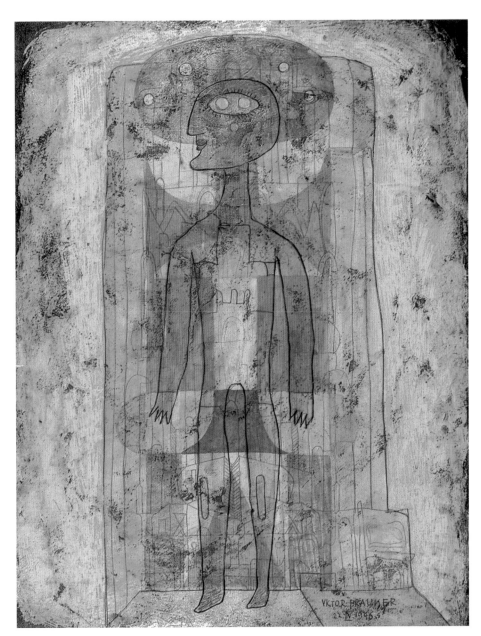

Victor **BRAUNER**

Oneiric Transmutation
Transmutation onirique
1946
Parafin wax and oil on panel
63 × 50 cm [25 × 20 in]
Private collection

Brauner first began working with wax in 1942 when taking refuge in the Alpine region during the Nazi occupation of France. In a 1943 letter to René Char, he described the new technique which he felt set 'in motion all the mysterious forces of the created image'. Initially adopted due to wartime scarcity, the process continued to be used and refined by Brauner when he returned to Paris in 1945. His work of this period is rich in mythopoetic symbolism from diverse occult and folkloric sources. Influenced by Karl Jung's work on archetypes and the collective unconscious, Brauner referred to the complex intertwining of myths and symbolic systems in his work as 'mythosensitivity'. *Oneiric Transmutation* depicts a figure superimposed on the fainter linear structures of a townscape. The image is intricately layered with lines and blocks of colour, which give the impression that the figure is rising above its normal habitation and transmuting into a kind of astral body. Oneirism is a term used in psychology to indicate a series of hallucinations induced, for example, while under the influence of alcohol or drugs. In Surrealism it is understood in a wider sense to denote all of the dreamlike phenomena which do not accord with, or which transform, the logical perception of the rational mind.

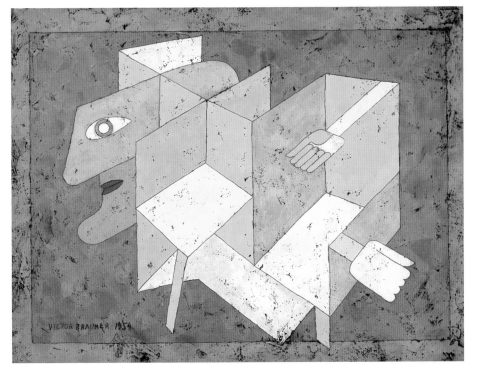

Victor **BRAUNER**

Box of Surprises
La Boîte à surprises
1954
Encaustic on paper
60 × 73.5 cm [23.5 × 30 in]
Private collection

In this work the flat shapes of a head, arms and hands emerge from a hybrid construction which looks like a combination of screens, free-standing sculpture, furniture, and a kind of architectural model of open walled spaces. With its outward gaze and its gesturing arms, the figure has a strongly realized presence which reads simultaneously as a flat, graphic image and as a perpectival representation of a three-dimensional form. Combining the styles of many indigenous and ancient cultures, Brauner's works of this period often depict hybrid beings composed of different elements – parts of human figures, animals, plants, symbolic forms and man-made constructions. In 1955 he collaborated with Matta on several drawings and paintings titled *Intervision*, where figures with heads and arms similar to the one depicted here gather to watch, and be addressed by, a hybrid creature which appears on a large screen. This reflected Matta's gravitation away from personal 'psycho-morphology' towards the 'social morphology' represented in Brauner's work by 'the cultural, totemic expressions of civilizations … the formations of cultures in confrontation with social landscapes'. (Roberto Matta, *Entretiens morphologiques, 1936–1944*, 1987.)

Kay <u>SAGE</u>
Journey to Go
1943
Oil on canvas
26 × 22 cm [10 × 9 in]
Private collection

Journey to Go depicts a terrain like a desert, with a clearly defined horizon. Two ghostly apparitions haunt the landscape: one, vertical and suggestive of a standing figure, could be formed of softly folded cloth or dangerously sharp stone, a red ball at its base suggesting some kind of life or interaction. The other spectral form seems suspended in motion, as in a photograph, while traversing the scene, gliding like a paper aeroplane. Both cast dark shadows which increase the ominous feel of the emptiness and the dusky sky. For part of her childhood Sage lived in San Francisco, where, as she later recalled, she lived in constant fear of earthquakes. The band receding into the landscape might suggest a fault line, a portent of imminent rupture.

Kay <u>SAGE</u>
All Soundings Are Referred to High Water
1947
Oil on canvas
91.5 × 71 cm [36 × 28 in]
Collection, Davison Art Center, Wesleyan University, Middletown, Connecticut

While Sage's paintings of the late 1940s retained the bleak landscapes of the previous years, their forms moved from the sculptural to the architectural. Large structures appear, similar to scaffolding, which suggest the ghostly atmosphere of towns abandoned in mid-construction. Muted in colour, her scenes are lit with a glacial clarity or an other-worldly glow. The scaffold imagery entered Sage's art in 1946 and would develop after her meeting with the exiled constructivist sculptor Naum Gabo, who the following year came to live near Sage and Yves Tanguy in Connecticut. This painting also recalls Sage's disturbing experience when living in Rome around 1930. She woke up one night to hear the sound of fire and a commotion of human voices outside her bedroom window. At the time the façade of the neighbouring Palazzo del Quirinale was covered in scaffolding, and Sage expected to see it engulfed in flames. On opening her shutters, however, she was confronted with silence, and the sight of the scaffold intact. The experience occurred several more times throughout the night. She later heard from a local priest that her experience was identical to that recorded in the memoirs of a French abbé in the sixteenth century.

Léonor FINI

Hip Bone

Os iliaque

n.d.

Oil on canvas

38.5 × 46 cm [15 × 18 in]

Private collection

Fini's work often refers to death and decay, reinventing the *memento mori* tradition in new contexts. In this image a hip bone, bleached and picked clean, is a still, almost monumental presence in the midst of an undergrowth creeping with life. Although its date is not known, the painting is characteristic of Fini's work of the mid 1940s, when she made meticulous studies from nature. She embarked on her study of the natural world in 1943 when she spent six months on the western Italian island of Giglio, where she made 'detailed and analytic compositions based on flowers, plants, insects, and debris thrown up by the sea' (Whitney Chadwick, *Women Artists and the Surrealist Movement*, 1985).

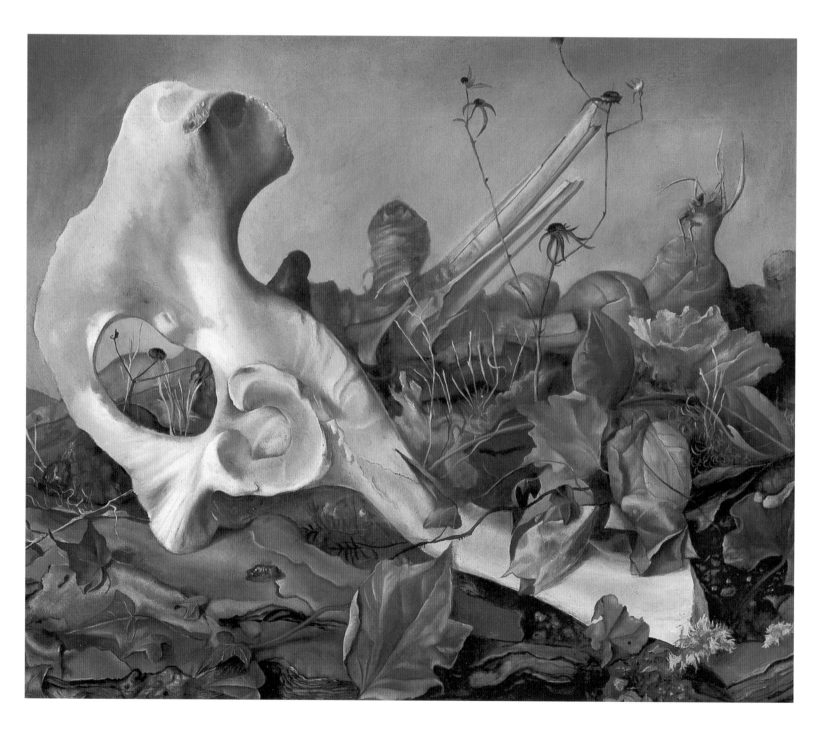

Leonora CARRINGTON

Baby Giant

1947

Egg tempera on panel

117.5 × 68.5 cm [46 × 27 in]

Private collection

Carrington painted *Baby Giant* in Mexico where, since settling there in 1942, she had pursued the study of alchemy, mythology and magic. The figure stands in what Whitney Chadwick has described as a 'Lilliputian' landscape of tiny, busily engaged figures, reminiscent of scenes by the seventeenth-century Flemish painter Brueghel. In the background sailors on the high seas are surrounded by whales and other large, swirling sea creatures; in the foreground men and hounds pursue a fleeing, enigmatic figure. Around the baby giant circle large, prehistoric-looking birds, possibly related to the phoenix, a symbol of regeneration. Such mythologically derived iconography can be seen, as Chadwick describes, in details such as the halo of golden wheat which surrounds the figure's head, replacing its hair (*Women Artists and the Surrealist Movement*, 1985). The gender of this magical character seems ambiguous, reflecting Carrington's interest in the symbolism of androgyny.

Dorothea <u>TANNING</u>
Children's Games
1942
Oil on canvas
28 × 12 cm [11 × 5 in]
Private collection

Children's Games was painted the year Tanning showed her work for the first time at the Julien Levy Gallery, New York, meeting Max Ernst, whom she would marry in 1946. Here she creates a disquieting scene in which the two girls are engulfed in a struggle with the living walls, while a third girl lies ominously prostrate on the floor. The work resonates with evocations of unconscious childhood fears and the turbulent onset of adolescent sexuality. 'Tanning once referred to her hometown of Galesburg, Illinois, as a place "where nothing happens but the wallpaper". Here a cosy domestic image becomes the source for the powerful forces that the painter uses to propel the viewer into the unknown.' (Whitney Chadwick, *Women Artists and the Surrealist Movement*, 1985) The painting was reproduced in *VVV*, 2–3 (March 1943), along with Tanning's self-portrait, *Birthday*, and her text 'Blind Date'. As Ernst wrote in the catalogue for her solo show in 1944: '… in the daring undertaking that involves painting the intimate biography of the universe, the emotions of the child's soul, the mysteries of love and that entire monstrousness that is swallowing up the age of reason, she has found a method of figurative representation which is both new, spontaneous and convincing … Precision is her mystery. This precision has allowed her to attain the power to guide us with the confidence of a sleepwalker through the real world as well as through that of the imagination.'
– Max Ernst, *Dorothea Tanning*, Julien Levy Gallery, New York, 1944

Dorothea <u>TANNING</u>
Eine Kleine Nachtmusik
1943
Oil on canvas
41 × 61 cm [16 × 24 in]
Collection, Tate Gallery, London

Taking its title from Mozart's composition, this painting depicts a shabby staircase landing in what appears to be a hotel, school or institution with numbered doors, in which two apparently sleepwalking young girls are confronting a huge sunflower. The doorways, three closed and one ajar, revealing an eerie yellow luminescence, suggest a symbolization of the unconscious. The image has been compared with Pierre Roy's well-known surrealist painting *Danger on the Stairs* (1927) which depicts a large exotic snake sliding down a typical staircase in a European apartment block. Noting Tanning's rejection of Roy's Freudian symbolism in favour of more personal imagery, Whitney Chadwick describes the different effect of the 'torn and writhing sunflower, an image strongly identified with Tanning's midwestern origins, close to nature and capable of conveying impressions of both fecundity and menace'. (*Women Artists and the Surrealist Movement*, 1985.)

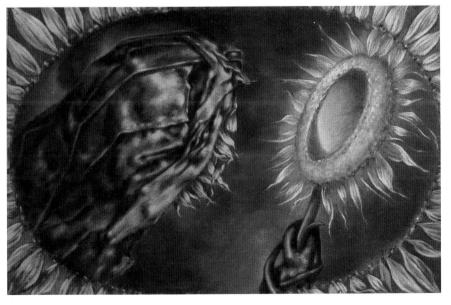

Dorothea <u>TANNING</u>
The Mirror
1950
Oil on canvas
30.5 × 46.5 cm [12 × 18.5 in]
Private collection

This canvas was painted during Tanning and Ernst's travels in France, 1949–50. It frames with the petals of a sunflower what might be read as a golden-haired woman clad in black, holding a mirror. On closer inspection the woman's hand appears vegetal and she too, like the mirror, appears to have taken on a sunflower's form. Ambiguously angled, the mirror reveals nothing of her visage. The sunflower has a personal significance in Tanning's works, and could be seen here to symbolize a form of female identity or appearance, simultaneously shrouded and illuminated. The sunflower-frame seems 'round like a mandala, like an eye', suggesting that the perceived woman, although faceless, gazes back at us. (Mary Ann Caws, *The Surrealist Look*, 1997.) Sunflowers also appear in works such as *Off Time, On Time* (1948) which evoke mutability and the passage of life.

APPEN-
DICES

The following key surrealist group exhibitions are indicated by their place and date only: 'La Peinture surréaliste', Galerie Pierre, Paris [1925]; 'Exposition Surréaliste: Peintures, dessins, sculptures, objets, collages', Galerie Pierre Colle, Paris [1933]; 'Exposition Surréaliste', Galeria Ateano, Santa Cruz de Tenerife [1935]; 'International Kunstudstilling: Kubisme-Surréalisme', Copenhagen [1935]; 'Exposition d'Objets Surréalistes', Galerie Charles Ratton, Paris [1936]; 'International Surrealist Exhibition', New Burlington Galleries, London [1936]; 'Fantastic Art, Dada, Surrealism', The Museum of Modern Art, New York [1936]; 'Album Surréaliste', Nippon Salon, Tokyo [1937]; 'Exposition Internationale du Surréalisme', Galerie Beaux-Arts, Paris [1938]; 'Exposition Internationale du Surréalisme', Galerie Robert, Amsterdam [1938]; 'Exposicion Internacional del Surrealismo', Galeria de Arte Mexicano, Mexico City [1940]; 'Surrealism Today', Zwemmer Gallery, London [1940]; 'First Papers of Surrealism', New York [1942]; 'Exposition Internationale du Surréalisme' [Le Surréalisme en 1947], Galerie Adrien Maeght, Paris [1947]; 'Exposition Internationale du Surréalisme', Prague [1947]; 'EROS' [Exposition inteRnatiOnale du Surréalisme], Galerie Daniel Cordier, Paris [1959]; 'L'Écart absolu', Galerie de l'Oeil, Paris [1965].

Eileen AGAR [b. 1899, Buenos Aires; d. 1991, London] was a painter, photographer and maker of objects and collages. She studied art in London [1926-27] then Paris [1928-30] where she was introduced to Surrealism, integrating its ideas with her earlier abstraction and interest in natural forms. From 1933 she was a member of the British surrealist group and was the only woman included in London's International Exhibition of Surrealism [1936]. Surrealist group exhibitions include London [1936]; New York [1936]; Tokyo [1937]; Paris [1938]; Amsterdam [1938]; London [1940]; Paris [1947]. Retrospectives include Commonwealth Art Gallery, London [1971], and Scottish National Gallery of Modern Art, Edinburgh [1999].

Louis ARAGON [b. 1897, Paris; d. 1982, Paris] was a poet, novelist, essayist and journalist, and a crucial figure in Surrealism's early years. In 1917 with Breton and Philippe Soupault he rediscovered Lautréamont's writings; in 1919 he co-founded the journal Littérature with Breton and Soupault; he published Le Paysan de Paris in 1926. He left the movement after the scandal of his poem Front Rouge in 1930 and his ensuing advocacy of socialist realism. A leading member of the wartime resistance movement [like René Char, Paul Éluard, and a number of other surrealist and ex-surrealist writers and artists who stayed in Europe] in 1953 he co-founded the journal Les Lettres françaises. He continued to defend official communism until the 1960s, when he made gestures of reconciliation with other original members of the surrealist group.

Jean ARP [Hans Arp, b. 1886, Strasbourg; d. 1966, Basel] was a poet, painter and sculptor. Between 1904 and 1915 he moved between Switzerland, Germany and France and met artists such as Ernst and Picasso and writers such as Apollinaire. In 1915 he moved to Zurich, where he made geometric abstract works, often in collaboration with his future wife, the artist Sophie Taeuber. In 1916, with Hugo Ball, Marcel Janco, Tristan Tzara and others he co-founded the Dada movement, continuing his involvement, with Ernst, when he moved to Cologne in 1919. He contributed to Dada reviews and from 1924 to La Révolution surréaliste. He was included in the first surrealist group show at the Galerie Pierre, Paris [1925]. In 1926 he settled in Meudon where he stayed until 1942, when he took refuge in Zurich; he returned to Meudon in 1946. By 1931 he was associated with the Abstraction-Création group and the periodical Transition. However he continued to participate in surrealist events until 1965. Surrealist group exhibitions include Paris [1925]; Copenhagen [1935]; Tenerife [1935]; London [1936]; New York [1936]; Tokyo [1937]; Paris [1938]; Amsterdam [1938]; Mexico City [1940]; Paris [1947; 1959; 1965]. Retrospectives include The Museum of Modern Art, New York [1958]; Musée national d'art moderne, Paris [1962]; and Joan Miró Foundation, Barcelona [2001].

Antonin ARTAUD [b. 1896, Marseille; d. 1948, Ivry-sur-Seine] was a poet, dramatic theorist, actor and director. A performer in theatre and cinema in the 1920s, he suffered periodic mental disorders from the age of eighteen. Through André Masson he was introduced to the Surrealists in 1924, contributing to La Révolution surréaliste, managing the Bureau des recherches surréalistes, and writing texts such as L'Ombilic des limbes and Pèse-nerfs [Umbilical Limbo and Nerve Scales, 1925]. He wrote the scenario for La Coquille et le clergyman, made into a film by Germaine Dulac, which he disowned, in 1926. He left the group in 1927 and co-founded with Roger Vitrac the experimental Théâtre Alfred Jarry. Ritual practices were formative in his concept of a 'theatre of cruelty', for which he wrote two manifestos [1932; 1933]. After the failure of his 1935 experimental production Les Cenci, he went in 1936 to the Tarahumaras region of Mexico, recorded in D'un voyage au pays des Tarahumaras [1936-48; published 1955]. Returning to France, he published his major work, Le Théâtre et son double [1938]. From this year he was interned in psychiatric institutions and subjected to electro-convulsive therapy. Robert Desnos intervened to have him treated by Dr Gaston Ferdière at Rodez; in 1947 he was released. After the publication of his last major text, Van Gogh, le suicidé de la société [1947], he ended his own life in 1948. His Rodez drawings were shown at the Galerie Pierre, Paris [1947] and in 'Antonin Artaud: Works on Paper', The Museum of Modern Art, New York [1996].

Georges BATAILLE [b. 1897, Billom, Puy-de-Dôme, France; d. 1962, Paris] was a writer whose work explored art, philosophy, ethnography, sociology and fiction. He was one of the most important theorists associated with Surrealism, as a highly sceptical critic with a contrasting vision. Briefly linked with Breton's group in the mid 1920s, he soon disassociated himself from its automatism and validation of idealism. His journal Documents [1929-30] attracted dissidents from official Surrealism. His writings connected with Surrealism are collected in The Absence of Myth: Writings on Surrealism [1994] and Visions of Excess: Selected Writings 1927-39 [1985].

Hans BELLMER [b. 1902, Katowice; d. 1975, Paris] was a painter, object-maker and photographer. After studying technical drawing in 1923, he pursued his own interests, influenced by artists such as Aubrey Beardsley and Albert Böcklin. In 1924 he visited Paris and first encountered Surrealism. In 1933, on Hitler's accession as Chancellor, he renounced his commercial job and made his first doll, based partly on his obsession with his cousin Ursula. His first book of photographs of the doll, Die Puppe, was published privately in 1934 in Karlsruhe. When Ursula brought some of the images to Breton in Paris, he published them in Minotaure, 6 [1935]. The second, more elaborate doll was presented in hand-coloured photographs in series of images such as in Les Jeux de la poupée [1937-38], with texts by Paul Éluard. In 1938 Bellmer fled to France; he settled in Paris in 1946. He never joined the Surrealist movement officially. In 1953 he met the artist and writer Unica Zürn; they collaborated and lived together until her suicide in 1970. Surrealist group exhibitions include Tenerife [1935]; London [1936]; New York [1936]; Tokyo [1937]; Paris [1938]; Amsterdam [1938]; Mexico City [1940]; Paris [1947; 1959; 1965]; Prague [1947]. Retrospectives include International Center of Photography, New York [2001].

Jacques-André BOIFFARD [b. 1902, Epernon, France; d. 1961, Paris] was a photographer associated with Surrealism [1924-35]. He met Pierre Naville in 1920 when they were both medical students and Naville later introduced him to the surrealist group. From 1924 to 1929 he worked in Man Ray's studio. With Paul Éluard and Roger Vitrac he contributed the preface to the first issue of La Révolution surréaliste, and texts in subsequent issues. In 1928 he made the photographs for Breton's Nadja. In 1929-30 he contributed photographs for Bataille's texts in Documents. From 1932 he gave up all artistic activity to pursue a medical career. His photographs were exhibited at the Julien Levy Gallery, New York [1932], alongside Man Ray, Roger Parry and Maurice Tabard, and included in 'Atelier Man Ray', Centre Georges Pompidou, Paris [1982], and 'L'Amour fou: Surrealism and Photography', Corcoran Gallery of Art, Washington, DC. [1986].

BRASSAÏ [Gyula Halasz, b. 1899, Brassó, Transylvania; d. 1984, Paris] was a photographer associated with Surrealism. He first met the group in 1924 while in Paris

as a correspondent for Hungarian and German newspapers. He took up photography in the 1930s, working for *Harper's* magazine and in collaboration with André Kertész. In 1933 he produced the series *Paris de Nuit*. His work was published in *Minotaure*, *Verve* and *Labyrinthe*. Retrospectives include The Museum of Modern Art, New York [1968], and Centre Georges Pompidou, Paris [2000].

Victor **BRAUNER** [b. 1903, Piatra Neamt, Romania; d. 1966, Paris] was a painter and sculptor. After Dadaist beginnings in Bucharest, with Constantin Brancusi's support he acquired a Paris studio in 1930 and officially joined the Surrealists in 1932. During the occupation he lived as a refugee in the Basses-Alpes. In 1945 he returned to Paris but in 1947 abandoned Surrealism in protest at Breton's exclusion of Roberto Matta. Surrealist group exhibitions include Copenhagen [1935]; Tenerife [1935]; London [1936]; New York [1936]; Tokyo [1937]; Paris [1938]; Amsterdam [1938]; Mexico City [1940]; London [1940]; Paris [1947]; Prague [1947]. Solo exhibitions include Galerie Pierre, Paris [1934]. Retrospectives include Centre Georges Pompidou, Paris [1972].

André **BRETON** [b. 1896, Tinchebray; d. 1966, Paris] was a poet and essayist and the leading theoretician and organizer of the surrealist movement. Influenced in his youth by the Symbolist generation, by 1913 he was acquainted with the poets Guillaume Apollinaire and Paul Valéry. In 1917 while working in psychiatric wards with soldiers traumatized by war, at Saint-Dizier and Val-de-Grâce hospitals, Paris, he met Louis Aragon and Philippe Soupault. Together they founded the review *Littérature* in 1919. On Tristan Tzara's arrival in Paris in 1920 he abandoned medicine and joined the Dada movement, which overlapped with incipient Surrealism over the next four years. He published the *Manifeste du suréalisme* in 1924 and the *Second manifeste du surréalisme* in 1929. His many writings include key texts of surrealism such as *Nadja* [1928], *Les Vases communicants* [1932] and *L'Amour fou* [1937]. He edited the major part of the review *La Révolution surréaliste* and then *Le Surréalisme au service de la révolution* and was a leading contributing editor of *Minotaure*. In 1939 he fled from France to New York, where he organized exhibitions and events and contributed to journals such as *VVV*. He returned to Paris in 1946, continuing to organize significant large exhibitions and

contribute to journals for the next twenty years. Before he died in 1966, a major celebration of his work, which he was too ill to attend, was held at the international conference at Cerisy-la-Salle. His objects and poem-objects were included in the Surrealist group exhibitions in Paris [1933; 1936]; London [1936]; New York [1936]; Tokyo [1937]; Paris [1938]; Amsterdam [1938]; and Paris [1947; 1959; 1965].

Jacques B. **BRUNIUS** [Jacques Borel, b. 1906, Paris; d. 1967, Exeter, England] was a filmmaker, actor, poet and artist. An actor in films by the Prévert brothers and Jean Renoir in the early 1930s, he assisted on Buñuel's *L'Âge d'or* and made several short films of his own. He contributed to *Minotaure*, also producing collages and poems from this period onwards. In 1937 he made the influential film *Violon d'Ingres* on 'naïve' artists. After moving to London in 1938 he edited the English Surrealists' *London Bulletin*. He contributed to *VVV* [1943-44] and was a founding committee member of the Institute of Contemporary Arts in 1948. In 1954 he published *En marge du cinéma français*.

Luis **BUÑUEL** [b. 1900, Calanda, Spain; d. 1983, Mexico City] was a filmmaker and a founder of Surrealist cinema. In 1928 he collaborated with Salvador Dalí on *Un chien andalou* [*An Andalusian Dog*]; in 1930 they collaborated again on *L'Âge d'or* [*The Golden Age*]. Buñuel's later films and documentaries are more overtly political. After fifteen years in the USA and ten years in Mexico, he returned to Europe in 1955, continuing to satirize bourgeois values, with echoes of Dada and Surrealism, in films such as *Viridiana* [1961] and *The Discreet Charm of the Bourgeoisie* [1972].

Claude **CAHUN** [Lucy Renée Mathilde Schwob, b. 1894, Nantes; d. 1954, Saint Helier, Jersey] was an artist and writer. The niece of Michel Schwob, a writer admired by the Surrealists, from 1917 she began to experiment with photography and self-portraiture. Often sporting cropped hair dyed green or pink in the 1920s, she staged a wide range of personae and gender identities through her self-images. Her first photomontages and objects date from 1927-28, a number of them made colla-boratively with Marcel Moore [pseudonym of Suzanne Malherbe, her lifelong companion]. Her writings include *Aveux non avenus* [1930] an autobiographical

work illustrated with photomontages, and *Les Paris sont ouverts* [1934], an essay on revolutionary poetry noted by Breton, who then met her through the Association des Ecrivains et Artistes Révolutionnaires. In 1935 she co-founded, with Breton and Bataille, the anti-Fascist organization Contre-Attaque. In 1937 she settled in Jersey where she was active in the wartime resistance. She was included in the Exposition Surréaliste d'Objets, Galerie Charles Ratton, Paris [1936]. Much of her work was only rediscovered in the 1980s. Retrospectives include Musée d'Art Moderne de la Ville de Paris [1995], and IVAM, Centro Julio Gonzalez, Valencia [2001].

Roger **CAILLOIS** [b. 1913, Rheims; d. 1978, Paris] was a writer and sociologist, briefly connected with Surrealism in the mid 1930s, when he published his influential texts on animal mimicry and camouflage, 'La Mante religieuse', *Minotaure*, 5 [1934] and 'Mimétisme et psychanasthénie légendaire', *Minotaure*, 7 [1935]. Although he shared with the Surrealists an interest in esoteric knowledge and myth his approach was rationalist, in contrast to the poetic lyricism, automatism and ideological affiliations of Breton's group.

Leonora **CARRINGTON** [b. 1917, Lancashire] lives in Mexico. A painter and writer, she studied in England, Florence and Paris before meeting Max Ernst in London in 1937, moving with him to Paris, then to St. Martin d'Ardèche. After her internment in 1940 she fled first to Spain, where she experienced a mental breakdown, recorded in her book *En bas* [1944], then to New York, where she contributed to *View* and *VVV* before moving to Mexico in 1942. There she developed a type of Surrealist figurative painting and writing which combined personal symbolism with mythopoetic fantasy. Surrealist group exhibitions include Paris [1938]; Amsterdam [1938]; New York [1942]; Paris [1947]. Retrospectives include Museo Nacional de Arte Moderno, Mexico City [1960].

Aimé **CÉSAIRE** [b. 1913, Martinique; d. 2008, Martinique] worked and lived in Martinique. He was a poet, dramatist, former politician, and one of the most influential Caribbean intellectuals of the twentieth century. His surrealist-influenced poetry includes *Les Armes Miraculeuses* [1946]; *Corps perdu* [1950]; *Cahier d'un retour au pays natal* [1956].

René **CHAR** [b. 1907, L'Isle-sur-Sorgue, France; d. 1988, Paris] was a lyrical provençal poet, briefly associated with Surrealism from 1930, when he collaborated on several surrealist tracts and, with Breton and Éluard, on the collection *Ralentir travaux*. In the same year his long poem *Artine* was published by the Éditions surréalistes. In 1934 he collected his surrealist poems in *Le Marteau sans maître*, and then pursued his own individual path.

Giorgio de **CHIRICO** [b. 1888, Volos, Thessaloniki, Greece; d. 1978, Rome] was a painter, writer and sculptor. He studied in Athens, then moved to Munich, Florence and Turin, settling in Paris [1911-15], where Apollinaire first described as 'metaphysical' his poetic paintings of melancholy urban scenes with disorienting juxtapositions and perspectives. These were a central early influence on Breton, Ernst, Magritte and others. From 1924 he contributed to *La Révolution surréaliste*, but the group's criticism of his 1920s work, drawing on classical themes, established a rift between them in 1926. His poetic novel *Hebdomeros* was published in 1929. He participated in the first surrealist group exhibition [Paris, 1925] and his work was included in others that followed. Retrospectives include The Museum of Modern Art, New York [1955], and Palazzo Reale, Milan [1970].

Joseph **CORNELL** [b. 1903, Nyack, New York; d. 1972, Flushing, New York] was an artist, filmmaker and writer. Working independently from the Surrealists, whom he first met during their 1940s exile in New York, he made collages influenced by Ernst in the early 1930s, followed by his first objects, shown by the Julien Levy Gallery, New York. These developed into his major series of assemblages in box frames, and other assembled objects which combine collage and found materials to evoke romantic and metaphysical associations. His short films, including the influential *Rose Hobart* [1936], were first screened at the Julien Levy Gallery [1936]. He was included in 'Surrealism', Julien Levy Gallery, New York [1932] and 'Fantastic Art, Dada, Surrealism', The Museum of Modern Art, New York [1936]. Solo exhibitions include Julien Levy Gallery, New York [1932; 1939]. Retrospectives include The Museum of Modern Art, New York [1980] and subsequent tour to Paris, Dusseldorf and London.

René CREVEL [b. 1900, Paris; d. 1935, Paris] was a novelist and one of the most significant theorists of Surrealism's relation to Marxism and psychoanalysis. While supportive of Breton he did not allow this to prevent him from subjecting Surrealism's claims to rigorous scrutiny. His novels explored the highly difficult project of reconciling Surrealism with a subjective, narrative genre. They include *Les Pieds dans le plat* [1923]; *Êtes-vous fous?* [1929]; and *La Mort difficile* [1926]. His theoretical texts include *Le Clavecin de Diderot* [1932].

Salvador DALÍ [b. 1904, Figueras, Spain; d. 1989, Figueras] was an artist and writer. He studied in Madrid, forming close associations with Buñuel and the poet Federico García Lorca. He first exhibited in 1925, around this time reading Freud, independently discovering the writings of Lautréamont and following Surrealism through local arts journals. In 1927 he began trying various surrealist techniques and forms of depiction. He collaborated with Buñuel on the film *Un chien andalou* [1928], followed by *L'Âge d'or* [1930] and was introduced by Miró in Paris to Picasso and Breton's group in 1929. That year Paul and Gala Éluard, Camille Goemans and René Magritte stayed with him at Cadaqués. Gala left Éluard and became Dalí's guiding influence and lifelong companion; he developed his 'paranoid-critical method' which enabled him rigorously to connect his private obsessions with collective symbolism. In the early 1930s he was a central presence in Surrealism both as an artist and as a theoretical writer. Criticized for his political amorality, he was finally rejected by the group after his 1937 support for Franco. From 1939 in New York, then from 1948 after his return to Spain he refined an exuberant self-image, ironically becoming the world's most famous icon of 'surrealism' after he had embraced a nationalism and catholic mysticism which were at the furthest remove from the movement's beliefs. Nevertheless, his work continued until the 1970s to enter into a dialogue with his earlier surrealism and more contemporary cultural currents such as Pop. Surrealist group exhibitions include Copenhagen [1935]; Tenerife [1935]; London [1936]; New York [1936]; Tokyo [1937]; Paris [1938]; Amsterdam [1938]; Mexico City [1940]. Retrospectives include Centre Georges Pompidou, Paris [1980], and touring centennial exhibition inaugurated at Palazzo Grassi, Venice [2004].

Paul DELVAUX [b. 1897, Antheit, Belgium; d. 1994, Veurne, Belgium] was a painter and printmaker. He studied architecture, then academic painting, at the Academie des Beaux-Arts in Brussels [1920-24]. In the mid 1930s he became influenced by de Chirico and made contact with the Belgian Surrealists. His most characteristic images are of female figures in urban or classical architectural settings, where he radically reworked themes from academic and history painting from a surrealist perspective. Surrealist group exhibitions include London [1938]; Mexico City [1940]. Retrospectives include Museum Boijmans Van Beuningen, Rotterdam [1973]. In 1982 the Musée Paul Delvaux was established at Saint-Idesbald, Belgium.

Robert DESNOS [b. 1900, Paris; d. 1945, Terezin, Czechoslovakia] was a poet who was a central figure in Surrealism from 1922, when he was one of the foremost contributors to the language experiments published in *Littérature* and was the 'star' of the sleep-séance experiments, to his rift with Breton in 1929. His poems of this period were collected in *Corps et biens* [1930]. He continued to write for clandestine publications in France during the war until he was arrested and interned in a series of concentration camps, eventually to die at Theresienstadt [now Terezin].

Óscar DOMÍNGUEZ [Oscar Manuel Domínguez Palazon, b. 1906, La Laguna, Tenerife; d. 1957, Paris, France] was a painter and sculptor. Although he visited Paris from 1927 onwards, he officially joined the Paris group in 1934, working until then mainly in Tenerife, where he organized surrealist exhibitions in 1933 and 1935. In 1936 he introduced the decalcomania technique into Surrealism [see page 66]. He was also an important creator of surrealist objects. He remained in France after the war, and continued to exhibit until his suicide in 1957. Surrealist group exhibitions include Tenerife [1935]; Copenhagen [1935]; London [1936]; New York [1936]; Tokyo [1937]; Paris [1938]; Amsterdam [1938]; Mexico City [1940]. Solo exhibitions include Círculo de Bellas Artes, Tenerife [1933]. Retrospectives include Fundación Telefónica, Madrid [2001].

Marcel DUCHAMP [b. 1887, Blainville; d. 1968, Paris] was an artist and chess player. Independent of any official group, he was nonetheless a close collaborator with the Surrealists throughout the movement's history and was of central importance to Breton, Frederick Kiesler and Roberto Matta, among others. His readymades of 1913-17 [everyday objects exhibited unaltered] and assisted readymades such as *Why Not Sneeze Rose Sélavy* [1921] were instrumental in the conception of surrealist objects. His highly influential 'Large Glass' [*The Bride Stripped Bare by Her Bachelors, Even*, 1915-23] synthesized notions of the erotic drives with ideas derived from mathematical, scientific and alchemical sources. His installations for three of the international exhibitions of Surrealism in Paris [1938; 1947; and 'EROS', 1959], and for 'First Papers of Surrealism' in New York [1942] expanded the fields of experience and participation, disrupting the merely 'retinal' experience of art, which he had abandoned since 1915. Retrospectives include Pasadena Museum of Art [1963], and Palazzo Grassi, Venice [1993].

Nusch ÉLUARD [b. 1906, Mulhouse, Franco-German border; d. 1946, Paris] was an artist and model. German-born, she met the poet Paul Éluard in 1930 while working as a performer in Paris, marrying him in 1934. She collaborated with the Paris group in activities such as making *exquisite corpse* drawings, and modelled for Man Ray. She made a series of photomontages between 1934 and 1936 and was the subject of Man Ray's photographs in Éluard's book of poems *Facile* [1935]. With Éluard she was active in the French wartime resistance. Surrealist group exhibitions include Amsterdam [1938]. Her collages were published by Editions Nadada, New York [1978].

Paul ÉLUARD [Eugène Grindel, b. 1895, Saint-Denis; d. 1952, Charenton, France] was a renowned poet closely associated with the Surrealists from 1920 until he joined the official Communist Party in 1942. His most significant surrealist works include *Répétitions* [1922], with engravings by Max Ernst; *Capitale de la douleur* [1926]; *Notes sur la poésie* [1929] and *L'Immaculée conception* [1930], co-written with André Breton; and *Facile* [1935], love poems inspired by his second wife, Nusch, combined with photographs of her by Man Ray.

Max ERNST [b. 1891, Brühl, Germany; d. 1976, Paris] was a painter, sculptor and creator of collages. In the First World War he was a leading member of the Cologne Dada group. His discovery of de Chirico led to the collages and 'overpaintings' of 1920-21 which attracted the attention of Breton's group. He moved to Paris in 1922, exhibiting his first surrealist paintings at the Salon des Indépendants. In 1925 he developed his *frottage* technique, a parallel practice to automatism, followed by the related scraping technique of *grattage*. His next major contributions were the collage novels, beginning with *La Femme 100 têtes* [1929-30]. When Éluard was excluded from the group in 1938, he moved away to Saint-Martin d'Ardèche. Interned during the occupation he eventually escaped to New York, helped by the art collector Peggy Guggenheim, to whom he was briefly married before meeting the artist Dorothea Tanning in 1942, marrying her in 1946 and moving with her to Sedona, Arizona; they later returned to France. In New York in the early 1940s his new techniques, such as the use of paint dripped from a can, influenced younger artists such as Jackson Pollock. Surrealist group exhibitions include Copenhagen [1935]; Tenerife [1935]; London [1936]; New York [1936]; Tokyo [1937]; Paris [1938]; Amsterdam [1938]; Mexico City [1940]; London [1940]; Paris [1947; 1959; 1965]; Prague [1947]. Retrospectives include Kunsthalle, Bern [1956]; Musée d'art moderne, Paris [1959]; The Museum of Modern Art, New York [1961]; Solomon R. Guggenheim Museum, New York [1975]; and Tate Gallery, London [1991], with European tour.

Léonor FINI [b. 1918, Buenos Aires; d. 1996, Paris] was a painter, theatre designer and illustrator. Raised in Trieste from the age of two, she exhibited for the first time in a group exhibition in Trieste in 1935. In 1936 she encountered Éluard, Ernst, Magritte and Brauner in Paris and participated in Surrealist exhibitions, although not officially a member of the group. She spent the war years in Rome and Monte Carlo, returning to Paris in 1946. Surrealist group exhibitions include London [1936]; New York [1936]; Tokyo [1937]. Solo exhibitions include Julien Levy Gallery, New York [1939]. Retrospectives include Musée Ingres, Montauban [1981].

Esteban FRANCÉS [b. 1913, Port Bou, Gerona; d. 1976, Barcelona] was a painter. He studied in Barcelona, meeting fellow Barcelona artist Remedios Varo and visitors such as Domínguez, Éluard and Péret in the early 1930s. He fought on the Republican side in the Spanish Civil War. Exiled in 1937, he joined the surrealist group in Paris. He introduced his *grattage* technique [distinct from Ernst's] and with Roberto

Matta began to explore the concept of 'psychological morphology'. In 1940 he joined the socialist mural painters Jose Orozco and Diego Rivera in Mexico. In 1942 he went to the USA, settling in New York in 1945. After the war he returned to Spain. Surrealist group exhibitions include Mexico City [1940]; New York [1942]. His work was included in 'El Surrealismo en España', Museo Nacional Centro de Arte Reina Sofía, Madrid [1995].

Wilhelm **FREDDIE** [b. 1909, Copenhagen; d. 1995, Copenhagen] was a painter and sculptor. He studied in Copenhagen, becoming influenced by Surrealism from 1929 onwards. With Vilhelm Bjerke-Petersen he started the Danish surrealist periodicals *Linien* and *Konkretion*. His often sexually provocative images led to scandal and persecution in the Nazi era. After the war he collaborated on surrealist-influenced films with Jørgen Roos [*The Definitive Refusal of Permission for a Kiss*, 1949; *Eaten Horizons*, 1950]. Surrealist group exhibitions include Copenhagen [1935]; London [1936]. Solo exhibitions include 'Sex-surreal: pull the fork out of the eye of the butterfly', Copenhagen, 1937.

Alberto **GIACOMETTI** [b. 1901, Stampa, Switzerland, d. 1966, Chur, Switzerland] was a painter and sculptor. He studied in Geneva, then from 1922 in Paris. His sculptures based on non-western sources, such as *Spoon Woman* [1926] attracted Masson's interest and they were shown alongside Miró and Arp in 1930. His surrealist period lasted from 1930 to 1934 and included *La Boule suspendue* [1930-31]; *Cage*, and *Femme égorgée* [1932]; *Le Palais à quatre heures du matin* [1932-33] and *L'Objet invisible* [1934]. In 1935 he abandoned objects and Surrealism, returning to figurative sculpture and painting. Surrealist group exhibitions include Paris [1933]; Copenhagen [1935]; Tenerife [1935]; Paris [1936]; London [1936]; New York [1936]; Tokyo [1937]; Paris [1938]; Mexico City [1940]; Paris [1959; 1965]. Retrospectives include Solomon R. Guggenheim Museum, New York [1974], and National Museum of American Art, Smithsonian Institution, Washington, D.C. [1988].

Arshile **GORKY** [Vosdanig Manoog Adoïan, b. 1905, Dzov, Armenia; d. 1948, Sherman, CT, USA] was a painter. From Turkish Armenia he went to the United States in 1920, settling in New York in 1925. He taught

painting in various colleges during the 1920s and 1930s. Influenced by Kandinsky and Miró, he had reservations about Surrealism, but was indebted to the exiled Surrealists and their introduction of automatism for the emergence of his mature style in the early 1940s. In 1947, after a series of personal tragedies, he committed suicide. He was included in 'Bloodflames', Hugo Gallery, New York [1947]. Solo exhibitions include Julian Levy Gallery, New York [1945]. Retrospectives include Solomon R. Guggenheim Museum [1981].

David **HARE** [b. 1917, New York; d. 1992, Jackson Hole, Wyoming, USA] was a sculptor, painter and photographer, associated with the exiled Surrealists in the early 1940s. With Breton, Duchamp and Ernst he founded the journal *VVV* [1942-44]. He participated in the group of younger surrealist followers, led by Roberto Matta, Robert Motherwell and Gordon Onslow Ford, and with Frederick Kiesler designed the *Totem for All Religions* for the Exposition Internationale du Surréalisme [Galerie Adrien Maeght, Paris, 1947]. He was for some years married to the artist Jacqueline Lamba after she left Breton in 1943. After 1948 he moved away from Surrealism.

Jindrich **HEISLER** [b. 1914, Chrast, Czechoslovakia; d. 1953, Paris] was a poet and artist. Closely associated with the artist Toyen and the Czech Surrealist group, he produced his major body of work while in hiding in Prague during the Nazi occupation. His collages often convey an atmosphere of wartime terror and devastation. The series *De la même farine* are 'photo-graphique' images produced using objects and substances such as glue on photographic paper. After the war he moved to Paris, where he published poems, collages and book-objects, and contributed to the surrealist extension of definitions of poetry. Retrospectives include 'Styrsky, Toyen, Heisler', Centre Georges Pompidou, Paris [1982].

Georges **HÉNEIN** [b. 1914, Cairo; d. 1973, Paris] was a writer and communist activist associated with Surrealism between 1934 and the mid 1950s. After encountering the group while a student in Paris, he introduced its ideas to Cairo on his return in the mid 1930s, founding the Art and Freedom group, which published the texts of the Surrealists and writers such as Henri Michaux. In 1944 he organized the Egyptian section of the Trotskyist Fourth

International. In the late 1940s he went to Paris, now distanced from the official group but contributing to journals on the fringes of Surrealism during the 1950s. His works include *Déraison d'être* [1938].

Georges **HUGNET** [b. 1906, Paris; d. 1974, Paris] was a poet, critic and collagist. Introduced to the circles of Max Jacob, Tristan Tzara and others in the 1920s, in 1932 he began a major study, 'L'Esprit Dada dans la peinture' [first parts published in *Cahiers d'Art*, 1932; finally published as *L'Aventure dada 1916-1922*, Paris, 1957], through which he was introduced by Tzara to Breton and became an active member of the group, initiating the *Petite anthologie poétique du surréalisme* [1934]; publishing his *La Septième face du dé* [1936] and co-ordinating the Paris international exhibition in 1938. During the war he distanced himself from Breton's group and was active in La Main à Plume and among the communist members of the resistance. Retrospectives include Centre Georges Pompidou, Paris [1978], and Galería de Arte Manuel Barbié, Barcelona [2003].

Valentine **HUGO** [b. 1887, Boulogne-sur-Mer; d. 1968, Paris] was a painter and illustrator. She studied painting in Paris, marrying Victor Hugo's great-grandson, Jean Hugo, in 1919. They collaborated on ballet designs for Cocteau and others. She met the Surrealists around 1928 and participated in the movement from 1930 to 1936, illustrating Éluard's poems, the texts of Lautréamont, Rimbaud and others. Surrealist group exhibitions include Tenerife [1935]; Copenhagen [1935]; New York [1936]; Tokyo [1937]. Retrospectives include Centre Culturel Thibaud de Champagne, Troyes [1977].

Radovan **IVSIC** [b. 1921, Zagreb; d. 2009, Paris] had lived in Paris since 1954. He was a poet, dramatist and translator, who introduced Croatian readers to the writings of Breton, Péret and other important figures in Surrealism. He was closely associated with the surrealist group in Yugoslavia, as well as with the Czech artist Toyen. In Paris, he contributed to journals such as *Bief*, *La Brèche* and *L'Archibras*, and participated in all surrealist events. His works include *Mavena* [1960], with a frontispiece by Miró; *Le Puits dans la tour* [1967], *Le Roi gordogane* [1968] and *Les Grandes ténèbres du tir* [1973], all accompanied by Toyen's images; *La Traversée*

des Alpes [1972], in collaboration with his companion Annie Le Brun, and Fabio De Sanctis; a monograph on Toyen [1974]; and *Reprises de vue* [1999], with photographs by Jindrich Styrsky.

Marcel **JEAN** [b. 1900, La Charité-sur-Loire, France; d. 1993, Louveciennes] was a painter and writer. He joined the surrealist group in 1933; his artworks include objects, decalcomania images and Surrealist reinterpretations of heraldic signs. From 1938-45 he collaborated with the philosopher Arpad Mezei in Hungary on a number of texts and on his *Histoire de la peinture surréaliste* [1959; trans. 1960]. He also edited the comprehensive anthology *L'Autobiographie du surréalisme* [1978; trans. 1980]. Surrealist group exhibitions include Tenerife [1935]; London [1936]; New York [1936]; Paris [1936]; Tokyo [1937]; Paris [1938]; Amsterdam [1938]; Paris [1947] and Prague [1947]. Retrospectives include Kölnischer Kunstverein, Cologne [1981].

Frida **KAHLO** [b. 1910, Coyoacán, Mexico City; d. 1954, Mexico] was a Mexican painter. After a near-fatal car accident at the age of fifteen she was severely disabled and taught herself to paint while convalescing. She married the painter Diego Rivera in 1929. Breton discovered her work in Mexico in 1938 while visiting Leon Trotsky in exile. He described her work as surrealist; she was ambivalent about her relationship with the movement. Surrealist group exhibitions include Mexico City [1940]; New York [1942]. Solo exhibitions include Julien Levy Gallery, New York [1939]; Galeria de Arte Contemporaneo, Mexico City [1953]. Her work only became well known in the late 1970s after retrospectives at the Instituto Nacional de Bellas Artes, Mexico City [1977], and Whitechapel Art Gallery, London [1978].

André **KERTÉSZ** [b. 1894, Budapest; d. 1985, New York] was a photographer admired by the Surrealists. He moved from Hungary to Paris in 1925, staying there for eleven years, during which time he moved in the same circles as Man Ray and other figures in the surrealist movement. In 1933 he made the *Distortions* series, published as a book in 1976. Retrospectives include International Center of Photography, New York [1987]; Palais de Tokyo, Paris [1990] and tour; and J. Paul Getty Museum, Los Angeles, California [1994].

Frederick KIESLER [b. 1890, Vienna; d. 1966, New York] was an architect and artist. After working with Adolf Loos and the De Stijl group in the early 1920s he began experimenting with notions of 'endless' space, to be realized in structures of curved reinforced concrete. Exiled to New York in the 1940s, he designed innovative interiors for Peggy Guggenheim's surrealist and constructivist gallery, Art of This Century. A close associate of Duchamp, he collaborated with him on projects for *VVV* and designed the Hall of Superstitions at the second international exhibition of Surrealism, Galerie Maeght, Paris [1947]. He exhibited models in 1950 and 1959 for his long-term project, *The Endless House*. Its organic principles, directly countering Le Corbusier's concept of a 'machine for living in', are set out in Kiesler's *Manifeste du Corréalisme* [1947; translated in *Frederick J. Kiesler: Endless Space*, Hatje Cantz/D.A.P., 2001].

Greta KNUTSON [b. 1899, Stockholm; d. 1983, Sweden] was a painter, poet and writer. Married to Tristan Tzara between 1925 and 1939, she participated in surrealist group activities for several years in the early 1930s. She was primarily a post-Cubist abstract painter and later became a noted art critic.

Wifredo LAM [Wifredo Oscar de la Concepcion Lam Yam y Castilla, b. 1902, Sagua la Grande, Cuba; d. 1982, Paris] was a painter and sculptor. After studying in Havana he continued in Madrid in 1923 with Dali's teacher, becoming interested in Surrealism by the early 1930s. Influenced by a Picasso exhibition in Spain in 1936, he visited the artist in Paris two years later, after fighting on the Republican side in the Spanish Civil War, and Picasso became a supporter of his work. In the same year he visited Frida Kahlo and Diego Rivera in Mexico. By now part of the surrealist group, he shared their political exile in Marseille and travelled in 1941 on the same boat as Breton, reaching Martinique in 1942, where he met the writers Aimé and Suzanne Césaire, then going on to Havana via the Dominican Republic. There he associated with the ethnologist and folklorist Lydia Cabrera and the author and journalist Alejo Carpenter, who reintroduced him to Afro-Cuban rituals he had been aware of from his youth. He remained in Havana until 1952 [afterwards living in Paris], taking trips in the 1940s to Haïti, where with Breton and

Pierre Mabille he studied Voodoo practices. His work synthesizes these various fields of enquiry with traces of both Cubism and Surrealism. Surrealist group exhibitions include New York [1942]; Paris [1947]; Prague [1947]. Solo exhibitions include Pierre Matisse Gallery, New York [1942]; Pierre Loeb Gallery, Paris [1945]. Retrospectives include Musée d'art moderne de la Ville de Paris [1983], and Museo Nazionale de la Havana, Cuba [1989].

Jacqueline LAMBA [b. 1910, Paris; d. 1993, Le Rochecorbon, France] was a painter and photographer. In the late 1920s she studied decorative arts in Paris. The subject of Breton's *L'Amour fou* [1937], she married him in a double ceremony with Paul and Nusch Éluard in 1934. They combined their honeymoon with the 1935 Tenerife exhibition; in the same year she gave birth to their daughter, the artist Aube Elléouët. She exhibited objects and paintings with the Surrealists and accompanied Breton on his visits to Prague [1935] and Mexico [1938]. From the late 1930s she developed a form of automatism in painting which paralleled the innovations of Masson and Matta. In 1943 she left Breton and married the sculptor David Hare. By 1948 she had abandoned Surrealism and destroyed much of her earlier work; she continued her life as a painter in France. Surrealist group exhibitions include Paris [1936]; London [1936]; Tokyo [1937]; Paris [1947]; Her work was also included in '31 Women', Art of This Century, New York [1942]; 'Surrealistas en el exilio', Museo Nacional Centro de Arte Reina Sofia, Madrid [1999]; and 'La Révolution surréaliste', Centre Georges Pompidou [2002]. Retrospectives include the Salvador Dalí Museum, St. Petersburg, Florida [2001].

Annie LE BRUN [b. 1942, Rennes, France] lives in Paris. She is a writer and critic, and a leading figure in the active legacy of surrealist thought and revolutionary critique. She began to participate in the group's activities in the early 1960s, publishing surrealist writings from the mid 1960s onwards. These include *Sur le champ* [1967], with images by Toyen; and *Tout près les nomades* [1972]. *Lâchez tout* [1977] was a groundbreaking critique of reactionary elements in feminism. *Les Châteaux de la subversion* reinvigorated debate on the relationships between imagination, revolution and desire. Her works on Sade include *Soudain un bloc d'abîme, Sade* [1986], and *Sade, aller et détours* [1989].

Michel LEIRIS [b. 1901, Paris; d. 1990, Saint-Hilaire] was a writer and poet. He was introduced to the surrealist group in 1924 through his friendship with André Masson. Originally trained as a chemist, he took an experimental approach to language, influenced by writers such as Raymond Roussel, and contributing texts such as *Glossaire: J'y serre mes gloses* [1925], which transformed the dictionary formula into a poetic medium. In 1929 he left the group and collaborated with Bataille on the journal *Documents* [1929-30]. From 1931-33 he accompanied Marcel Griaule on the Dakar-Djibouti ethnographic expedition documented in *Minotaure*, 2 [1933]. His semi-biographical account, *L'Afrique fantôme* [1933] was one of the first attempts to analyse the relationship between the observer and the observed, and to evolve a self-critical form of ethnology. As well as continued fieldwork in Africa, the Caribbean and Central America, he wrote on the work of artists such as Miró, Giacometti and Lam. His wife founded the important Paris centre for post-war art, Galerie Louise Leiris.

Len LYE [Huai, Leonard Charles, b. 1901, Christchurch, New Zealand; d. 1980, New York] was a filmmaker, sculptor and painter. He moved to England in 1926 and in the 1930s became active in the British surrealist group. Automatism was one of the influences on his 'direct' filmmaking in which solarization techniques, scratching or painting were applied to the celluloid emulsion. His experimental films, automatic paintings and kinetic sculptures form a bridge between surrealism and other modernisms and non-western cultural influences. Retrospectives include Centre Georges Pompidou, Paris [2000].

Dora MAAR [b. 1909, Tours; d. 1997, Paris] was a photographer and painter. After studying painting in Paris she switched to photography in the mid 1930s and was associated with the Surrealists between 1934 and 1937, when she was Picasso's model and lover and documented the stages of his painting *Guernica*, as well as contributing some of the most striking surrealist photographs of the period. She resumed painting in the 1940s and later renounced her earlier surrealist work. Surrealist group exhibitions include Tenerife [1935]; London [1936]; New York [1936]; Tokyo [1937]; Amsterdam [1938]. Solo exhibitions include Galerie de Beaune, Paris [1937]; Galeries Jeanne Bucher [1943] and Pierre Loeb [1945],

Paris. Retrospectives include Centro Cultural Tecla Sala de L'Hospitalet, Barcelona [2002].

Pierre MABILLE [b. 1904, Paris; d. 1952, Paris] was a writer and physician. His contact with Surrealism began in 1934 when he contributed regular articles to *Minotaure*, expanding upon surrealist theories of desire, perception and the marvellous with reference to folklore, symbolism and psychoanalytic case studies. In 1940 he published *Le Miroir du merveilleux*. In the mid 1940s he was French cultural attaché in Haïti, where he invited Breton to speak and Lam to exhibit; he also arranged for them to attend voodoo ceremonies. He later contributed to surrealist periodicals such as *Néon*.

F.E. MCWILLIAM [b. 1903, Banbridge, County Down, Ireland; d. 1992, London] was a sculptor. He studied painting in Belfast and London [1928-31] before turning to sculpture in the early 1930s. His earliest works in wood were influenced by African sculpture and the pure forms of Brancusi. Between 1936-39 he associated with the British surrealist group and made an important contribution to surrealist sculpture, exploring similar territory to Picasso and Moore, in his fragmentary studies of figurative and biomorphic forms. Solo exhibitions include London Gallery, London [1939]. Retrospectives include Tate Gallery, London [1989].

René MAGRITTE [b. 1898, Lessines, Belgium; d. 1967, Brussels] was an artist and writer. After studying in Brussels he became influenced by de Chirico in the early 1920s, by the middle of the decade becoming aligned with Surrealism, while remaining distant from many of the Paris group's interests such as automatism. Primarily interested in the relationships between philosophical and perceptual notions, visual signs and language, he considered himself as a thinker who used painting to explore ideas. He associated with the Surrealists in Paris from 1926, returning to Brussels in 1930, where he remained for most of his life, while continuing to contribute to exhibitions and reviews such as *Minotaure*. From the 1920s onwards he experimented with photography, and began producing short Surrealist films from 1956. In the 1960s he made a number of wax sculptures, cast in bronze after his death. Surrealist group exhibitions include Tenerife [1935]; London [1936]; New York [1936]; Tokyo [1937]; Paris [1938];

Amsterdam [1938]; Mexico City [1940]. Solo exhibitions include Galerie Le Centaure, Brussels [1927]; Palais des Beaux Arts, Brussels [1933] and Galerie de Faubourg, Paris [1948]. Retrospectives include The Museum of Modern Art, New York [1965]; Palais des Beaux-Arts, Brussels [1979]; and Galerie nationale du Jeu de Paume, Paris [2003].

MAN RAY [Emmanuel Rudnitsky, b. 1890, Philadelphia; d. 1976, Paris] was an artist, photographer and filmmaker. After making abstract paintings, exhibited at the Armory Show, New York [1911] and associating with the '291' gallery group led by the photographer Alfred Stieglitz, he took up photography in 1915, the year he met Marcel Duchamp, with whom he co-founded the Société Anonyme with Katherine Dreier and others in 1920, becoming a central figure in New York Dada. His photographs were among the first images reproduced in *Littérature* and *La Révolution surréaliste*. Welcomed to Paris in 1921, he made objects such as *Cadeau* [1921] and *Objet à détruire* [1923], 'Rayographs' [cameraless photographs] and solarized portraits. His surrealist films include *Le Retour à la raison* [1923]; *Emak Bakia* [1926]; *Étoile de mer* [1928]; *Les Mystères du Château du Dé* [1929]. He collaborated with Paul Éluard on the books *Facile* [1935] and *Les Mains libres* [1937]. From 1940-51 he returned to the United States, then settled again in Paris. Surrealist group exhibitions include Copenhagen [1935]; Tenerife [1935]; London [1936]; New York [1936]; Paris [1938]. Retrospectives include Museum Boijmans Van Beuningen, Rotterdam and Galleria Schwarz, Milan [both 1971]; Centre Georges Pompidou, Paris [1981]; National Museum of American Art, Smithsonian Institution, Washington, DC [1988]; and Centre Georges Pompidou, Paris [1998].

André MASSON [b. 1896, Balagny-sur-Thérain, France; d. 1987, Paris] was a painter. He studied in Brussels, then in Paris until mobilization in 1914. He was wounded in 1917, hospitalized, then interned in a psychiatric ward for insubordination. In 1922 he moved to a studio near Miró's at 45, rue Blomet, a meeting place for Artaud, Bataille, Leiris and others. He first associated with Breton's group from 1924 to 1928, developing a highly influential form of automatic drawing and painting. In 1928 he left the group, frustrated by its

strictures. In the following years he associated closely with Bataille and continued to work in both abstract and more figurative idioms, but with harsher colours and exploring more overtly violent subjects. From 1934-36 he lived in Spain, supporting the republicans. When civil war broke out he returned to Paris and in 1937 was reconciled with the Surrealists. In 1941 he travelled to the United States with Breton via Martinique, then settling in Connecticut, where his painting entered a lyrical phase, allied with the emergent work of the later Abstract Expressionists. He returned to France in 1945 and after a brief phase which drew on traditions of Chinese painting he resumed the intense, excessive graphic style and preoccupations of his earlier work. Surrealist group exhibitions include Paris [1925]; London [1936]; Paris [1938]; Mexico City [1940]; New York [1942]. Solo exhibitions include Galerie Simon, Paris [1924]; Galerie Louise Leiris, Paris [1968]. Retrospectives include Baltimore Museum of Art [1941]; The Museum of Modern Art, New York [1976]; and Hayward Gallery, London [1987].

Roberto MATTA [Roberto Sebastian Matta Echaurren, b. 1911, Santiago, Chile; d. 2002, Civitavecchia, Italy] was a painter. Trained as an architect in Santiago de Chile, he worked in Le Corbusier's practice in Paris from 1933. He was introduced to Surrealism in the mid 1930s and met the group in 1937. Breton included his drawings, based on his concept of 'psychological morphology', at the Paris international exhibition of Surrealism [1938]. He gave up architecture and began to paint, becoming a central figure among the exiled group in New York in the 1940s and an important precursor of Abstract Expressionism. In 1948 his relationship with Breton deteriorated and he was expelled from the group, not to be reinstated until 1959. In 1949 he returned to Europe, moving between Rome, Paris and London. Much of his later work directly addresses political events such as the Algerian war of independence and the Vietnam war. Surrealist group exhibitions include Paris [1938]; Mexico City [1940]; New York [1942]; Paris [1947]; and 'Bloodflames', Hugo Gallery, New York [1947]. Solo exhibitions include Julien Levy Gallery, New York [1940; 1943]; Pierre Matisse Gallery, New York [1942; 1944; 1945; 1948]. Retrospectives include Centro Cultural Caixa, Barcelona [1999], and Museo Nacional Centro de Arte Reina Sofía, Madrid [1999].

Henri MICHAUX [b. 1899, Namur, Belgium; d. 1980, Paris] was a poet and painter. In 1919 he briefly studied medicine in Brussels, then after travels in North and South America began writing in 1921. In 1923 he started to write for the Belgian review *Le Disque Vert*. He went to Paris in 1924, visited the first surrealist group exhibition in 1925 and associated with figures on the periphery of the movement such as Claude Cahun, Jules Superville and the photographer Gilberte Brassaï, contributing to reviews such as *Commerce* and *Bifur*. He began to paint and draw in the same year. From 1927 to 1937 he travelled extensively in South America, Turkey, China and India; these and later travels influenced his writings. In the mid 1950s he experimented with forms of automatic drawing and writing induced by drugs such as mescaline. Among his major works are *Un Certain Plume* [1930]; *Misérable miracle* [1956]; and *L'Infini turbulent* [1957]. Retrospectives include Centre Georges Pompidou, Paris [1978].

Lee MILLER [b. 1908, Poughkeepsie, New York; d. 1977, Sussex, England] was a photographer. After studying in New York she moved to Paris in 1929, working with Man Ray until 1932, when she returned to New York to open her own photo studio. Visiting the Paris Surrealists in 1937 she met Roland Penrose and moved with him to England in 1939, becoming first a fashion photographer, then a war correspondent for Condé Nast publications. Surrealist group exhibitions include London [1936]; Paris [1947]. Solo exhibitions include Julien Levy Gallery, New York [1933]. Retrospectives include J. Paul Getty Museum, Los Angeles [2003].

Joan MIRÓ [b. 1893, Barcelona; d. 1983, Palma de Mallorca] was a painter and sculptor. He studied in Barcelona, meeting Picabia there in 1917. He first visited Paris and met Picasso in 1919, from the following year dividing his time between Montroig and Paris, where he set up a studio near Masson's in Rue Blomet and associated with writers such as Artaud, Bataille, Desnos and Leiris. From late 1923 to 1927 his work evolved towards what Breton described as a 'pure' form of automatism in painting, although chance was always modified in his work by precise compositional decisions. In the late 1920s and early 1930s he explored the transformational possibilities of compositions derived from sources such as postcard reproductions and collages, and also made surrealist objects and

sculptures. In 1939 he settled in Varengeville and began the lyrical *Constellations* series, completed after his flight from the occupation to Palma de Mallorca, and published in 1959 with texts by Breton. He returned to Barcelona in 1942. Surrealist group exhibitions include Paris [1925]; Tenerife [1935]; Paris [1936]; New York [1936]; Paris [1938]; Paris [1947; 1959; 1965]. Retrospectives include The Museum of Modern Art, New York [1941]; Musée national d'art moderne, Paris [1962]; Grand Palais, Paris [1978]; The Museum of Modern Art, New York [1993]; and Centre Georges Pompidou, Paris [2004].

Pierre MOLINIER [b. 1900, Agen; d. 1976, Bordeaux] was a painter and photographer. A former student of Jesuits, by the late 1940s he had rebelled against their teachings, making Symbolist-influenced paintings which explored his erotic and fetishistic fantasies. Breton was familiar with his work since the 1930s and exhibited his paintings at the surrealist gallery L'Étoile Scellée, Paris [1955], contributing a catalogue essay, and in 'EROS', Daniel Cordier, Paris [1959]. In the mid 1960s, no longer directly connected with the group, Molinier took up photography and photomontage, combined with a form of self-performance for the camera, where he explored cross-dressing, fetishism and other sexual themes, such as in his series of the late 1960s, *Le Chaman et ses créatures* [The Shaman and its creations].

Henry MOORE [b. 1898, Castleford, Yorkshire, England; d. 1986, Much Hadham, Hertfordshire, England] was a sculptor. He studied in Leeds, then in London from 1921, where he drew inspiration from ancient African, Egyptian and Mexican figures in the British Museum. During the 1920s and 1930s he visited Paris and became familiar with the work of Picasso, Giacometti and the Surrealists. With Paul Nash, Herbert Read and others he was a member of the artists' group Unit One, which aimed to introduce continental modernism to Britain, and for a few years in the mid 1930s his work engaged with surrealist ideas and forms. In 1936 he participated in London's international surrealist exhibition. Retrospectives include The Museum of Modern Art, New York [1946], and Serpentine Gallery, London [1978].

Max MORISE [b. 1900, Versailles; d. 1973, Paris] was a writer. In the early 1920s he contributed to *Littérature*, was present

during the sleep-séances and later participated in the 'exquisite corpse' game. He contributed accounts of dreams and several drawings to *La Révolution surréaliste*. Like Pierre Naville, he could not reconcile Surrealism with painting. He left the group in 1929.

Robert **MOTHERWELL** [b. 1915, Aberdeen, Washington State, USA; d. 1991, Provincetown, New Jersey] was a painter, teacher and writer. After studying painting in Los Angeles and philosophy at Stanford and Harvard universities in 1940 he went to Columbia University, New York, to study art history with the critic Meyer Schapiro, who encouraged him to be a painter. He met Matta and other exiled Surrealists as well as artists such as William Baziotes and Jackson Pollock, and became an influential catalyst and teacher, absorbing and transforming the idea of automatism. In 1942 he was included in 'First Papers of Surrealism', New York, and his first solo show was held at Art of This Century in 1944. Retrospectives include Albright-Knox Art Gallery, Buffalo [1983], and tour.

NADJA [Léona Camille Ghislaine D., b. 1902, near Lille, France; d. 1940, France] was the self-adopted name of a woman whom Breton met in Paris in 1926 and who inspired him to write *Nadja* [1928]. Penelope Rosemont [*op cit.*] records that she worked in Paris as a sales clerk, a theatrical bit-actor and dancer. She visited the Galerie Surréaliste and met some other members of the group but her involvement was chiefly with Breton, who had an open relationship with Simone Kahn. Nadja wrote more than twenty letters to him and made a number of drawings, such as the 'Lover's Flower', reproduced in *Nadja*. She was arrested by police in 1927 and placed in a psychiatric institution. She remained in institutions for the remainder of her life.

Pierre **NAVILLE** [b. 1903, Paris; d. 1993, Paris] was a sociologist and a leading member of the Trotskyist movement [1927-39]. In 1924 with Benjamin Péret he co-edited the first issue of *La Révolution surréaliste*. With Max Morise, he maintained that surrealism and painting were incompatible, to which Breton responded in his *Le Surréalisme et la peinture* [1928]. He left the group in 1927 to devote his time to activism. After the war he pursued a vast study on the sociology of work [*Le Nouveau Léviathan*, 1957-75]. In 1977 he returned

to Surrealism in *Le Temps du surréel*, emphasizing the way the marvellous must be immediately capable of transforming our relationship with the real world. [From Gérard Durozoi, *L'Histoire du mouvement surréaliste*, 1997.]

Paul **NOUGÉ** [b. 1895, Brussels; d. 1967, Brussels] was a poet, photographer and theorist. After training and working as a biochemist, he joined a circle of Belgian writers and artists who were evolving a parallel movement to Surrealism, based on systematic critique of cultural forms rather than automatism. In 1924 he launched their journal *Correspondance*, and published important critical texts on the work of Magritte, among others. Although sceptical of aspects of Surrealism, he participated with the Belgian surrealist group in contributing to *Variétés* and the *Bulletin international du surréalisme*. After the war he allied himself with a position similar to the 'Revolutionary Surrealists', leading to a rift with the official surrealist movement. Later, however, he collaborated with Marcel Mariën on the periodical *Les Lèvres nues*, which published his *Subversion des images* [1929-30] in 1968.

Gordon **ONSLOW FORD** [b. 1912, Wendover, England; d. 2003, Inverness, California] was a painter and writer. In 1937 he moved to Paris and was introduced to the surrealist group. He experimented with automatism and collaborated with Matta in developing the theory of psychological morphology. By 1939 he was fully integrated into the Paris group, and spent the summer in Chémilleu with Matta, Tanguy, Francés, Sage and the Bretons. At the outbreak of war he returned to London and was closely involved in the London surrealist group. In 1941, the exiled Surrealists invited him to New York, where he became the English-speaking spokesperson for Surrealism through his lectures at the New School of Social Research. He began to distance himself from Surrealism from 1942 when he moved to Mexico, collaborating with Wolfgang Paalen on the periodical *Dyn* and gravitating towards metaphysical and mystical concepts which he would explore in his painting thenceforward. In 1998 he established the Lucid Art Foundation [1998] at his home in Inverness, California. Surrealist group exhibitions include New York [1942]; 'Surrealist Diversity', Arcade Gallery, London [1945]. Retrospectives include San Francisco Museum of Art [1948], and Oakland Museum, California [1978].

Meret **OPPENHEIM** [b. 1913, Berlin; d. 1985, Bern] was a painter, sculptor, object-maker, designer and writer. She moved from Switzerland to Paris in 1932 and was introduced to the Surrealists the following year by Arp and Giacometti. She first exhibited with the group in the Salon des Surindendépendents [1933]. With her wide-ranging, diverse body of work she represented a strong critical voice within Surrealism from a feminist perspective and was particularly active in the group during the 1950s. Surrealist group exhibitions include Tenerife [1935]; Copenhagen [1935]; London [1936]; New York [1936]; Paris [1938]; Mexico City [1940]; New York [1942]; Paris [1959]. Solo exhibitions include Galerie Schulthess, Basel [1933]; Retrospectives include Moderna Museet, Stockholm [1967]; Kunsthalle, Zurich [1989]; and Solomon R. Guggenheim Museum, New York [1996].

Wolfgang **PAALEN** [b. 1905, Baden, Austria; d. 1959, Taxco, Mexico] was a painter and writer. He was aligned with the surrealist movement from 1935 to 1942, and again from 1951. He was initially a member of the Abstraction-Création group, but joined the Surrealists after meeting Breton in 1935, contributing his *fumage* technique to surrealist painting. In 1939 he fled France for New York, then visiting Mexico, where he met the Peruvian surrealist poet César Moro and the artists Diego Rivera and Frida Kahlo. In 1942, Paalen founded the bilingual periodical *Dyn*, which reflected his ethnographic interests and his desire for a synthesis of science and art. Surrealist group exhibitions include New York [1936]; London [1936]; Paris [1936]; Paris [1938]; Mexico City [1940]; New York [1942]. Solo exhibitions include Galerie Pierre, Paris [1936; 1951]; Galerie Colle, Paris [1938]; and Julien Levy Gallery, New York [1940].

Roger **PARRY** [b. 1905, Paris; d. 1977, Paris] was a photographer. In the late 1920s he became an assistant to Maurice Tabard, when he was working for *La Nouvelle revue française*. His remarkable photomontages for the book of poems by Léon Paul Fargue, *Banalité*, published in 1930 by the NRF, introduced him to the circles of Man Ray, André Kertész and others. Some of his photographs were exhibited by Julien Levy Gallery, New York, in 1932. He continued his career as a succesful press photographer until 1948, when with the critic and art historian André Malraux he edited the

collection *L'Univers des formes* for Éditions Gallimard.

Roland **PENROSE** [b. 1900, London, England; d. 1984, Sussex, England] was an artist and writer. In 1922 he went to study painting in Paris, met the Surrealists and, with the English poet David Gascoyne, whom he met in 1935, began to introduce Surrealism to England, organizing the international exhibition in London [1936] with a committee which included Herbert Read. In the 1930s he was married to the poet Valentine Boué, and after the war to the photographer Lee Miller. He collaborated with E.L.T. Mesens in 1938 in founding the London Gallery and the *London Bulletin*. He was the chief catalyst in the creation of London's Institute of Contemporary Arts and organized its first exhibitions, '40 Years of Modern Art' [1948] and '40,000 Years of Modern Art' 1949], as well as later retrospectives and monographs on the work of Picasso, Man Ray, Miró and others. His own work included paintings, objects and an innovative form of collage using postcards. Surrealist group exhibitions include London [1936]; Paris [1938]; Paris [1947]. Solo exhibitions include Galerie Van Leer, Paris [1929]; Mayor Gallery, London [1939]; London Gallery [1949]. Retrospectives include 'The Surrealist and the Photographer: Roland Penrose and Lee Miller', Scottish National Gallery of Modern Art, Edinburgh [2001].

Benjamin **PÉRET** [b. 1899, Rézé, France; d. 1959, Paris] was a poet and political activist. He met Aragon, Breton, Soupault and others in 1920, contributing to *Littérature* and co-editing the first issue of *La Révolution surréaliste* with Pierre Naville in 1924. He contributed to all the group's collective declarations, joining the Communist Party in 1926. In the early 1930s he travelled in South America as a supporter of Trotsky, and subsequently fought for the republicans in the Civil War in Spain, where he met Remedios Varo who became his companion. During the war they went to Mexico, where he stayed until 1948. His works include *Le Grand Jeu* [1928]; *Je ne mange pas de ce pain-là*, and *Je Sublime* [1936]; *Au paradis des fantômes* [1938]; and *Le déshonneur des poètes* [1945].

Pablo **PICASSO** [Pablo Ruiz Blasco, b. 1881, Málaga, Spain; d. 1973, Mougins, France] was a painter, sculptor and writer. The development of Cubism by Picasso and others broke with Western traditions of

illusionism, paving the way for surrealist art, and Breton's group recognized his importance from the outset. He was often invited to join the group but remained independent, while closely associated. His most surrealist period was in the early 1930s when he made objects, sculptures, drawings and paintings which have affinities with surrealist objects and themes. He also experimented with automatic writing, and his poems were published by Breton in *Cahiers d'Art*, 7-10 [1936]. The tour of his painting *Guernica* [1937] to England, Scandinavia and New York was initiated by Roland Penrose and other Surrealists and supporters of the group. He became distanced from Surrealism in 1944, when he joined the French Communist party and became an 'official' painter of political subjects. Surrealist group exhibitions include Paris [1925; 1936]; London [1936]. His most important retrospectives in the surrealist era were at The Museum of Modern Art, New York [1939], and the Musée des Arts Décoratifs, Paris [1955].

Kay **SAGE** [Katherine Linn Sage, b. 1898, Albany, New York; d. 1963, Woodbury, Connecticut] was a painter and poet. From 1925 she lived for ten years in Rome and Rapallo. In 1937 she moved to Paris and met the Surrealists, moving from abstraction towards visionary scenes comparable in intensity to the early work of de Chirico. In 1939 she returned to New York and married Yves Tanguy there in 1940, moving with him to Woodbury, Connecticut. Seriously depressed after Tanguy's death in 1955 and by her progressively deteriorating eyesight, she committed suicide in 1963. She was the author of four volumes of poetry. Surrealist group exhibitions include New York [1942]; Paris [1947]. Solo exhibitions include Galleria il Milione, Milan [1936] and, with Tanguy, Wadsworth Atheneum, Hartford, Connecticut [1954]. Retrospectives include the Herbert F. Johnson Museum of Art, Cornell University [1976].

Kurt **SELIGMANN** [b. 1900, Basel; d. 1962, Sugar Loaf, New York] was a painter, printmaker and maker of objects. He joined the surrealist group in Paris at the end of the 1920s, making prints and paintings which bore some resemblance to Masson's work of the mid 1930s, but with more explicitly macabre references to such subjects as the dance of death and prefigurations of the coming war. He also produced a number of surrealist objects, combining, for example, furniture with

parts of mannequins. In 1939 he left for the United States, where he was instrumental in rescuing many other artists from the Nazi occupation. He began to study Native American art, adding to his earlier interests in alchemy and mysticism. Partly influenced by Breton and Matta's notion of 'great invisible' beings, he produced a series of paintings of swirling figures composed of drapery-like forms. In 1948 he published *Miroir de la Magie*, his modern reinterpretation of hermetic traditions. He contributed to *VVV* and *View* and was included in 'Artists in Exile', Pierre Matisse Gallery, New York [1942], and 'First Papers of Surrealism', New York [1942].

Philippe **SOUPAULT** [b. 1897, Chaville, France; d. 1990, Paris] was a poet. His first collection, *Aquarium*, was published in 1917. Through the poets Pierre Reverdy and Blaise Cendrars he was introduced to Breton and Aragon. Together they rediscovered the writings of Lautréamont. In 1919 he co-wrote with Breton the first automatic texts, *Les Champs magnétiques*, and co-edited *Littérature*. While actively participating in the early group activities up to 1925, he had remained connected with the wider literary world and after this date he left Surrealism to become a professional journalist and critic, continuing to write and publish poetry.

Jindrich **STYRSKY** [b. 1899, Cermna, Czechoslovakia; d. 1942, Prague] was a painter, photographer and poet. With the artist Toyen in 1927 he founded Artificialism, a pictorial version of the Czech literary movement Poetism, allied to Surrealism, and in 1934 he became one of the first members of the Czech surrealist group. His photographs and collages were often created in series, such as *L'Homme aux oeillères* [1934] and *Après-midi parisien* [1935]. He wrote studies of Rimbaud and the Marquis de Sade and edited the *Revue érotique*, which he launched in 1930, and *Odéon*, where many of his shorter texts appeared. He was included in the Czech Surrealists' first group exhibition at Manes Gallery, Prague [1935]. Retrospectives include 'Toyen, Styrsky, Heisler', Centre Georges Pompidou, Paris [1982], and Ubu Gallery, New York [1994; 1997].

Maurice **TABARD** [b. 1897, Lyon; d. 1984, Nice] was a photographer. In 1914 he emigrated with his family to the United States, where his father worked in the

textile industry. After studying silk design and painting he progressed to photography, which became his profession. In 1928 he moved to Paris, where he began to work as a fashion photographer and met Man Ray, who introduced him to the technique of solarization. He also associated with Magritte and Soupault. From this period onwards he alternated between commercial work and experimental photography influenced by Surrealism, using multiple exposures, montage, solarization and other techniques and processes to form complex compositions. His work was included in 'Film und Foto', Stuttgart [1929] and '*L'Amour fou*: Surrealism and Photography', Corcoran Gallery of Art, Washington, D.C. [1986] and tour. Solo exhibitions include Galerie de la Pléiade, Paris [1933].

Yves **TANGUY** [b. 1900, Paris; d. 1955, Woodbury, Connecticut] was a painter. He grew up in a fishing community in Brittany and was introduced to art through meeting his future dealer Pierre Matisse while at school before the First World War. In 1918 during military service he travelled to Africa and South America and in 1920 met the poet Jacques Prévert. Circa 1922 or 1923 he saw de Chirico's work and decided to become a painter. In 1924, he, Prévert and Marcel Duhamel moved into the house at rue du Château that became a surrealist gathering place. Breton welcomed him into the group in 1925; he began experimenting with automatic drawing and hermetic, dream-like paintings. His first solo exhibition was held at the Galerie Surréaliste in 1927. In various phases, the figurative elements in his paintings were replaced by 'smoky' indistinct forms, then by more solid biomorphic shapes; definable landscape elements and horizons gave way to an ambiguous continuum; colouration became progressively more refined, creating shimmering effects and transitions of mood. In 1939 he met the painter Kay Sage in Paris and later that year travelled with her to the American Southwest. They married in 1940 and settled in Woodbury, Connecticut. Surrealist group exhibitions include Paris [1933]; Tenerife [1935]; London [1936]; Paris [1936]; New York [1936]; New York [1942]. Retrospectives include Staatsgalerie, Stuttgart and Menil Collection, Houston [2001].

Dorothea **TANNING** [b. 1910, Galesburg, Illinois] lives in New York. A painter and writer, she studied in Chicago, moving to New York in 1937 where she was influenced by

the exhibition 'Fantastic Art, Dada, Surrealism' at The Museum of Modern Art [winter 1936 to early 1937]. She travelled to Europe in 1939, seeking to meet several surrealist artists, but found Paris already deserted. She met Max Ernst in New York in 1942, they married in 1946 and lived in Sedona, Arizona, then Huismes, France, and Paris, until Ernst's death in 1976, when she returned to the USA. Her stature as an artist and writer is completely independent of Ernst, a fact which he keenly admired. Her accomplished autobiographical writings and poetry and her fusion of surrealist ideas with figurative traditions have been among the major contributions to latter-day Surrealism. Surrealist group exhibitions include Paris [1947]. Solo exhibitions include Julien Levy Gallery, New York [1944]. Retrospectives include Centre National d'Art Contemporain, Paris [1974].

TOYEN [Marie Cerminová, b. 1902, Prague; d. 1980, Paris] was a Czech painter. After studying in Prague she met Jindrich Styrsky in Yugoslavia. They joined the Czech avant-garde group Devetsil in 1923. She lived in Paris, 1925-28, then returned to Prague, making a transition to Surrealism in 1929. She was a founder member of the Surrealist group in Prague from 1934 until the German occupation forced them underground. In 1947 she moved to Paris. Highly respected by Breton and Péret both as a painter and as a standard bearer of the movement's revolutionary spirit, she was a significant figure in the Parisian group during the remainder of Breton's lifetime and afterwards, when she worked closely with the writers Radovan Ivsic and Annie Le Brun, publishing her images alongside their texts. Surrealist group exhibitions include London [1936]; Tokyo [1937]; Amsterdam [1938]; Paris [1947; 1959; 1965]. Solo exhibitions include, with Styrsky, Galerie d'Art Contemporain, Paris [1927]. Retrospectives include 'Toyen, Styrsky, Heisler', Centre Georges Pompidou, Paris [1982].

Tristan **TZARA** [Sami Rosenstock, b. 1896, Moinesti, Romania; d. 1963, Paris] was a poet and writer. In 1916 he co-founded the Cabaret Voltaire and the Dada movement in Zurich. Through correspondence and the exchange of contributions in journals initiated by his meeting with the artist Francis Picabia in Switzerland, he came into contact with the *Littérature* group, who in 1919 invited him to Paris. When he came in 1920 he organized events with Breton's group until they broke with Dada

in 1923. From 1929 he began to collaborate with the Surrealists again, contributing articles and poems to *Le Surréalisme au service de la révolution* and *Minotaure*. In 1935 he joined the official Communist Party and after the war his political convictions distanced him from Breton, Péret and others. His writings include *L'Homme approximatif* [1931] and *Où boivent les loups* [1932].

Raoul **UBAC** [b. 1910, Malmédy, Belgium; d. 1985, Paris] was a photographer, painter and sculptor. After studying painting and literature, and travelling extensively in Europe [1927-30] he first became acquainted with the Parisian surrealist group in 1930 and in the early 1930s switched from painting to photography, experimenting with a series of developing and printing techniques. In 1936 he also learned engraving techniques, working in William Hayter's Paris studio. His extensive body of work from this period includes portraits and studies for which his wife Agui was the model; the *Stones of Dalmatia* series; and many variations of the frieze-like tableaux which include the *Battle of Amazons* series. Relationships between the human body and stones, rocks, petrification, fossilization, are abiding themes in his work. He actively joined the surrealist group from 1936 to 1939. On Breton's recommendation his images were published in *Minotaure*, numbers 10, 11 and 12-13. During the Second World War he contributed to the group La Main à Plume's periodical of the same name and another surrealist-related periodical, *Messages*. After the war he turned to abstract painting, sculpture, printmaking and engraving on slate. Retrospectives include Galerie Maeght, Paris [1970], and Fondation Maeght, Saint-Paul, France [1978].

Remedios **VARO** [Remei Lissaraga Varo, b. 1913, Anglès, Catalonia; d. 1963, Mexico City] was a painter. In the mid 1930s she met the poet Benjamin Péret in Barcelona, moving with him to Paris where she participated in the Surrealist group between 1937 and 1939. They settled in Mexico in 1942. There, closely allied with Leonora Carrington, she developed a form of figurative painting which drew together diverse bodies of reference, from science and psychoanalysis to alchemy and mythology. Surrealist group exhibitions include Tokyo [1937]; Paris [1938]; Amsterdam [1938]; Mexico City [1940]; New York [1942]; Paris [1947]. Solo exhibitions include Galeria Diana, Mexico City [1956].

Retrospectives include Museo de Arte Moderno, Mexico City [1971].

Roger **VITRAC** [b. 1899, Pinsac, Lot, France; d. 1952, Paris] was a writer and dramatist. In the early 1920s he associated with Artaud, Crevel and the 'rue Blomet' group which included Masson, Miró and Leiris. He contributed to *Littérature* and to the first issues of *La Révolution surréaliste*. Partly due to Breton's aversion to theatre he was excluded in 1926 when he co-founded, with Artaud and Robert Aron, the experimental Théâtre Alfred Jarry. He wrote six plays which defied both social and dramatic convention, the most well-known being the black comedy *Victor ou les enfants au pouvoir* [1928] in which a nine-year old, six-foot tall *enfant terrible* has delirious visions and precipitates several deaths around him.

WOLS [Wolfgang Schulze, b. 1913, Berlin; d. 1951, Paris] was a painter, photographer and writer. In his youth in Dresden he studied music and photography. In 1931 he briefly studied anthropology in Frankfurt-am-Main, then in 1932 moved to Berlin, followed by Paris, where he met surrealist artists such as Ernst and Miró and members of the surrealist-influenced literary group Le Grand Jeu, outlawed by Breton since 1929. His portrait and still life photographs of this period show surrealist influences, as do his Klee-like ink and gouache drawings of the late 1930s. After living in hiding during the war, in 1946 he returned to Paris, associating with Artaud, Giacometti, Georges Matthieu, Jean Paulhan, Jean-Paul Sartre and Tristan Tzara, and became one of the first exponents of the 'informel' style of expressionist gestural painting and drawing. Influenced by Taoism, he also wrote aphoristic texts and poems which expressed his philosophical and artistic ideas. He was included in 'Huit oeuvres nouvelles', Galerie René Drouin, Paris [1949]. Solo exhibitions include Galerie René Drouin, Paris [1947]. Retrospectives include Stedelijk Van Abbemuseum, Eindhoven [1966], and 'Wols Photographs', Busch Reisinger Museum, Harvard University, Cambridge, Massachusetts [1999].

Unica **ZÜRN** [b. 1916, Berlin; d. 1970, Paris] was a writer and artist. After working in Berlin for the UFA film production company, in 1949 she began publishing her writing in German and Swiss periodicals. After a divorce and a period of great hardship, in 1953 she met Hans Bellmer,

whom she lived with in Paris where she began to write her anagrams series and make automatic drawings. She participated in 'EROS', Galerie Daniel Cordier [1959]. From 1962 onwards her mental condition required a number of periods spent in psychiatric institutions. She developed an obsession with a being she called 'the man of jasmine', whom she identified with the writer Henri Michaux when they met. In 1970 she committed suicide. Her text *L'Homme-jasmin* was published in 1971.

BIBLIOGRAPHY

Adamowicz, Elza 'Surrealist Collage in Text and Image: Dissecting the Exquisite Corpse', *Cambridge Studies in French*, 56, Cambridge University Press, 1998

_____ *Ceci n'est pas un tableau*, Éditions Age d'homme, Paris, 2004

Adès, Dawn 'Notes on Two Women Surrealist Painters: Eileen Agar and Ithell Colquhoun', *The Oxford Art Journal*, April, 1980

_____ *Dada and Surrealism Reviewed*, Arts Council of Great Britain, London, 1978. With introduction by David Sylvester, essays by Adès and Elizabeth Cowling, bibliographic catalogue of dada and surrealist journals and periodicals.

_____ *Dalí and Surrealism*, Thames and Hudson, London and New York, 1982

_____ *Photomontage*, Thames and Hudson, London and New York, 1986

_____ 'Visions de la matière: Breton, Cubisme et Surréalisme', in *Pleine marge*, 13, Paris, June 1991

_____ *André Masson*, Rizzoli, New York, 1994

_____ *Surrealist Art: The Bergman Collection*, The Art Institute of Chicago/Thames and Hudson, London and New York, 1997

Agar, Eileen Scottish National Gallery of Modern Art, Edinburgh, 1999

Album surréaliste: Nippon Salon Ginza Galleries, Tokyo, 1937

Alexandrian, Sarane *L'Art surréaliste*, Hazan, Paris, 1969; trans. Gordon Clough, *Surrealist Art*, Thames and Hudson, London and New York, 1970

Alquié, Ferdinand *Philosophie du surréalisme*, Flammarion, Paris, 1956; trans. *The Philosophy of Surrealism*, University of Michigan Press, Ann Arbor, 1965

Aragon, Louis *Le Libertinage*, Éditions Gallimard, Paris, 1924; trans. Jo Levy, *The Libertine*, John Calder, London, 1987

_____ *Le Paysan de Paris*, Éditions Gallimard, Paris, 1926; trans. Simon Watson Taylor, *Paris Peasant*, Pan, London, 1971; reprinted by Exact Change, Boston, 1994

_____ *La Peinture au défi* [cat.] Galerie Goemans, Paris, 1930

_____ *Anicet ou le panorama*, Éditions de la Nouvelle revue française, Paris, 1921

Arasse, Daniel *Le Detail, pour une histoire rapprochée de la peinture*, Flammarion, Paris, 1999

Arp, Jean *Collected French Writings*, John Calder, London, 1974 [based on *Jours effeuillés*, ed. Marcel Jean, Paris, 1966].

Arp Musée d'art moderne de la Ville de Paris, 1986

Artaud, Antonin *Oeuvres Complètes*, Éditions Gallimard, Paris, 1956; trans. Victor Corti, *Collected Works*, John Calder, London, 1999 [Vols. 1-4]

Artaud, Antonin: Oeuvres sur papier Musées de la Ville de Marseille, 1995; trans. *Antonin Artaud: Works on Paper*, ed. Margit Rowell, The Museum of Modern Art, New York, 1995

Ashbery, John 'Tanguy - The Geometer of Dreams', *Yves Tanguy*, Acquavella Galleries, New York, 1974

Ashton, Doré *A Joseph Cornell Album*, Viking Press, New York, 1974

Baker, Simon 'The Thinking Man and the *Femme sans tête*: Collective Perception and Self-representation', *Res*, 38, Cambridge, Massachusetts, Autumn 2000

Balakian, Anna *Surrealism: The Road to the Absolute*, University of Chicago Press, 1959

Barr, Alfred H., Jr. *Fantastic Art, Dada, Surrealism*, The Museum of Modern Art, New York, 1936. With essays by Georges Hugnet.

Bataille, Georges *Visions of Excess: Selected Writings, 1927-1939*, trans. Allan Stoekl, University of Minnesota Press, Minneapolis, 1985

_____ *The Absence of Myth: Writings on Surrealism*, trans. Michael Richardson, Verso, London and New York, 1994

Bate, David *Surrealism and Photography: Sexuality, Colonialism and Social Dissent*, I.B. Tauris, London, 2004

Baum, Timothy and François Buot, Sam Stourdzé, *Georges Hugnet: Collages*, Éditions Léo Scheer, Paris, 2003

Benjamin, Walter 'Surrealism: The Last Snapshot of the Intelligentsia' [1929], trans. Edmund Jephcott, in Walter Benjamin, *Selected Writings*, Vol. 2: 1927-1934, ed. Michael W. Jennings, Howard Eiland and Gary Smith, Belknap Press, Harvard University, Cambridge, Massachusetts, 1999

Benoît, Jean 'Notes concernant l'exécution du testament de Sade', in *Petits et grands théâtres du marquis de Sade*, ed. Annie Le Brun, Paris, 1989

Bois, Yve-Alain and Rosalind Krauss, *Formless: A User's Guide*, Zone Books/MIT Press, Cambridge, Massachusetts, 2000

Bonnefoy, Yves *Giacometti*, Flammarion, Paris, 1991

Bonnet, Marguerite *André Breton: Naissance de l'aventure surréaliste*, Éditions José Corti, Paris, 1975

Borhan, Pierre et al., *André Kertész: His Life and Work*, Bulfinch Press; Little, Brown, New York, 2000

Bouqueret, Christian *Raoul Ubac: Photographie*, Éditions Léo Scheer, Paris, 2000. An exceptional monograph, with catalogue raisonné and complete bibliography

Bouhours, Jean-Michel and Patrick de Haas, *Man Ray: Directeur du mauvais movies*, Centre Georges Pompidou, Paris, 1997

Breton, André *Les Pas perdus*, Nouvelle revue française, Paris, 1924; trans. Mark Polizzotti, *The Lost Steps*, University of Nebraska Press, 1993

_____ 'Le Surréalisme et la peinture', *La Révolution surréaliste*, 4, Paris, July 1925

_____ *Le Surréalisme et la peinture*, Éditions Gallimard, Paris, 1928; trans. Simon Watson Taylor, *Surrealism and Painting*, Harper and Row, New York, 1972

_____ *Nadja*, Nouvelle revue française, Paris, 1928; trans. Richard Howard, Grove Press, New York, 1960; reprinted by Penguin Books, 1999

_____ *Les Vases communicants*, Éditions des Cahiers libres, Paris, 1932; trans. Mary Ann Caws and Geoffrey T. Harris, *Communicating Vessels*, University of Nebraska Press, Lincoln, 1997

_____ *Point du jour*, Éditions Gallimard, Paris, 1933; trans. Mark Polizzotti and Mary Ann Caws, *Break of Day*, University of Nebraska Press, Lincoln, 1999

_____ *L'Amour fou*, Éditions Gallimard, Paris, 1937; trans. Mary Ann Caws, *Mad Love*, University of Nebraska Press, Lincoln, 1987

_____ *Anthologie de l'humour noir*, Éditions du Sagittaire, Paris, 1940; trans. Mark Polizzotti, *Anthology of Black Humour*, City Lights Books, San Francisco, 1997

_____ *Arcane 17*, New York, 1945; Éditions du Sagittaire, Paris, 1947; trans. Zack Rogow, *Arcanum 17*, Sun and Moon Press, Los Angeles, 1994

_____ *La Clé des champs*, Éditions Sagittaire, Paris, 1953; trans. Michel Parmentier and Jacqueline d'Amboise, *Free Rein*, University of Nebraska Press, Lincoln, 1995

_____ *Entretiens, 1913-1952, avec André Parinaud* [et al.], Éditions Gallimard, Paris, 1952; trans. Mark Polizzotti, *Conversations: The Autobiography of Surrealism*, Paragon House, New York, 1993

_____ , Jindrich Heisler and Benjamin Péret, *Toyen*, Éditions Sokolova, Paris, 1953

_____ *Manifestos of Surrealism*, trans. Richard Seaver and Helen R. Lane, University of Michigan Press, Ann Arbor, 1969

_____ *Poems of André Breton*, trans. Jean-Pierre Cauvin and Mary Ann Caws, University of Texas Press, Austin, 1982

_____ *Oeuvres Complètes*, ed. Marguerite Bonnet, Vol. 1, in collaboration with Philippe Bernier, Étienne-Alain Hubert and José Pierre, 1988; Vol 2, in collaboration with Étienne-Alain Hubert and José Pierre, 1992; Vol. 3, ed. Étienne-Alain Hubert in collaboration with Philippe Bernier, Marie-Claire Dumas and José Pierre, 1999 Collection Bibliothèque de la Pléiade, Éditions Gallimard, Paris

_____ *Selections*, ed. Mark Polizzotti, University of California Press, Berkeley and Los Angeles, 2003

Breton, André: La Beauté convulsive Centre Georges Pompidou, Paris, 1991

Brotchie, Alastair and Mel Gooding [eds], *A Book of Surrealist Games*, Shambala [with Redstone Press], Boston and London, 1995

Buck, Louisa 'Faceless *Femmes Fatales*: Unearthing Surrealist Women Using Bodies as Source and Subject', *Women's Art Magazine*, 49, London, November-December 1992

Cahun, Claude: Photographe Éditions Jean-Michel Place, Paris, 1995. Texts by Laura Cottingham, François Leperlier, Peter Weibel, Dirk Snauwart.

_____ *Ecrits*, ed. François Leperlier, Éditions Jean-Michel Place, Paris, 2002

Caillois, Roger *A Roger Caillois Reader*, ed. Claudine Frank, trans. Frank and Camille Naish, Duke University Press, Durham, North Carolina, 2003

Camfield, William A. et al., *Max Ernst: Dada and the Dawn of Surrealism*, Prestel, Munich, 1993

Cardinal, Roger and Robert Stuart Short, *Surrealism: Permanent Revelation*, Studio Vista, London, 1970

_____ *Outsider Art*, Studio Vista, London, 1972

Carrington, Leonora *La Maison de la peur*, H. Parisot, Paris, 1938

_____ *The House of Fear: Notes from Down*

Below, E.P. Dutton, 1988

_____ *The Seventh Horse and Other Stories*, E.P. Dutton, 1988

Caws, Mary Ann *Surrealism and the Literary Imagination: A Study of Breton and Bachelard*, Mouton & Co., The Hague and Paris, 1966

_____ *Eye in the Text: Essays on Perception, Mannerist to Modern*, Princeton University Press, 1981

_____ , Rudolf E. Kuenzli and Gwen Raaberg [eds], *Surrealism and Women*, MIT Press, Cambridge, Massachusetts, 1991

_____ *The Surrealist Look: An Erotics of Encounter*, MIT Press, Cambridge, Massachusetts, 1997

_____ [ed.] *Joseph Cornell's Theater of the Mind: Selected Diaries, Letters and Files*, MIT Press, Cambridge, Massachusetts, 2000

_____ *Dora Maar, with and without Picasso*, Thames and Hudson, London and New York, 2000

_____ [ed.] *Surrealist Painters and Poets: An Anthology*, MIT Press, Cambridge, Massachusetts, 2001

_____ [ed.] *Manifesto: A Century of isms*, Bison Books, University of Nebraska Press, Lincoln, 2001

_____ [ed.] *Surrealist Love Poems*, Tate Publishing, London/University of Chicago Press, 2002

Cernuschi, Claude 'Mindscapes and mind games: Visualizing thought in the work of Matta and his Abstract Expressionist contemporaries', in Elizabeth Goizueta, ed., *Matta: Making the Invisible Visible*, McMullen Museum of Art, Boston College, Boston, 2004

Chadwick, Whitney *Women Artists and the Surrealist Movement*, Little, Brown & Co., Boston, 1985

_____ [ed.] *Mirror Images: Women, Surrealism and Self-Representation*, MIT Press, Cambridge, Massachusetts, 1998

Char, René *Oeuvres Complètes*, ed. Jean Roudaut, in collaboration with Lucie and Franck André Jamme, Tina Jolas and Anne Reinbold, Collection Bibliothèque de la Pléiade, Éditions Gallimard, Paris, 1983

_____ *Selected Poems*, trans. Mary Ann Caws, with Tina Jolas, New Directions, New York, 1992

Chénieux-Gendron, Jacqueline *Le Surréalisme*, Presses Universitaires de France, Paris, 1984; trans. Vivian Folkenflik, *Surrealism*, Columbia University Press, New York, 1990

_____ [ed.] *'Il y aura une fois': Une anthologie du surréalisme*, Éditions Gallimard, Paris, 2002

Claverie, Jana [ed.] *Styrsky, Toyen, Heisler,*

Le Centre, Paris, 1982

Cohen, Margaret *Profane Illumination: Walter Benjamin and the Paris of Surrealist Revolution*, University of California Press, Berkeley and Los Angeles, 1993

Colville, Georgiana *Scandaleusement d'elles: trente-quatre femmes surréalistes*, Éditions Jean-Michel Place, Paris, 1999

Combalía, Victoria *Dora Maar Fotógrafa*, Centre Cultural Bancaixa, Barcelona 1995

Conley, Katharine *Automatic Woman: The Representation of Woman in Surrealism*, University of Nebraska Press, Lincoln, 1996

_____ 'Modernist Primitivism in 1933: Brassaï's *Involuntary Sculptures* in *Minotaure*', *Modernism/Modernity*, 10: 1, January 2003

Conlin, Aimée Holloway *et al.*, *Convulsive Beauty: The Impact of Surrealism on American Art*, Whitney Museum of American Art, New York, 1988

Cottom, Daniel *Abyss of Reason: Cultural Movements, Revelations and Betrayals*, Oxford University Press, New York, 1991

Cowling, Elizabeth *Picasso: Style and Meaning*, Phaidon, London, 2002

Crevel, René *Babylone* [1927] Jean-Jacques Pauvert, Paris, 1986; trans. Kay Boyle, *Babylon: A Novel*, North Point Press, San Francisco, 1985

_____ *Les Pieds dans le plat*, Éditions du Sagittaire, Paris, 1933; trans. Thomas Buckley, *Putting My Foot in It*, Dalkey Archive Press, Normal, Illinois, 1992

Curiger, Bice *Meret Oppenheim: Defiance in the Face of Freedom*, Parkett verlag, Zurich; MIT Press, Cambridge, Massachusetts; Institute of Contemporary Arts, London, 1989. Includes catalogue raisonné.

Dalí, Salvador *The Collected Writings of Salvador Dalí*, trans. and ed. Haim Finkelstein, Cambridge University Press, 1998

Dalí, Salvador retrospective, 1920-1980, Centre Georges Pompidou, Paris, 1980

De Chirico, Giorgio *The Memoirs of Giorgio de Chirico*, Da Capo Press, New York, 1994

Demos, T. J. 'Duchamp's Labyrinth: First Papers of Surrealism, 1942', *October*, 97, Cambridge, Massachusetts, Summer 2001

De Naeyer, Christine *Paul Nougé et la photographie*, Didier Devillez, Brussels, 1995

Derrida, Jacques and Paule Thevenin, trans. Mary Ann Caws, *The Secret Art of Antonin Artaud*, MIT Press, Cambridge, Massachusetts, 1998

Desnos, Robert *La Liberté ou l'Amour!*, Éditions du Sagittaire, Paris, 1927; trans. Terry Hale, *Liberty or Love*, Atlas

Press, London, 1993

_____ *Écrits sur les peintres*, ed. Marie-Claire Dumas, Flammarion, Paris, 1983

_____ *Oeuvres*, ed. Marie-Claire Dumas, Éditions Gallimard, Paris, 1999

Dessins surréalistes: visions et techniques Centre Georges Pompidou, Paris, 1995

Didi-Huberman, Georges *La Peinture incarnée*, Éditions de Minuit, Paris, 1985

_____ *L'Invention d'hystérie*, Paris [1982]; trans. *Invention of Hysteria: Charcot and the Photographic Iconography of the Salpêtrière*, MIT Press, 2003

Dumas, Marie-Claire *Robert Desnos ou l'exploration des limites*, Klincksieck, Paris, 1980

_____ and Katherine Conley [eds], *Desnos pour l'an 2000*, Éditions Gallimard, Paris, 2000

Dupin, Jacques *Joan Miró: Life and Work*, Harry N. Abrams, New York, 1962

Dupuis, Jules François [Raoul Veneigen] *A Cavalier History of Surrealism*, trans. Donald Nicholson-Smith, AK Press, Edinburgh, 1999

Durozoi, Gérard *Histoire du mouvement surréaliste*, Éditions Hazan, Paris, 1997; trans. Alison Anderson, *History of the Surrealist Movement*, University of Chicago Press, 2002. Includes a 25-page bibliography, arranged by subject categories and artists' names.

Dyn facsimile reprint edition, Springer verlag, Vienna, 2000

Eburne, Jonathan P. 'That Obscure Object of Revolt: Heraclitus, Surrealism's Lightning-Conductor', *Symploke*, 8: 1-2, 2000

L'Écart absolu Galerie de l'Oeil, Paris, 1965

Éluard, Paul *Oeuvres Complètes*, ed. Marcelle Dumas and Lucien Scheler, préface de Lucien Scheler, 2 vols., Collection Bibliothèque de la Pléiade, Éditions Gallimard, Paris, 1968

Ernst, Max *Histoire naturelle*, J. Bucher, Paris, 1926; reprinted, Jean-Jacques Pauvert, Paris, 1960

_____ *La Femme 100 têtes*, Éditions du Carrefour, Paris, 1929; trans. *The Hundred Headless Woman*, George Braziller, New York, 1981

_____ *Une Semaine de Bonté*, J. Bucher, Paris, 1934

_____ *Beyond Painting*, Wittenborn, Schultz, New York, 1948

Exposition Surréaliste d'Objets Galerie Charles Ratton, 1936

Fer, Briony *On Abstract Art*, Yale University Press, 1997

First Papers of Surrealism Co-ordinating Council of French Relief Societies, New York, 1942

Flam, Jack with Miriam Deutch, Carl Einstein [eds] *Primitivism and Twentieth-Century Art: A Documentary History*, University of California Press, Berkeley and Los Angeles, 2003

Foster, Hal *Compulsive Beauty*, MIT Press, Cambridge, Massachusetts, 1993. See also 'L'Amour faux', *Art in America*, January 1986; 'Signs Taken for Wonders', *Art in America*, June 1986; and 'Armour fou', October, Spring 1991

Foucault, Michel *Ceci n'est pas une pipe*, Fata Morgana, Montpellier, 1973; trans. James Harkness, *This is Not a Pipe*, University of California Press, Berkeley and Los Angeles, 1983

Fouchet, Max-Pol *Wifredo Lam*, Rizzoli, New York, 1976

Francés, Esteban Fundaçion Eugenio Granell, Santiago de Compostela, 1997

Gablik, Suzi *Magritte*, Thames and Hudson, London and New York, 1970

Gale, Matthew *Dada and Surrealism*, Phaidon Press, London and New York, 1997

Gascoyne, David *A Short History of Surrealism*, Cobden-Sanderson, London, 1935

Giacometti, Alberto *Écrits*, Hermann, Paris, 1990

Gibson, Ian *The Shameful Life of Salvador Dalí*, Faber and Faber, London, 1997

Gille, Vincent [ed.] *Si Vous aimez l'amour: Anthologie amoureuse du surréalisme*, Syllepse, Paris, 2001

Greeley, Robin Adele 'Dalí's Fascism; Lacan's Paranoia', *Art History*, 24: 4, September 2001

Greenberg, Clement 'Surrealist Painting' (1944-45), in *Clement Greenberg: The Collected Essays and Criticism*, Vol. 1, ed. John O'Brian, University of Chicago Press, 1986

Guerlac, Suzanne *Literary Polemics: Bataille, Sartre, Valéry, Breton*, Stanford University Press, Stanford, California, 1997

Hammond, Paul *The Shadow and Its Shadow: Surrealist Writings on the Cinema*, City Lights Books, San Francisco, 2000

d'Harnoncourt, Anne, and Kynaston McShine [eds] *Marcel Duchamp*, The Museum of Modern Art, New York, 1973

Harris, Steven 'Beware of Domestic Objects: Vocation and Equivocation in 1936', *Art History*, 24: 5, November 2001

_____ *Surrealist Art and Thought in the 1930s: Art, Politics and the Psyche*, Cambridge University Press, 2004

Hollier, Denis *La Prise de la concorde*, Paris, 1974; trans. Betsy Wing, *Against Architecture*, MIT Press, Cambridge, Massachusetts, 1989

Hubert, Renée Riese *Surrealism and the Book*, University of California Press, Berkeley and Los Angeles, 1988

Hulten, Pontus [ed.] *The Surrealists Look at Art*, The Lapis Press, Santa Monica, 1991

Infra-noir [1947]; reprinted periodical. Collection of publications by the Romanian surrealist group, La Maison de Verre, Paris, 1996

International Exhibition of Surrealism/Exposición internacional del surrealismo Galeria de Arte Mexicano, 1940

International Surrealist Exhibition Preface by André Breton. New Burlington Galleries, London, 1936

L'Invention collective [1940], ed. René Magritte and Raoul Ubac; reprinted periodical, Didier Devillez, Brussels, 1995

Ivsic, Radovan *Toyen*, Filipacchi, Paris, 1974

Jean, Marcel *Histoire de la peinture surréaliste*, Éditions du Seuil, Paris, 1959; trans Simon Watson Taylor, *The History of Surrealist Painting*, Grove Press, New York, 1960

_____ [ed.] *Autobiographie du surréalisme*, [anthology], Éditions du Seuil, Paris, 1978; trans. Marcel Jean, *et al.*, *The Autobiography of Surrealism*, Viking Press, New York, 1980

Jouffroy, Alain *Brauner*, G. Fall, Paris, 1959; revised edition, 1996

Kachur, Lewis *Displaying the Marvellous: Marcel Duchamp, Salvador Dalí and Surrealist Exhibition Installations*, MIT Press, Cambridge, Massachusetts, 2001

Kahlo, Frida, and Tina Modotti Whitechapel Art Gallery, London, 1982. With texts by Laura Mulvey and Peter Wollen

Kaplan, Janet *Unexpected Journeys: The Art and Life of Remedios Varo*, Abbeville Press, New York, 1988

Kiesler, Frederick J., Endless Space ed. Dieter Bogner, Hatje Cantz, Ostfildern, Germany, 2001. Includes essays by Lisa Phillips and Anthony Vidler, and reprint of Kiesler's *Manifesto of Correalism*.

Krauss, Rosalind E. *Passages in Modern Sculpture*, Grossman/Viking, New York, 1977; reprinted by MIT Press, Cambridge, Massachusetts, 1981

_____ 'Giacometti', in William S. Rubin [ed.] *'Primitivism' in Twentieth-Century Art: Affinity of the Tribal and the Modern*, Vol. 2, The Museum of Modern Art, New York, 1984

_____ 'The Photographic Conditions of Surrealism', *The Originality of the Avant Garde and Other Modernist Myths*, MIT Press, Cambridge, Massachusetts, 1985

_____ and Jane Livingston [eds] *L'Amour fou: Photography and Surrealism*, Abbeville

Press, New York, 1985. With essays by Krauss, Livingston and Dawn Adès.

_____ *The Optical Unconscious*, MIT Press, Cambridge, Massachusetts, 1993

_____ *Bachelors*, MIT Press, Cambridge, Massachusetts, 1999

Kuenzli, Rudolf E. [ed.] *Dada and Surrealist Film*, Willis, Locker and Owens, New York, 1987; reprinted by MIT Press, Cambridge, Massachusetts, 1996

Lacan, Jacques *Écrits: A Selection*, trans. Alan Sheridan, Tavistock Press, London/W.W. Norton, New York, 1977

Lamba, Jacqueline Norlyst Gallery, New York, 1944

Lebel, Jean-Jacques 'On the Necessity of Violation', in Mariellen R. Sandford [ed.] *Happenings and Other Acts*, Routledge, London and New York, 1995

Lebel, Jean-Jacques: *des années cinquante aux années quatre-vingt-dix* Mazzotta, Milan, 1991

Le Brun, Annie *Vagit-Prop, Lâchez tout, et autres textes*, Ramsay J.J. Pauvert, Paris, 1990

_____ *Qui vive! Considerations actuelles sur l'inactualité du surréalisme*, Ramsay-Pauvert, Paris, 1991

_____ *Hans Bellmer et son graveur Cécile Reims*, Issoudun, 1992

Légitime défense [1932]; reprinted periodical, Éditions Jean-Michel Place, Paris, 1979

Leiris, Michel and Georges Limbour, *André Masson et son univers*, Éditions des Trois Collines, Geneva and Paris, 1947

_____ *Wifredo Lam*, Fratelli Fabri, Milan; Harry N. Abrams, New York, 1970

Les Lèvres nues [1954-58], ed. Marcel Marien; reprinted periodical, Éditions Plasma, Paris, 1978; Éditions Allia, Paris, 1995

Levy, Julien [ed.] *Surrealism*, Black Sun Press, New York, 1936; reprinted Da Capo, New York, 1995

Lewis, Helena *The Politics of Surrealism*, Paragon House, New York, 1990

Linhartova, Vera 'La Peinture surréaliste en japon, 1925-1945', *Cahiers du Musée National d'Art Moderne*, 11, Paris, 1983

Linsley, Robert 'Wifredo Lam: Painter of Négritude', *Art History*, 11, December 1988

Livingston, Jane *Lee Miller: Photographer*, W.W. Norton & Co., New York, 1989

Littérature [1919-24], reprinted periodical, Éditions Jean-Michel Place, Paris, 1978

Lomas, David *The Haunted Self: Surrealism, Psychoanalysis, Subjectivity*, Yale University Press, New Haven, Connecticut, 2001

Mabille, Pierre *Le Miroir du Merveilleux*,

Éditions du Sagittaire, Paris, 1940; reprinted by Editions de Minuit, Paris, 1977

McEvilley, Thomas 'Basic Dichotomies in Meret Oppenheim's Work', in Jacqueline Burckhardt, Bice Curiger, McEvilley, Nancy Spector, *Meret Oppenheim: Beyond the Teacup*, Solomon R. Guggenheim Museum, New York, 1996

McShine, Kynaston [ed.] *Joseph Cornell*, The Museum of Modern Art, New York, 1980

Magritte, René *Écrits complets*, Flammarion, Paris, 1979

Magritte, René Galerie Nationale du Jeu de Paume, Paris; English edition D.A.P., New York, 2003. Essays by Jean Roudaut, Patrick Roegiers, Daniel Abadie, Jean-Michel Goutier, Bernard Noël, Sarah Whitefeld, Renilde Hammacher; introduction by Alain Robbe-Grillet.

Man Ray *Self-Portrait* [1963] Little, Brown and Co., Boston, Massachusetts, 1998

Masson, André *Le Plaisir de peindre*, La Diane française, Nice, 1950

_____ *Le Rebelle du surréalisme: Écrits*, ed. Françoise Will-Levaillant, Hermann, Paris, 1976

Matta, Roberto *Entretiens morphologiques: Notebook No. 1, 1936-1944*, Sistan, Paris, 1987

Matthews, J.H. *The Imagery of Surrealism*, Syracuse University Press, 1977

Minotaure [1933-39], reprinted periodical, Skira, Geneva, 1981

Mélusine Cahiers du Centre de Recherche sur le Surréalisme, ed. Henri Behar, L'Âge d'homme, Paris. Published since 1980, this journal includes special issues on Czech Surrealism, Surrealism in Egypt, etc.

Miró Joan Centennial Retrospective, The Museum of Modern Art, New York, 1993; essay by Caroline Lanchner; catalogue raisonné; full bibliography

Miró Joan Centre Georges Pompidou, Paris, 2004; texts by Agnès de la Baumelle, Rémi Labrusse, Rosalind E. Krauss, *et al.*

Monahan, Laurie 'Massoni: The Face of Violence', *Art in America*, 88: 7, July 2000

Morise, Max 'Les Yeux enchantés', *La Révolution surréaliste*, 1, Paris, 1 December 1924

Mundy, Jennifer *et al.* *Surrealism: Desire Unbound*, Tate Publishing, London/Princeton University Press, New Jersey, 2001

Nadeau, Maurice *Histoire du surréalisme* [first volume, Paris, 1944]; definitive edition: Éditions du Seuil, Paris, 1964; trans. Richard Howard, *The History of Surrealism*, Macmillan, New York, 1965; reprinted Belknap Press, Harvard

University, Cambridge, Massachusetts, 1989. Includes concise bibliographies of 'principal works in which the surrealist spirit has been manifested'; periodicals, manifestos, tracts, leaflets, catalogues, etc.

Naville, Pierre *La Révolution et les intellectuels*, Éditions Gallimard, Paris, 1927; reprinted 1975

Neff, Terry Ann R. [ed.] *In the Mind's Eye: Dada and Surrealism*, Museum of Contemporary Art, Chicago/Abbeville, New York, 1985; includes essays by Dawn Adès, Rosalind Krauss, Lowery Stokes Sims, and catalogue of works in Chicago collections

Néon [No. 1, 1948], reprinted periodical, ed. Sarane Alexandrian, *et al.*, Maison des Arts Thonon-Évian, Thonon-les-Bains, France, 1996

Nochlin, Linda *The Body in Pieces: The Fragment as a Metaphor of Modernity*, Thames and Hudson, London and New York, 1994

_____ *Representing Women*, Thames and Hudson, London and New York, 1999

Nougé, Paul *Magritte ou les images défendues*, Les Auteurs Associés, Brussels, 1943

_____ *Subversion des images*, Les Lèvres nues, Brussels, 1968

Oesophage [1925], reprinted periodical, Didier Devillez, Brussels, 1993

Onslow Ford, Gordon *Towards a New Subject in Painting*, San Francisco Museum of Modern Art, 1948

Onslow Ford, Gordon: Retrospective Oakland Museum, Oakland, California, 1977

Paalen, Wolfgang *Form and Sense*, Wittenborn and Co., New York, 1945

Paris–New York Centre National d'Art et de Culture Georges Pompidou, Paris, 1977; reprinted 1991

Paz, Octavio and Roger Caillois, *Remedios Varo*, Ediciones Era, Mexico City, 1966

Penrose, Roland *The Road is Wider Than Long*, London Gallery, London, 1939; reprinted in facsimile, Arts Council of Great Britain, 1980; J. Paul Getty Museum, 2003

_____ *Picasso*, Grasset, Paris, 1961

_____ *Man Ray*, Éditions de Chêne, Paris; Thames and Hudson, London and New York, 1975

Péret, Benjamin and the Association des amis de Benjamin Péret, *Oeuvres Complètes*, 7 vols., Losfeld/José Corti, Paris, 1969

_____ *A Marvellous World: Poems* [French/English] trans. Rachael Stella, Louisiana State University Press, Baton Rouge, 1985

_____ trans. Rachel Stella, *Death to the Pigs and Other Writings*, University of

Nebraska Press, Lincoln, 1988

Perpetual Motif: The Art of Man Ray National Museum of American Art, Smithsonian Institution, Washington, D.C./Abbeville Press, New York, 1989

Picon, Gaëtan *Journal du surréalisme, 1919-1939*, Éditions Skira, Geneva, 1976; trans. *Surrealists and Surrealism*, Rizzoli, New York/Macmillan, London, 1983

Pierre, José [ed.] *Recherches sur la sexualité: Janvier 1928-août 1932*, Éditions Gallimard, Paris, 1990; trans. Malcolm Imrie, *Investigating Sex: Surrealist Research, 1928-1932*, with afterword by Dawn Adès, Verso, London and New York, 1992

Polizzotti, Mark *Revolution of the Mind: The Life of André Breton*, Farrar, Straus and Giroux, New York, 1994

Pontalis, J.-B. 'Les Vases non communicants', *La Nouvelle revue française*, 302, 1 March 1978

Powers, Edward D. 'Meret Oppenheim, or These Boots Ain't Made for Walking', *Art History*, 24: 3 June 2001

Pressley, William 'The Praying Mantis in Surrealist Art', *Art Bulletin*, December 1973

Raeburn, Michael [ed.] *Salvador Dalí: The Early Years*, Thames and Hudson, New York, 1994

Read, Herbert *Surrealism*, Faber & Faber, London, 1936

Regards sur Minotaure: la revue à tête de bête Musée d'art et d'histoire, Geneva/Musée Rath/Musée d'art moderne de la Ville de Paris, 1987

Remy, Michel *Surrealism in Britain*, Lund Humphries, London, 2001

La Révolution surréaliste [1924-29], reprinted periodical, Éditions Jean-Michel Place, Paris, 1975

Richardson, Michael and Krzysztof Fijalkowski [ed. and trans.] *Surrealism Against the Current: Tracts and Declarations*, Pluto Press, London, 2001

_____ and Krzysztof Fijalkowski, *Refusal of the Shadow: Surrealism and the Caribbean*, Verso, London and New York, 1996

Roscoe Hartigan, Lynda and Richard Vine, Robert Lehrman, Walter Hopps, *Joseph Cornell: Shadowplay Eterniday*, Thames & Hudson, London, 2003

Rosemont, Franklin *André Breton and the First Principles of Surrealism*, Pluto Press, London, 1978

Rosemont, Penelope *Surrealist Women: An International Anthology*, University of Texas Press, Austin, 1998

Roudinesco, Elisabeth *Jacques Lacan & Co. - A History of Psychoanalysis in France, 1925-1985*, trans. Jeffrey Mehlman, University of Chicago Press, 1990

Rubin, William S. *Dada and Surrealist Art*, Harry N. Abrams, Inc., New York, 1968

_____ [ed.] *'Primitivism' in Twentieth-Century Art: Affinity of the Tribal and the Modern*, 2 vols., The Museum of Modern Art, New York, 1984

Sage, Kay, 1889-1963 Herbert F. Johnson Museum of Art, Cornell University, Ithaca, New York, 1977

Sage, Kay–Yves Tanguy Wadsworth Atheneum, Hartford, Connecticut, 1954

Sartre, Jean-Paul *What is Literature?* trans. Bernard Frechtman, Harper and Row, New York, 1965

Sawin, Martica *Surrealism in Exile and the Beginning of the New York School*, MIT Press, Cambridge, Massachusetts, 1995. See also the colour illustrated catalogue, *Surrealistas en el Exilio y los Inicios de la Escuela de Nueva York*, Museo Nacional Centro de Arte Reina Sofía, Madrid, 1999. With texts by Martica Sawin, Lisa Jacobs, Charles Seliger, *et al.* [Spanish/English]

Sayag, Alain *Bellmer photographe*, Filipacchi; Centre Georges Pompidou, Paris, 1984

_____ and Claude Schweisguth, *Matta*, Centre Georges Pompidou, Paris, 1985

_____ *et al.*, *Brassaï*, Centre Georges Pompidou, Paris/Thames & Hudson, London, 2000

_____ and Emmanuelle de L'Ecotais, *Man Ray: Photography and Its Double*, Ginkgo Press, Corte Madera, California, 2000

Scott, David *Paul Delvaux: Surrealizing the Nude*, Reaktion Books, London, 1992

Schaffner, Ingrid and Lisa Jacobs [eds] *Julian Levy: Portrait of an Art Gallery*, MIT Press, Cambridge, Massachusetts, 1998

Schneede, Uwe *The Essential Max Ernst*, trans. R.W. Last, Thames and Hudson, London and New York, 1972

_____ *Surrealism*, Du Mont Schauberg verlag, Cologne, 1973; English edition, Harry N. Abrams, Inc., New York, 1974

Schor, Naomi *Reading in Detail: Aesthetics and the Feminine*, Routledge, London and New York, 1987

Schuster, Jean *Archives 57/68*, Éric Losfeld, Paris, 1969

Schwarz, Arturo *Man Ray: The Rigour of the Imagination*, Thames & Hudson, London, 1977

_____ [ed.] *I Surrealisti*, Mazzotta, Milan, 1989

Semin, Didier *Victor Brauner*, Filipacchi, Paris, 1991

Senghor, Léopold Sédar [ed.] *Anthologie de la nouvelle poésie nègre et malgache de langue française*, prefaced by Jean-Paul Sartre, 'Orphée noir', Presses Universitaires de France, Paris, 1948; reprinted 1977

Shattuck, Roger *The Banquet Years: The Origins of the Avant-garde in France, 1885 to World War I*, Harcourt, Brace & Co., New York, 1955; revised, Vintage Books, New York, 1968

Soupault, Philippe *Écrits de cinéma, 1918-1931*, Plon, Paris, 1979

_____ and William Carlos Williams, *Last Nights of Paris*, 1st ed., Full Court Press, New York, 1982

Spies, Werner *Loplop the Artist*, Thames and Hudson, London and New York, 1983

_____ *Max Ernst: Collages: The Invention of the Surrealist Universe* [1974]; trans. John W. Gabriel, Abrams, New York, 1991

_____ [ed.] *Max Ernst: A Retrospective*, Prestel verlag, Munich/Tate Publishing, London, 1997

_____ *et al.*, *La Révolution surréaliste*, Centre Georges Pompidou, Paris, 2002

Spiteri, Raymond and Donald LaCoss [eds] *Surrealism, Politics and Culture*, Ashgate Press, Burlington, Vermont, 2003

Srp, Karel *Karel Teige*, Torst, Prague, 2001

Stich, Sidra *Anxious Visions: Surrealist Art*, University Art Museum, Berkeley, California/Abbeville Press, New York, 1990

Stone-Richards, Michael 'Encirclements: Silence in the Construction of Nadja', *Modernism/Modernity*, 8: 1, January 2001

Suleiman, Susan Rubin *The Female Body in Western Culture: Contemporary Perspectives*, Harvard University Press, Cambridge, Massachusetts, 1986

_____ *Subversive Intent: Gender, Politics and the Avant-Garde*, Harvard University Press, Cambridge, Massachusetts, 1990

Le Surréalisme au service de la Révolution [1930-33], reprinted periodical, Éditions Jean-Michel Place, Paris, 1976

Le Surréalisme en 1947: Exposition internationale du surréalisme Éditions Maeght, Paris, 1947

Le Surréalisme et le livre Galerie Zabriskie, Paris, 1991

El surrealismo en España Museo Nacional Centro de Arte Reina Sofía, Madrid, 1994

Surrealism: Revolution by Night [eds Michael Lloyd, Ted Gott, Christopher Chapman], National Gallery of Art, Canberra, 1993

Sylvester, David [ed.] *René Magritte, Catalogue raisonné*, 7 vols., The Menil Foundation, Houston, Texas; Rizzoli, New York, 1992-97

_____ *Magritte: The Silence of the World*, The Menil Foundation, Houston, Texas, 1992

Tanning, Dorothea *Birthday*, The Lapis Press, Santa Monica, 1986

Tashjian, Dickran *A Boatload of Madmen: Surrealism and the American Avant-Garde, 1920-1950*, Thames and Hudson, London and New York, 2001

Taylor, Sue *Hans Bellmer; the Anatomy of Anxiety*, MIT Press, Cambridge, Massachusetts, 2000

Thirion, André *Revolutionaries Without Revolution*, Macmillan, New York, 1975

Thrall Soby, James *Yves Tanguy*, The Museum of Modern Art, New York, 1955

Toyen Moderna Museet, Stockholm, 1985

Tropiques [1941-45], ed. Aimé Césaire and René Menil; reprinted periodical, 2 vols., Éditions Jean-Michel Place, Paris, 1978

Tzara, Tristan *Oeuvres complètes*, ed. Henri Béhar Henri, 6 vols., Flammarion, Paris, 1975-1991

Vasseur, Catherine 'L'Image sans memoire: a propos du cadavre exquis', *Cahiers du Musée National d'Art Moderne*, 55, Centre Georges Pompidou, Paris, Spring 1996

von Maur, Karin [ed.] *Salvador Dalí, 1904-1989*, Staatsgalerie, Stuttgart/Kunsthaus, Zurich, 1989

_____ *Yves Tanguy and Surrealism*, Staatsgalerie, Stuttgart/Hatje Cantz, 2000/Menil Collection, Houston, Texas, 2001

Vovelle, José *Le Surréalisme en Belgique*, André de Rache, Brussels, 1972

Waldberg, Patrick *Max Ernst*, Jean-Jacques Pauvert, Paris, 1958

_____ *Surrealism*, Thames and Hudson, London and New York, 1965

Waldman, Diane *Joseph Cornell: Master of Dreams*, Abrams, New York, 2002

Walker, David H. *Outrage and Insight: Modern French Writers and the 'Fait Divers'*, Berg French Studies, Washington, D.C., 1995

Walker, Ian *City Gorged with Dreams: Surrealism and Documentary Photography in inter-war Paris*, Manchester University Press, Manchester, England, 2002

Walz, Robin *Pulp Surrealism: Insolent Popular Culture in Early Twentieth-Century Paris*, University of California Press, Berkeley and Los Angeles, 2000

Weisberger, Edward *et al.*, *Surrealism, Two Private Eyes: The Nesuhi Ertegun and Daniel Filipacchi Collections*, 2 vols, Solomon R. Guggenheim Museum, New York, 1999. With introductory texts by Rosalind E. Krauss, José Pierre, Werner Spies

Winter, Amy *Wolfgang Paalen: Artist and Theorist*, Praeger, New York, 2002

Zürn, Unica *L'Homme jasmin*, Éditions Gallimard, Paris, 1971; trans. Malcolm Green in *The Man of Jasmine and Other Texts*, Atlas Press, London, 1994

INDEX

PUBLISHER'S ACKNOWLEDGEMENTS
We would like to thank all those who gave their kind permission to reproduce the listed material. Every effort has been made to secure all reprint permissions and the editors and publisher apologize for any inadvertent errors or omissions. If notified, the publisher will endeavour to correct these at the earliest opportunity.

We would also like to thank all those who, directly or indirectly, have contributed to the making of this volume; in particular: Mary Ann Caws' Assistant Editor, Jonathan Eburne, Postdoctoral Fellow at the Center for Humanistic Enquiry, Emory University, Atlanta, Georgia; Professor Dawn Adès, Director of the AHRB Research Centre for Studies of Surrealism and its Legacies at the University of Essex, who generously accepted the role of external reader during the book's early stages; Dr Donna Roberts, also of the Research Centre, for contributing the extended captions on pages 67, 80, 87 (a), 101 (b), 102 (a), 104 (b), 107 (a), 111 (a), 114 (b), 118, 120–3, 126 (a), 141–3, 156–7, 161, 163, 165, 166, 168, 171, 175, 178, 180, 183 (a), 184–9. For their generous co-operation we particularly thank the Daniel Filipacchi Collection, New York; and Adam Boxer, Director, Ubu Gallery, New York. We would also like to acknowledge the following individuals and organizations: Estate of Eileen Agar, London; Hans Arp and Sophie Taueber Arp Foundation and Museum, Rolandseck, Germany; The Art Institute of Chicago (The Lindy and Edwin Bergman Collection; The Mary and Earle Ludgin Collection; The Marjorie Blum-Kovler Collection and the Harry and Maribel G. Blum Foundation); Artothek, Weilheim, Germany; Mme. Soizic Audouard, Paris; Kunstmuseum, Basel; Bayerische Staatsgemäldesammlung, Munich; Galerie Berinson, Berlin; Museo de Bellas Artes, Bilbao; Kunstmuseum, Bern (Hermann und Margrit Rupf-Stiftung); Museum Boijmans Van Beuningen, Rotterdam; Brent Sikkema Gallery, New York; Bridgeman Art Library, London; British Film Institute, London; Alastair Brotchie, London; Bibliothèque Charcot, Salpêtrière, Paris; Christie's Images Ltd. London; The Salvador Dalí Museum, St. Petersburg, Florida; Davison Art Center, Wesleyan University, Middletown, Connecticut; Galerie Patrick Derom, Brussels; Bibliothèque Paul Destribats, Paris; Mme. Aube Elléouët; Museum Folkwang, Essen; Galerie 1900–2000, Paris; J. Paul Getty Museum, Los Angeles; The Solomon R. Guggenheim Foundation, New York; Peggy Guggenheim Collection, Venice; Catherine Heard, Toronto; Galleria Internazionale d'Arte Moderna, Venice; Ishibashi Museum of Art, Kurume, Japan; IVAM, Institut Valencià d'Art Modern, Valencia; Jersey Heritage Trust, St Helier, Jersey; Los Angeles County Museum of Art;

Lucid Art Foundation, Inverness, California; Len Lye Foundation, Govett-Brewster Art Gallery, New Plymouth, New Zealand; Fondation Marguerite et Aimé Maeght, Saint-Paul, France; Maison Européenne de la Photographie, Paris; Massimo Martino Fine Arts and Projects, Mendrisio, Switzerland; The Menil Collection, Houston; Lee Miller Archives, Sussex, England. All works by Lee Miller © Lee Miller Archives, England 2004; Moderna Museet, Stockholm; The Henry Moore Foundation, Leeds, England; Vik Muniz, New York; The Museum of Modern Art, New York; National Gallery of Art, Smithsonian Institution, Washington, D.C.; Kunstsammlung Nordrhein-Westfalen, Dusseldorf; Musée d'Orsay, Paris; The Roland Penrose Collection, Sussex, England. All works by Roland Penrose © Roland Penrose Estate, England 2004; Philadelphia Museum of Art; Musée Picasso, Paris; Musée national d'art moderne, Centre Georges Pompidou, Paris; Museo Nacional Centro de Arte Reina Sofía, Madrid; Royal Museums of Fine Arts of Belgium, Brussels; Musée d'Art Moderne de Saint-Etienne, France; San Francisco Museum of Modern Art; Scala Archives, Florence and London; Scottish National Gallery of Modern Art, Edinburgh; Kunstmuseum Silkeborg, Denmark; Staatsgalerie, Stuttgart; Tate Gallery, London; Vassar College Art Gallery, Poughkeepsie, New York; and those private collectors who wish to remain anonymous.

PHOTOGRAPHERS
Lars Bay/Kunstmuseum, Silkeborg, Denmark: p. 100; Joachim Blauel/Artothek: p. 150; Kunstmuseum Bern: p. 64; Bibliothèque nationale, Paris (Roger-Viollet, Paris): p. 32; Yves Bresson/Musée d'Art Moderne de Saint-Etienne: p. 156; Christie's Images, London: p. 56; © CNAC/MNAM/Dist RMN: pp. 43, 152, 162, 164, 174–5; Kristin Fiore: p. 42 (centre); Claude Germain/Fondation Maeght, Saint-Paul, France: p. 22 (centre); John Kasnetz-kis: p. 166; Bernd Kirtz BFF/Wilhelm Lehmbruck Museum, Duisburg: p. 71; Peter Lauri/Kunstmuseum Bern: p. 59; Christian Manz. Zurich: p. 116 (top); George Platt-Lynes: p. 39 (right); Public Art Fund, New York: p. 42 (left); © Photo SCALA, Florence/The Museum of Modern Art, New York: pp. 54, 62, 173, 182; John Schiff, New York: pp. 2–3; 117 (bottom); Raoul Ubac: p. 38 (right); Graydon Wood/Philadelphia Museum of Art: pp. 90–91.

AUTHOR'S ACKNOWLEDGEMENTS
What an amazing team for this project, as for the others in this series. Ian Farr, who invited me to write and edit this volume, was a great in-house editor, with a remarkable energy in his discoveries, suggestions, and research for the extended captions, undertaken collaboratively with Dr Donna Roberts, to whom I am also indebted. I owe major thanks to my assistant editor Jonathan Eburne for his very constructive critical reading of all the material throughout the project. The insuperable Dawn Adès gave invaluable suggestions when the manuscript was in its early stages. I would also like to thank Melissa Larner for her editorial work; the designer Adam Hooper for his elegantly conceived layouts; Samantha Woods for researching the artists' biographies; Lisa Cutmore for typing all the texts in the anthology; Diana LeCore for compiling the index; and Bill Jones for supervising the proofing and printing stages.

For their assistance over the years, I would like to thank François Chapon, Yves Peyré, and the staff, respectively, of the Bibliothèque littéraire Jacques Doucet and the Bibliothèque nationale in Paris; as well as the staff of the Museum of Modern Art; the Thomas Watson Library in the Metropolitan Museum; and the New York Public Library, all in New York City. The fellowships of the Getty Foundation, Guggenheim Foundation, the Rockefeller Foundation, the National Endowment for the Humanities, the Florence Gould Foundation, and the Research Foundation of the City University of New York have been invaluable, as have many stays at the Camargo Foundation in Cassis, France.

The various lectures I have been invited to give and the discussions following them at museums in France, at the Sorbonne (the University of Paris IV), at Jussieu (the University of Paris VII), at the University of Bordeaux and the University of Tours; in London, at the Architectural Association, and for surrealist conferences at the Edward James house in West Dean, Sussex; in Canada: at the museums of Winnipeg, Manitoba, and of Hamilton, Ontario, have been most useful, as have those in St. Petersburg, Florida, the University of Florida, Gainesville, the University of Toledo, Ohio, the Institute of Visual Arts and the Guggenheim Museum in New York; at various lectures for conferences of the Comparative Literature Association, the Modern Language Association, and the College Art Association. For their featuring of my anthology of Surrealist Love Poems (published to coincide with Jennifer Mundy's wonderful 'Desire Unbound' exhibition at Tate Modern, London) and my talk connected with it, I want to thank the Chicago Humanities Festival, one of my favourite annual events.

For his continuous enthusiasm and support, I want most earnestly to thank Roger Conover of the MIT Press. For their collaborative enthusiasm in our overseeing of the French Modernist Series, my thanks as always to Richard Howard and Patricia Terry, which whom I have had a grand time translating poetic texts over the years. This issues forth from the University of Nebraska Press, where Willis Regier founded so very much; to him, we are, many of us, always grateful. The Yale University Press, and its super-energetic John Kulka, in publishing my overambitious Yale Anthology of Twentieth Century French Poetry gave the present volume a further impetus, for some of the translations of poetry found here.

Over the years, my discussions with my students at the Graduate School of the City University of New York have been of great assistance, probably more to me than to them, as have the many interchanges with my colleagues and friends in the field of Surrealism, and in adjoining fields of intellectual/poetic/aesthetic and moral endeavour. I want to express my absolute conviction that without their hospitality to ideas as to persons, images and texts, much, much less would have been done: Above all, first, to Yves Bonnefoy, Jacques Derrida, Annie Le Brun and Radovan Ivsic, the late Marguerite Bonnet; to Marie-Claire Dumas, Aube Elléouët, and the late Jacqueline Lamba, the late Elisa Breton, Etienne-Alain Hubert and Philippe Bernier; to the late Edmond Jabès; to Rosalind Krauss, with whom I had the privilege of giving seminars in Surrealism and in the Theory of Representation; to Hedda Sterne, and Dorothea Tanning; to Ruedi Kuenzli, with whom editing the journal DADA/SURREALISM has been a great joy; to Henri Béhar and Jacqueline Chénieux-Gendron; to Dore Ashton and Jack Flam; and to Elza Adamowicz, Jill Anderson, Arakawa and Madeline Gins, Howard Argenbraum, Paul Auster, Michel Beaujour, Ian and Deborah Boyd-Whyte; Roger Cardinal, Roger Celestin, Michèle Cone, Kate Conley, Tom Conley, Tom Czaszar, Donna De Salvo, my cousin Deborah Gage, Carolyn Gill, Franck André Jamme, Gerhard Joseph, Rosemary Lloyd, Judith Mallin, Renate Motherwell, Alastair Noble, Mark Polizzotti, Jean-Yves Pouilloux, Christopher Prendergast, Michael Pretina, Valérie Richez, Michael Riffaterre, Ronnie Scharfman, Michael Sheringham, Robert Stuart Short, Ellen Handler Spitz, Malcolm and Janet Swan, Alyson Waters; and of course, as always, to Boyce Bennett, Matthew Caws, Hilary Caws-Elwitt, and Jonathan Caws-Elwitt, Peg Rorison, and Sarah Bird Wright.

Phaidon Press Limited
Regent's Wharf
All Saints Street
London N1 9PA

Phaidon Press Inc.
180 Varick Street
New York, NY 10014

www.phaidon.com

First published 2004
Abridged, revised and updated 2010
© 2004 Phaidon Press Limited
All works © the artists or the estates
of the artists unless otherwise stated.

ISBN 978 0 7148 5673 5

A CIP catalogue record of this book
is available from the British Library.

Designed by Hoop Design

Printed in China

cover, Frida Kahlo
What the Water Gave Me
(Lo que el agua me ha dado)
1938–39

pages 2–3, Marcel Duchamp
'Mile of String', exhibition installation,
'First Papers of Surrealism', New York,
1942. Photograph by John Schiff

page 4, Max Ernst
Habakuk
1934
Collection, Wilhelm Hack Museum,
Ludwigshafen, Germany